"Blakelock is one of the great treasures and great mysteries of the American nineteenth century." —*The New York Times*

Praise for *The Unknown Night:*

"One of the most extraordinary art scams I have ever read about. *The Unknown Night* is an exceedingly readable book. Vincent's descriptions of old New York are marvelous . . . and the narrative of Blakelock's travels among the Indians in the lost world of the West is compelling."
—Arthur C. Danto, *Bookforum*

"Compelling reading . . . Vincent succeeds admirably, giving weight and complexity to his subject's life, examining the artistic and intellectual influences on his work, and tracing the emergence of his own original style." —Judith Maas, *The Boston Globe*

"As fascinating as any fiction . . . *The Unknown Night* sheds light on a period in American history that seems distant in its details, yet contemporary in its attitudes about artists, art and celebrity."
—S. L. Berry, *Indianapolis Star*

"Spellbinding. Compellingly and empathetically told, this chronicle is a must for art lovers and anyone with a passion for turn-of-the-century history and culture." —*Publishers Weekly*

"Vincent makes a fair case for considering [Blakelock] as a man who has more in common with late-twentieth-century art practices than those of the 1880s, and whose initial obscurity, followed by the notoriety of his final years, says a good deal about art, money and reputation in America."
—John Loughery, *The Washington Post Book World*

"As fast-paced as an Agatha Christie, but too mad to be invented and completely unsettling by dint of its reality."
—Andrew Solomon, author of *The Noonday Demon*

"A probing, top-flight study. Vincent shows how [Blakelock's] landscapes had a poetry and glow suggesting not just an intuitive vision but a startlingly Modernist one—focused, luminous, pulling the landscape out of the pastoral and into, if not the subconscious, at least the imagination."
—*Kirkus Reviews* (starred review)

"Glyn Vincent explores quintessential themes of American optimism and despair: mysticism vies with the market, true artistry is bitterly shadowed by con-artistry, and genius ricochets into madness."
—Philip Gourevitch, *New Yorker* staff writer and author of *We Wish to Inform You That Tomorrow We Will Be Killed With Our Families*

"Vincent brilliantly relates the startling story of America's 'most expressive and idiosyncratic' nineteenth-century painter with the suspense and metaphorical richness of fiction, eloquently defining the particular vision and magic of Blakelock's highly charged landscapes. . . . An arresting and ultimately haunting portrait."
—*Booklist* (starred review)

"An exceptionally well researched and admirably written account of one of the most poetic stories in the history of American art."
—Caleb Carr, author of *The Alienist*

THE UNKNOWN NIGHT

Glyn Vincent

THE UNKNOWN NIGHT

THE GENIUS AND MADNESS OF R. A. BLAKELOCK, AN AMERICAN PAINTER

Grove Press
New York

Published simultaneously in Canada
Printed in the United States of America

FIRST PAPERBACK EDITION

Library of Congress Cataloging-in-Publication Data
Vincent, Glyn.
The unknown night : the genius and madness of R. A. Blakelock,
an American painter / Glyn Vincent.— 1st ed.
p. cm.
Includes bibliographical references and index.
ISBN 0-8021-4064-5 (pbk.)
1. Blakelock, Ralph Albert, 1847–1919. 2. Painters—United States—
Biography. I. Blakelock, Ralph Albert, 1847–1919. II. Title.
ND237 .B6 V55 2003
759.13—dc21 2002029747

Grove Press
841 Broadway
New York, NY 10003

04 05 06 07 08 10 9 8 7 6 5 4 3 2 1

CONTENTS

PART IV: ON THE LINE

PART V: MOONLIGHT

PART VI: FAME AND MISFORTUNE

INTRODUCTION:
LOOKING FOR BLAKELOCK

One bright winter morning, in the course of writing this book, I set out to visit Ralph Albert Blakelock's grave. It didn't seem to require much research. At the time of his death in 1919, Blakelock was the most celebrated artist in America, his life chronicled on the front pages of newspapers across the country. The art cognoscenti deemed him a founder of modern American landscape painting. His funeral, at the Grace Episcopal Church on Broadway at Tenth Street in New York, was well attended. President Woodrow Wilson sent his condolences. After the service, Mrs. Van Rensselaer Adams, the artist's companion and guardian, read the president's message to the newspaper reporters who had gathered on the steps outside the church. While the publicity-savvy Mrs. Adams talked up the press, Mrs. Blakelock and five of her children—the youngest, Douglas, dressed in his U.S. Navy uniform—brooded on the sidelines in the summer heat. The funeral cortege then proceeded to Woodlawn Cemetery in the Bronx where, according to the newspaper accounts and the few published works that exist on Blakelock, he was buried.

The Sunday following his burial, the *New York Times Magazine*—in an issue dominated by pictures of victorious American soldiers cele-

brating the end of World War I—ran a spread on Blakelock. The article's author, sensitive to the sensationalism surrounding the artist's mental health, was quick to disassociate Blakelock's genius from his insanity. Passing skittishly over Blakelock's more disturbing modern works, the author focused on the naturalistic and "sane" paintings of the artist's career. He particularly liked one of Blakelock's fairy-tale Indian scenes that hung in the Metropolitan Museum of Art in New York.

> *The Indian Encampment* . . . is one of the canvases into which the artist has packed the fruits of close observation and has succeeded in fusing the detail in one noble and serene vision . . . No one can look at the picture without feeling the peculiar sanity of its appeal and the soothing quality of the performance.

Following World War I the country, a powerful, industrial nation wracked by strikes and division, longed for uncomplicated peace and prosperity. Blakelock's quiet images of American Indians in the wilderness seemed safe and distant. His romantic vision of America's past, the author implied, made a fitting coda to an era.

If nostalgia was Blakelock's calling card for some, his mystic, jarringly personal vision attracted others. It was Blakelock's moody, hallucinogenic landscapes that made his reputation as America's most daring experimental artist of the nineteenth century. Sanity and mental illness aside, it was the critics' growing admiration of Blakelock's radical, expressive style that led to his rise to prominence and significance in the contentious struggle to define American art at the turn of the century.

Given Blakelock's flirtation with greatness, I expected his grave at Woodlawn to stand out. I imagined a modest monument with a distinguishing stone cross or angel at its head. Perhaps there would be a revealing epitaph inscribed in the gray marble. His parents or his wife, I thought, might lie nearby. I should have known better. Few facts about Blakelock's life are set in stone.

A call to Woodlawn Cemetery confirmed that Blakelock had been buried there, but a clerk informed me that he had been "removed" in May 1921. It turned out that he had been taken to Kensico Cemetery in Valhalla, in New York's Westchester County. The records offered no explanation for the move, but considering the ill will and legal proceedings that had taken place between Mrs. Blakelock and Mrs. Adams, I guessed that his relations had moved Blakelock to a family plot.

However, the authorities at Kensico informed me that Blakelock's plot was owned not by the Blakelocks but by Mrs. Adams and her associate John Agar. Blakelock had, in fact, been moved to Valhalla in 1921, but for some reason his burial date was recorded as 1929—that is, eight years later. This was pretty unusual, the cemetery clerk conceded on the phone, but he couldn't give me an explanation. I was told the section and row where Blakelock was buried. Upon my arrival I would be given a cemetery map in order to find the exact location of the grave.

As it turned out, I didn't drive up to the stone entrance of the cemetery until nearly four in the afternoon. Kensico is a vast, bucolic graveyard lying in a broad hollow between two sets of wooded hills. The ground was covered with a stiff mantle of snow. The sky, blue earlier, had become pale, tinted by the weak rays of the lowering sun. The last funeral cortege of the day wound its way to a freshly dug-up plot.

Armed with my map, I drove to section 32, then got out of my car to trudge through the snow. I was at the bottom of a small ridge. The rows of monuments rose up to the crook of the incline, then petered out near a line of trees that descended the northern side of the hill. A glade of rhododendron bushes partially obscured the slope. Marching this way and that I finally found the right area. I located two of the three grave sites marked on the map as adjoining Blakelock's. His grave was, supposedly, at the end of the row nearest the tree line. At first I saw nothing. Then I noticed peeking out from under the snow a large granite monument lying horizontally along the ground. I kicked away the icy crust and used my bare hand to brush away the dry snow underneath. I made out the name Rebecca—Blakelock's wife's middle

name—but the last name was wrong. This was the third grave. According to the map, Blakelock's plot was no more than ten feet farther down the incline. But where the grave was supposed to be there was only a tall, spindly tree. I kicked away the snow all around the tree until I got to the frozen yellow grass. No grave. Blakelock had seemingly disappeared again.

There was nothing to do but look up at the fading sky—which Blakelock loved to paint—and watch the crows flap from tree to tree, cawing as they went. I was perplexed and yet gratified somehow by Blakelock's stubborn evasiveness. Monuments did not suit this mystic who believed (like William Blake and George Inness, he was a Swedenborgian) that the spiritual world was as present as the physical one. It seemed only appropriate that Blakelock, whose perambulatory life was filled with evictions and insult, should have been bandied about after his death and then vanished.

This, then, is the strange story of Ralph Albert Blakelock, an artist who dared to paint like no other in his time, a man raised in a crowded tenement who traveled to the American West to live with the vanishing tribes of American Indians, and who, after a tumultuous career and incarceration in a mental hospital, became at the dawn of the modern era America's most famous, revered, and exploited artist.

THE UNKNOWN NIGHT

I

EXHIBITION

Lovers and Madmen have such seething brains
Such shaping fantasies that apprehend
More than cool reason ever comprehends
 —Shakespeare, *A Midsummer Night's Dream*

I never went into the street but I thought the people stared and
laughed at me and held me in contempt. They who knew me
seemed to avoid me and if they spoke to me they seemed to
do it with scorn.
 —William Cowper, 1763

1

NEWS

One damp April morning in 1916, Harrison Smith, a young reporter for the *New York Tribune*, left the Tribune Building on Nassau Street in a hurry. Dodging the crowds on the narrow sidewalks of lower Manhattan he headed for the subway kiosk on Park Row. He was on his way uptown to catch the Hudson Tubes to the New Jersey side of the Hudson River. In Jersey City he would board another train for Middletown, New York. It wasn't an obvious destination to chase down a story. In fact, senior reporters, who routinely got their names on the front page, hardly left the office at all. They were too busy writing up the dispatches that arrived from all over the world via telegraph, telephone, and that new noisy mechanical angel the aeroplane, which appeared like a gnat against the blustery American sky. There was plenty of news. German zeppelins were raining bombs on the English coast. The French were defending Verdun. Pancho Villa was hiding out from the American Tenth Cavalry in the rocky gulches of the Sierra Nevada Mountains. Smith, on the other hand, faced a two-hour trip on a hard bench seat in a drafty carriage with a view of bare trees and muddy farm fields. He was on his way to interview an American artist, Ralph Albert Blakelock, who

for the past fifteen years had been incarcerated, and largely forgotten, in an asylum in Middletown.

Smith later claimed that he personally rediscovered Blakelock. In fact, he was heading to Middletown at the suggestion of Beatrice Van Rensselaer Adams, a young woman he had found waiting outside the city editor's office early that very morning. Adams was a well-coifed vamp—attractive, with dark hair and "glittering" black eyes—who passed herself off as a philanthropist. She had already tipped off the *Tribune*'s competitors to the Blakelock story. In fact, by the time Smith got on the train that day both the *New York Times* and New York's largest paper, Joseph Pulitzer's *World*, had already run a series of prominent articles on Blakelock. Far from being the first on the scene, Smith was actually playing catch-up. Two weeks before, a lifetime in the fiercely competitive world of New York's battling dailies, the *World*, at Beatrice Adams's bidding, had sent an editor up to the asylum to do a front-page story on the artist who was being bandied about in the papers as "America's greatest painter."

Blakelock, once a prominent New York artist, had been committed first to the Long Island State Hospital in Flatbush in 1899. He was transferred to the more isolated hinterlands of Middletown in 1901. Blakelock, the man, was soon forgotten. Yet almost as soon as the doors closed behind him Blakelock's reputation redoubled, as did the market for his work. Considered on a par with such American masters as Whistler, Sargent, Inness, Homer, and Ryder, the paintings Blakelock had sold in hard times for $25 or $30 were being sold by dealers and collectors for hundreds, sometimes thousands of dollars (paying more than a thousand dollars for a painting was considered wildly extravagant at the time). There was such a demand for Blakelocks that the *New York Evening Post* noted in 1903 that "every exhibition or sale has one or more of his [Blakelock's] work, and no collection, however small, is thought to be complete without a canvas or two by him." In particular demand were Blakelock's luminous moonlights, which, well known among the cognoscenti, had achieved a legendary status among collectors and artists. By 1913, a Blakelock moonlight, now in the Corcoran Gallery in Washington, D.C., sold for a record auction price

of $13,900. The sale caused quite a stir. That same year, Blakelock was finally elected an associate academician at the National Academy of Design. Soon after, Elliott Daingerfield, a fellow artist, published a biography of Blakelock, and an important exhibition of Blakelock, Inness, and Wyant was held in Chicago, further solidifying their reputation as America's top three landscape painters. Despite his fame in the art world, Blakelock remained sequestered in Middletown, unheralded and penniless. He passed his time painting small impressionistic landscapes on cigar box lids that no one, except for certain members of the staff, took any notice of.

It wasn't until 1916, fifteen years after his incarceration in Middletown, that Blakelock's anonymity was shattered. The extraordinary sale on February 22, 1916, of *Brook by Moonlight*—a brooding canvas in the Romantic style, completed about 1890—set a second record price. The moonlight was auctioned along with the rest of the famous art collection of the bankrupt silk mill tycoon Catholina Lambert. The stubby, self-made Yorkshireman had built a three-story art gallery in his castle—dubbed Balmoral by William Carlos Williams—on the cliffs overlooking Paterson, New Jersey, to show off his collection. Estimated to be worth more than $1 million, it included artists from Botticelli to Monet. But it was Blakelock's four-by-six-foot moonlight that was the most talked about during the presale exhibition. One newspaper review of the exhibit observed:

> Although higher prices may be obtained for the Titian, the Andrea del Sarto, the Rembrandt, the Botticelli and other of the old masters, undoubtedly the most interesting picture in the collection is the marvellous *Moonlight* by the American, R. A. Blakelock.

As it turned out, the top price on February 22 went to Blakelock. It has been suggested that the record-high prices paid for Blakelock paintings at this time were brought on by the public "hysteria" about the artist. The truth is that at the time of the sale, Blakelock, in Middletown, was still being ignored by the press, and the sensationalist stories

about him didn't begin to circulate until after his record-setting sales. Indeed, one of the strangely overlooked facts about Blakelock's career is that the popularity of his moonlights began not in 1916 but decades before, when he had received enthusiastic praise for his first exhibited monumental moonlight, *A Waterfall, Moonlight,* in 1886.

Blakelock's moonlights often left critics breathless and somewhat inarticulate. The paintings, they said, had a mystical or spiritual presence, a color-saturated luminosity that was difficult to describe with words. They were repeatedly called "poetic" or "lyrical." Certainly, there was a dramatic, romantic sentiment attached to some of Blakelock's more popular moonlight compositions that today appears dated, but even these paintings have a tenebrous, chiaroscuro veil that evokes something other, something beyond. In *Brook by Moonlight,* the viewer is sequestered in a secret dark place on the bank of a forest stream. Overhead a large tree leans precipitously from the opposite steep bank, its massive canopy of lacy foliage splintering the lambent glow of the moon. It's a dreamy landscape, naturalistically depicted but entirely imaginary in setting. Blakelock was not so much duplicating a place as he was an experience, a state of consciousness. It was as if the viewer himself were lying on the bank of a stream under the summer moonlight, with the trees rustling above and the vast lonely universe all around.

The dark, melancholy aspect of Blakelock's painting evidently appealed to the tycoon Lambert, who had a tragic personal history of his own. Not that that made him any more generous when he acquired the painting in 1891. He bought the painting either early that year when Blakelock, in a fragile state of mind, was playing the piano on the vaudeville circuit in Paterson or—there are several different stories—later that summer when Blakelock was resting on Lambert's estate in Pennsylvania after his first breakdown. Blakelock had, in any event, asked for at least one thousand dollars for the canvas and only reluctantly accepted Lambert's final offer of six hundred dollars.

In the auction in the Plaza Hotel ballroom on February 22, the first bid after the olive-green curtains were swept aside to reveal the moonlight was $14,000. In four minutes, amid considerable applause, it was sold to the Toledo Museum for $20,000—a record in 1916 for the sale at auction of work by a living American painter. The suave auctioneer, Thomas E. Kirby, obviously pleased, called *Brook by Moonlight* the "finest work ever done by an American artist."

Such high-flown praise was, some thought, exaggerated. Even so, most critics agreed that there was no other nineteenth-century American painter quite as original as Blakelock. He had done more than any other artist, with the possible exception of Albert Pinkham Ryder—whom he frequently was compared to—to wrest American landscape painting from its pastoral foundations. In Blakelock's hands, an art that was once considered the reflection of an "objective" place became an expression of subconscious feelings. "Blakelock was by nature a dreamer," wrote the critic Raymond Wyer in 1916. "To call him a landscape painter is incorrect. No artist has used the landscape as means to an end more than he."

Indeed, Blakelock's radical paintings of the 1880s and 1890s took self-expression into an imaginary realm that had as much in common with the abstract expressionist ideas of Jackson Pollock, Franz Kline, and Mark Rothko in the mid-twentieth century as it did with the painters of his own time. "It goes, in certain directions, beyond anything produced by any other American," *The Nation* commented in 1916 on the precocious nature of Blakelock's work. Contrasting his paintings to the "more objective" work of Homer, Wyant, and Inness, *The Nation* opined that Blakelock "has occupied a field which has scarcely been touched by any of these . . . Blakelock goes furthest in his freedom from conscious premeditation and his complete triumph over the limitations of his medium."

There was considerable pride in the many articles that followed up the *Brook by Moonlight* sale that an American work brought such a high price (a Pierre-Auguste Renoir sold for only $16,000). It was noted, too, that the total for the eleven Blakelocks in the sale, more than

$46,000, was well above those achieved by the Botticellis, the Rembrandts, the Renoirs, the Monets, the Pissarros, and the rest. In a country whose art market had been dominated for more than a century by European paintings, this was considered quite a coup.

No sooner had *Brook by Moonlight* arrived at the Toledo Museum than it was packed up and shipped back to New York to be shown at an exhibit of Blakelock's paintings being held at the Reinhardt Galleries on Fifth Avenue. The exhibit opened to great fanfare on April 3, 1916. It had been organized as part of a concerted effort to gain the release of Blakelock from the asylum and provide a fund to support the impoverished artist and his family. Photographs of Blakelock, his paintings, and Mrs. Adams, the pretty, photogenic philanthropist who had "rescued" the painter from anonymity, had been featured in many of the city's papers. The Blakelock story seemed to have been more than adequately covered. Still, Harrison Smith, who claimed to have "a scent for a front-page story," was convinced that the artist's impending visit to the city would grab even grander headlines. About this Smith was right. The public's curiosity for Blakelock was to prove insatiable. The discovery of a destitute mad genius whose mysterious paintings had millionaires bidding fortunes was the kind of Horatio Alger myth Americans loved. Blakelock was fast becoming an American success story, a tragedy averted, a calamitous life with a happy ending. At least it seemed so.

As the train slowly puffed its way through the Ramapo hills, Smith had more than two hours to mull over what he had learned about Blakelock. The commonly known, or rather *believed* known, facts were few. Blakelock was born in New York in 1847, the son of a physician. His father wanted him to study medicine, but Blakelock's passion was for music and art. "So repugnant was the thought of the career of a physician," one early biographical article stated about Blakelock, "that he resolved, whatever might be the cost, to become his own master, and unaided, to seek fame with brush and palette." Blakelock was ambitious, no doubt about that. He was a small wisp of a man who moved quickly, taking the stairs two at a time even in his sixties. His long fine hands were like a leprechaun's, Smith later wrote, and they

dashed through the air as he spoke. He was ethereal in a down-to-earth sort of way. He mostly wrote home asking for art materials, but he was also quite concerned about getting new tailored clothes, his cigars and cigarettes. He was not a heavy drinker, but he mentioned bouts of drinking wine—real or imagined—to the staff. At the hospital, Blakelock never missed an "entertainment." He was not at all averse to playing a popular tune on the piano. His tastes were democratic; he was as happy with vaudeville as with opera, a reader of Longfellow, one suspects, more often than of Virgil.

Blakelock was said to be a pleasant companion, but he was hardly a cosmopolitan or social person, and he was far too esoteric and sensitive to be a truly gregarious man. He was moody, and at the hospital he often kept to himself, spending many hours with his nose buried in a newspaper or a book. Sometimes he went to the piano to play— insofar as he could—more serious music like Beethoven and Wagner. He was a devotee of the arcane spiritual writings of Emanuel Swedenborg, a mystic whose unorthodox interpretation of Christianity was popular among nineteenth-century intellectuals and spiritualists. Blakelock's favorite activity was to be outside alone, close to nature, deep in the woods by some babbling brook. Indeed, most of his early career was spent tramping through the forests of New England and exploring the deep wildernesses out west. Several newspapers had gotten hold of a picture of him as a young adventurer, his hair swept back, his handsome, aristocratic face held high, his eyes beaming with idealism.

If time had allowed, Smith might also have found in the *Tribune* archives references to Elliott Daingerfield's brief 1914 biography of Blakelock. In it Daingerfield stressed that Blakelock was a self-taught artist who, he stated, had learned about color on his journeys west among the American Indians. "When the barbaric depth of their color, the richness and plenitude of reds and yellows, the strength and brilliancy of light awakened his vision," Daingerfield wrote, "his own soul, an untamed one, responded to no conventional law; these children of the forests and plain appealed to his deepest instincts."

Many writers mentioned Blakelock's childlike, impractical personal-
ity. Those who knew him attested to his "unswerving convictions" and
his devotion to art. There were those who considered his idealism
"lofty." He was known to become quite testy when criticized. Invariably,
people meeting Blakelock came away uttering clichés about his vitality,
his genius, his soulful blue eyes. Critics often likened him to Romantics
such as Walt Whitman or Edgar Allan Poe. One critic, Harriet Moore,
compared him to Chopin. "He was a combination of painter and musi-
cian," she ventured. "Blakelock was a mystic and a colorist . . . a soul so
sensitive, so fiery, highly wrought, that he could scarcely be at home on
earth."

The most recent newspaper articles Smith found played up Blake-
lock's years of hardship and neglect, the times when he walked the
streets, his long hair beaded, a dagger in his waistband, carrying his
canvases under his arm in search of a buyer. If Smith had dug deeper
he would have found stories alluding to Blakelock's previous erratic
and violent behavior—that he had burned and torn up hundred-dollar
bills in the streets, attacked people, and threatened his family. The
painter was, the articles said, still deluded. He was prone to "exalted"
states. He imagined that he was royalty and that his paintings were
worth millions. He conflated money and art, painting million-dollar
bills on rectangular sheets of cloth, landscapes on one side, denomi-
nations on the other. He sometimes rambled incoherently about
strange subjects—dissertations "on astral bodies and communications
with Mars." But these were merely aberrant eccentricities, the sto-
ries intoned, attributable to his years of poverty and suffering. Given
the right support and environment, it was believed, Blakelock might
soon get back to creating masterpieces. The *World* wrote:

> Blakelock is no longer violently insane; his illusions are now
> no more pronounced than they were during the years when
> he painted his greatest pictures, when the line between
> insanity and genius was barely distinguishable . . . His
> interest in art and his ambition to paint have recently shown
> signs of revival.

Blakelock had been diagnosed with dementia praecox, the term then used for illnesses of a schizophrenic nature. But the director of the asylum, Dr. Maurice Ashley, said that Blakelock's mental deterioration had been "arrested," and that his interest in his work was reviving. "He . . . sits around and sketches and has made scores of paintings under the most difficult conditions," Ashley reported at a meeting at the Biltmore Hotel in New York to raise funds for the artist. He added that Blakelock came frequently to his house to dine and play the piano, and had "adopted" his two daughters. "He is as harmless and appreciative as a child," Ashley told an audience composed of wealthy patrons of the arts, museum directors, and reporters.

Blakelock's visitors remarked that he became noticeably more focused when discussing art or his paintings. He was conversant with the Impressionists and Barbizon painters, knew a Diaz from a Dupré, admired Rousseau. Reporters scoured his recent work for signs of genius. "One sketch, especially attractive for the sky tints, approaching the beauty of the old Blakelock colorings, was done on a scrap of brown wrapping paper seven by four inches," a reporter dutifully wrote.

Was Blakelock a visionary genius or were his paintings just the haphazard expressions of a disturbed mind? Romantic notions held that genius and madness went hand in hand. No doubt the specter of insanity added an aura of mystery to Blakelock the artist, linking him with edgy luminaries like Poe and Coleridge. Still, there was a powerful stigma associated with mental illness as well. Perhaps Blakelock's "vision" was a freak of nature, and his art was no more conscious than a child's. Most critics assumed, incorrectly, that because Blakelock was mentally ill, he did not know how to draw or make something look like it "should." It had taken a lifetime for Blakelock's work to be accepted by the artistic establishment. There was a very thin line between having work dismissed, like so much Impressionist and Cubist art was at the time, as the work of a true madman or lauded as the masterpiece of a prescient genius.

There was a lot at stake. For the moment, though, Smith could take solace, as most everyone was rooting for Blakelock, the genius.

*　*　*

It was almost midday by the time Smith saw the tannery stacks of Middletown. A short car ride out of town and up a hill afforded him a view of the vast landscaped grounds of the Middletown State Homeopathic Hospital. It was a dignified asylum, a sort of Rhenish manor built with tall walls of brick and pitched slate roofs with turrets and cupolas. It looked like a prestigious college, and it seemed to promise that there was something to be learned or gained from the experience of being mad. The white gravel drive swept up to the main steps of the administration building. There, patients could be dropped off and, presumably, picked up. It was hoped one would graduate. At least that was the aspiration of the progressive thinkers who had founded the asylum in 1874, and who believed, in their utopian fervor, that insanity could be cured by a pleasant environment, a proper diet, and plenty of fresh air.

Inside, Smith found that Middletown, unlike the urban asylums known as "snake pits," had all the trappings of a Victorian home. There were parlor rooms and solariums furnished with rocking chairs, card tables, and heavy tasseled curtains. Potted palms filled the empty corners. Here the inmates could discuss the news in the papers, the probabilities of Villa's capture, the dalliances of Pickford and Chaplin. On holidays, the patients were allowed to gather in the recreation room to dance around a Victrola. Female nurses stood watch, wearing starched aprons over their ankle-length uniforms.

Yet even such a seemingly genteel atmosphere could not conceal the fact that Middletown, in its forty-two years of existence, had been able to cure few of its patients. The population had grown exponentially to the point where Middletown had, in all but name, become an ill-financed warehouse for more than two thousand mostly incurable mentally ill patients. Hundreds of depressives, schizophrenics, and epileptics were housed in open wards. The noise was deafening. Many patients had little control over their behavior. They bit attendants, thrust their hands through panes of glass, ranted against unseen enemies for hours on end. The hospital had, at times, as few as nine certified doctors on hand, and a staff of uneducated, badly paid nurses

to control the population. The job was so demanding that many left after only a few months.

Smith had a tiresome wait the morning he arrived at the asylum. But at length a staff physician was found to escort him. The doctor led Smith away from the cheery entranceway through a warren of long, gloomy corridors, where the reporter described encountering "hundreds of blank, hideous faces, the wandering and inane glances, the gibbering mouths and idiotic laughter of the hopelessly mad inmates." By the time they reached the door of Blakelock's small room Smith was expecting the worst. The moment of truth had arrived.

> The first glimpse of him was a shock of a different kind than had been expected. A little brown-faced man was reading a paper in the sunlit room. His iron-gray hair and the bright gray eyes that his spectacles could not dim seemed to belie his sixty-nine years, and when he threw down his paper and jumped to his feet to welcome the visitor his hand clasp was as firm as a young man's. Outwardly his appearance bears no trace of the tragic life that has been his fate, and the courtesy with which he offered his guest the spare chair in the room was a characteristic that must have been born in the man.

At least momentarily, Blakelock seemed the very model of propriety, composure, and sanity.

2

THE ASYLUM

By the time of Harrison Smith's visit to Middletown in 1916, Blakelock's most troubled and violent years were well behind him. Years of enforced routine, various treatments, and freedom from the worries and pressures of the world had calmed him. He had been given a semiprivate room in an open wing. It was a small, spartan cell on the first floor, which Blakelock shared with a patient we know only by his nickname, Lizzie. They had two cots, two chairs, and a beat-up wardrobe, which had only a few worn pieces of clothing hanging inside it. The window was guarded by a diamond-patterned iron grille and looked out on a flat expanse of lawn crisscrossed by gravel paths that were shaded in the summer by young maple trees. Three times a day Blakelock had to line up at the stairs to descend into the cavernous basement dining room where hundreds of patients were served at the same time. There were work hours and activities, but the rest of the time Blakelock was free to do as he pleased.

It had not always been so. When Blakelock had first been transferred to Middletown in 1901 he was sometimes kept in locked quarters. Only fifty-three years old, he was not at all ready to spend the rest of his life in an asylum. He told his keepers that he had been put

in Middletown by mistake. "[He] wants it understood that no one has any authority over him: he is a 'guest' not a patient. 'He ought to be in the Union League club, not here.'" He was working as a secret agent for the government, which he said would pay a large ransom for his return. Uncooperative, he sometimes became "irritable," "quarrelsome," and "violent." He was on a number of occasions sent to a special ward to be disciplined and was subject to a number of experimental treatments at Middletown, the most ubiquitous, and relatively harmless, "cure" at the time being hydrotherapy. Patients were strapped under canvas covers for several hours at a time in large tubs of circulating, steaming hot water (occasionally, at other hospitals, it was reported that patients were forgotten and had scalded to death). Not surprisingly, the patients were in a limp and pliant state on their emergence from their hot baths. But the baths did not stop Blakelock from wishing he was back in New York.

In his letters to his wife, Cora, Blakelock pined for home, always being sure to mention just how long—sometimes to the month—he had been away. Despite his aggressive behavior, his separation from her and their children had been a terrible blow. He had known Cora since 1865, when she had been just a child. In their thirty-two years of marriage, before he was institutionalized, they had hardly spent a night apart. Despite the abusive behavior, Cora never doubted her husband's deep affection for his family. "He was extremely fond of his children never wanting to be separated from them and doing all in his power to keep the family together," Cora wrote. "His highest ambition was to make a pleasant home for us; an ambition that was never realized." In his letters he wrote that his return to New York was imminent. He frequently demanded that a new suit be ordered from his tailor, Smith and Gray, and that his studio on Fifty-seventh Street (which was no longer his) be prepared for his return.

My Dear Cora,
I received a visit from our little daughter, almost as large as you are, a few days ago, and requested some writing paper, stamps and one bottle of Sochnee Freres's varnish. It was given to Mr. Richmond, here; he placed it rightly with me. . . .

I hope you will further all things for my immediate
departure to 58 W. 57th St. New York City. There are some
more paintings ready for here now, I hope you will call and get
them soon. You may bring this letter with you, so in case of
[my] absence, you might select what you want . . . This letter
will show that I intend for you to have them. I hope Mary got
home safely. My regards as the papa to C.E.B., Marion, Ralph,
Melville, Mary, Louis, Ruth, Allen, Douglas and memories
for little Claire [who had died in 1884] and many kind wishes
for your best welfare to your hearts desire. I try my best to
flirt with the girls, but knowing that I am not just quite the
proper caper. I am yet the same.

<div style="text-align:right">

Yours,

R. A. Blakelock

</div>

Only gradually, as the years went by, did the permanence of his situ-
ation sink in. In October 1903 he wrote to Cora: "Home again, I can-
not say, it is as yet; if not soon to be, I guess it will be in some far off
sunny clime because so long delayed."

Cora's request to have Blakelock paroled from the asylum in 1902
failed, and after that communication between the two dwindled. At
times Blakelock lost all interest in doing anything. One hospital re-
port noted:

Patient slowly but progressively deteriorating mentally . . . He
is indifferent to surroundings and it has often been necessary
to place canvases and material in his room in order to get him
interested in his work. Eats poorly.

Schizophrenia, a form of which he was most likely suffering from, can
be a progressively debilitating disease. Without chemical treatment
many schizophrenic patients become increasingly paranoid and with-
draw from the world; some patients become catatonic, lose their appe-
tite, and waste away until, eventually, they die. However, with what is
now being called late-onset schizophrenia (describing people who first

exhibit symptoms of schizophrenia after the age of forty), it has been observed that some patients' most radical symptoms actually diminish with age. They learn to deal with their auditory and visual hallucinations and their behavior moderates. The economics genius John Nash, who also suffered from schizophrenia, is said to have recovered from the disease. Few in the medical community, however, believe that a complete cure is possible (extended periods of remission, though, are common). The key determinant of the disease, experts say, is a patient's emotional detachment—the more catatonic, the more serious the condition. Middletown hospital records kept over the course of Blakelock's stay indicate that the artist's mental condition seesawed between lucidity and psychosis; some of Blakelock's symptoms resemble those of people suffering from bipolar disorders. He had periods of severe mania and withdrawal, and weighed at times less than seventy pounds, but at other times the physicians noted that Blakelock behaved "but little differently from a normal individual . . . He plays pool at night and reads the papers." Records indicate that gradually his behavior became less violent and bizarre. Except for occasions when Blakelock was acting out, Dr. Ashley placed him in an unlocked ward and gave him the privilege to roam the grounds and to paint.

On good days, when Blakelock was feeling well, he gathered what materials he had—sometimes reduced to painting with the brushes that he had constructed by wiring cat hairs to sticks and, to paint on, pieces of torn window shades—and set off across the fields to some lonely place. Surrounded by the rustling trees, he painted the landscape: tiny summer scenes with impressionistic daubs of bright color, abstract watercolors—some made with tobacco juice—of autumnal forests being stripped clean of their leaves, white winter oils tinted with a blue reminder of the cold that easily penetrated his threadbare clothes.

Cora sent Blakelock a small supply of art materials whenever she could afford it. Benjamin Altman, the department store magnate, once sent Blakelock twenty dollars with which the hospital supplied him with a few oils and canvases. Other times he was dependent on the meager odds and ends that the state-funded hospital would give him. Nevertheless, Blakelock continued to paint, except during his most

debilitating depressions. Painting was more than a career; it was a way of life for him, a kind of Joseph Cornell–like obsession. Blakelock lived in his own world. He was, as was Cornell, often inspired by found objects—a piece of board, a mottled stone, or a wrinkled piece of tin. At Middletown he made jewelry and painted on anything he could find: wallpaper, cigar box lids, candy wrappers, or old shirttails. Textures and surfaces entranced him. In his masterpieces he applied layer upon layer of paint, scraping down each application with a pumice stone, then adding on top thin inky images so palpable and fragile that the dark lacy outlines of his trees seem to ignite on contact with his molten skies.

Moody, and in love with the paint, in his prime some of his canvases became not so much landscapes as conflagrations of contrasting deep colors and shadow. In his best paintings, "everything in the landscape—tree trunks, branches, clouds, rocks, hills—are whipped up by an all-consuming, convulsive rhythm," writes Abraham Davidson in his 1996 monograph on the artist.

There was both a Romantic and a precociously modern passion at work in Blakelock; that is to say, while he was inspired by nature and landscape in *some* form, he also felt compelled to express his own viewpoint and emotions. "The laws of the art of painting are the laws of the creator," he said.

At Middletown, Blakelock's brief painting forays into the countryside were all that remained of his former life. Removed from the wider arena of New York's highly competitive art world, Blakelock was no longer painting to secure a reputation or to pay the rent. If anything, his paintings had become more carefree, more open, brighter, and far more colorful. On his way home from his walks, Blakelock knew that his dinner was waiting for him, that his bed was still there, that there were no creditors knocking on the door. Middletown had become another kind of home, the doctors and nurses his family. Back in his room, he carefully placed his creations in the shoe drawer of his wardrobe.

Until 1916, Blakelock's ascension in the art world had little practical or psychological effect on the painter. Occasionally informed of the honors being bestowed upon him, Blakelock continued his life in the

asylum as before. At times he was engaged, painting his pictures and giving them as gifts to his friends and physicians. At other times, however, Blakelock's condition deteriorated to a dangerous point. He had few, if any, visitors. He received no money. The press ignored him.

In the spring of 1916, however, the dam burst and Blakelock's quiet days at the asylum were rudely interrupted by fame and fortune. What happened that spring is partly attributable to the legendary reputation of Blakelock's moonlights and, specifically, to the extraordinary price paid for *Brook by Moonlight* at the auction of Lambert's collection at the Plaza Hotel in February. In and of itself, however, the sale— the money did not go to Blakelock but to Lambert—did little to change the artist's circumstances or significantly raise the profile of his work in the general public's eye. It was, rather, the arrival on the scene of a strange, attractive thirty-two-year-old firebrand, Beatrice Van Rensselaer Adams, which was to forever change the course and legacy of Blakelock's life.

3

BEATRICE ADAMS

The exact date of Beatrice Adams's first visit to the asylum is uncertain. She had been interested in Blakelock's situation since the previous summer, but it isn't until the sensational sale of *Brook by Moonlight* on February 22, 1916, that there is any evidence of a visit. Adams may have rushed up to Middletown the very next day, for we have a card that Blakelock wrote to her on February 23 indicating that she had just come to see him.

She arrived dressed to impress—she liked to wear expensive large hats and furry boas—full of confidence, and armed with a smile that could melt a bucket of ice. She made quite an impact with the dapper Dr. Maurice Ashley, who, under her spell, would henceforth accede to all of her requests.

Blakelock, too, fell for her. In his note to Adams he called her the "gazell eyed one" and gushed with adolescent longing. Indeed, Mrs. Adams had a seductive figure and large, dark eyes that seemed to gaze with warmth and compassion. The most staunch, middle-aged patriarchs, men of affluence and position, appeared to crumble in the wake of her attentions and flattery. Mrs. Adams knew nothing about art but she told everybody, including Blakelock, that he was a genius. Most

important to Adams, who despite her invented pedigree was born dirt poor, was the fact that his paintings were worth lots of money. Unlike Blakelock's demure wife, Cora, Mrs. Adams did not intend to stand by while his career foundered on the shoals of neglect. On the contrary, she was going to make sure he received the praise and money he deserved. To Blakelock, Mrs. Adams's arrival was the answer to a prayer. As Davidson points out, Blakelock, in a garbled note he had written sometime earlier, expressed the hope that he would one day escape the asylum and regain his place among the sane. "It would certainly be a benediction of joy to walk on real earth again," he wrote, adding, "Who can divine the messenger?"

Mrs. Adams, it would turn out, was not at all what she represented to the public, but for the time being few people had cause to be suspicious of her, or doubt her credentials as a philanthropist. She was quick to point out that she had been appointed President Wilson's representative to the National Child Labor Conference in New Orleans in 1914. Many in New York social circles knew Mrs. Adams for her persistent efforts on behalf of the needy students of Lincoln Memorial University. In the summer of 1915, while visiting Catskill, New York, a friend of Mrs. Adams told her about Mrs. Blakelock and her children, who were then living in a small cottage by Kaaterskill Creek about a mile outside town. Friends were trying to raise money to keep her youngest son, Douglas, in school. Mrs. Adams was vaguely interested; she became far more intrigued as she learned about Mrs. Blakelock's husband, the famous artist whose paintings were commanding so much money and attention. By the spring of 1916, Mrs. Adams's fixation with Blakelock had begun.

Mrs. Adams was not a particularly educated woman but she was a natural at public relations and cleverly seized upon two important shifts in public sentiment to turn the media spotlight on Blakelock.

One was an increased interest in American painting, arising, partly, in reaction to the invasion from Europe of Cubist and other disturbingly modern art styles. Mrs. Adams recognized that in the chaotic, swiftly changing cultural atmosphere of the time patriotism could be used to Blakelock's advantage. Blakelock was an authentic American

artist, one of the few who could be said to be truly homegrown. In fact, the critic Frank Jewett Mather, not long after Blakelock's death, identified only two: Ryder and Blakelock. They were, he said "the most American artists we have. Neither their works nor their methods betray any alien tinge." Blakelock not only had solid American credentials, he was an artist who, in Whitmanesque fashion, had provided a romantic and poetic vision of America that Americans longed to recapture. Certainly his dark, mind-bending landscapes were different, perhaps even weird. The beauty the critics rhapsodized over was imbued with loneliness and alienation, but in the charged context of modernism, that made them all the more exciting to understand.

Mrs. Adams enlisted vocal patriotic artists like J. Carroll Beckwith—a society artist and close friend of John Singer Sargent—in Blakelock's cause and, through the press, roundly denounced the nation's negligence in protecting its artists. In doing so, she took advantage not only of the cultural xenophobia of the moment but also of the broad social reform movement that was sweeping the nation. Progressives were calling on politicians to pass laws protecting the rights of disadvantaged Americans—particularly women, children, the sick, and the poor.

With the country in a mood to help its underprivileged classes, Mrs. Adams saw a golden opportunity in Blakelock. The work she had done to raise funds to educate women and children in the South was, for the most part, a tedious letter-writing campaign that enabled her occasionally to have tea with the wives of important industrialists. In Blakelock she found a more glamorous cause and a potentially more lucrative occupation. It required simply that she widen the scope of the public's concern to include the plight of the country's impoverished artists—starting, of course, with Blakelock.

Adams began her Blakelock campaign in earnest in early March 1916. She walked into the editorial offices of the city's most important newspapers and demanded a hearing. She informed the editors that she was an established philanthropist, a representative of the president of the United States. She was outraged, she made it clear, at Blakelock's treatment. Here was a great American genius whose

paintings wealthy dealers and collectors were selling for tens of thousands of dollars, and yet the artist remained dependent on the charity of the state. He was living in an asylum sketching watercolors on bits of cardboard, and his wife and children were living in poverty in a shack in upstate New York. It was disgraceful. America should be ashamed. Something had to be done.

The editors of the *World*, among other papers, recognized a good story and made Mrs. Adams an important part of it. Trumpeting her charitable efforts in the past and her association with President Wilson, Adams—the compassionate, attractive young philanthropist— became Blakelock's rescuer and spokesperson. "To think that the greatest artist America has produced should be a public charge. . . . Why have not the American people had more pride than to permit the suffering of his family, while the pictures he painted in the days of his poverty are now worth half a million dollars?" Mrs. Adams asked.

By this time, Mrs. Adams had thrust herself to the forefront of a group of prominent New Yorkers who were organizing the Blakelock exhibit at the Henry Reinhardt Galleries on Fifth Avenue. At her insistence a one-dollar admission fee would be charged at the door. The admission proceeds from the show, and from the sale of paintings at an accompanying exhibit at the Knoedler Galleries, were to be donated to a fund she was forming for the benefit of Blakelock and his family.

In order for the fund to succeed, however, Mrs. Adams needed an abundance of publicity. By way of getting that attention, she sought out Cora Blakelock. On March 16, the *World*, at Adams's suggestion, sent a reporter up to Catskill to find Cora and invite her—all expenses paid—to New York to meet Mrs. Adams. The very next day, Cora found herself on a New York shopping expedition with her newfound patron. Shod in a new pair of shoes, Mrs. Blakelock then accompanied Adams and Earl Harding of the *World* to Middletown. The staged reunion of the famous painter and his wife in the presence of Adams and a reporter had its uncomfortable moments, but the resulting front-page story in the *World* could not have better suited Adams's purposes if she had written it herself. The four lead paragraphs extolled the painter's talent and lent credence to the possibility that he again

would produce valuable masterpieces. All that was needed to restore the artist's sanity, the article suggested, using words suspiciously similar to Mrs. Adams's, was proper support and encouragement. "If lovers of art and humanity supply the means, opportunity for the redemption of Blakelock's genius will be afforded. It is for them to say whether changed environment and adequate care shall be given him or whether 'America's greatest artist' shall continue to be a public charge, neglected and forgotten—the victim originally of the poverty that drove him violently insane and left his family in direst poverty."

The *World* article announced a forthcoming public meeting to organize the Blakelock fund. Mrs. Adams was so moved by Blakelock's plight that her ambition for the fund was growing by leaps and bounds. "The truth should shame Americans to give not only enough to remove Blakelock from a State asylum . . . but it should cause the fund to be made large enough so that only the interest need be used and the principle be left as an endowment of future cases of similar merit."

In other words, Mrs. Adams was now toying with the idea of enlarging the purpose of the fund to aid all impoverished American artists. That would, of course, necessitate raising an enormous amount of money. Exactly how the fund was to be organized and who would administer it was not yet clear. Mrs. Adams assured readers, however, that the fund committee would be "truly representative of artists, art lovers and citizens with a public spirit."

The article was a publicity coup for Mrs. Adams. On March 23, the *New York Times* reported the first gift, from A. Augustus Healy, president of the Brooklyn Institute of Art, to the Blakelock Fund. Other generous donations began to roll in. There ensued a spate of follow-up articles and profiles in the *Times*, the *New York Herald*, the *World*, and other newspapers in the city. On April 3, the day of the opening of the Reinhardt exhibit, a photograph not of Blakelock or his art but of Mrs. Adams looking as coy as a melting chocolate appeared in the *New York Times*. An important meeting, it was announced, was to be held that afternoon in the music room of the swank Biltmore Hotel. Edward Robinson, director of the Metropolitan Museum of Art, John

Agar, president of the National Arts Club, Mr. Healy, Dr. Ashley, J. Carroll Beckwith, Harry Watrous, and other artists would be present to help organize Mrs. Adams's new Blakelock charity.

After the opening, Adams ran around town generating more publicity for the exhibit by convincing those newspapers that had not yet climbed aboard the Blakelock wagon to join the cause. It was during this first week of April that she showed up at the *Tribune*'s offices on Nassau Street.

The *New York Tribune* was one of the most established and respected papers in the city. Though its circulation had fallen off, and it was dwarfed by its competitors, it had a very important asset in Royal Cortissoz, the nation's most influential art critic. A glowing review of Blakelock's exhibit from Cortissoz—which was soon forthcoming— would be a great boost.

A boa wrapped around her neck, Adams pestered the *Tribune* city editor until he passed her on to cub reporter Harrison Smith. To induce Smith to join the media fray over Blakelock, Adams told Smith that she was, at the moment, trying to secure Blakelock's temporary release from the asylum so that the artist could visit the exhibit in New York. Though other newspapers had already covered the Blakelock story, she suggested that perhaps the *Tribune* would be interested in obtaining the exclusive right to have a reporter travel with Blakelock from the asylum to the city. There were some incidental expenses to be paid. The artist needed train fare, new clothes, and a hotel room in the city. There was to be a lunch held in the artist's honor. Any donations would be appreciated. In the meantime, Adams reminded him, she was the only one with access to Blakelock.

"I was just the man for Mrs. Adams. It so happened that I knew about Ralph Albert Blakelock," Smith wrote. Flaunting his acquaintance with art, he compared Blakelock favorably with Camille Corot, and agreed to pursue the story. He continued, "I poured all this in one long sentence into the ear of the city editor who looked at me as if I was offering him a dose of poison. But he picked up a phone and called Middletown State Insane Asylum, still glaring at me."

Undoubtedly, the decision to cover the Blakelock story was more calculated than Smith later made it appear. The fact was the *Tribune* was being scooped by its competitors. The day after Smith arrived in Middletown, the *Tribune* introduced its readers to Blakelock by running an enthusiastic review by Cortissoz of the artist's exhibit as well as a second article—a pastiche of items cribbed from other newspapers, perhaps written by Smith—on the spate of recent Blakelock events.

Smith's interview with Blakelock at Middletown was printed the next day—on page six. A week later, Smith finally got his wish when his account of Blakelock's journey and arrival in New York was printed across two columns of the front page. By then, the selling of Blakelock was in full swing.

4

RELEASE

The second week of April 1916 brought a warm southerly breeze to Middletown. After a bitterly cold March, spring was finally in the air. In the early morning a cold mist rose from the soggy fields around the asylum and drifted lazily away with the rising sun.

On the morning of April 11 Blakelock was up early. A new Brooks Brothers suit had been placed in his wardrobe, along with new shoes, coat, tie, and beret. For the better part of fifteen years Blakelock had woken up to the same routine, the same view beyond the bars on his window. He had sketched just about every corner of the surrounding landscape in every season. Interestingly, these drawings and paintings created at the state hospital have a distinct sense of place missing from much of the work Blakelock did when he was sane and lived in the "real" world. After a lifetime of perambulations and evictions, the hospital grounds had become a haven where, ironically, Blakelock could reconnect with nature, with the physical environment around him. It was a lonely but secure refuge that in the weeks leading up to his trip to New York was increasingly breached by the outer world.

In the month before the Reinhardt exhibit, Blakelock had many more visitors than he'd had in all his years at Middletown. Several reporters

had come to interview him. The staff and patients at the hospital were suddenly deluging him with attention. He was invited to dinner at Dr. Ashley's house. A studio and materials were put at his disposal. Quite suddenly Blakelock, in a bizarre and ironic mirror image of his disturbed mind, had become somebody—somebody important.

There's little doubt Blakelock enjoyed the attention. At times, he even embraced his newfound celebrity, but he did so warily, like a child cast suddenly in a starring role in a school play. He was not quite sure what the play was about, or if he would remember all his lines. He was reluctant to think of his new stature and freedom as anything permanent. In his mind, at least, he was still a resident of the hospital and would be for the foreseeable future. His ambition in going to New York City, he told Smith, was first to pay off his old debts and secondly to see his paintings. Aware of the growing sensationalism attached to his work, he was adamant that his paintings be judged and shown "on their merits alone."

By 5:30 in the morning Blakelock stood on the front steps of the asylum wearing his new wool suit (which hung loosely about his small frame) with a silk tie and a pearl-gray beret. With him was Maurice Ashley, C. H. Moore, a physician assistant, and Harrison Smith, still determined to get his front-page story. Blakelock was in high spirits, "smiling like a boy," and commenting on the beauty of the dawn light. As their car approached, he turned around for Ashley's inspection. "Are you sure that I look all right?" he asked. Smith reported:

> A new suit and overcoat . . . not only made him look years younger, but more important still, they had restored the self-respect and pride in himself, eloquent in every word and look during the entire day. He was no longer the hopeless dependent on the state's charity; he was Blakelock, the artist, whose paintings hold an honored place in every great gallery in the country.

Maurice Ashley's chauffeured touring car pulled up to the front steps. It was a large shiny Selden with a powerful engine; more important, it

was the first car that Blakelock had ever set foot in. Somewhat apprehensively Blakelock got in with the others for the short ride to the Middletown train station. The artist was amazed at the speed with which the car accelerated downhill, pushing him back into the leather seats as trees rushed by overhead. In moments they had sped away from the hospital, hurrying down the road toward the town and a new life.

On the platform of the small railroad station a local reporter snapped a fuzzy photograph of Blakelock as he stepped onto the train, one foot on, one still hanging in the air. The artist was already hamming it up for the camera. It was the first time Blakelock had left Middletown since his arrival in 1901.

> Everything on the long journey to New York was new and delightful to him, from the roar and hiss with which the train stopped at the station to the tree-clad slope of Ramapo Hills, half way to the city.
> Constantly the artist pointed out things that interested him. "That's a good composition," he remarked once, when the train rushed by a white farmhouse and a brook. "I would like to paint that scene." It was like watching the return to consciousness in a man who had lost his memory for nearly twenty years.

On the train Smith was sitting next to a kind of living American artifact, a man brought up at a time when Ralph Waldo Emerson dominated the intellectual climate of New York, John Ruskin's aesthetic principles held sway over the art world, and Walt Whitman was inventing a new form of poetry. Blakelock grew up in New York when it was still a provincial town. He had witnessed firsthand the epidemics and violent class conflicts that had preceded and followed the American Civil War. He had seen the West when the Indians were still roaming free.

As they rode between the Ramapo hills (the tracks can still be seen beside the busy eight-lane New York State Thruway) Blakelock reminisced, telling the reporter about life in another era.

Dr. Ashley . . . was astonished at the clearness of his remarks
for the excitement had aroused him to such a point that his
mind and memory seemed almost unnaturally keen. He
described his trip to the Rockies years before with remarkable
detail and told of old friends and art dealers who have long ago
disappeared.

Blakelock spoke so much, in fact, that Ashley tried to quiet him down
for fear that he might overexert himself. Both Ashley and Mrs. Adams,
who was waiting with an entourage at the Hotel Woodstock in Manhat-
tan, had high stakes in Blakelock's visit to New York being a success.
They had groomed and coached him like a star attraction. Mrs. Adams
had even made a special trip up to Middletown a few days earlier to show
Blakelock a catalogue of his own work in order to refresh the artist's
memory of the titles and dates of his paintings.

Certainly, Ashley had reason to be cautious. Though Blakelock was
in good spirits and seemed to have temporarily left his despondent
preoccupations behind him, his mind was still fragile. He had been
dangerously delirious and depressed as recently as the fall of 1915.
Ashley could not be sure what Blakelock's return to New York might
provoke. An ugly incident would be a black mark for the hospital and
could damage its reputation with the Albany politicians who funded
its budget.

As the train rolled into Jersey City, the sight of Manhattan across
the river must have been an awesome and unsettling one to Blakelock.
The New York he had left, a city of primarily five- or six-story build-
ings, had become a metropolis with fifty-story skyscrapers. High over
the Singer Tower and the Banker's Trust building, the Gothic spires
of the Woolworth Building, known as the Cathedral of Commerce,
reached 750 feet into the sky.

Along the Hudson River, three-masted clippers had been replaced
by steel liners the size of the *Titanic*. Most disconcerting of all, the
quaint steam ferries that Blakelock once traveled on from New Jersey
to Manhattan had been replaced for the most part by crowded elec-
tric trains that ran *under* the river through the Hudson Tubes.

Blakelock is a little man, and the early morning rush in the Hudson Tubes almost submerged him, but it did not extinguish his admiration for what he maintained was a miracle of engineering or his wonder at the sight of Broadway when he emerged, ruffled, but still smiling, at Thirty-fourth street.

Blakelock knew New York well. He'd strolled the narrow cobblestone streets of Greenwich Village from childhood. He had seen the waterfront when it was a mass of rigging and Sixth Avenue when it was a patch of weeds. He'd painted the African-American and Irish shantytowns that once stood where Fifty-seventh Street was now lined with buildings. He had been into the dark pockets of Central Park at night. He knew the seedy quarter of the Bowery, the vaudeville theaters of Union Square, the red velvet–backed seats of Carnegie Hall. He had been to the Century Club and the Union League Club. He'd sauntered the marble halls of the millionaires' mansions. His paintings hung in the Metropolitan Museum of Art. But as much as Blakelock was a part of the history of the city, the city had never truly accepted him. He had been evicted from his apartments and lost his studios. At a time when clubs were the very heart and soul of New York's social and artistic life, not a single one ever accepted him for membership. No art organization took him in until 1913. He was a native New Yorker, and yet until the morning of April 11, 1916, he had been treated like a stranger.

That day, though, all the doors of the city were finally flung open to him. He would be wined and dined, toured through the Metropolitan Museum, and taken to the heights of the Woolworth Building. He was accompanied by reporters to his exhibits at the Reinhardt Galleries on Fifth Avenue and at Knoedler around the corner. His friends and his family were waiting for him. There was nothing to fear, no reason to suspect the door that was opening was ultimately just another trap.

II
BLOOD AND ART

5

FROM YORKSHIRE TO NEW YORK

Blakelock was born in the wake of a tremendous storm, a gale with hurricane-force winds that drove up the Atlantic coast, leaving a trail strewn with shipwrecks and shoreline debris. Three days later they were still cleaning up the mess—shredded ships' rigging, over-turned barrels and wagons—along the Christopher Street wharf, just a few long strides from the building where Blakelock was born on Friday, October 15, 1847. It was a beautiful cold fall day. "The air is clear and exhilarating and the mornings are delightful," wrote one of William Cullen Bryant's more exuberant copywriters at the *Evening Post*. "Now is the time to lay in a large stock of health for future as well as present use." It was advice that the mewling baby Blakelock might well have heeded.

A photograph was taken of Blakelock's father, also named Ralph, some fifteen years later, in the 1860s. Mr. Blakelock was, by then, in his forties, a homeopathic physician with a busy, respected practice in New York City. He looked the part. His back was straight and he had an ascetic face, with distant blue eyes and a long, wispy beard. A bushel of tightly coiled blond locks about his ears—a Civil War–era vogue—lent a slightly eccentric and sensitive cast to the portrait.

Mr. Blakelock was a frustrated poet and often made up jingles and rhymes. "He called it poetry," Cora Blakelock remembered. "He would make verses about everything." In the mid-1890s, for instance, the six-year-old Charles H. Martens (later the mayor of Orange, New Jersey) delivered a bouquet of flowers from his mother to the elderly and, by then, blind Mr. Blakelock. The doctor scribbled down a thank-you poem:

> *She looked upon one that is blind*
> *For him a blossom went to find . . .*
> *Flowers you sent were sweet to me*
> *May life as fragrant be to thee.*

In the photo Mr. Blakelock is wearing a dignified, dark jacket and something, perhaps a medallion, hangs from a thin ribbon about his neck. According to family tradition Mr. Blakelock was the twelfth Ralph in a long line of Blakelock physicians. Mrs. W. D. Washburn, Mr. Blakelock's niece, said the family was comfortably off. Mr. Blakelock had "plenty of money" when Blakelock was young. The doctor was generous with his sons, perhaps too easy with the money, Mrs. Washburn asserted—and many blithely agreed.

There were, however, cracks in this fairy tale, not the least being the comment by Blakelock that his father had once been a sergeant in the police force. Nor did anyone seem to know where exactly this affluent family was from or when they had arrived in this country. What was a middle-class family doctor doing living on the gritty West Side waterfront?

The truth was more complicated. Though the family did have ancient English lineage, the Blakelocks were hardly affluent. At the time Blakelock was born, his father was not a successful physician, nor yet a policeman, but a carpenter living in a crowded working-class neighborhood. Mr. Blakelock was an intelligent and unusual man. He had attained some sort of education and had a sensitive disposition, but it would be fourteen long years before he became a physician. For most of that time Blakelock's family lived a simple and, at moments, pre-

carious existence. There *was* a spirit of generosity, of cultural appre-
ciation and togetherness in this large rambling family of clerks and
waiters, carpenters and minor civil servants. But Blakelock's upbring-
ing was accomplished with very modest means. (Mrs. Washburn was
much younger than Blakelock and her memories date from a later
period.) As a boy, he saw life from street level with its deadly epi-
demics, its riots, and its boisterous celebration of good times. Blake-
lock was, until he went mad, always a gentleman, but he did not grow
up in a gentleman's world, and he always retained his democratic taste.
Though millionaires would become his patrons and on occasion invite
him to their mansions, Blakelock, like Whitman, George Inness, and
Vincent van Gogh, counted his closest friends among the ordinary
working people of the world: the postman, the hunting guide, the
vaudevillian, the artistic doctor.

The deeper one looks into Blakelock's life, the clearer it becomes
that his story is rooted in his family's long struggle to amount to
something in America. Four Blakelock brothers arrived together in
New York, but only Dr. Blakelock, as far as is known, warranted an
obituary. And at Greenwood Cemetery in Brooklyn, where many
Blakelocks are buried, none has a tombstone. The limited circum-
stances of Blakelock's childhood deeply influenced his outlook on
life, his need to both distinguish himself from and belong to society.
It also helps explain why he was so often perceived as an outsider.
The fact is it would have been very difficult for anyone with his back-
ground to become an artist. That he did so was due to his determi-
nation, his father's eclectic career, and a bizarre and fortuitous set
of circumstances.

Blakelock's father was ten years old when his family left Lastingham,
a tiny clot of red-roofed stone cottages buried in a dale of the York-
shire moors. The heather and peat barrens of the moors extend across
the shoulders of northeastern England to the wind-pummeled bluffs
on the North Sea. Here and there the desolate land is dotted with
stone markers, some sites of neolithic ritual, others scrawled with runic
and Christian inscriptions. Roman and Viking soldiers tramped

through its rough beauty; the Christians built stone monasteries in its isolated dales, including one in Lastingham. "It lay among remote and craggy hills where there seemed rather to be . . . dens for wild beasts than dwelling places for men," the Venerable Bede wrote, describing the monastery founded by Cedd about A.D. 650 (and where many Blakelocks would eventually be buried). Yorkshire was the most distant corner of the civilized world, on an isle so remote it was called *alter orbis*, another world, a place where the unworldly might be contemplated and the complacent punished. "We have frequently seen the whole season of summer overturned in violent winds and wintry storms," Bede wrote. More than a thousand years later the Brontë sisters would use this same lonely, gale-swept landscape as the backdrop to their nineteenth-century Romantic novels.

The Blakelocks' unusual arrival in Lastingham took place in 1568. "Soon after the battle of Langside . . . two brothers called Blakelock came to the village of Lastingham . . . They were disguised as drovers but it was soon found they were men of good social position and they were learned and were 'Queensmen,' followers of Mary Queen of Scots. These men we believe were called Ralph and Luke. They had in their possession the Coat of Arms."

Though no records have been found of these two rebel Catholic noblemen from the north (most likely from the wilds of Cumberland), the family has in its possession a well-documented tree that goes back to 1633 in Lastingham. The Blakelocks of Lastingham did well, accumulating a fair amount of land and marrying into locally prominent families. They were renowned for their riding abilities and love of the outdoors. Many of the Blakelocks preferred to farm their land, while others went on to become solicitors and clergymen. One went into banking in Sheffield; another was a flax merchant. Following tradition, every generation named a son Ralph. The name Albert came from Albert Smith, married to Elizabeth Blakelock. His grandson, Albert Blakelock Smith (this branch of the family later reverted to their maternal surname), was educated at Oxford and became a barrister. The family, on the whole, was well educated, and many were wealthy enough to have liveried servants and to devote their free time to shoot-

ing game birds. Yet there must have been others who did not do as well, or who suffered a sudden reversal in fortune. The Blakelock land holdings in Lastingham, in any event, had been divided generation after generation and soon there was little left to pass on. It was time for some of the Blakelocks to leave Yorkshire and find their fortunes elsewhere.

If a region can be said to stamp a particular character on its people, certainly the imprint of the Yorkshire moors is one not easily shaken off. Even as an old man, Mr. Blakelock, an eccentric gentleman physician with a long white beard and a shaggy white dog to guide him along the streets of Orange, New Jersey, would speak wistfully of the moors where he once had wandered as a child. He certainly passed on stories about the family ancestry to his son, who, as his mind degenerated in the late 1890s, began to call himself Albert the First, or, alternatively, the Duke of York.

In 1828, Blakelock's grandfather Richard, his wife, Christiana, and their six children left England and boarded a ship bound for America. In early-nineteenth-century woodcuts, the bustling little port of New York looks ideal as the set for an old Broadway musical. The artists show us slim town houses on cobblestone streets sprinkled with elegant carriages, women walking with parasols, gentlemen with top hats. The only sign of the working class is the apron-donned shopkeepers hawking their wares. The riverbanks were still composed of sand, sloping to the river, where beyond the overhanging trees a sloop was sometimes depicted leaning over in a stiff breeze.

It was a good time to have arrived in the city, just before the big rush and in the midst of a trade and manufacturing boom brought on by the opening of the Erie Canal. Richard Blakelock arrived in New York with some savings, perhaps a box containing the remnants of the family silver, and the dream of becoming a successful American merchant. As an educated Englishman he had a distinct edge over the Irish who were then spilling into the Five Points ghetto. Richard managed to get settled on the more prosperous west side of lower Manhattan. By 1834 he had opened a grocery at 283 Greenwich Street near the busy intersection with Chambers Street. At the time, to own even a

small business at a good address meant that he had acquired a certain amount of capital and enough clout with the city council to obtain a license.

The Blakelocks' hold on prosperity was precarious, however. By the mid-1830s, the once well-behaved town of New York was wracked by labor strikes and unrest. Rampant inflation made profits for small shop-keepers hard to come by. On the night of December 16, 1835, a fire broke out that raged uncontrolled for two days, gutting more than six hundred buildings and destroying a good portion of the eastern part of the city. The destruction and rebuilding effort caused a wave of dislocation in the city. Richard Blakelock moved his shop northward and reopened on Chapel Street. The family hardly had time to recoup, however, before the financial panic of 1837 brought New York's economy to a standstill. Dubbed the "year of national ruin," it ush-ered in the nation's worst economic downturn until the Great Depres-sion of the 1930s. "This is the most gloomy period which New York has ever known," wrote former New York mayor Philip Hone. "All is still as death; no business is transacted." The Blakelocks were not spared. Richard Blakelock lost his business and the family moved into a crowded working-class neighborhood on Hester Street, where they managed a boardinghouse. Three years later, Richard Blakelock died. His eldest son, Luke, moved for a time to Canada to try his luck there, leaving behind his brother Ralph, twenty-two, to provide for his mother, Christiana, his aunt Mary, and the younger siblings, Thomas, John, Jane, and Emily.

The depression lasted six years. But Ralph Blakelock was a hard worker who, it was later said, "never took a holiday." He and his younger brother Thomas found work as carpenters and in 1844 opened a shop, R&T Carpenters, on John Street. By then prosperity was returning to New York. The population had almost doubled, from 167,000 in 1825 to 313,000 by 1840. The city expanded as far north as Fourteenth Street. In the new, more expensive residences, water flowing through the recently constructed Croton reservoir system filled bathtubs, gas lights replaced the old oil lamps, and coal stoves took a central place

in the kitchen. There was a great demand for builders and carpenters. In northern Greenwich Village, Christopher Street became an important thoroughfare for building supplies. It was to this street that Ralph Blakelock moved with his new wife, Caroline Amelia Carey Blakelock, in 1845.

Mr. Blakelock had married Caroline, a pretty, dark-haired twenty-three-year-old, in 1843. Very little is known about Caroline Blakelock. There are no surviving letters or anecdotes about her but for a small, folded handwritten note found in an old family photo album. It tells us that she was an orphan who, at a young age, had married a Spaniard named Oliveria from the Canary Islands. He died suddenly, leaving her a considerable amount of money, which she never obtained, though oddly, the note goes on, her sister did get ahold of at least some of it. It's a peculiar story, but Ralph Blakelock's obituary does identify her as Caroline Oliveria. It also says she was from Poughkeepsie, New York, where the Careys—presumably the family that adopted her—were prominent. In a photograph taken in her early thirties, Mrs. Blakelock wears a large loop earring and modest striped blouse. The most striking aspect of the photo is the expression captured on her face, somehow saintly and yet at the same time grimly fatalistic. She looked in some uncanny way like her husband Ralph. Though she is darker in complexion they share the same countenance, long aquiline nose, and a faraway, dreamy look in their eyes. Four years after they married, their first child, Ralph Albert Blakelock, was born.

6

VILLAGE LIFE

The first five years of Blakelock's life were spent in a tenement at 166 Christopher Street. From some of the apartment windows the family saw the wharves of the Hudson River, located just a few steps from their door. At the time the Christopher Street pier was a busy and noisy place. Oyster barges, ferries, and scows competed for berths to unload their passengers and freight. During the day, cartloads of building material and cotton rattled under the apartment windows on their way into the city, while at night the carts would change direction, carrying tons of garbage, which was dumped into the river. Adding to the congestion and noise, a railroad spur along West Street brought in products from factories located upriver. And since "car men" had lately displaced builders as the predominate residents of the area—mostly Englishmen—the street was always littered with horse-drawn cabs and carriages.

At one time or another Ralph Blakelock's brothers (John and Luke, both clerks, and Thomas, the carpenter), their wives and children, his sister, Emily, and their mother lived together at Christopher Street. They shared the building with a cabinetmaker and widower. Next door lived two butchers. Down the street there were more coach driv-

ers, butchers, bakers, grocers, and the occasional watchman. It was a frenzied, working, ramshackle neighborhood, its only claim to gentility being the nearby prosperity of Hudson and Greenwich Street. The local parish church, St. Luke's, had been consecrated in the early 1820s when the area was still a rural retreat for the well-to-do. By the 1840s, though, St. Luke's saw fit to build a wall around its cloistered gardens, an expense that promptly depleted its diminished treasury.

Nine months after Blakelock was born, his father was offered an opportunity to advance himself, albeit in a profession perhaps not best suited to his temperament. New York City had recently formed its first official police force. The old ad hoc group of private night watchmen was being replaced by an organized (though still not uniformed) force of police officers who were nominated by local ward aldermen, and then officially appointed by the mayor. The appointments, admitted George Walling, who became a policeman in 1847 and later chief of police, were due "entirely to political preferences." There were no civil service examinations or physical requirements. In the closely knit ethnic community where Mr. Blakelock lived (nearly all the family names on the street were English—the Pottses, the Beardsleys, the Staffords, the Baileys, and, notably, a city inspector, Thomas Button, who lived next door to the Blakelocks at 168 Christopher), a man of his correctness, responsible demeanor, and education stood out.

On July 26, 1848, Mr. Blakelock was appointed to a two-year term by Mayor Caleb S. Woodhull to be a patrolman assigned to the station house at Jefferson Market on Sixth Avenue. The salary, $500 a year, was not large, but it was steady income and it allowed him to escape the laboring workers whose fragile livelihood was determined by New York's whimsical economic booms and busts. "The merely physical work to a young man like myself," Walling wrote, "was not all onerous." The hours, however, were long: eighteen hours on patrol, fourteen on reserve at the station, followed by sixteen off. There was not much time for Mr. Blakelock's wife and young son.

Mr. Blakelock's duties as a patrolman were described as reporting "all suspicious persons, bawdy houses . . . [and] all places where idlers,

tipplers, gamblers and other disorderly and suspicious persons congregate." The police, then as now, spent a good deal of their time putting drunks into a cell for the night to cool off. The permanent post in the Ninth Ward, where one could count on locating a patrolman, was conveniently located at the foot of Christopher Street. When he was posted there, Mr. Blakelock could drop in on his family and keep an eye on the revelers in the West Street taverns. Then, too, there were the occasional riots—such as the Astor Place riot in 1849—to be quelled.

New York in the 1840s experienced a massive influx of destitute immigrants, many of them Irish, which set off an inflammatory anti-foreigner sentiment. The city's patricians despised the Irish and the Irish, in turn, hated all things aristocratic, most notably the snobby English. The new police force was created, in part, to deal with these agitating gangs. But the force itself (increasingly Irish in the 1850s) became one of the battlegrounds. The messy politics involved— between the Irish and the English, the reformers and the corrupt— certainly made Mr. Blakelock's position difficult and would come to a head a decade later.

Mr. Blakelock's brothers often shared or swapped apartments, moving frequently in and out of Christopher Street—which remained the family seat—and other residences over the years. In 1851 a new arrival joined the clan at Christopher Street. Emily Blakelock, Mr. Blakelock's younger sister, married at eighteen an Englishman named James Arthur Johnson. Johnson was a music instructor and an amateur artist. Like the Blakelocks, he had arrived in the country as a young boy in the late 1820s. He, too, survived the great depression and had a more refined outlook on life than his neighbors. Superficially, Ralph Blakelock and Johnson might have seemed an odd couple— Blakelock the "copper" and Johnson the composer of madrigals. But Ralph invited his brother-in-law, then a struggling vocal instructor, to live at Christopher Street, and the two became friends. Their families were to live within blocks of each other for most of the next fifteen years.

For the four-year-old Ralph Albert, the arrival of Johnson into the household in 1851, with his piano and his palette of paints, signaled a dramatic change in routine. The long days he had spent in the company of cousins and his mother and grandmother (while his father and uncles worked) were interrupted by the presence of his new uncle, a young gentleman who did not wear work clothes and whose fingers raced over the keys of the piano playing Haydn and Beethoven. A few times a week Johnson taught music at the local ward school. He supplemented his income by taking pupils who came by appointment for singing lessons. For hours Johnson sat at the piano teaching his pupils, listening to their voices as they marched up and down the scales—sounds that young Blakelock could not help imitating.

With Johnson, an aesthetic and musical ambience invaded the house that stood in stark contrast to the workaday chores and atmosphere of Christopher Street. It was a change that Mrs. Blakelock could readily approve of. It's safe to say (in light of the extended time and summers she allowed her young son later to spend with Johnson) that she encouraged his admiration for his new uncle. Johnson's own children later spoke of the interest their father took in his nephew. When he had free time he gave Ralph Albert lessons in piano and song. On other occasions he opened his box of paints and pencils and taught the boy how to draw.

The Johnsons and the Blakelocks lived together on Christopher Street for only a short time, but it was a transforming experience for young Blakelock. He had been introduced to music and art. And Johnson, who was to become the director of the New York Vocal Society, choirmaster at one of New York's most influential churches, and an amateur painter of some talent, was someone to emulate. Indeed, Johnson became Blakelock's lifelong friend, mentor, and teacher. Quite certainly, Blakelock spent as much time with Johnson as he did with his father, who would be for the next ten years too busy with his duties as a policeman to encourage his son's burgeoning talent. It was Johnson who introduced Blakelock to the wider world of culture, music, and art. Ultimately, too, when the time came, it would be Johnson's influence that would be decisive in Blakelock's choice to become an artist and not a doctor.

Blakelock's childhood years on Christopher Street left another impression that the artist could never quite forget or leave behind. The crowded, somewhat bohemian atmosphere, where families shared what little they had, where children played on the floor and shared space with a piano, paints, and canvases, became a constant in Blakelock's adult life. It was a strange mélange of the ordinary and extraordinary, which would cling forever to Blakelock. This lifestyle, which shocked his future neighbors, was, for Blakelock, a normal way of life. In fact, it appears from Blakelock's later peripatetic existence, moving in and out with friends and relatives, that, consciously or not, he was seeking out the wider hearth of his childhood. Thirty years later, by then with a family of his own and his career well under way, he would again live with the Johnsons, yet in far more comfortable surroundings.

Two days after Christmas, on December 27, 1852, Blakelock's sister, Caroline Amelia, was born. Soon after, Mr. Blakelock moved his immediate family to Patchin Place, a short private lane in the heart of Greenwich Village near Sixth Avenue. Conveniently, Patchin was right around the corner from the Jefferson Market police station where Mr. Blakelock worked. The Blakelocks moved into number 1, the residence closest to the street, while Mr. Blakelock's older brother Luke (who had returned from Canada) and his four children lived a few doors up the lane at number 8.

The move to Patchin was a small step up. Built in 1849, Patchin Place was a new development of modest, connecting brick residences, wrought-iron gates, and flagstone sidewalks. Compared with the impressive, large private town houses in the area, the squat, three-story buildings on Patchin were low and narrow, and the rooms inside small. But they were clean buildings with amenities like running water and coal stoves. Even today—it still exists largely unaltered—Patchin Place is a protected, if unassuming, enclave. At the time, however, it was anything but quiet. Jefferson Market, just across a narrow street, was a major meeting place. With its fishmongers, butchers, and vegetable farmers bawling out for attention, with heavily loaded carts roll-

ing in and out from Sixth Avenue, it was almost as boisterous and loud as Christopher Street.

During the 1850s, the population of New York was marching north through Greenwich Village at a relentless pace. Hills were leveled, swamps and ponds filled in. Town houses and buildings popped up on vacant lots and former pastures. In 1852 a new surface rail line was installed on Sixth Avenue, and in the summer of 1853 crowds of families boarded the rail cars for a trip up to Forty-second Street, where on July 14, President Franklin Pierce opened the world art and industry exhibition at the Crystal Palace. The Crystal Palace was a marvel, made of some fifteen thousand panes of glass that spanned a dome 123 feet high and 100 feet in diameter, the largest in the country. The art exhibit—meant to dazzle, educate, and refine the masses—was the most important collection of painting and sculpture ever assembled in America. In a democratic fashion it celebrated both science and art. Paintings were hung alongside the latest mechanical inventions like the cotton gin and the electric telegraph.

On Patchin Place Blakelock continued to be, as he had been on Christopher Street, surrounded by his extended family. A good deal of his time was spent playing with his many cousins on the streets outside his home, where his father was a familiar and, undoubtedly, often sought-after figure. Blakelock was called Albert or "Ally" by the family, and we are told that he had a "nervous temperament." Given Blakelock's rapid pace as an adult, we can take that to mean he was an energetic and excitable child. However, we also glean from school reports that Blakelock was, if anything, exceedingly polite and well behaved. Brimming under all this control was a boy described as being "highly imaginative" and talented. In this regard he stood out. Johnson selected Albert, among all the children (Johnson's own sons eventually went into hardware and other businesses), upon whom to focus his attention. Under Johnson's tutelage Blakelock's early interest in music and art grew into a regular pastime. Blakelock's cousin, Mrs. W. D. Washburn (James Johnson's daughter), said that "Albert was always drawing when he was a child." She showed Lloyd Goodrich a watercolor of a bouquet of flowers that Blakelock had made when he was

twelve. "It was very painstaking, meticulous, but unusually well drawn for a child," Goodrich remarked.

While living at Patchin Place Blakelock attended primary school—located two blocks away on Greenwich Street—where Johnson was a music teacher, and, while still a young boy, Blakelock joined the choir at the Church of the Holy Communion on Sixth Avenue where Johnson was soon the choirmaster.

The church (still standing, but in the 1990s a popular discotheque called Limelight) was a Gothic, brownstone affair located approximately a half mile north of Patchin Place in an area once surrounded by vacant grassy lots, squatters' huts, and the ruins of an old country estate. Rehearsals for the choir and congregational singers were held on Friday evenings. Sunday services—in which the choir led the congregation in antiphonal chanting of the psalms—were an almost all-day affair.

Participation in the Holy Communion choir was considered an honor, and Blakelock's affiliation with the church—proudly mentioned in family letters—would soon broaden his intellectual and social horizons. As it happened, Holy Communion wasn't just any church. It was one of the city's first "free" churches and its congregation was led by the inspired and progressive New York civic leader William Augustus Muhlenberg. His flock was made up of enlightened Episcopalians, that is to say liberal traditionalists. These were somewhat intellectual, middle-class citizens determined that humanitarian social reforms take place and that equality be pursued. Even so, they were too practical to be puritanical (few of them signed temperance vows or joined the anti-vice brigades that were then popular among some Protestants), and not quite principled enough to call themselves abolitionists.

Muhlenberg must have left quite an impression on Blakelock. He was a large, charismatic man with a mop of silver hair, deep pockets under his eyes, and a particular interest in ecclesiastical music—and in his choirboys. His eloquent sermons were well known. An anti-sectarian, a pioneer in enlisting women in church activism, and a free thinker, he did not shy away from controversy and strong opinions. In the 1850s the issue of slavery and national unity was becoming an ever more divisive

question. But Muhlenberg had long before made up his mind. In a sermon in 1820, at the age of twenty-four, he had already condemned slavery as "an immense national evil." As the Civil War approached he suspended his usually politically impartial sermons to voice his support for Lincoln and the Union. Young Blakelock learned by heart Muhlenberg's popular "On for Freedom" (also called "Republican Battle Hymn"), a song the reverend composed, he said, to demonstrate his zeal for Lincoln and his desire to see the "slave power" defeated.

Muhlenberg backed up his philanthropic sermons with action. He had already founded St. Paul's College and went on to establish a number of charitable organizations, including the Fresh Air Fund and St. Luke's, an important hospital for the poor. At a time when most parishes rented out their pews to the highest bidder, with special boxes reserved for the wealthy, Muhlenberg abolished the fees, stripped the pews of their velvet cushions, and opened his church doors to a wider audience. "This will rebuke all the distinctions of pride and wealth, the high and the low, the rich and the poor." Well, almost all distinctions. In a subsequent letter to the editor of a New York newspaper, Muhlenberg quickly assured people that the church would not be flooded with rabble. The free pews, he said, were "guaranteed not to all comers, but to all persons worshipping agreeably to the forms of the church." Furthermore, he added, the open-door policy was not "to interfere with the formation of a settled congregation."

Over the years, Holy Communion became a popular parish and, ironically, its services attended by the highest-ranking members of New York society. Part of the attraction, paradoxically, was Muhlenberg's inclination toward ecclesiastical ceremony and music. Dr. Clinton Locke, a reverend, described the services at Holy Communion as being considered at the time "the extremest height possible" of ceremony and ritual. "I remember . . . how novel it all was, how one had the feeling of doing something very much out of the way, with a flavor of wrong to it. Flowers on the altar were like red rags to a bull at that time." Muhlenberg brought not only lilies and hyacinth into the sanctuary; he was the first to introduce a boys' choir into regular church services in New York.

Muhlenberg's enthusiasm for ecclesiastical music was matched by his special regard for choirboys. As soon as he arrived in New York, as Anne Ayres, his biographer, noted, "He at once gathered around him several young men and boys, as his household; the former, students for the ministry, the latter, young choristers, whom after the old fashion he took into his heart of hearts, as his very sons." Muhlenberg's knowledge of music and his and Johnson's supervision of the choir established its reputation. "The benefit to a boy of such an association [with Muhlenberg's church] soon became understood; so that he had always his choice of singing boys." Many years later Cora wrote that Blakelock, when a boy, had "a beautiful, high, soprano voice . . . [and at] the Church of the Holy Communion . . . he always sang the solos."

Whether Muhlenberg had other interests in his choirboys is uncertain. It seems, however, from Ayres's continual harping on the subject— in her ingenuous Victorian way—that it remains a possibility. She seems almost unable to refrain from commenting on Muhlenberg's affection and "strong religious influence over the young of his own sex." It was, she wrote, "a predominant feature of his life," and "one of the most striking characteristics of succeeding years. His love for boys never waned . . . He was truly an apostle to them." Ayres goes on, at one point, to describe an incident that occurred when she once abruptly walked in on Muhlenberg without warning. She found the reverend clutching a choirboy to his chest, the boy's cheeks flushed, as Muhlenberg suddenly admonished him on the evils of masturbation.

By the late 1850s, Muhlenberg was devoting most of his time and energy to administrating St. Luke's Hospital. His presence at Holy Communion was more that of a distant, magisterial figure who came and went, leaving the day-to-day running of the parish to Reverend Lawrence. Indeed, it was Lawrence's associate Reverend Horatio Potter, not Muhlenberg, who eventually confirmed Blakelock at Holy Communion in March 1863 (his mother followed in his footsteps in 1864).

Blakelock's affiliation with Holy Communion—which continued until 1871—was the most lasting contact he had with any one community in the first few decades of his life. While Muhlenberg's progressive ideals left their mark on Blakelock, it was Blakelock's contact

with this new social milieu that was to have a much more enduring effect on his future. Several of his first collectors would come from the congregation. More expediently, it was Johnson's connection with certain influential parishioners that would gain for the young aspiring painter entrée among the entourage of eminent artists who had moved into the Tenth Street Studio Building just across Sixth Avenue from Patchin Place.

In 1857, while the Studio Building was still being constructed, disastrous economic and political events once again threatened the family's finances and middle-class aspirations. Three years before, in December 1854, Fernando Wood, a swank, appealing demagogue who had made a fortune in real estate and gambling operations, ran for mayor. Wood, a Democrat, was proslavery, but he was also a champion of the working class. The economy was in a severe dip. Many were unemployed. In the mid-1850s, as the wealthy were putting up their mansions on Fifth Avenue, the police precincts were regularly providing shelter for more than 50,000 homeless people a year. Mr. Blakelock was still a patrolman in daily contact with the bitterest and most desperate people in the city. His family hardly needed reminding of how precarious the situation had become. Some of Wood's campaign platform—he ran as a moderate promising reform and food, shelter and jobs for the poor—would have appealed to them. But Wood was also pro-southern, pro-Irish, and had considerable connections with the seedier elements of the city. "The underworld was for him. Saloonkeepers were for him. Tarts were for him. Abortionists were for him. And enough decent, but hoodwinked, people were for Wood to elect him mayor."

For Mr. Blakelock the election meant that a pro-Irish mayor was now in charge of the department and Wood's kind of people were coming in and running the show. In 1857, three years into Wood's tenure and after ten years on the force, Mr. Blakelock still had not earned a promotion or a raise in pay. When Wood was reelected he dropped his initial efforts at reform and began to run the city and the police department as a private fiefdom. Corruption and bribery scandals were

ubiquitous. The police force, though finally in uniform, was, according to George Walling, universally "ridiculed and condemned." This state of affairs had so disintegrated authority that in April 1857, the newly formed Republican legislature in Albany declared that the city was too corrupt to govern its own police force.

The New York State Metropolitan Police Act of April 11, 1857, created a new metropolitan police force to be formed and controlled by a committee of commissioners appointed by the state governor. Wood's municipal police force was ordered to disband. Wood claimed that the state act was unconstitutional and went to court. In May, the Supreme Court ruled against the mayor. Wood called on the police to ignore the authority of the new state police commissioners and remain loyal to him. Over the weekend of June 5, confusion and debate broke out in the station houses; new state-appointed captains' and sergeants' orders were immediately countermanded by officers loyal to Mayor Wood. Impromptu roll-call votes were taken in each station house. The police force voted overwhelmingly—800 to 300—in favor of staying with Wood. Those who dared to disagree were told to turn in their stars and caps and then hastily tried and fired for insubordination.

It was a critical time for Ralph Blakelock. In the Jefferson Market station house, most of the men and their commanding officer, Captain Ackerman, were behind Wood. If Mr. Blakelock broke with Ackerman, he was, in essence, severing his ties with the political patronage system that had long fed and supported his family. As it was, Mr. Blakelock walked the plank and voted against Wood. It was not just an important career decision; it was an act of political faith. In siding with the newly formed state forces he was taking a stance as an antislavery, reform-minded Republican. In essence, Mr. Blakelock was turning in his working-class overalls (and Democrat ideology) for a new uniform and a stake in the future of a unified and more liberal nation.

In practical terms, Mr. Blakelock joined First Lieutenant Sebring and twenty-two other men who had turned in their uniforms and stars. They marched off to sign up with the hastily formed Metropolitan Police. Over the next few days, more officers from other precincts joined them. The city soon had two competing police forces, some-

times saluting each other as they passed on their rounds in the street, but as often arresting and accosting each other.

A bloody skirmish between the two forces erupted on the steps of City Hall on June 16 when the state authorities attempted to have Mayor Wood arrested. A month later, the mayor finally capitulated and disbanded his municipal police force. More than one thousand men were thrown out of work. Mayhem and riots broke out in the streets on the city's Lower East Side. Rival gangs, several hundred strong, fought one another and turned on the poorly manned Metropolitan Police, including Mr. Blakelock, whenever they tried to interfere. Police stations were armed with pistols. The militia was called upon to put down the riots. In the end more than a hundred men were badly wounded and a dozen citizens and policemen killed.

The news only got worse in September and October when a financial panic took hold of Wall Street. Eighteen banks shut their doors and ceased making payments. Thousands of people were thrown out of work. Radical workers' groups banded together and demonstrated in Tompkins Square Park; more riots broke out. To Mr. Blakelock it must've seemed like 1837 all over again. Fortunately this time the economic disaster was less protracted. The city put many unemployed to work in clearing Central Park. And Ralph Blakelock, unlike his father, who had lost his business in the collapse of 1837, managed to hold on to his job and even prosper. In December, Wood was defeated for reelection. A few months later, in July 1858, Officer Blakelock, at the age of forty, was finally promoted to sergeant and second in command at the Charles Street police station.

By 1858 the Studio Building on West Tenth Street was completed and its twenty-three studios rented out to artists. From the outside it was an unprepossessing building with a simple sandstone facade and four small iron balconies. Inside it had the wood-paneled ambience of a club, which in essence it soon became, complete with a concierge and a cook. There was little that was grand about it—except perhaps its main two-story, sky-lit gallery—but there was no other studio building like it in the country. Before long it became the

inner sanctum of the New York art world. Just about every major American painter of the mid-nineteenth century lived there at one point or another. Its residents included Winslow Homer, Frederic E. Church, Albert Bierstadt, and William Merritt Chase; many Hudson River School and Luminist painters, such as Martin Johnson Heade, Sanford R. Gifford, Jervis McEntee, and Worthington Whittredge, also had their studios there.

The building became widely known to the public in May 1859. For a few weeks, young Blakelock had only to step outside his home on Patchin Place to see the long wavering line of people that stretched from the Studio Building to Sixth Avenue. Frederic Church, who had attained a national reputation in 1857 with his vertiginous painting of Niagara Falls, was exhibiting his new, grand panorama *The Heart of the Andes*. Actually, it might have been said in a declamatory fashion— *Ha-a-a-rt . . . of . . . the . . . An-n-d-ies*—with the booming baritone of a circus barker. These one-painting exhibits of hyperreal, richly colored views of exotic places had become a popular form of entertainment, and *Andes,* the panorama, was a major event, written up by the news-papers and promoted with window advertisements and pamphlets. During the exhibit more than 12,000 visitors paid an entrance fee to view the painting. Poets were inspired to verse by Church's work and overdecorous treatises were written to explicate his art. The critics' praise for *The Heart of the Andes* was "close to hysteria," commented the art historian David Huntington. Some were calling *Andes* the finest painting ever painted.

One viewer described the painting as a "complete condensation of South America—its gigantic vegetation, its splendid Flora, its sapphire waters, its verdant pampas and its colossal mountains." Soon this vi-sion of the New World would cross the Atlantic to England and put American art on the map.

Church had been taught by Thomas Cole, often called the founder of the Hudson River School of painting. He brought to Cole's classic compositions and moral art a new sense of realism and harmony. Church was also a disciple of naturalist and author Alexander von Humboldt, who urged artists to travel the world and record the natu-

ral order and harmony of the cosmos, and of John Ruskin, whose influential writing on art at that time called for an impersonal representation of nature. Blending religion and science, Church's paintings provided both a vision of an exotic Eden-like world and a detailed naturalism. Viewers were encouraged to bring their opera glasses in order to best appreciate the mauve petals of the painter's flowers and the exuberantly colored feathers of his tropical birds. But the secret of Church's success lay beyond mere bravura of detail; it had as much to do with the overarching grandeur of his vision—its intrinsic worship of the divine in nature and its patriotic approval of manifest destiny. At a time when the slavery question, labor unrest, and secession were dividing the nation, Church, in one landscape, painted a wavering American flag in the twilight sky. The American public was hungry for great national paintings, for an art they could call their own, and Church and his rival Albert Bierstadt supplied it.

Stealing a theatrical trick from Barnum's American Museum, the promoters of panorama exhibits often hung the paintings behind a curtain in darkened rooms. Once the room or hall was filled, the curtains were pulled back, revealing the painting lit by the brilliant glow of gas jet lamps. At the Studio Building on Tenth Street the crowds lowered their voices to a whispered hush as they entered Church's darkened second-floor studio. The walls of the studio had been covered in black crepe, with here and there the decorously placed exotic palm or the odd antiquity recovered from a faraway ruin. In a sense the studio had been transformed into a sort of chapel, lending a quasi-religious atmosphere to the viewing. Draped by black curtains, *Andes* had been framed as if it were a vista viewed through a window—a shimmering gnostic postcard from another, more extraordinary world.

The clamor to see the painting attracted such a mob on the sidewalks that the police were called in to help manage the crowd. Sergeant Blakelock might have discreetly slipped his wife and son in near the front of the line, which began at eight A.M. and wasn't dispersed until ten in the evening. Blakelock had better access to the Studio Building through his uncle Johnson. The choirmaster gave singing lessons to the daughters of the well-to-do whom he'd become ac-

quainted with at Holy Communion. He was also a devoted amateur painter, and among his newfound artistic acquaintances were two of the original residents of the Studio Building: the landscape painter James Renwick Brevoort and none other than Frederic Church himself. From the evidence on hand Johnson did not know Church terribly well. But a passing acquaintance with Church, and a friendship with Brevoort—whose family attended Holy Communion—warranted occasional visits to the Tenth Street building. If Johnson did wrangle a viewing of Church's *Andes* for himself and his young nephew, it was an honor accorded to a fellow artist—albeit a brief one.

A visit by the local vocal instructor and his young awestruck protégé—the son of a policeman—would hardly have been a memorable event for the great artist. However, from Blakelock's point of view *any* visit to the Studio Building, much less an audience with the tall, lank, muttonchopped reigning master of American art, would have been a seminal experience. And the canvases spread about the Studio Building like *National Geographic* foldouts—full of lollipop colors and the transfixing details of tropical lands—were so many invitations to dream.

Church came under increasingly hostile critical fire as the 1860s progressed, but it's a mistake to overlook the spell that he and Bierstadt cast over New York artists in the mid-nineteenth century—and the profound effect his nearby presence would have had on an aspiring painter of Blakelock's age and temperament. Painting style aside, the two stars influenced the manner in which other artists aspired to live, the places to which they traveled, and the subjects they chose to depict. Jervis McEntee, a respected painter of the Hudson River School and an influential member of the National Academy, complained in a letter that he could no longer paint in Europe. "Church goes there and everything he sees and does is wonderful. I go and although I may see things in a different way I am lost in his shadow." Likewise, many Rocky Mountain views were said to have already been "copyrighted" by Bierstadt. Worthington Whittredge, in a letter to McEntee, noted Bierstadt's return from the West, and the

extravagant sale of his work *Rocky Mountains, Lander's Peak* (1863).
"Bierstadt is certainly a success," he commented with biting envy.
Then, soon after, Whittredge himself set off to the West in an attempt
to emulate Bierstadt's lucrative explorations.

Church and Bierstadt were America's first art celebrities. Portraits
of Jefferson and Washington hung over Church's painting at the 1864
Sanitary Fair. Congress commissioned their work. They were, on oc-
casion, paid more than $10,000 for a painting while other well-known
painters were lucky to get one or two hundred dollars. Their promo-
tional antics, which were widely condemned, helped make them rich
men. At their height, they had fancy carriages with six-horse teams to
take them to their country estates. They traveled about the world and
mingled with the high and mighty. Neither shied away from excess.
Church wore expensive calfskin boots and built an Ottoman palace,
called Olana, on a bluff overlooking the Hudson River. Bierstadt, too,
had his mansion on the Hudson. He entertained the Grand Duke
Alexis of Russia and was later invited by President Rutherford B.
Hayes to spend a week in the White House. When Church and
Bierstadt came into town they trounced through the tiny artistic sa-
lons like bulls in a china shop and threatened to withdraw their paint-
ings from the academy's exhibits if they weren't made exempt from
jury examination. The artists in the Studio Building—where Bierstadt
took the central gallery as his studio—noted their every move and
opinion. After the success of *Andes* in 1859, and of Bierstadt's *Rockies*
four years later, scores of other American painters exhibited oversize
canvases, called "Great Paintings," in special, one-painting exhibits.
It was no mere coincidence that Blakelock later ended up traveling to
Panama and Jamaica (both places visited by Church) and trying his
own hand at the panorama.

A year after the *Andes* exhibit, a change in the family's fortunes brought
Blakelock's growing aspirations to become an artist within the realm
of distant possibility. After twelve years as a policeman, Mr. Blakelock
decided to abandon his profession. Despite his promotion to ser-

geant, the dire and sometimes brutal events of 1857 had taken their toll, perhaps driving home to this sensitive man how unsuited he was for this line of work. Furthermore, the surprise return to power of Fernando Wood as mayor of the city in late 1859 once again jeopardized Ralph Blakelock's future with the department. By 1861 he had turned in his badge and opened up his practice as a homeopathic physician.

7

THE BLOOD

R alph Blakelock's decision to become a homeopath came at a time of growing opposition to the treatments being prescribed by the orthodox medical community. "The . . . public attach too much importance to the mere administration of medicine," began one editorial written by an anonymous physician in the *New York Evening Post*. "It is important to understand that there is a great power in the human body to throw off disease, and to restore health without any help." Underlying this skepticism of medical treatment was the widespread practice by orthodox physicians of bleeding patients, sometimes to death, and, if not, the prescribing of toxic and sometimes lethal doses of calomel—a form of mercury—laudanum, arsenic, and other substances to "cure" their patients' illnesses.

The practice of bleeding in the United States had been spurred on by the American patriot and physician Benjamin Rush of the University of Pennsylvania. Rush urged his students "never to stop the flow of blood once it was started." He became something of a misguided American Nosferatu, rushing from bedside to bedside during a yellow-fever epidemic in 1793 while emptying his patients of up to four-fifths of their blood in order to calm their symptoms. "Tis a very hard Mat-

ter to bleed a Patient to Death," he assured his students. Soon accred-
ited physicians all over the country were using their lancets like ice
picks, spilling amphorae of blood to cure all the diseases known to man.
Two quarts of blood were removed from George Washington on the
day he died complaining of a bad sore throat.

If bleeding didn't work, the physicians turned to cures of an emetic,
cathartic, or purging nature. Calomel could be counted on to incite all
three reactions in the body. It was recommended for everything from
a fever and tonsillitis to dysentery and pneumonia. Eminent doctors
prescribed it "in as large doses as the system will bear." The conse-
quence of ingesting large numbers of these blue pills "were salivations,
loosening of the teeth, falling of the hair, and other symptoms of acute
mercuric poisoning." If a patient, subject to a dozen or more bleedings
and blisterings in a day, vomited his dose of calomel, he or she was
often forced to take it again. The situation had grown so absurd that a
song, "A Dose of Calomel," became a popular tune in the middle of
the nineteenth century.

The limitations of these orthodox treatments could not have been
clearer to Mr. Blakelock, who had lived through several cholera and
yellow-fever epidemics and whose own daughter suffered from debili-
tating bouts of epilepsy—for which doctors had prescribed leeching,
cupping, bleeding, and calomel. As a policeman charged with enforcing
the city's health code, he was often on the front lines of the diseased
population. He saw firsthand the dead being thrown into uncovered
wagons and the bodies piled high in potter's fields until the papers com-
plained of the "insupportable stench." The dead were not all strangers.
In the 1849 epidemic, when Ralph Albert was a vulnerable two-year-
old, Mr. Blakelock lost a fellow officer at the precinct, and the disease
swept off two of the choirboys at Holy Communion as well.

In the early 1800s, Samuel Thomson, a New Hampshire naturalist,
was the first to challenge the prevailing medical practice of the time.
Thomson and his followers advocated the use of natural, botanical
medicine. Their home remedies and painkillers—bayberry, pond lily,
sumac, cayenne pepper, and steam baths—were mostly innocuous.
But their Jacksonian democratic ideology "to make every man his own

physician," and their practice of selling their patented cures for just twenty dollars to individuals, threatened the medical establishment. It also, admittedly, offered opportunities to "quackery" and fakes. Laws were quickly instituted requiring physicians to pass exams and obtain expensive diplomas. In 1809 Thomson was charged with medical malpractice and manslaughter in the death of a patient. Ultimately, Thomson was acquitted, but the medical establishment's attacks on any alternative practices of medicine were unremitting for most of the nineteenth century. Orthodox physicians, known as allopaths, who turned coat and joined the homeopaths were regularly expelled from their professional medical societies.

In becoming a homeopath Mr. Blakelock, or, we may say, *Dr.* Blakelock, was leaving one battlefield and entering another. This war, too, involved politics and economics, but it was also fought in the more abstract arenas of religion and metaphysics—the latter a field increasingly of interest to his son. Homeopathy, while scientific in practice, was based, philosophically, on a spiritual premise. Samuel C. Hahnemann, a highly respected German physician and the founder of homeopathy, wrote: "Illness only exists because the spirit of Man considers that illness can exist. By presenting to the spirit (or vital force) the correct medicine in the correct dose for the correct period of time, the spirit changes its considerations and the illness is gone."

Hahnemann was looking for a more rational method of healing, and soon he turned away from bleeding, blistering, and purging. Instead he prescribed exercise, a nourishing diet, fresh air, and minute doses of medicine—medications that he first tested on himself before prescribing them to others. Hahnemann found that small doses of medicines such as quinine induced the same symptoms in a healthy person as the illnesses they cured in sick people. According to Hahnemann's theory of *similia, similibus, curantur* (let likes be cured by like), the minute dose of medication prescribed created in the body an artificial form of the same illness, but one that the body was able to combat. "He [Hahnemann] felt that without the assistance, the vital powers of the body were helpless in the struggle with the disease. The homeopathic dose enabled the vital spirit to defeat the illness.

Thus, the spiritual being was capable of playing a role in causing material change."

Unlike the orthodox doctors who were "prone to materialism" and who believed that man was simply a "sum of functions," the homeopaths set out "to prove that such an entity as Spirit really exists." It was his spirit that brought the organism of man to life. "This, in effect, meant that to prescribe homeopathically and to believe in its efficacy, the physicians had to have an intense belief in a God who established natural laws. He also had to believe that there was an interrelationship between the spiritual and material aspects of life. Homeopathic physicians, as a result, then tended toward Swedenborgianism and Transcendentalism."

Homeopathy's quasi-mystical premise fed right into the hands of its opponents. They claimed that homeopathy was based on "wild" transcendental theories and denounced homeopaths as "advocates of delusion," or simply as quacks. Their attacks were not convincing. The publication in English of Hahnemann's voluminous pharmacological encyclopedia, *Materia Medica Pura,* and the comparative success of homeopathic treatments during the cholera epidemics of 1849 through 1852, won the practice many new adherents. By 1852 there were three hundred homeopathic physicians in New York State. In 1856 a homeopathic dispensary opened on Eleventh Street right around the corner from the Blakelocks' residence on Patchin Place. That same year the Homeopathic Medical Society of the State of New York was legally incorporated and recognized by the state legislature. It was, of course, right about at this moment that the future Dr. Blakelock was in battle with his fellow cops and wondering what to do about his career.

Sometime in the late 1850s, Dr. Blakelock began his training as a physician, attending clinical courses given in the evenings at Bellevue Hospital. In 1861, after the birth of his second son, George Clinton Blakelock, Dr. Blakelock moved his family uptown to 286 West Nineteenth Street and hung out his shingle as a homeopathic physician. If any one event signaled the Blakelocks' entrance into middle-class society, this move uptown was it. They had moved into the comfortable residential area now known as Chelsea. Many of the smart town houses

that were built then are still standing today. They are mostly redbrick buildings, taller and wider than those on Patchin Place, with proper front steps, elegant front doors, shutters on the windows, and small gardens in front. Hatted black gas lamps placed at the foot of every house capped the effect of civil charm. To Blakelock, then going on fourteen, and his sister, Caroline, their new quarters were practically palatial. It was the first time that Dr. Blakelock and his brood had moved into a residence alone without relatives nearby. The extended family of aunts and uncles, cousins, and even Blakelock's aging grandmother, Christiana, had been left behind downtown.

Dr. Blakelock's fees—$5 to $10 a consultation, up to $50 for childbirth—represented, even in a slow practice, many times his salary as a police officer. Mrs. Blakelock was now able to shop at the latest department stores for her linens and dinnerware. Furniture had to be purchased to accommodate the doctor's patients. His office was lined with shelves holding hundreds of glass vials containing herbs, powders, and potent-smelling medications. There were, in addition, anatomical charts—which Blakelock would use to study the human figure—reference tomes, books, and medical journals for Dr. Blakelock to consult. The magical aura of the office, with its peculiar mix of medicinal potions, scientific instruments, and spiritual writings, was not lost on young Blakelock. In the homeopathic asylum where Blakelock ended up forty years later, he complained to his physicians and attendants that he knew more about medicine than they did. He could, he said, prescribe his own medication and spouted Latin medical jargon to prove it. It was in puttering about his father's office, and perhaps, at times, in assisting him, that he learned a great deal about the practice and metaphysical musings of homeopathy. Cora maintained that Blakelock's interest in Emanuel Swedenborg's mystic writings began when he was a young man. Though Dr. Blakelock was not a Swedenborgian, many of his fellow homeopathic doctors were and the homeopathic books and journals that his son saw in his home were littered with Swedenborgian and transcendentalist thought.

Blakelock had grown up and was now coming into his teens at a time when Americans were, as Emerson put it, "fanatics in freedom." In

antebellum America free will, self-reliance, individuality, and nonconformity (in ideas, not in dress or behavior) were the watchwords of the time. "I have no chair, nor church, nor philosophy," Walt Whitman declared. Anything that smacked of institutions, governments, and authority was viewed with suspicion. Orthodox religion was being widely questioned. In the aftermath of the liberal revolts in Europe in 1848, socialist ideas about a universal brotherhood spread to America. A humanitarian reform movement, led by the likes of Reverend Muhlenberg, demonstrated a growing awareness of the rights of women, the poor, and the disenfranchised segments of society.

Ideological debate, among those still backward enough to have an ideology, was rampant. Unionists versus capitalists, states' rights versus national interests, homeopaths versus allopaths, puritans versus libertarians. Pamphlets and essays, lectures and sermons were the intellectual currency of the day.

It could all be a bit bewildering. Freedom inevitably led to questions. Inasmuch as Whitman's *Leaves of Grass* (published in 1855) was an exuberant celebration of self, there was also voiced in his poetry a Romantic desire to lose that self in others and in nature. And while progress, science, and liberty were seen to be marching hand in hand, exalting the individual in his or her pursuit of happiness, there was a gnawing doubt as to whether material advancement could sufficiently feed the soul.

In groping for a faith free of institutional encumbrances, Emerson's homegrown transcendental philosophy, with its relativistic outlook and its idolization of nature, appealed to many. Likewise, Swedenborg's pseudoscientific explanation of the spiritual world, his antisectarian view of religion, and his mystic's interpretation of man's relationship with God offered an intriguing alternative to numerous others.

Emanuel Swedenborg, a highly respected Swedish scientist, had a mystic vision of God in 1744. Inspired by his communications with angels, Swedenborg subsequently wrote more than thirty books that set out to demonstrate, philosophically and scientifically, that the universe had a unifying spiritual structure. Works such as *The True*

Christian Religion adopted a gnostic, less ecclesiastical interpretation of the Bible. The Swedenborgian, as did the homeopaths, believed in the indivisibility of the body and the soul. They also held that the material world corresponded directly with the spiritual world. That is, that every physical thing, be it a chair or the sun, had a spiritual counterpart. These "correspondences" extended not only to man's feelings and thoughts, but to every organ of his body. Swedenborg placed an erotic or, to borrow Whitman's word, "electric" charge upon the body's mystic relationship with the universe. It also followed in Swedenborg's concept of Christianity that since everything was related, so was every-*body* bound together in a universal brotherhood of love. European socialists embraced this unifying perspective on the cosmos, and liberal American intellectuals, poets, artists, and spiritualists found its unique mélange of science and mysticism hard to pass up. Emerson, who applied many of Swedenborg's ideas, declared, "This age is Swedenborg's." Whitman went out on a limb, saying Swedenborg would leave "the deepest and broadest mark upon the religions of future ages here, of any man that ever walked the earth."

After a few years as the son of a homeopathic physician, Blakelock would have been familiar with many of Swedenborg's basic tenets. To be sure, some of Swedenborg's more radical ideas—about conjugal love and man's ability to communicate directly with the spiritual world—may have been too extreme at the time for either Dr. Blakelock or his son. In the years that followed, however, as Blakelock's art became increasingly abstract and philosophical, Blakelock, like Whitman, William Blake, William James, George Inness, and William Page, found that Swedenborg's equation of material and spiritual reality had a resonance with his own work that he could not quite shake off. Blakelock's experiences with Native Americans further spurred his interest in Swedenborg's ideas and, by the 1870s, he was intimately acquainted with spiritual circles in New York.

In the mid-nineteenth century, essential questions about the material and spiritual, the rational and the irrational, were informing the arts, medicine, and philosophy all at the same time and poured freely onto the front pages of the newspapers. Whitman and Henry James

Sr. emptied their pens on Swedenborg. It seemed that Emerson, who had written *Nature* in 1836 and "The Transcendentalist" in 1842, was in the papers almost daily. Of course the newspapers in the Blakelock household were more literary than the ones we read today. William Cullen Bryant, the noted American poet, friend to the painter Thomas Cole, and a leading light among New York's literate elite (and occasional spiritualist), was editor of the *New York Evening Post*. Charles Dana, a transcendentalist, was editor of the *New York Sun*. The most brazen romantic poetry and fiction, amounting to thousands and thousands of tiny printed words, sometimes covered the front page and were devoured by their devoted readers. The most popular poet of Blakelock's generation, Henry Wadsworth Longfellow, was also often found in the newspapers and journals of the day. His *Song of Hiawatha*, an epic Romantic saga about the exploits of an Indian hunter, became his most famous poem when Blakelock was a child. Blakelock knew the poem well, and its evocation of natural man communing with the universe in the dark forests somewhere on the other side of the Appalachians kindled his imagination and found a permanent place in his heart. Years later, he would base several paintings on the poem, including one of the Indian hunter Hiawatha, a ghostly figure emerging from the forest gloaming with his bow and arrow.

If in adolescence Blakelock was entertaining romantic notions of primitive peoples and pondering the mysteries of the spirit world, it was the impending Civil War that most gripped the minds and emotions of his generation. On April 12, 1861, the Confederates shelled Fort Sumter, and eight days later, more than 100,000 New Yorkers gathered in Union Square, rallying at last behind the flag. Only three months earlier Mayor Wood, openly proslavery, had suggested that New York secede from the Union. By the end of April overt Southern sentiment in the city had evaporated, and dozens of regiments of young men were ceremoniously marching off to protect the capital in Washington. Sitting in their pew, listening to the sermons of Reverend Muhlenberg, the Blakelocks justifiably felt they had landed on the right side and were among New York's freethinking society. Theirs

was a free congregation of social reformers and egalitarians. They stood firmly behind Abraham Lincoln and the Union.

Their liberal cause, it also turned out, had finally become a popular one. By the mid-1860s some of New York's oldest and most prominent families, among them the Astors, the Suydams, and the Aldrichs, had joined their congregation. Ironically, Holy Communion, a free church once isolated in an undistinguished area, where blacks could sit with whites, poor with well off, found itself in the midst of a booming neighborhood, only a block away from the new mansions being built on Fifth Avenue. By 1862 "the services were crowded, many often being turned away for want of room."

Blakelock never really got over missing the Civil War. As he sang Muhlenberg's "Republican Battle Hymn," thousands of teenage boys, including his older cousin Richard, were racing off to join the blue-jacketed regiments of the Union army. But Blakelock never had the chance. At Middletown he contrived elaborate invented missions that he had purportedly carried out for General Sherman. The truth is that in 1861 Blakelock was too young to enlist, and even in 1865 he was not quite old enough to be drafted. He insinuated at the asylum that he was too slight of frame to volunteer. His father, in any event, had other plans for him. He wanted his son to become the first member of the family to attend college and he was most "anxious that his son should follow in his footsteps and become a doctor."

In the spring of 1864, at P.S. 45, Blakelock was placed in an advanced class to prepare for college. On July 1, 1864, he was one of the twenty-seven students nominated by the principal to take the competitive examination to enter the Free Academy (later known as the City College of New York). Several hundred students from other public schools also took the exam. It was a notable annual city event, often reported in the newspapers. The exam lasted several hours; the questions were quite technical. Students were expected to be able to, among other things, reduce one pound avoirdupois to the decimal of a ton, calculate square roots to three decimal points, reckon longitude and latitude,

and name the countries bordering the Adriatic, Black, North, and Red seas. Eighty-five students failed the exam, but 350 students, including Blakelock, passed and were informed several weeks later that they had been admitted to the Free Academy's class of 1869.

The college, established in 1847, was located on the corner of Twenty-third Street and Lexington Avenue. The building, with its ivy-covered walls and four Gothic spires, was an impressive destination for the boys who trekked there from all parts of the city. Most of the seven hundred or so students who attended the college were from modest middle-class families: their fathers were clerks, tailors, druggists, printers, small merchants, and physicians. By virtue of their college acceptance, these young men had reached a level unimaginable to the local East Side ruffians who bullied and stoned them on their way to school. The Free Academy students banded together for protection. On the campus, dressed in their dark jackets and ties, they swaggered for the camera.

Blakelock's class was the last to enter the academy during the Civil War, when the "lads" still "talked more of battles than books." It wasn't all abstract talk. In 1863, the year before Blakelock entered the academy, the introduction of the draft incited the most violent riots in the city's history. For several days, angry, armed Irish mobs ruled the streets, destroying the homes and businesses of white liberals. Black men were taken from their homes and hung from lampposts. A black children's orphanage was burned to the ground just a few blocks away from St. Luke's Hospital, where Blakelock's pastor, Muhlenberg, spent the time fending off angry gangs. "The city cars had ceased running, the telegraph wires were cut and St. Luke's was almost isolated . . . There was a stifling oppressive stillness in the suspended traffic of the street, and now and again from the window could be seen men and women assailing the few carriages that passed . . . Knots of ill-looking men were seen standing about . . . Night came on, a night of horrors. Yells and shrieks at no great distance, with now and again the report of a street howitzer, or the rattle of musketry, filled the darkness."

The students joined in the fiery debate about secession and slavery. One senior composed a poem called "Cotton Is King."

How strange this custom of our world, of late
Confounding living and inanimate
Cotton, raised by the slave, is called our "King"
While he who raised it still remains a "Thing."

Most students sided with the Union. Effigies of Confederate rebels were hung from the rafters of the barnlike assembly hall while the students sang "Hang Jeff Davis on a Sour Apple Tree." At night, torch-lit marches were held to celebrate the Union victories.

The curriculum placed special emphasis on practical and "useful" areas of learning. Bookkeeping was taught "in order to qualify young men for mercantile pursuits." Chemistry, mechanics, architecture, and navigation also had their purposes. The inclusion of classical languages and the humanities had populist Horace Greeley fulminating that the school was too elitist and should be shut down. It did not. However, it was run with strict discipline and rigor. Its principal, Dr. Horace Webster, was a West Point graduate known as a "strict disciplinarian, with a quick, sharp military manner and no patience whatsoever with indolence or incompetence." Students learned by rote and mechanical drill. Demerits for discipline were taken seriously.

It was easier to enter the Free Academy than to remain there. Hardly any students completed the five-year BA program. In fact, the curriculum was designed in self-contained semesters that were meant to provide "a tolerably good education" should a student (and the vast majority did) elect for financial or other reasons to drop out. Academic standards were exacting and competitive, with tests being given every two weeks. About 140 of Blakelock's fellow classmates left after the first semester—often after failing a test—and another seventy after completing their first year. Only thirty-one students were left among the senior class of 1865.

Blakelock was, as his school records attest, a good student. He enjoyed literature and history. But he excelled at drawing, ranking sixth in the school. In his two years of attendance, Blakelock learned a great deal more than he wished of mathematics (his weakest subject) and chemistry. He also took classes in rhetoric, European and American

history, and the classics, reading Cicero, Virgil, Homer, and Sophocles. Blakelock was supposed to be preparing for a career in medicine, but one suspects that he devoted most of his energies to and was, perhaps, most disappointed by his lessons in art.

Drawing at the school was taught "in view of its varied and eminently practical uses." The second-year course was called "descriptive geometry." The professor of drawing, Hermann Koerner, was nick-named "point of space" because of the emphasis he placed on perspective. Koerner, a large man with long white hair and beard, was a political exile from the German revolution of 1848, an idealist who tended toward philosophic musings. His aesthetic posture was, as one student put it, "full of the defense of simplicity and truthfulness in art." In this regard he was not out of step with the times.

In 1863 a small group of American artists (led by a graduate of the Free Academy), who were disciples of Ruskin, formed the Association for the Advancement of Truth in Art. In his book *Modern Painters*, Ruskin complained that the old, Claudian conventions of landscape painting drew more attention to formulas of art than to nature. He wrote, "That which ought to have been a witness to the omnipresence of God, has become an exhibition of the dexterity of man." Ruskin's American disciples elevated the notion of fidelity to nature to a religious creed. In their journal, *The New Path*, the editor wrote, "We believe that all nature being the perfected work of the Creator should be treated with the reverence due to its Author, and by nature we do not mean only the great mountains . . . but also . . . every blade of grass that waves and shivers in the wind; every beautiful pebble that rolls and rattles on the sea sand." Their ideas remained quite literal, minimizing the Romantics' attachment to individual intuition, imagination, and interpretation. The association, as it turned out, did not last long, but the question of what constituted "truth" in art was to linger and become the fundamental debate of mid- and late-nineteenth-century American art.

In Koerner's classroom, a large studio lit by skylights, the students sat side by side at narrow tables copying classical busts or the plaster casts of Greek friezes that were attached along the length of one wall.

That was their most creative endeavor, the preponderance of the exercises being in architectural and geometric drawing. At the end of each week, Koerner graded the students' drawings, and the names of the students were called off in the order of the excellence of their work. Being near the top of his class, Blakelock had nothing to fear and took his lessons to heart.

His drawings of the period show a conscientious attention to detail and perspective. In his literal study of a dilapidated riverside mill, every blade of grass is meticulously rendered, as are the boards of wood, with some placed in odd angles to show off his mastery of perspective. He drew studies of the human figure with careful anatomical precision and correct proportion. Up until the late 1870s, Blakelock continued to draw prodigiously—hundreds of his sketches survive—and he used sketches as the basis of many of the paintings he completed in the first twelve years of his career. There has been much confusion on this point, some of it fed by the early critics who rightly observed that after 1879 Blakelock abandoned an already loose conformity to reality in favor of a more moody and expressionistic style. Therefore, it was later assumed that Blakelock had never used drawings for his paintings. Other critics ignorantly dismissed all such rogue artists as being incapable of drawing. And still other critics in the early 1900s implied that Blakelock's mental illness precluded or curtailed his ability to draw. In fact, Blakelock was still knocking off draftsmanlike architectural studies of buildings when he was in the asylum. The truth is, Blakelock held the rather orthodox view that the fundamentals of drawing had to be mastered before an artist could give sway to personal interpretation. However, he also believed, like a true student of the Romantic style, that once achieved that freedom was absolute. On several occasions in the 1880s he became annoyed at the suggestion that an artist of certain abilities—such as himself—should have to conform his work to the dictates of realism. Gazing one day at a literally rendered still life by Meissonier, he snapped, "If I ever painted an apple like that, I would eat it."

In college, as conscientious a student as he was, Blakelock was coming to the inevitable conclusion that Koerner had little to teach him

and that medicine might not be his true vocation. Every day, on his way to and from college, he passed the construction site of the new National Academy of Design building going up on Twenty-third Street and Fourth Avenue. It was an ornate Venetian-style palazzo built to celebrate New Yorkers' flourishing interest in art. Weeks before the new building was finished, on April 9, 1865, the students of the Free Academy celebrated General Lee's surrender and the end of the Civil War. Sixteen days later they donned black mourning bands and marched behind President Lincoln's catafalque in a funeral procession that stretched four miles along city streets draped in black crepe. Not a week had passed when the new art palazzo opened to great fanfare on April 27—it was, a writer for *Harper's* wrote, a presentiment of "the soft dawn of returning peace."

The opening gala of the National Academy was widely reported in the newspapers. Fancy carriages jammed the street, fashionably dressed couples gathered on the stately staircase to admire one another. Looming above the entranceway, in the place of honor, hung Bierstadt's giant panorama *Looking Down Yosemite Valley*. Blakelock, however, observed the opening festivities from afar, as it were. He was still a student and remained at school another year.

The following spring, on April 30, 1866, the students again marched in a funeral procession. This time it was a mock one, held at 10:30 at night, in a festive torchlit parade down Fifth Avenue. The name of the school had officially been changed from the Free Academy to the City College of New York. To mark the event a senior hit upon the idea of staging a "burial" of the old academy—marching band, coffin, bonfires, beer, eulogy, and all. It would be the last important event of Blakelock's student career. Two weeks later, on May 15, 1866, Blakelock left the school: "His love of painting proved too strong for him," Cora recounted, "and he made up his mind to devote himself to art."

Blakelock's college years were marked by tragedy at home. During the winter of 1864, Blakelock watched as his younger sister, Caroline, to whom he was very close, grew increasingly ill. There was little he

or his family could do. Epileptic attacks are unpredictable. On February 1, shortly after her eleventh birthday, Caroline had a severe seizure. Dr. Blakelock was unable to help her and she never revived. Two days later, as an unexpected snowstorm descended on the city, the family took the ferry across the East River and climbed the hill to Brooklyn's Greenwood Cemetery to bury her. A few months later, in June 1864, Blakelock's younger cousin John Blakelock died of tuberculosis and was buried in the family plot that had been acquired by Dr. Blakelock at Greenwood. In January 1866, Blakelock's uncle Thomas, who had lived on Christopher Street and been his father's partner in the carpentry shop in the 1840s, contracted pneumonia and died.

It was not an easy time for Blakelock, who was losing interest in school and spent his free time wandering the marginal areas of the city—much like Edgar Allan Poe and Walt Whitman had done—in search of scenes to paint. Pursuing a career in art against his father's wishes was a difficult and risky proposition at best. No other student in the academy became an artist while Blakelock had attended. But if Blakelock was feeling more than the usual stress and anxieties of young adulthood, typically the time when schizophrenia hits the majority of its victims, there was no outward sign of the disease. In two years he didn't miss a day of school, nor did he ever receive a single demerit, an unusual achievement at a school known for its strict code. In his second year his behavior and comportment grade was 900, which was the highest a student could receive. If anything this polite, high-strung young man was charged with optimism. He had adopted the "cheerful disposition," as Cora would call it, of the age—when young American men believed their futures were unbounded.

In the year that followed his "graduation" from college (he did, in fact, receive a diploma) in 1866, his skill as an artist progressed so rapidly he seemed to be on a kind of romantic high, unwilling to let anything get in his way or any of the personal challenges he faced bring him down. He had one ambition: to enter the National Academy of Design and see his own works exhibited on its walls.

8

THE ART

Supplying the Union armies during the Civil War proved to be a great economic boon to New York City. As business thrived, successful merchants looked for new ways to spend their money. They built mansions and decorated them with luxurious furniture and expensive, mostly European art. Already a growing interest before the war, the collection of art became a phenomenon during the 1860s. Art had, the noted chronicler of American artists, Henry Tuckerman, pointed out, become a commodity. New art journals were published, art galleries opened up on Broadway, the National Academy of Design had raised the equivalent of millions of dollars to build its new marble palazzo, and plans were afoot to establish the Metropolitan Museum of Art.

In 1864, at the widely attended Metropolitan Sanitary Fair, Frederic Church's *The Heart of the Andes* was hung opposite Albert Bierstadt's *The Rocky Mountains, Lander's Peak*. Bierstadt later sold his painting for a reported $25,000—an unprecedented price that sent shock waves through the art world and beyond. Bierstadt and Church were now dueling for top billing. Lillian Aldrich, wife of a well-known writer—and a fellow parishioner with the Blakelocks at Holy Communion—described the private parties for Bierstadt and the invitations to

receptions at the Tenth Street Studio Building as among the most coveted in high society.

> Three or four times a season all the artists combined and sent out cards to friends and acquaintances for an "at home" or "artist reception" . . . For that evening every studio would be brilliantly lighted, gay with flowers, small tea tables or punch tables set in each one. The crowds of visitors wandering from room to room, here and there as the spirit moved, through the big building . . . Not only were the artists themselves to be seen in their varied and picturesque studios, but distinguished strangers and guests from other cities were also to be met, and during the war there was certain to be the latest news from every front, for every-where officers and soldiers were much in evidence.

At the close of the war the artists recommenced their seasonal migrations to and from the city. There was always a good deal of excitement and anxiety on their return from their summer voyages. "Everything and everybody is flying about here with the wildest disorder and things look well for the artists," Worthington Whittredge wrote in the autumn of 1865. "The usual cry of the season is of want of room to live in . . . with predictions that everything is going to be dear heard everywhere."

During the winter the artists turned their summer sketches into paintings, entertained potential patrons, and submitted their finished works to the jury of the National Academy for its annual gala exhibit in the spring. At that time, and for most of the nineteenth century, the academy was the single most important venue for artists in the country. An artist's reputation, if not his livelihood, was secured by being elected an associate or full academician to the academy. Acceptance into the annual exhibit was a prerequisite to having any kind of career—attracting critical notice, much less achieving an actual sale of a painting. Although art dealers such as Samuel Avery were beginning to represent some important American artists, most sales, gener-

ated by the publicity that accompanied the major exhibits, took place in the artists' studios.

After the annual spring exhibition at the academy, as May turned into June the Studio Building was deserted. The artists tacked their cards to their doors and took off for the countryside, Europe, and beyond. Some went to visit the ancient ruins of the Mediterranean and the Middle East, some traveled to South America. A few ventured out west, but the majority stayed within the confines of the gentle wilderness at their doorstep: the Catskills, Adirondacks, and White Mountains of New England. Blakelock in the summer of 1865 took his first step toward joining this larger migration of artists, traveling to Arlington, Vermont, where he stayed at his aunt Emily and uncle James Johnson's new summer home.

The village of Arlington, later made famous by Norman Rockwell's homey illustrations of life on Main Street, had twelve times more sheep than people during the time that Blakelock visited. It was really nothing more than a cluster of square white clapboard houses, surrounded by pastures and the steep slopes of the Green Mountains to the east and the Taconic hills to the west. The main street was a dirt road bisected by an oblong, irregular patch of grass, lined with split-rail white fences and maple trees on either side. The Gothic spires of the church could be seen for miles around.

The Johnson place was a boxy, two-story house with a semicircular portico and an adjacent small barn structure on the grassy bank of the Battenkill River. For at least six years the Johnsons returned to Arlington every summer, bringing with them guests to share their enjoyment of nature, music, and art. During the days Blakelock went out to sketch, walking along the tree-shaded road by the river or wandering across the lower slopes of the surrounding hills. He was often accompanied by his uncle, who continued to teach him how to paint in the conventional Hudson River School–style of the time. In the evenings, the Johnsons, their children, and Blakelock gathered around the piano to sing. There were occasional "social hops" held in the town hall, oyster dinners at the hotel, and visits with neighbors, such as the

Canfields, who were also musical and the most prominent family in Arlington.

It was during that first summer that Blakelock met his future wife, Cora Rebecca Bailey, who was then only nine years old and had come up with her family to spend the summer. "I met Mr. Blakelock who was then a young man of seventeen full of love and enthusiasm for his art. He had recently lost a younger sister, of whom he was very fond, [and] I in measure took her place. We roamed the country together all that summer; he sketching and painting while I sat by his side." Cora's description, written more than forty years later, retains a blush of nostalgia, the romantic lilt of a girlish crush. It's easy to see how the artistic and good-looking Blakelock cut a dashing figure for young Cora to fawn over. Cora recalled that she met Blakelock again "one day" in 1868, but did not become reacquainted with him until after his return from the West. By then Cora was an attractive, teenage woman.

As it turns out Cora did not have Blakelock all to herself. He had another female companion who wandered about the fields with him that summer, one much closer to him in age. This young woman is mentioned—though she remains nameless—in a note written by her daughter, Margaret Hewitt, in the files of the Montclair Museum in New Jersey: "When Albert was . . . going to the College of the City of New York he and my mother, then in her early twenties, were both guests of the James Johnsons at a place in upper Vermont. My mother grew fond of him and used to go out with him when he was drawing everything that took his fancy—hence these sketches." Blakelock had given Hewitt's mother two pencil drawings. One is of a bluestone spring cap, the tin dipping cup, which they had used to drink the water, resting on top. The second pencil drawing is that of the ruined mill by the riverside. It's dated August 1865. Across the bottom Blakelock couldn't resist showing off his new skill in Latin, signing it *Fecit B*, with an elaborate flourish of his pen. Ms. Hewitt's mother kept these little studies for decades, so she evidently held some affection for Blakelock. They must have cut a romantic image, the young artist and his friend ambling through the countryside, sitting quietly and talking as he sketched and the crickets buzzed in the dry August grass.

Neither could foresee that, nearly twenty years later, they would be-
come reacquainted in quite different and more trying circumstances.

In the summers that followed his "graduation" from college Blakelock
often visited Arlington on his way to or from sketching trips to the
White Mountains in New Hampshire and the coastline of Maine.

"Go first to Nature to learn to paint landscape," declaimed Asher
B. Durand in his well-known series "Letters on Landscape Painting,"
published in the art journal *The Crayon* in 1855. Blakelock took this
advice to heart, proud in subsequent years to say that he had learned
his craft in what he called "the palace of nature," and not in some dry
academic studio. Using stagecoaches and newly opened rail lines
Blakelock crisscrossed New England with relative ease. He traveled
as far north as the remote Androscoggin River and down the coast along
the rocky bays and inlets of Maine. At other times he visited the
Adirondacks. His days were quiet and contemplative, but he was not
always alone. Along the way he was bound to cross paths with many of
his confederates (Homer and Church were among the better-known
artists traveling in the area at the time). The hinterland of New En-
gland was hardly virgin territory. Many of the views in New Hamp-
shire, like Mount Washington and Franconia's Notch, had already been
made famous by other artists. Thomas Cole had explored and painted
the primeval cloves and remote lakes of the White Mountains as early
as 1828. Durand, John F. Kensett, Church, and the other Hudson
River artists followed. The roads of New Hampshire were dotted with
inns catering to summer tourists and traveling artists. The painter
Benjamin Champney had founded a year-round colony of artists in the
lush valley of North Conway facing Mount Washington, "a New World
Eden . . . bathed in a clarified morning light ideal for sketching and
painting *en plein air*."

No longer a terrifying place inhabited by beasts and wild savages,
nature had come to be seen by the Romantics of the late eighteenth
and early nineteenth centuries in a benign, divine light. Nature re-
vealed the true moral order of the universe. In nature man could dis-
cover his higher, universal self. Emerson wrote that a divine spirit was

"present" throughout nature and that a work of art was an expression of nature. Nowhere was the spirit of God more present than in the still-pure American wilderness, which remained largely unsullied by human civilization. Artists like Blakelock set off to climb its mountains and explore its quiet glens and crevices where the only sound was the shrill of a hawk or the hiss of a distant waterfall. In painting their landscapes, the Americans were influenced and stirred by the Romantic furor in Europe: the music of Wagner and Beethoven, the poetry of Wordsworth, and the fiery skies of Turner. Like the solitary Romantic hero in Caspar David Friedrich's painting *The Wanderer Above the Mists*, the artists—clad in tweed and carrying walking sticks—saw themselves standing on some craggy mountaintop communing with the vastness of the natural world.

"To the artist, I say, has been given the command to go forth unto all the world and preach the gospel of beauty," intoned Whitman. Free of the burden to paint historical or religious images, artists aimed for the ethereal, what William Wordsworth called "a sense sublime / . . . A motion and a spirit, that impels / All thinking things, all objects of all thought, And rolls through all things."

In America the rhetoric was unbound, intense, mystical. "Standing on the bare ground," Emerson famously wrote, "—my head bathed by the blithe air and uplifted into infinite space, —all mean egotism vanishes. I become a transparent eyeball; I am nothing; I see all; the currents of the Universal Being circulate through me; I am part or parcel of God." The desire to transcend material reality and unite the self with a larger spiritual *other*, paradoxically, also led inward to a greater reliance on intuition and feelings. Already in the early 1800s, Washington Allston, at that time America's most painterly artist, was suggesting this subjective change in direction. "Trust your own genius," he wrote, "listen to the voice within you, and sooner or later she will make herself understood not only to you, but she will enable you to translate her language to the world, and this it is which forms the only real merit of any work."

Blakelock echoed these Romantic sentiments about originality and nature in a somewhat stentorian comment he made in the 1880s. "The laws of the art of painting are the laws of the creator," he said.

"When . . . knowledge is obtained, then we may trust our emotional nature or spirit to create, and then, upon comparison . . . find them like nature." Underlying Allston's and Blakelock's words was an implicit faith that there was a universal language to be discovered in nature and that landscape painting, along with music and poetry, was the means to convey it.

To be sure, conversations about Romantic and transcendentalist ideas took place in the comfortable surroundings of a country inn, fire burning, glass of wine in hand. Mystical sentiments aside, the Hudson River artists approached their palettes somewhat gingerly—keeping their imaginations in check. They had to be careful, after all, not to trammel God's work. They gave heed to the critics' call for "truth," for good taste, and the market's demand for certain locations and compositions.

Some postmodernist thinkers have reduced Hudson River School artists to so-called commodifiers of nature, poster boys for the tourist trade that followed in their wake. Other modern social scientists are now calling them America's first environmentalists. Ironically, in commodifying nature, the artists gave it a value; in other words, they sanctified it. The panoramas of artists like Thomas Moran and Bierstadt inspired the first national and state parks, sanctuaries set aside so that future generations could enjoy a transcendent experience of nature all over again.

In truth, American landscape compositions were both influenced by and, at the same time, trying to break away from a conventional tradition that can be traced back to the pastoral work of Dutch artists like Jacob van Ruisdael and the arcadian works of Claude Lorrain. Blakelock, too, was familiar with the Dutch painters and, of course, with his Hudson River School predecessors like Cole and Durand. He had, it is said, an abiding admiration for the Old Masters, especially Titian. But the demands of neither tradition nor the marketplace stripped the experience Blakelock felt as he walked down a secluded forest path at dawn to paint the first shimmering light on a secluded lake, or the feelings he described in a poem, upon sitting down and watching the sun set over the ocean. He called this poem, simply enough, "Setting Sun."

One radiant outburst of surpassing splendor
And with the perfect peace of self surrender
Without a tear; without a fear
Like some high spirit passing from our sight
The Sun steps down into the unknown night.

Blakelock, it seems, from everything we know about him—from his penchant for Longfellow to his love for the music of Wagner and Beethoven—was a hopeless romantic. He spent much of his time as a young man exploring the woods, the lonely meandering rivers and lush mountain valleys of America's wilderness. His experience of nature bordered on the ecstatic; he even named one of his landscapes *Ecstasy*. His difficulty, if anything, was in conforming his enthusiasm and nervous temperament to the conventions of his time. At the beginning, he mustered all his patience and discipline and did what every novice artist does. He absorbed the sentiment and the style of the artists who had come before him.

The earliest known Blakelock painting, probably completed in 1865, may depict the Johnsons' summer home on the Battenkill River in Arlington, Vermont. Blakelock gave or sold the painting to the Johnsons' Arlington neighbors, the Canfields. They left "the little Blakelock" with their friend Dr. John Munn in New York, and eventually it found its way to Harvard, where for sixty years or so it was stored in a basement drawer of the Fogg Museum. It's a small canvas, longer than it is wide. The painting, a dull, grayish thing in color, is covered in a layer of grime and dust. A close look reveals a sweet and simple picture of a house on a river. The house, including the window sashes and the columns on the porch, is carefully drawn in thin paint, using the same literal approach as the drawing of the mill that Blakelock had completed that same summer. A patch of blue pigment still remains in the sky; the trees about the house are clearly delineated. The most impressive technical accomplishment of the painting, though, is the wavering reflection of the house on the surface of

the river. The only impulsive touch appears to be a broad brush stroke of olive-green paint squished along the riverbank.

There are at least two other examples of Blakelock's work from this very early period. They, too, are the work of a dexterous beginner, featuring roller-coaster hills and flattened clouds. But a pencil drawing of a New England valley completed in 1866, now in the Wadsworth Atheneum in Hartford, Connecticut, shows a leap forward in ambition and scope. The drawing, of a sleepy town on the banks of a river with the sun rising over the distant mountains, adds a panoramic scope and mood missing from the earlier works. A few wispy cirrus clouds—reminiscent of Church—catch the sun's rays.

Blakelock's most remarkable transition takes place over the next year or two, in which time his skill as a painter attains a level comparable to the masters of the Hudson River genre whom he was studying. In his 1868 painting *Sunrise,* of a lake in autumn, each tree in the forest is individually rendered while the misty atmosphere of early morning bathes the scene in a quiet shivery glow. In *Sunny Morning in the Catskills* every leaf on the small birch trees in the foreground, hit by the morning sun, leaps out at the viewer. Likewise, the rocks on the path are conspicuously delineated by the sunlight, showing off a realism on par with Church's. In the space of two or three seasons Blakelock, who was essentially a self-taught artist, had mastered the bucolic ingredients of nineteenth-century American landscapes—the licked sheen of a lake's surface, the Gothic drama of granite cliffs, and the subtle poesy of a twilight sky with its gradations of blue to lavender to chartreuse pink. All that was needed was the addition—and these came in short order—of picturesque details: a farmer's house, a few paddling ducks, or cows, à la Corot, crossing a stream complete with flippant silver splashes of water about their hooves.

At the time, James Johnson was still Blakelock's most important influence. Johnson's daughter later told Lloyd Goodrich that Johnson and Blakelock "were always going out painting together," and that her father was the only teacher Blakelock ever had. In fact, Goodrich found Johnson's work to be "extraordinarily similar to Blakelock's early land-

scapes; even the drawing and handling looked similar." Johnson, in turn, painted in the style of William L. Sonntag, a fairly typical Hudson River School painter, albeit of the quieter and less dramatic variety. That said, there are elements of Blakelock's early paintings that can be traced to a number of Hudson River artists, from the symbolic dead trees of Cole to the softer landscapes of Thomas Doughty or Worthington Whittredge.

Similarly, as Davidson points out, Blakelock's paintings, like *A Woodcutter's House* (1868), demonstrate an awareness of themes—in this case, the incursions of man and industry on the wilderness—explored by other Hudson River School artists of the time. The point is, Blakelock though self-taught was not working in a vacuum, nor does it seem from these paintings that he was struggling to find a singular vision of his own. The first painting he showed at the National Academy of Design was a view of Mount Washington. A more popular, less original subject matter could hardly be found.

There are other paintings from this same period, however, that tell us an entirely different story. These works display a more daring and experimental artist trying on different styles. In one particular small painting of farmers gathering hay in a field (*Landscape—Evening*, 1868, Krannert Art Museum), Blakelock has chucked the careful, polished approach of the Hudson River variety in favor of a more spontaneous and painterly manner. The trees in the background and the mounds of hay in the field lack any detail, reduced to idealized forms of color. The oxcart, farmers, and farm buildings, though, still retain a literal rendering, giving the picture a naive quality far from the sophisticated realism of a painting like *Sunrise*, completed that same year. In another painting of the same era, *Landscape with Houses and Boat*, in the John D. Rockefeller collection, Blakelock has paved the sky with thick swaths of paint applied with a palette knife and added a Corot-like misty, nervous quality to his trees and water.

Most important, it was during the late 1860s that Blakelock began a series of works known as his shanty paintings that are unique in subject matter, revel in the painted surface, and display a rough-hewn tonal harmony that is entirely his own.

Through the mid-1870s much of Manhattan above Fifty-ninth Street remained undeveloped. It was here in the broad, treeless expanses of marshy fields and rocky escarpments that the poor Irish and, farther north, the African Americans built their shantytowns. Herds of goats and pigs wandered about. Women and children in the shanties were reduced to becoming rag-and-bone pickers. "By the standards of 'respectable' New York, these were lawless places well beyond the reach of the city's churches and civil society." It was here that Blakelock often came to sketch. "Some portions of its interior have a certain air of rocky sterility which may impress some imaginations as simply *dreary*—to me it conveys the sublime," wrote Edgar Allan Poe, who also once had wandered the area.

Many of the shanties were precariously perched on rock outcroppings. Blakelock went to great lengths to display the makeshift, but intrepid, ways in which the squatters had tried to build their homes and re-create a domestic environment—complete with chimneys and rickety white-picket fences—in a harsh and forbidding terrain. In several drawings Blakelock leaves a detailed record of the squatters' hardy attempts to carry on daily life in less than perfect circumstances—men and women carrying heavy sacks, bundles of kindling, pails of water, others mending roofs and driving wagons. Though Blakelock was one of the first American artists to consider the urban poor as subject matter, he had no interest in creating a kind of picturesque, Eastman Johnson–type genre painting of America's lower classes. Instead, in the finished paintings, he distances himself from the shanty and reduces the squatters' activity to the presence of a distant solitary figure, always a woman, sometimes with her child waiting at the gate. By isolating the shanties in a desolate landscape with a faraway treeless horizon and a wide blustery sky, Blakelock transforms this picturesque urban scene into a more generalized commentary on nature and mortality. Interestingly, there is a suggestion of the painting style and social conscience of the French Barbizon painters—such as Jean-François Millet and Diaz de la Peña—in these works. The Barbizons had only just been introduced into America, and it would be another decade before they would dramatically influence painting on this side

of the Atlantic. In the late 1860s it was unlikely that Blakelock had more than a passing familiarity with their work. Yet with the shanty paintings he has taken on a different style and seems released by the subject matter. He attacks and layers the surface of the canvas. At times he adds brilliant color to the sky. In one painting, *Fifth Avenue at Eighty-ninth Street in 1868* (Museum of the City of New York), he dollops thick globules of golden paint (which threaten to fall off the canvas) to imitate a heavy stack of hay piled on the roof of a shed. In every manner the shanties are painted in a far more expressive and spontaneous way than are his Hudson River–style works.

"Here practically at the outset of his career," art historian Norman Geske has written, "he is seemingly torn between two possibilities, one the correct and detailed naturalism of the accepted landscape paintings of the day, and the other, a spontaneous indulgence in painterly qualities which could only be considered unorthodox and somewhat radical. This oscillation between what was expected and what came naturally can be seen as an underlying pattern in his work for some time to come."

In the fall of 1867, Blakelock needed to impress the exhibition jurists at the National Academy of Design. The academy, established in 1826 by Samuel F. B. Morse (for the then controversial purposes of exhibiting the works of contemporary, living artists), had by the 1860s adopted a recalcitrant and conservative stance. Its council of academicians quibbled endlessly over whether or not the academy students were getting a thorough enough instruction in anatomy and antique drawing. They were less interested with experiments and originality than they were with what they felt represented a "finished" painting.

Under growing pressure, in May 1867 the academy established a fall exhibition in addition to the annual show held every spring. For the fall exhibit the rules were loosened to include previously hung works of well-established painters, but its principle aim was to show off the younger, up-and-coming crop of artists. To broaden the exhibit's appeal, the academy also invited painters from the newly formed American Society of Painters in Water Colors to exhibit their work.

To be included in an academy exhibit involved a long and anxiety-filled process that often ended in disappointment for the artist. Paintings had to be framed at considerable expense and submitted to the selection committee, which, in theory, impartially chose the paintings to be included in the exhibit. In practice, there was a tremendous amount of political jockeying to include the paintings of friends and ensure that the academicians were reserved the most favorable places on the wall—that is, at eye level, or "on the line." Months later, on "varnishing day" or "hanging day," those artists who had received an acceptance notice in the mail lined up outside the academy to confirm that their names were on the list. There were always a few without acceptance letters who came hoping their notice had been lost in the mail, and they were turned away. The others were allowed inside to find out where their paintings had been hung and to add final touches of paint or varnish. The artists hoped "to find that his work has been appreciated and awarded a position appropriate to its merits," a newspaper critic wrote at the time. "But the best places to hang are few, and even very desirable ones, in respect to light and *the line*, are not as numerous as they ought to be." The experienced academician Jervis McEntee found "varnishing day at the Academy . . . always a very discouraging time."

Several days following the hanging of the paintings, a private preview was held, known as "buyer's day." Artists, critics, guests, and collectors were invited. The artists, now competitors, watched nervously as buyers reserved the paintings they wished to purchase. Finally, the exhibit was opened to the public—frequently a front-page item ran in the newspapers—and the younger, lesser-known artists had to wait and see if the critics singled out their work for praise or damnation.

Blakelock's submission, *Mount Washington*, was a safe bet, unlikely to roil the conservative tastes of the selection committee. In 1867 the committee comprised some of the leading, elder artists of the time, including John F. Kensett, Eastman Johnson, Worthington Whittredge, and Jervis McEntee. McEntee was recording secretary at the academy, and a friend of Frederic Church. He presided in a genial, snobby manner as the unofficial social host at the Tenth Street Studio Building,

where he lived, worked, and entertained with his wife, Gertrude. He was a conservative force at the academy, more preoccupied with his status as an artist than in artistic innovation. Whittredge, also a Tenth Street denizen, had studied in Düsseldorf with Bierstadt and would later serve as president of the academy. These men, along with painters such as Jasper F. Cropsey, Martin Johnson Heade, and Sanford R. Gifford, formed the inner circle of artists who made up the art world in New York at the time. Many of them had studied and traveled together in Europe. They had studios on Tenth Street, belonged to the Century Club, and, whenever they could afford it, dined at Delmonico's. Often bickering among themselves, they deferred to Kensett, Daniel Huntington, and Durand (the éminence grise, mostly retired and living in South Orange, New Jersey) and wallowed in the wake of the stars Church and Bierstadt. The latter knew and socialized with the clique but lived in a different sphere. Usually too busy to bother with the banalities of committees, they entered and left the inner circle as they pleased.

A coterie of lesser-known artists helped run the show and decide the policies of New York's art institutes. James Brevoort was prominent among them. He never became a terribly successful artist, but he lectured at the academy, came from an old New York family, knew everybody in the clique, and was invited to their picnics and parties. He was also, it will be remembered, a friend of James Johnson. It would not have been difficult for him to put in a word for young Blakelock (some connection with the inner circle was eventually made, as McEntee mentions corresponding with Johnson's wife and Blakelock's aunt, Emily Johnson, in his diary). The committee, in any event, was suitably impressed with *Mount Washington*. On varnishing day Blakelock found not only that he was on the list to enter the palazzo of art but that his painting had been hung in the main room along with those of Thomas Cole and the rising new star Winslow Homer.

On the evening of Thursday, November 14, 1867, the doors to the academy's first fall exhibit were opened for private viewing. Although not on the scale of the annual exhibit, it was still a crowded, formal occasion. The halls were brightly lit, an orchestra played music. The

men wore long coats with tails and the women elegant dresses and loose, wide silk bonnets.

Blakelock, too, was suitably attired. A picture taken about this time shows him wearing a stiff collar, polka-dotted ascot, and vest, an extremely handsome young man with a high forehead, clear blue eyes, and a confident expression. He had every reason to believe in a bright future. After all, he had spent most of his childhood as the son of a policeman, growing up with the children of clerks and grocers, admiring the art world from afar. Now he was *in* it. Not that Blakelock felt entirely at home in this room full of sophisticated and important people. His perspective on the world was considerably different. He had seen firsthand the chaos of the city, the building and destruction, the riots and epidemics, the struggles and setbacks of working people. His life was less sheltered than those of many of his artist contemporaries, less buffered by highbrow aesthetic and literary ideas. He spent his days sketching among the poor Irish in their shantytowns, as he later would with the last free Indians on the plains. He picked up his many friends as he went along, not from the social or artistic elite but from among the ordinary people he lived with, the liberally minded and the spiritually inclined. Despite his soaring ambition, Blakelock would spend little of his time smoking cigars in the clubs. Though he wished to belong, he never honed the niceties of social advancement.

In the halls of the National Academy that night Blakelock was just one of a hundred or so hopeful young artists trying to act dignified and make polite conversation with the right people. One supposes that he brought along his parents and his mentor uncle, James Johnson, and that this small group felt somewhat overshadowed by the cosmopolitan cumulus about them. Certainly he had reason to be proud. His paintings, which only two years before hardly surpassed those of a talented youngster, had since arrived at a level commensurate with the masters' hanging next to his. Blakelock had accomplished what he had set out to do. He was only nineteen years old and on his way to becoming a professional artist.

As the family members gazed up at Blakelock's pastoral view of Mount Washington, however, it signified more than just his accom-

plishment. It was a testament to the family's long struggle in New York and their arrival at a certain *niveau* of American life. Any other kind of painting—say, one of his painterly shanties—would have been a source of confusion and disappointment.

The review of the exhibition that appeared in the *New York Times* the following morning was brief and polite.

> The first Fall and Winter Exhibition of the National Academy of Design was opened for private view last evening. As usual on such occasions the rooms of the Academy were so densely crowded that viewing the pictures critically was simply impossible. There are about two hundred and fifty works of all kinds—paintings and drawings—on the walls, and among them we had the pleasures of recognizing quite a large number of old favorites.

The reviewer never got around to mentioning names or singling out the discovery of new talent. Most of the press about the fall exhibit focused on the novelty of including the watercolors of the American Society. A later *Times* review on November 29 did single out and discuss a few artists, but Blakelock was not among them. He did not, however, have time to mull over being omitted from the reviews. He was soon notified by the academy that it would, in mid-December, "send for pictures" being submitted to the next year's annual exhibit. His paintings needed to be finished by then. The long cycle of ups and downs, of triumphs and rejections, had now begun in earnest.

III

ON THE SNAKE RIVER

Behold a Sacred Voice is calling You;
All over the sky a Sacred Voice is calling.
 Black Elk

9

UP THE MISSOURI RIVER

Two years after his paintings were first shown at the National Academy of Design, Blakelock found himself far away from the cosmopolitan goings-on in New York City—far away, in fact, from anything he had ever known. In June 1869 Blakelock traveled up the Missouri River to a distant trade and military outpost on the frontier, Fort Pierre, nine hundred miles northwest of St. Louis and two hundred miles from the nearest white settlement.

For centuries, the confluence of the Bad and Missouri rivers had been an important trading place for Native Americans, who converged on the riverbank from as far west as the Rocky Mountains and as far east as the Mississippi and Great Lakes regions. It was here that Pierre Chouteau, the French trader, set up his American Fur Company trading post, called Fort Pierre. It was here that Lewis and Clark first encountered the Sioux, and here, too, that artist George Catlin, thirty years before Blakelock's visit, had climbed the bluffs to draw the post surrounded by six hundred Indian lodges. By the time Blakelock arrived the original Fort Pierre had been abandoned and replaced by a new fort (though renamed Fort Sully, the general area was still known as Fort Pierre) some thirty miles upriver. "It was an ideal spot for

defense. It stood on an elevated plateau about 160 feet above a wide and beautiful valley of the Missouri . . . and about the same elevation above the surrounding prairie."

The boat landing was on the bank opposite the fort, so people and supplies had to be ferried across the river. Provisions were loaded into wagons and hauled up to the fort by mule teams. Upon arriving at the top of the bluff a visitor comes upon a vast, unending view of the plains, a bowl of grass that dips ever so slightly toward the horizon in the west. It is, today, a lonely, otherworldly place, but at the time the 350-foot-long fort palisades—bustling inside with four companies of infantry—stood on the crest of the hill, and before it the Sioux had planted their tepees. To the twenty-one-year-old Blakelock it was an exciting and unforgettable sight: "Hundreds of lodges were pitched in the vicinity of the fort—bands of horses were feeding over the prairie," he scribbled in his sketchpad. "A pretty squaw wore a dress made from the skin of the big horn, tanned soft & white & lavishly embroidered with beads— [she rode] on a spirited American horse."

According to one account, Blakelock had arrived on the plains from New York via the Great Lakes. "Blakelock took a boat to Albany, from there to Buffalo. He got a job working on a lake schooner bound for Duluth. He found some Indian traders who were going to the Sioux country in Minnesota and Dakota." From Duluth traders typically descended, via St. Paul, the Minnesota and James rivers (which Blakelock painted) to the Missouri. At Yankton, traders and soldiers traveled up the Missouri by canoe or, if conditions permitted, boarded one of the small steamers that risked the hazardous trip northwest as far as Fort Buford near the border with Canada.

It was not an easy trip. Even in high water, snags and sandbars often grounded the steamers, which then had to be unloaded of passengers and provisions and hauled back into deeper water, a process that sometimes took days. The navigable season on the Missouri was short. By mid-July the heat and lack of rain took their toll, exposing the broad, sweeping gravel beds that made the river impassable to large craft. Prairie fires and locusts swept over the land.

In traveling the upper Missouri Blakelock was following the route taken by the great explorers Meriwether Lewis and William Clark, as well as painters such as Karl Bodmer, John Mix Stanley, and Catlin. Catlin's books about his travels during the 1830s in the Missouri region were popular and had made the Missouri headwaters famous, inspiring later trips up the river by artists like John F. Kensett and William Jacob Hays. By the late 1860s, however, after several years of Indian warfare, attitudes had changed and the Missouri route became a neglected and out-of-the-way passage. Blakelock, who, like Catlin, traveled independently, found himself in remote areas that held little attraction for the great tide of pioneers by then streaming overland on the Santa Fe, Bozeman, and Oregon trails farther south and west.

In the Dakotas the powerful but lonely Missouri carves through rounded bluffs beyond which the prairie—in the spring a carpet of green buffalo grass, wild grapes, and prairie flowers—rolls to the horizon. In the hollows, cottonwood and ash, willow and oak trees flourish, providing refuge for deer and elk. The northern plains are predominantly treeless, however, a vast, deserted landscape cursed for its changeable disposition and flattered for its ascetic beauty. Reaching a high terrace on the northern plains, Catlin wrote: "There is a sublime grandeur in these scenes . . . which must be seen and felt, to be understood. There is a majesty in the very ground that we tread upon, that inspires awe and reverence . . . Man feels here, and startles at the thrilling sensation, the force of *illimitable freedom*—his body and his mind both seem to have entered a new element—the former as free as the very wind it inhales, and the other as expanded and infinite as the boundless imagery that is spread in distance around him."

Blakelock rarely discussed his trips out west. He left little other than scattered notes, a detailed itinerary, and several sketchbooks with which to reconstruct his journeys. But the hundreds of drawings and sketches he made speak for themselves. On his first extensive trip away from home, Blakelock was intoxicated by the exotic sights at hand; he drew the Indians riding bareback on galloping horses, coyotes sniffing the ground, buffalo spread out like balls of dark cotton

across the prairie. Blakelock had become part of a world he had till then only read about, experiencing things that he could not have imagined. It was a world that would consume his interest for the better part of the next four years and influence his art for decades to come.

It's not difficult to understand why Blakelock left New York. By 1869 he had been out of school for three years. He was still living at home, at the time on West Twenty-fourth Street, with his parents. Though he had sold a few paintings—mostly to friends of the family—his work had appeared in four shows at the National Academy without being mentioned in a single review or leaving a marked impression on the art scene in New York. The art scene, for that matter, was deteriorating. Public interest in the Hudson River landscapes was on the wane and critics were clamoring for something new. Blakelock had traveled and painted the New England countryside, from New Hampshire to the Catskills, for four years. It was time for a change.

The obvious choice for Blakelock should have been Europe. At that time, just about every American painter of Blakelock's generation traveled and studied in Europe. All but the hardiest and most talented of them returned with a confused agenda, painting a slightly trendy (i.e., Europeanized) version of American academic art that would leave barely a dent in art history.

Blakelock's decision to stay in America would one day earn him the reputation of being one of the few "authentic" American painters of his time, but it also isolated him from other artists his age. Goodrich, on the occasion of the centenary exhibit of Blakelock's work at the Whitney Museum of American Art, in 1947, wrote: "The fact that in a day when most young American artists were heading for Paris, Blakelock elected to get his training by going out to the wildest region of America, living in the most primitive conditions, and studying primeval landscape and aboriginal life, shows that for all his slight physique and nervous temperament, he was entirely his own man." Blakelock had wholeheartedly engaged himself in the American experience, and central to the American imagination at that moment was its westward expansion.

In May 1869 the final spike of the transcontinental Union Pacific–Central Pacific Railroads was hammered into place. Interest in the West, which had steadily mounted since the end of the Civil War, had reached a fevered pitch.

A few of the important painters in New York—with whom Blakelock had at least a hallway acquaintance—had recently made the trip west. Bierstadt had accompanied government expeditions west on several occasions, dating back to 1859, and had exhibited his panoramic landscapes of the Rocky Mountains in New York with great success. In 1865 his *Yosemite* sold for $10,000, igniting a competitive spirit among artists. Six years later, when Thomas Moran was attempting to join Ferdinand Hayden's expedition to Yellowstone, his patron, A. B. Nettleton, assured Hayden that Moran would surpass Bierstadt's *Yosemite.*

Whittredge took his initial trip west in 1866 when he accompanied General Pope's expedition. He returned with John F. Kensett and Sanford R. Gifford in 1870. Few artists, however, traveled out west on their own. They joined U.S. government survey teams, or army expeditions and explorations. They stuck, by and large, to the principle avenues of travel, visited well-known scenic sites, and kept their contact with Indians—if any—to a minimum. Bierstadt, one of the more adventuresome travelers, took his first trip out west with Colonel Frederick Lander's survey expedition. He occasionally encountered Indians and said that they were "kindly disposed," but he quickly added, ". . . it [meeting them] is always a little *risky,* because being very superstitious and naturally distrustful, their friendship may turn to hate at any moment. We do not venture a great distance from the camp alone." Whittredge had a lower opinion of the "wily" Indians, calling them "murderous," "wanton," and "capricious." He must have formed his opinion through what he had read in the popular press, for he had little occasion to meet Indians in "the wild." While Gifford joined expeditions into the mountains—where he spent one morning visiting a Shoshone camp—Whittredge kept close to the ranches where he lodged.

Illustrators for *Scribners* magazine and *Leslie's Illustrated Weekly* did most of their work where the action was—in town. They depicted the

dance halls and brothels, the jostle of Main Street, and the hard-
scrabble pioneers gathered around their campfires at night. Their job
was to dramatize the West, and most of the gunslingers and Indians in
their works were drawn from their salaried imaginations.

Blakelock did not travel under the auspices of the government or
any newspaper or other private organization, but "alone"—a thin
young man of Romantic inclinations, who was without government
commission or pocket money from *Harper's* or *Scribners.* "He had very
little money," Cora wrote. "And many times was compelled to work at
anything he could find to do in order to earn money enough to con-
tinue on his travels." He brought with him only what he could carry in
a linen knapsack that he sewed himself and in which he kept his paper,
pencils, and pens.

While the initial accounts of his disappearing into the wilderness
on horseback and living among the Indians for four years are primarily
fiction, Blakelock did spend a considerable amount of time, compara-
tively speaking, in remote areas among the Sioux, Assiniboins, and
Uinta Indians.

During his trip up the Missouri in the summer of 1869, Blakelock
passed through the Lakota Sioux, Arikara, Mandan, Assiniboin, and
Gros Ventre territories. These were the same Native American tribes
encountered by Lewis and Clark and by Catlin. But by the 1860s the
onslaught of smallpox and the invasion of their hunting grounds had
reduced them to a shadow of their former strength. Nevertheless, they
and their more fierce Sioux neighbors, under chiefs Crazy Horse, Red
Cloud, and Sitting Bull, continued to resist the white invasion. In the
years prior to Blakelock's visit the Sioux fought back, burning forts,
killing soldiers, pillaging white settlements, and setting off the Great
Plains War in the mid-1860s—a conflict that continued sporadically
into the 1870s. Blakelock's arrival coincided with a break in the hos-
tilities, a year after the second Treaty of Laramie was signed in 1868.
But this treaty, by which some Indian tribes agreed to settle on reser-
vations in exchange for annuities, amounted, like so many others, to
unfulfilled promises and worthless pieces of paper. Already, by the
spring of 1869, the local military commanders were sending angry and

worrisome reports to Washington. In March, the agent at the Crow Creek reservation (south of Fort Pierre) reported that Indians were conducting sporadic raids, killing cattle, soldiers, and farmers, stating, "This can not be complained of from the fact that they are in a starving condition and are driven to desperate remedies. They are anticipating and talking of war as being more profitable to them than peace and starvation." The situation was as bad near Fort Pierre, where agent J. R. Hanson reported that if assistance "commensurate with our promises" was not forthcoming, "we shall have war with the entire Sioux Nation."

War did not break out, but when Blakelock arrived in early summer, the fort commanders and their agents were dashing off memos to one another in an attempt to get the greatly delayed annuities delivered to the Indians in the right place. Blakelock noted, at the time of his arrival, that the Two Kettle and Minneconjou bands—amounting to several thousand Sioux Indians—were still "assembled" in the vicinity of the fort, indicating that he had arrived immediately prior to the dispersal of their annuities, which was finally accomplished near the Big Cheyenne Agency north of Fort Pierre in early July.

At Fort Pierre, Blakelock reprovisioned and evidently hooked up with government-contracted traders who were at that time traveling from fort to fort delivering supplies. As the Indians he visited were sometimes as much as a hundred miles from a fort or the river, Blakelock spent a great deal of his time on horseback, camping out on the plains, sleeping under the stars. It was an experience few forgot. Catlin speaks of the "sad delight" that shook him with "terror" as he watched "the swollen sun shoving down upon the mystic horizon." He continues: "Thus have we laid night after night and descanted on our own insignificance . . . We have sighed in the melancholy of twilight, when the busy winds were breathing their last, the chill of sable night was hovering around us, and nought of noise was heard but the silvery tones of the howling wolf."

Even the tight-lipped military reports of traveling soldiers paused to reflect on the "quiet" and "solitary moon" on the plains. It was an experience that was to find its way into Blakelock's mystic moonlights,

his apocalyptic sunsets, his foreboding twilights. Still, it was the Indians that he most remarked upon in his scattered notes.

Upriver, Blakelock encountered the Ricarees. "Unlike the Sioux," Blakelock noted, the Ricarees "have large dirty lodges." They were poor, he wrote, "disfigured, diseased and lame." They certainly did not conform to the romantic literary accounts of the Indians he had read about as a boy. Their customs, he added, were "savage." The Ricarees' dog-sacrifice ritual was surely not a practice Blakelock would have found particularly poetic. "The dog's liver and heart are taken raw and bleeding," Catlin wrote, "and placed upon a crotch; and, being cut into slips, each man dances up to it, bites off and swallows a piece of it, boasting, at the same time, that he has thus swallowed a piece of the heart of his enemy, whom he has slain in battle." During the June Medicine Lodge, in a far more widely practiced ritual among the plains Indians called the Sun Dance, young warriors pierced their chests with a line attached to a high lodge pole and leaned all their weight against it for hours at a time to prove their courage and worthiness. Other dances lasted days; Indian warriors jumped up and down while blowing on whistles and shaking rattles, continuing until they collapsed from exhaustion.

Farther north, in the vicinity of Fort Buford, a small trading post established near where the Missouri meets the Yellowstone, Blakelock stayed with the Assiniboins. The Assiniboins had long been known as a "friendly" tribe. Bodmer had painted a number of Assiniboin portraits in 1834, and Stanley had visited them in 1853. Though their number had been steadily reduced to about fourteen hundred, their freedom remained relatively undiminished thirty-five years later. Blakelock wondered at "the great numbers" of bison and elk that still migrated through this remote territory near the Canadian border—providing the Assiniboins with ample game to hunt during the summer months. Both Bodmer and Blakelock also remarked on how few horses they had—depending on raids on neighboring tribes to acquire them—and how the Assiniboins used their dogs to pull their travois and sleds.

Nominally on a reservation under the authority of Fort Berthold, the commander of the region, General Henry A. Morrow, reported

that, in fact, the fort was "too remote for the tribe." "No communica-
tion or contact," he wrote, was made with the Assiniboins except for
the delivery of annuities, "which have been totally inadequate to the
necessities and desserts of the tribe." General Morrow observed that
the Assiniboins, who wintered about a hundred miles from the fort,
still wandered to and from their ancient hunting grounds and "subsist
. . . principally by the chase." His job was to keep them from feeling
too free and joining their hostile neighbors—the Hunkpapas, Santees,
and other Teton tribes, who were "bitterly hostile to whites" and "the
scourge of the Missouri from Fort Rice to Fort Benton."

Morrow need not have worried. Blakelock writes that on his arrival
in the Assiniboin camp the Indians were "on the warpath" against the
Hunkpapas. A rough drawing survives of the sketches he made depict-
ing the Indians' elaborate preparations and dances. The drawing,
which had been buried in a family scrapbook, is faint and unfinished,
as if Blakelock had a hard time concentrating as the drums beat and
the dancers swirled around him.

Preparing for war, the Assiniboin warriors wove their long hair into
beaded braids with a tail of cropped bangs falling to the bridge of the
nose. They used dyed porcupine quills, painted stripes, beads, and hair
fringes to adorn their shirts. They decorated their faces with war paint,
applying swaths of red pigment on their foreheads, cheeks, and noses.
And they carried ceremonial bow lances decorated with feathers and
the ribbons of cured bear entrails dyed with red paint. Gathering in
circles, sometimes quietly shuffling, other times accompanied by a
drum and flute, the Indians danced for hours into the night. In the
morning Blakelock woke up and saw the warriors' solemn departure,
noting that "each carried a bundle of dry meat slung on his back in the
enemy country." Blakelock was still with the Assiniboins when the war
party returned.

This was, as far as we know, Blakelock's first extended stay with
any one tribe. Earlier visitors to the Assiniboins described the ex-
tended welcome rituals that accompanied a white man's arrival at
camp. There were prolonged introductions, sometimes lasting hours
due to the necessary exchange of gifts, the smoking of a pipe, and the

sharing of a meal. It was not unknown for the Assiniboins to sometimes offer a woman as a favor or in exchange for money. Geologist and explorer John Wesley Powell and Catlin, among others, wrote that white men traveling alone, without a military escort, had a much easier time getting along with Indians. If Blakelock did, as it seems, arrive in Indian camps with traders who were providing the Indians with supplies and, perhaps, annuities, his welcome would have been doubly hospitable. Blakelock, for his part, steeped in the universal creeds of Swedenborg and Emerson, was predisposed to understanding the Indians and their spiritual conception of the world more than most white men then cared to. Blakelock not only got along with the Indians, he identified with them. It was shortly after this trip that he adopted the Indian arrowhead as part of his signature—a practice he continued for most of his career. In the mid-1880s, Harry Watrous would find Blakelock in his studio tinkering on his piano in an effort to re-create Indian dance songs as he worked at the easel. As his mental illness grew worse, in the late 1890s, Blakelock would sometimes even dress like an Indian, braiding his hair with beads and carrying a sheathed knife in his pocket. Still later, he took to calling the Middletown asylum an Indian "trading post."

Among the Indian dances that Blakelock painted several times—in muted tones against a crepuscular, twilight sky—was the Pipe Dance, a dance that Catlin identifies specifically with the Assiniboins. In this ceremony, Catlin wrote, the dancers were "*smoked*" by the chief, who sat apart with his pipe, and were then pulled up into the dance as if by some mystical force. In Blakelock's monumental painting *Pipe Dance*, finished around 1886 and now at the Metropolitan Museum, a large circle of dancing Indians, intoxicated by the music, their arms waving in the air, seems transfigured by the last remnant of ruby-orange light in the sky.

10

INDIAN PAINTINGS

B lakelock painted many Indian dances but he never depicted anything explicit or dramatic. He was not interested, despite his occasional factual observations ("cottonwood bark is sometimes used for feeding horses"), in recording the anthropological details of North American Indian life or in sensationalizing their rituals.

The plains and Rockies paintings that he completed in the early 1870s soon after his trips to the West, however, are naturalistic and are among the last of his to be based on actual locations. Typically, as in *Western Landscape*, Blakelock has placed a group of tepees in the middle distance, subsumed by the great expanse of land and sky around them. In this and many other paintings the Indian figures are too small to be recognized individually. When Blakelock does portray the Indians, however, it is in a humane and sympathetic light. They are simply rendered, in a peaceful setting, existing in harmony with their natural surroundings. The painting *There Was Peace Among the Nations* was inspired, as Davidson points out, by a passage in Longfellow's epic poem *Hiawatha*, a work that Blakelock's generation had grown up reading.

Buried was all warlike weapons,
And the war-cry was forgotten.
There was peace among the nations
Unmolested roved the hunters,
Built the birch canoe for sailing,
Caught the fish in lake and river,
Shot the deer and trapped the beaver;
Unmolested worked the women . . .

In the foreground Blakelock placed two Indian women, dressed in soft white robes, seated under a thinly leafed, crooked tree. The women are holding hands and at their feet is a large beaded pouch, skins, and gourds. Behind them a long line of tepees stretches to the distant flat horizon. Mingling among the tepees are a great number of Indians, some of them couples, strolling casually in their long white buffalo robes, as if on a Sunday promenade through Central Park. It's an idyllic, peaceful scene—as well as a piece of humanistic propaganda—accomplished with little trace of the theatricality characteristically employed by Bierstadt and Church (or of the sentimental style of later Western painters like Frederic Remington).

Similarly, in *Encampment on the Upper Missouri* (ca. 1871–74), Blakelock developed a simple, undramatic composition. In this work a young Indian woman and an infant (women and children became a regular motif) are placed in the foreground, this time on a riverbank where they have come to fetch water. Once again, to their right is a crooked tree, and in the background we see the tepees and the distant figures of other Indians. The woman, like the older one in *There Was Peace Among the Nations*, stares directly at the viewer. In this painting the woman is too far away to make out her expression, but in other paintings, such as *An Indian Madonna*, Blakelock provides us a closer portrait. Here, an Indian squaw seated casually with her elbow resting on her upraised knee and her baby beside her in a cradleboard stares at us with disconcerting frankness. It's an expression photography has made familiar in the past century: the stunned, shy, but unself-conscious stare of people from the "undeveloped" world looking into the hard lens of a journalist's camera.

In the midst of rampant Indian hatred and the systematic genocide taking place at the time, Blakelock's paintings of these innocent Indian women and children provided, if not a radical political message, then an enlightened view that the "highbrow" Hudson River genre painters were attempting to put forth.

The only prominent Indian portraits that Blakelock completed, *Madonna* and *Indian Girl, Uinta Tribe*, were of Indian women. Both portraits are simple, down-to-earth, less than idealized. There is something vaguely seductive about the folds of the Madonna's skin dress, the upturned leg, the slightly askew neckline of her shirt, and the loose elk-tooth necklace that falls to her breast. Other paintings, such as one depicting two Indian women sitting on a stream bank cooling their feet in the water, display an intimacy with the daily routine and emotions of the Indians as they traveled and went about their lives.

Blakelock's notes on the Indians and his trip up the Missouri River end abruptly with his visit to the Assiniboins. This leaves him in the Montana territory, presumably sometime in late July or early August 1869, near the Missouri's confluence with the Yellowstone, that is, in the lands of northern Cheyenne and Crow Indians. Although the one account of this trip suggests that Blakelock "lived with the Sioux for some time, then painted his way from one tribe to another across country to the West Coast," neither his own map nor his admittedly incomplete itineraries confirm his actual passage to the coast. Instead, on the same sketch paper on which he wrote his notes, we find a proliferation of drawings of white pioneers, wagons, and camp scenes. Most probably Blakelock ascended the Yellowstone River through Cheyenne country (this might help account for his painting *Cheyenne Encampment*) to where it meets up with the Bozeman trail. Taking the Bozeman trail west to Virginia City, Blakelock's route would have been the stagecoach line to Corinne and Salt Lake City, and then west along the Humboldt River in Nevada, through Emigrant Gap into California, and eventually to San Francisco. This route was the quickest and most direct and would correspond closely with his notes, the listed itinerary, and his sketches, many noting the loca-

tion and one, from 1869, placing him in the redwood forests of northern California in August.

A great number of the sketches that Blakelock made on the plains are of animals: prancing horses, herds of buffalo, heads of antelope. Some of these are anatomical studies—the hindquarters of a buffalo seen from three different points of view—that display skills ranging from studentlike to masterly in the course of a single page. The artist was making a concerted effort to improve his technique. Thrown precariously into an unfamiliar terrain inhabited only by soldiers, Indians, and herds of wild animals, Blakelock appeared to be focused on the task at hand.

The sketches of the pioneers, though, have a somewhat more casual, relaxed feeling. There's a palpable sense of relief in his depiction of the familiar postures and activities of his fellow white men as if, his wonderful and risky detour up the Missouri aside, he was glad to be safely back among his own kind. Two seated men, arms on their knees, one with a hat and beard, are actually smiling—a rarity in Blakelock's work—as they converse. The women are too busy chatting to pay much mind to their chores. In one drawing, a woman is walking alongside another, midstep, the prairie wind unfurling the hem of her skirt about her calves. Other pioneer sketches—of men hitching their teams to covered wagons, planning their futures over cups of coffee—share a sense of common activity and purpose. Likewise, in several drawings of stagecoaches careening through mountain passes Blakelock demonstrates an illustrator's zeal in conveying the common adventure of America's westward journey.

By the time Blakelock reached the Pacific coast of California in late August he had reimmersed himself in the kinds of landscape compositions he had made back east. But if the subject was familiar, for instance, the path through the forest in *Redwoods, California,* Blakelock's approach was new and utterly different. Here the strokes in the drawing, first in pencil and later in ink, betray a bold, fluid confidence, free of any lingering student habits. In *Shwin Mill, California,* Blakelock has taken a subject he had completed many times in the past and transformed his formerly literal interpretation into something lyrical, po-

tent, and raw. Similarly, his near-abstract composition in drawings like *California Tree Study, Trees Near the Coast,* and *Petaluma River* displays an almost complete abandonment to impulse and free forms.

It is tempting to say that California awakened a new spirit in Blakelock. Certainly it was a region that attracted him, and that he would later revisit, but a careful study of Blakelock's drawings shows that these sketches did not necessarily signal a new trend so much as open up another possibility. Even though Blakelock completed series of drawings in the same style, his evolution is unpredictable— sometimes sketching with a single elegant line, sometimes with emotional abandonment, and sometimes with a careful by-the-numbers literalness. A sketch of the San Francisco wharves (probably completed within weeks of *Redwoods*), for instance, displays a return to a boyish, literal concern with the hulls and rigging of the clipper ships in the harbor. His variety of approaches, admittedly, had something to do with the ease he felt with some subjects—trees and landscape, for instance—and his relative awkwardness with others. But it's impossible to ignore the degree to which his patience varied and the early evidence in his drawings of unusual and extreme mood swings.

11

THE PACIFIC AND HOME

Whatever Blakelock found in the tawny arcadia of northern California, he did not have more than a few weeks to explore. His journey from the Montana territories to San Francisco took no more than a month, and on September 14, 1869, at eleven A.M., he departed on the Pacific Mail steamship S.S. *Colorado*, bound for Panama and New York via the Isthmus.

The monthly departure of these three-hundred-foot-plus side-paddle steamships was an event in the city of San Francisco. On "steamer day" hundreds of families, armed with handkerchiefs and accompanied on occasion by marching bands, flocked to the docks "with crowds aboard and ashore calling to one another as the ship backed out of her wharf and headed to sea."

Blakelock had mustered up less than the full price to New York, fifty dollars, for a steerage ticket. The steerage berths—canvas sacks— were hung in threes, each allotted a foot and a half in width and two feet in headroom. There was no privacy and, being below deck, it was hot. But because the steamer was carrying so few passengers, Blakelock was spared the ordeals and loud quarrels over soggy sea biscuits and salt beef commonly described among the laborers and min-

ers that predominated in steerage. The steamer, capable of carrying more than 1,500 passengers, had only 200 on board this 3,220-mile trip to Panama. The deck, on the outward journey to California normally packed with baggage, freight, livestock (slaughtered as fresh meat when needed), and too many passengers, was on the return trip wide open with room for all to sit and stroll. A cabin passenger, in somewhat richer circumstances, wrote to his wife:

> We have no noise . . . each passing the time as best suits his taste and some . . . taking the breeze, some leaning over the rails, others in chairs, or on seats under a large awning spread over the quarter deck, some reading, others smoking, others in little knots conversing, other little parties enjoying a little bit of a sing.

According to the report of the steamer's captain, W. H. Parker, the *Colorado* sailed down the California coast without mishap or troublesome weather. Blakelock's map and the steady stream of drawings he made from the deck of the distant shoreline record the ship's progress down the coast of southern California, past Cape St. Lucas, and along the coast of Mexico to Manzanillo, where the *Colorado* arrived early on the evening of September 20. Two days later, the ship stopped in Acapulco for fresh provisions and a new supply of coal. The passengers were allowed to disembark to visit the small picturesque port nestled at the foot of the jungle-covered mountains.

Blakelock made many drawings in and around Acapulco. In the village, he drew the thatched-roof adobe homes, the fishermen and cigarette vendors. He took special note of the types of trees and color of the foliage in the area and completed several other views of the port and the lush, tropical mountains. Evidently the brief, one-day visit left an impression as at least two paintings resulted from these drawings. One, *View Near Acapulco*, which he gave to his father, was shown at the National Academy of Design in the spring of 1872.

Less than a week after leaving Acapulco, on September 28, the *Colorado* arrived in Panama City—once called Porto Bello. The pas-

sengers were quickly shuttled via railroad to the Atlantic port, Aspinwall, and that same day loaded onto the waiting New York–bound steamer the *Alaska*. Blakelock, short on cash, was not among them. He made a more leisurely return, filling his notebook with sketches of tropical settings, as he sailed back to New York via Jamaica by fruit boat.

Blakelock arrived home that fall a little dusty and worn around the edges, but he came back a more confident and experienced young man—and with longer hair and a thicker mustache. Though still living with his parents, he was more determined than ever to remain an artist. Immediately upon his return, his painting *Valley of Agamenticus, Maine* was included in the fall/winter exhibit at the National Academy. The following spring, in 1870, Blakelock had himself listed, for the first time, independent of his father, as a professional "artist" in the New York City directory. By the following year he had acquired his own studio at 806 Broadway.

Blakelock's trip to the West in 1869 set a pattern for the next three years. In all he took at least three and possibly as many as four such trips. Every summer he headed out west, and every fall he came back east (except possibly for the winter of 1871–72). It has long been thought that Dr. Blakelock financed his son's excursions, but it appears that Blakelock was soon capable of supporting himself through his art. He was already developing a small coterie of collectors. Among the earliest of these admirers was Colonel William P. Roome.

Roome had briefly been an officer during the Civil War and became a partner in a tea-importing business soon afterward. Although he was not a man of great wealth, he had cultural aspirations and the means to throw together the occasional social fete. It was most likely through the Church of the Holy Communion, where his family had been parishioners, that Roome met Blakelock. He became a frequent visitor to Blakelock's studio on Broadway and decided to help finance Blakelock's trips to the West. Roome began to collect Blakelock's works during this period and would continue to do so for the next thirty years.

One of the first pictures that Roome purchased and perhaps had commissioned from Blakelock was *Rockaway Beach, Long Island* (now in the Boston Museum of Fine Arts), which Blakelock painted in the late spring of 1870. It's one of the most cheerful, optimistic paintings in the Blakelock oeuvre. The sky is a misty but cloudless blue, the flags above the pavilions are snapping in a stiff cool breeze, and a few brave-hearted, fully dressed beachgoers test the water. It's a seascape in which one can practically smell the salt breeze and, like the small crowd in the painting standing in their long dresses and hats and jackets, sense the promise of the oncoming summer. Though the figures are treated rather stiffly, Blakelock's short staccato brush strokes are assured and his palette subtle, ranging from the mauve pink of the wet sand to the dabs of greenish white in the crashing waves.

Oddly enough, the inspiration for the painting's unusual (for that time) subject may well have been Winslow Homer's paintings *Low Tide* and *Long Branch*, both shown, along with Blakelock's Maine painting, in the academy's winter exhibit of 1869. Homer's painting *Low Tide*, which received the lion's share of attention, was badly mauled by the press. But perhaps Blakelock agreed with the one critic who considered Homer's "total disregard of all conventionality" a strength and not a weakness—and thus meant his painting of Rockaway to be a kind of homage to the great idiosyncratic master.

As it was, Roome paid Blakelock two hundred dollars for *Rockaway Beach* and bought three other paintings as well. This amounted to a substantial sum of money and would go a considerable way to financing Blakelock's next trip to the West—his farthest exploration into the Western wilderness and the inspiration for the most ambitious painting of his early career.

12

TO WYOMING

Blakelock began his second trip out west by train. By 1870 the railroads were already lowering their prices and hitching two or three cheaper, emigrant cars to the backs of their trains. Once in Kansas City, according to Blakelock's carefully noted itinerary, he connected to the recently completed Kansas Pacific Railroad link to Colorado, which followed the old Smoky Hill Fork trail across the plains. For almost five hundred miles, the route is straight as a ruler, with few hills to blemish the horizon. "Never a tree or a patch of green grass in sight . . . on and on past slow-moving emigrants with white-covered wagons and herds of cattle, all half hidden in clouds of dust. The fine, flying sand, too, sifts in through our double [train] windows, and penetrates clothing to the skin." The passengers counted the trackmen shacks stationed every twenty miles along the tracks, noted the odd lonely ranch house, and shot at the small herds of buffalo and antelope that, in a panic, ran parallel to the train. Fifty miles from Denver the snowcapped tops of the Rocky Mountains became visible, standing like a mirage over the arid plains.

In Denver, well-off travelers immediately set out for excursions to the Garden of the Gods near Golden City or Estes Park and a view of

Long's Peak. One-day tourist excursions were well-organized affairs outfitted by guides who returned customers to their hotel in time for a hot bath and a dinner of antelope steak. Blakelock, on a shoestring budget, couldn't afford this kind of treatment and took the stage directly to the next railroad link north.

It isn't until Blakelock reaches Cheyenne that the trajectory of his ultimate destination becomes apparent. Cheyenne was a treeless city of five thousand, the last place to provision before making the Rocky Mountain crossing or, for those few so inclined, exploring the wilderness to the northwest. The Union Pacific ran a large frame hotel with a dining room for four hundred and rooms for fifty. Cheyenne also boasted "a few large warehouses; three or four blocks of low, flat-roofed, wooden shops full of goods; many scattered tents and shanties; two daily newspapers; two churches; [and] a score or two of drinking, gambling and dance-houses which are crowded after dark." It was Blakelock's last chance to make inquiries and acquire provisions for his trip into the wilderness.

The summer of 1870 was not a good time to be setting out on a solo journey into the remote areas of the Wyoming territory. In July, John A. Campbell, the governor of the territory, warned Washington that the "settlement" was exposed to Indian raids, "making it unsafe for any person to venture outside of the immediate vicinity of the towns." Campbell might have been exaggerating, but the situation was decidedly more volatile than that which Blakelock had faced on the Missouri the previous summer.

Treaties had been signed, in this case with Chief Washakie's Shoshone, and once again the U.S. Congress had failed to come up with the goods or, in this case, a protected reservation. Washakie—a much-admired and peaceful leader—warned that the situation was not tenable. "I am sick, I am cold. My reservation has been invaded many times by my enemies," he said, refusing to return to the reservation or meet with negotiators. The situation was complicated by the presence of Washakie's still bellicose enemies, the Arapaho and Cheyenne, as well as the steady stream of white settlers and miners pouring through the territory on the Overland Stage route and the Oregon trail.

Friction between the Indians and white men was inevitable. A spate of raids and killings came to a head on May 4, when a U.S. Army retaliatory attack resulted in the death of seven Arapaho Indians and two soldiers, including Lieutenant Charles B. Stambaugh. In Cheyenne, a hotbed of anti-Indian sentiment, the *Daily Leader* played up its account of Stambaugh's death. "Alive with Indians," began the headline. "The Country Is Literally Alive with Savages."

> When will the authorities begin to believe that Indians are really upon us? When will they consider the rights of the white population of this Territory? Will it be after the savage hordes have swept down upon us like a tornado, murdering, plundering, burning and ravaging all that stands in their way? . . . [The whites] are being threatened with annihilation . . . It becomes daily more and more apparent that Sheridan hit the nail on the head when he said that "We must kill the Indian or the Indian would kill us."

As anti-Indian sentiment peaked, the Big Horn Mining Expedition set out for the Black Hills looking for gold. Led by W. L. Kuykendall, the expedition's admitted purpose was to overrun the Indian treaty-protected lands in the Black Hills and provoke hostilities in order to secure a greater U.S. military presence in the area. President Ulysses S. Grant, unable to make up his mind, finally had the expedition stopped as it neared Camp Brown—which Blakelock would pass through a month later—on the threshold of the Indian lands.

Given the situation, even experienced, relatively well-intentioned explorers took precautions. General Henry D. Washburn's 1870 geological expedition to Wyoming's Yellowstone geysers was delayed several times by Indian hostilities, until a company of soldiers was put at his disposal. Likewise, the famous surveyor F. V. Hayden and his party, which in the summer of 1870 included the photographer William H. Jackson, the Hudson River painter Sanford R. Gifford, a wagon master, three cooks, and a troop of well-armed laborers and teamsters, had military protection and employed an old mountaineer as guide and

interpreter "through that portion of the country [the Wind River Mountains] supposed to be infested with hostile Indians." The next summer, in 1871, when Hayden took the painter Thomas Moran into Yellowstone, he brought along a cavalry escort as well.

Given the circumstances, it's remarkable that a twenty-two-year-old artist, who stood not quite five feet, five inches and weighed little more than a hundred and twenty pounds, was able to make his way through this political mayhem and land at the foot of the Teton range unharmed. It would hardly seem credible were it not for Blakelock's drawings, his own detailed itinerary, which mentions insignificant streams in the heart of the Teton and Wind River wilderness, and the fact that French trappers had been traveling on their own through the same Indian country since the eighteenth century.

Somewhere along the way, Blakelock—quite alone among gold speculators and thick-skinned Indian haters—had to have found an experienced hand to help him get to where he was going. As it turns out there is only one account of Blakelock meeting anyone on his trips out west, but the person we know he met was just the sort of man who could have been of great use to him. In the late 1960s, a researcher at the Oakland Art Museum discovered that Blakelock sold a small Western mountain scene to Nat Stein of Corinne, Utah, on October 16, 1871. It's quite possible the two had met when Blakelock passed through Corinne by stagecoach the previous summer. Nat Stein, it turns out, was a onetime pony express rider and stagecoach driver who had become an agent for the Overland Stage company and, subsequently, a prominent officer for Wells Fargo. During the 1860s Stein had been stationed in Denver, Salt Lake City, and Corinne. His extensive knowledge of the area and widespread connections made him invaluable to explorers and surveyors like Ferdinand Hayden, who obtained Stein's help in setting up his Wyoming and Yellowstone expeditions in the early 1870s. Stein was also something of a literary character, called "the poet of the stage line." His uneven iambic verses celebrated the stage route and the natural beauty of the plains. His brother, Aaron Stein, who also worked for Wells Fargo and sported the same twisted handlebar mustache, was an amateur painter. These

were just the sort of enthusiastic, eccentric personalities that Blakelock
made a habit, in his life, to befriend. The Steins, then, would be in an
excellent position to point Blakelock in the right direction.

Provisioned and presumably with some kind of plan, Blakelock left
Cheyenne and went out onto the high desert plateau to Laramie.
According to his itinerary, Blakelock followed the Medicine Bow River
up to the North Fork of the Platte River, then turned west along the
Oregon trail and Sweetwater River. At Atlantic City, a once booming
mining settlement on the wane, he turned north, over the Popo Aggie
and Little Popo Aggie rivers to the foot of the Wind River range. He
was soon "near Camp Brown," in sight of Lander's Peak, the moun-
tain that Bierstadt had immortalized in his famous painting *The Rocky
Mountains, Lander's Peak* of 1863. The Lander's view was the sort of
well-known art historical landmark that Blakelock would have wanted
to see. Indeed, he stopped long enough to make a brief sketch. But
Blakelock wanted to press on, to penetrate farther into the wilderness
and discover his own view—someplace never before painted by an
American artist.

The next place listed on his itinerary is the Shoshone Agency, at
the time no more than a few log cabins so poorly furnished the agent
in charge had to put in a special request for a writing desk, a chair, and
some ink. The post was nearly deserted, most of the Shoshone tribe
being away with Washakie south of the Wind River range.

Blakelock was, at this point, on the very edge of the regions regu-
larly traveled by soldiers, trading agents, and woodsmen. But here he,
in effect, steps off the white man's map, traveling north of the Wind
River into the buffalo hunting grounds of the Shoshone. This land,
southwest of the Big Horn River, had long been disputed between
Indian tribes, leading to clashes between the Shoshone, Crow, and
Cheyenne. After the Big Horn expedition fiasco, the area became, for
all practical purposes, off-limits to white men. So it's inconceivable
that Blakelock made his circumference of Washakie Needles and
crossed Grey Bull Creek on his own. He was with either the Shoshone
(the most likely scenario, as they were related to the Bannock and
Uinta tribes), a mountain man, or a scout; someone who knew the

territory well led him about the Big Horn basin and then up through the passes high into the Rocky Mountains and the still virgin and unexplored wilderness of northwest Wyoming.

For several years there had been unofficial reports about the wonders and pristine grandeur of the Yellowstone and Grand Teton area. Growing interest in Yellowstone resulted in the Washburn expedition (which approached Yellowstone from the north) that same summer and Hayden's foray in 1871. At the time, though, no artist had ever seen or painted the Teton region. Blakelock never quite made it to the geysers of Yellowstone, but before the summer was over he had trekked to the alpine waters of Gros Ventre Creek, then joined a group of Uinta Indians in the broad Snake River valley at the foot of the Grand Teton peaks. No other American artist had yet penetrated so far into the Rocky Mountain wilderness, or come so far alone.

Gros Ventre Creek flows into the Snake north of present-day Jackson and just south of the southern entrance of the Grand Teton National Park. Even today the sight of the vast Snake River plateau and the jagged glacier-topped 13,000-foot mountains that loom over it seems to belong to another world. The sheer scale of the land dwarfs the modern buildings, houses, and roads. In 1870, of course, it was pure wilderness, the last corner of the continental United States that was untouched by the white man. For the Uinta, it was a final refuge, a paradisiacal garden where elk still migrated in enormous herds and trout could be lifted from a stream as easily as picking daisies from a meadow. Blakelock had, in effect, stepped into a Bierstadt or Church painting and wandered into Arcadia. He had finally found his subject.

Blakelock spent a month or more with the Uinta Indians in the vast, secluded Snake River valley, part of what Hayden later called the "most beautiful scenery in America." Judging from Blakelock's sketches and itinerary, which include several mentions of the Uinta, his group slowly moved south along the Snake and Green rivers. It was part of an annual migration from the Rocky Mountain summer hunting grounds in the vicinity of Gros Ventre Creek to the warmer desert surroundings in northwest Colorado and southern Utah, where the Uinta spent their winters. It was a trip that drew Blakelock closer to the Indians. He

was with them every day as they hunted and fished, as they built and broke down their camps, as they floated downstream in their canoes and sat around the fire at night discussing the day's events. It was an experience that would inspire many of Blakelock's most intimate Indian scenes, his portrait *Uinta Girl,* and his most ambitious and panoramic canvas, *Indian Encampment Along the Snake River.*

This painting, measuring about four feet by seven feet, is the largest ever painted by Blakelock. Beyond the expansive shadow of a sprawling cottonwood tree, the late afternoon sun gently lights the surface of the Snake River, the Indian encampment, and the distant, lavender-shaded Teton Mountains. Yet for all its size there is a surprising intimacy in the scene. The Indians, close at hand, are under the cottonwood, the younger ones lolling in the grass as the elders converse among themselves. Whereas Blakelock usually omitted details, in *Indian Encampment Along the Snake River* he has gone to great lengths to paint in the Indians' clothing, their feather, shell, and elk-tooth adornments, and even the beaded patterns on a woman's high pommel and cantle saddle. They contribute to a casual, domestic Indian narrative that Blakelock has included within the larger arcadian message—replete with stunted dead trees à la Cole—so typical of high Hudson River School art.

Blakelock made an extraordinary effort in this canvas to prove a point. His experience of living intimately with the Uinta in virgin wilderness had not only reawakened a Romantic optimism in him, but it had also, momentarily, inspired a kind of retro-philosophical approach to his art. The art historian Robin E. Kelsey points out, "Both the picture's size and the meticulousness of its execution suggest . . . that it represents a vital moment in the artist's *oeuvre.*" Up close, Kelsey observes, the painting reveals characteristics of Blakelock's future "innovative and enigmatic style." Others argue that the painting marks a point of departure for Blakelock, away from the Hudson River School. The painting does contain elements of his later work—some loose brushwork, the looming silhouette of the tree—but to emphasize this aspect of the painting is to miss the point. Blakelock, brimming with confidence and unusual patience, is here staking out his claim to a bucolic and idealized tradi-

tion that was about to disappear. In the final analysis, *Indian Encampment Along the Snake River*, in its scope, subject matter, and naturalistic treatment, pays homage to the great Hudson River painters that Blakelock grew up admiring. True enough, Blakelock eschews the bombast and high drama of, for instance, Church and Bierstadt. But by presenting the art world with this detailed, panoramic view of unspoiled American wilderness, Blakelock was definitely making a bid to be noticed and accepted by his Hudson River peers. Six years after finishing his slight, awkward painting of the house in Arlington, Blakelock was saying to the masters that he was one as well.

Blakelock spent much of the winter and spring of 1871 in his new studio on Broadway working on *Indian Encampment Along the Snake River*. It was a busy period. That year his paintings appeared in the winter, spring, *and* summer exhibits at the National Academy. His small circle of collectors was gradually widening; in the spring annual exhibition he exhibited two paintings that had already been sold. Dated drawings show that he was still wandering about the city making sketches. But the majority of his time had to have been devoted to *Indian Encampment Along the Snake River*—a painting whose sheer size and detail required at least a month or two of painstaking work. Few of Blakelock's paintings show such restraint and discipline. Thousands of paper-thin dark olive leaves are painted against a sky whose light-blue color dissolves imperceptibly into the yellowish violet mist on the distant horizon. After so much work Blakelock had high expectations. But the painting failed to attract any attention and was never exhibited at the academy. No mention of the painting at that time has yet been found. Further humiliation followed. Thomas Moran's gigantic canvas of Yellowstone, completed in 1872, was bought by the U.S. government for $10,000 and was hung in the rotunda of the Capitol. There it became a deciding factor in convincing Congress to set aside the Yellowstone region in perpetuity as a national park.

Blakelock did succeed in selling *Indian Encampment Along the Snake River*, and probably for a considerable price, but he was never again to attempt a painting on such a scale or with quite so much detail. In retrospect, the completion of the panorama, albeit unheralded, was the

crowning achievement of Blakelock's first youthful, restless, and heady ambitions as a painter. It would never again be mentioned or exhibited in his lifetime, but almost a century and a half after it was painted the work finally received some recognition—when it eclipsed Bierstadt, Moran, Chase, and every other American painter in an auction sale at Sotheby's in New York in May 2000, selling for $3.5 million.

In the late summer of 1871, after the academy's summer exhibit, Blakelock again headed out west—and stayed there, perhaps, for as long as a year. During the course of his Western travels he passed through southern and central Colorado and visited the impoverished Root Digger Indians of the Nevada deserts. Much of his time was spent on a return trip to northern California; there are many sketches of the Russian and Navarro rivers, Cloverdale, the redwood forests, and the California coastline. In San Francisco he went out to Promontory Rock, a popular tourist attraction, and painted, in mawkish rainbow colors, the seals cavorting on and about their favorite rocks at sunset. Blakelock's risk taking and the daring aspects of his earlier trips into the remote wilderness, however, had ended. In fact, with money from the sale of his paintings, Blakelock was now traveling, at least occasionally, in style. On August 25, 1871, his arrival by railroad at the expensive Townsend House in Salt Lake City was announced in the newspapers. A month later he was in San Francisco with Nat Stein.

Blakelock stayed on in the San Francisco area. At the time, San Francisco was already the tenth most populated city in the country, with more people than the nation's capital. There were theaters and opera houses, and in 1871 the Art Association was established and threw "brilliant soirees . . . well filled by the dilletante [*sic*] of the city." Bierstadt was an honorary member, and William Keith and Thomas Hill were local artists gaining a reputation. As an artist from New York who had shown at the National Academy of Design, Blakelock would have had a certain amount of cachet. Yet aside from his acquaintance with Nat Stein, there is no record of Blakelock's involvement with the artist community in San Francisco.

At first glance it seems strange that Blakelock had so little, if any, interaction with other artists on his trips out west. Gifford, Whittredge, Kensett, James D. Smillie, not to mention Bierstadt, were all New York–based artists who had traveled through the same corridor between Denver, Cheyenne, and San Francisco during this period. They often traveled together and mentioned one another's whereabouts in their correspondence and diaries. Blakelock, though still young and not yet established, was not unknown to them. Whittredge, Gifford, and Kensett sat on the juries that selected Blakelock's paintings for the academy's annual exhibits. James Brevoort was a mutual friend. Smillie, closer to Blakelock in age, was a sensitive social fellow (he suffered from headaches and stomach cramps) who knew just about every artist in New York.

Many of these artists, however, were of another generation. Part of the old-boy network, they banded together, whether in America or in Europe, which they frequently visited. They mixed with a different class of people and preferred comfortable accommodations to roughing it on the ground, under the stars. Bierstadt, to take an extreme example, was at this time traveling across the country in a plush Pullman palace car with the Grand Duke Alexis of Russia, shooting buffalo from the train windows. Yet younger artists like Moran and Smillie, too, preferred to keep a certain distance from the more tawdry, dangerous, or indigenous aspects of the Wild West. Smillie, for example, crossed the country for the first time during the summer of 1871, hardly setting foot outside the train or an expensive hotel room until he reached Yosemite. There, on occasion, he did camp out, when not staying in a comfortable lodge, accompanied by a retinue of cooks, guides, and other travelers. His one account of meeting Native Americans puts his encounter with the West in perspective.

Dinner soon after 1 and at 2 went to my study of Sentinal [*sic*] Rock. Found Ablaho squaws, near my place at work making acorn bread. Interfered with my work materially as I was so much interested in the process that I had to watch it from beginning to end. They were very friendly and entertained

me more hospitably than my stomach cared for. They also cooked some kind of greens. I did not like either the bread or the greens. Back about 6. Wrote awhile—tea after 7—Read newspapers. To bed at 9:45.

This abbreviated, comfortable appreciation of the American "wilderness" and its lower classes was fairly typical. In San Francisco, Smillie made arrangements with a police officer to show him the gambling and prostitute houses of Chinatown and was back at his hotel by 10:30 in the evening.

Clearly, Blakelock's experience of the West and its cast of characters, from the Assiniboin warriors on the plains to the miners returning east in steerage below the deck of the Pacific Mail steamship in the tropics, was of a different nature. Partly, it was simply a question of money and connections. Blakelock did not arrive in the West and the tropics in the prime of his career armed with a coterie of friends, introductions, and commissions. He traveled, at least on his first two trips, inconspicuously, carrying a well-worn, dusty knapsack and a second-class ticket. He worked and painted along the way to support himself. In the Montclair Museum in New Jersey, a large sheet of thick white paper divided into dozens of tiny watercolors depicting well-known Western scenic sites has been attributed to Blakelock. They were, essentially, handmade postcards that the artist might have sold to passing tourists for a dollar or less.

Underlying this difference in vantage point, however, was a radical difference in sentiment as well. At this time, Blakelock, only twenty-four years old, was still looking for direction as an artist. His paintings over the course of the period vary greatly in style and content. There are quaint, brightly colored genre paintings—one of a Jamaican beach scene is replete with happy peasants riding a donkey—and there are muted evocations of Hudson River–grandeur. Increasingly, though, we see a more somber philosophical approach and a growing emphasis on man's solitary, mystical communion with nature. In *The Indian Camp* there is, in fact, just one ragged tepee, and a forlorn-looking Indian family scavenging the vast desert floor that stretches to a dusty ocher

horizon. In the drawing *Near Cloverdale,* Blakelock draws a quixotic image of a solitary rider dwarfed by the surrounding mountains and two tall, precarious pine trees. Likewise, in dozens of works the solitary figure, whether it's the man with a hat standing beside a redwood tree in *Valley of Tule* or the lonely peasant and his thatched-roof hut overwhelmed by tropical foliage in *Jamaican Landscape,* takes on a significant presence in the artist's oeuvre.

In *Indian Encampment at Sunset* the Indian presence has been reduced to tiny distant tepees in a lower corner of the painting. An Indian scout, so small as to be almost indiscernible, watches as the sun sets in quiet aqua and pink cloudiness above the brown, unforgiving earth—a somber evocation of the dying Native American culture on the plains. A decade later, as the last free Indians battled for survival, Blakelock's depictions of the Indians passed into another realm, one completely divorced from his early naturalistic renditions.

The scalp dance that Catlin so vividly described, the warriors "brandishing their war-weapons in the most frightful manner, and yelping as loud as they can scream," has been transformed into something distant and somehow magical. In Blakelock paintings such as *The Indian War Dance* and *Pipe Dance,* the rhythm of the drums remains in the air, but the shrieks and physical reality of the scene have been banished. The warriors themselves have become ghostlike figures bathed in the dying glow of twilight, most often encircled by the shadows of an invented forest. Blakelock in the mid-1880s was no longer painting the dance itself, but the dreamlike memory of a distant, primeval event.

On the subject of the American West's influence on Blakelock's art, Goodrich wrote, "In his art reappeared the obsession with the wilderness that had been so strong in American art since the days of Thomas Cole, but now transformed from literalism into the realm of the imagination. The wild poetry of the wilderness and the Indian had entered into Blakelock's mind and art, never to be forgotten. In a day when most of his generation had their eyes fixed on Europe, he almost alone remained aware of this ancient element in the American consciousness."

Blakelock's eventual withdrawal into the imaginative realm was, in part, a reaction to the rapid changes that were taking place in the coun-

try. Already in the four years since his first trip to the West in 1869, life on the plains had been drastically altered. Between 1872 and 1874, white men killed many millions of buffalo with high-powered rifles, leaving a path of destruction in their wake. A military officer described the scene a few miles outside of Fort Dodge in the fall of 1873: "Where there were myriads of buffalo the year before, there were now myriads of carcasses. The air was foul with sickening stench, and the vast plain, which only a short twelvemonth before teemed with animal life, was a dead, solitary, putrid desert."

Except for isolated bands of free Indians, more and more Native Americans came to resemble the people shown in the pictures taken by the photographers that accompanied government expeditions; for the most part, they were dressed in rags, dirty, malnourished, and robbed of their dignity. These pictures offer a stunning contrast to the Indians depicted in *Lander's Peak,* or in the works of artists like Frederic Remington, Charles F. Wimar, or George de Forest Brush. Blakelock, too, did not dare document the Indians in their most humiliated state, though he came very close. With the exception of *Indian Encampment Along the Snake River,* Blakelock's early Indian paintings were, as Goodrich put it, "authentic portraits of Indian life, with no idealization of the noble red man and no attempt at drama."

Blakelock was part of what the historian Lewis Mumford dubbed the post–Civil War "brown" generation, so named for what Mumford perceived as the predominant tint of their palette. They were, on the whole, a more introspective, questioning group than the preceding generation, one that had witnessed the Civil War, riots, depressions, the decimation of the environment, and the ongoing genocide of Native Americans. They were not cynics, but nor were they capable any longer of simply flying on the wings of eighteenth-century Romantic rhetoric. Confused and looking for answers, many of Blakelock's compatriots went overseas to try to catch the first stirrings of European modernity, while others, like Blakelock, Ryder, Inness, and Alexander H. Wyant, began to look for a new way to portray the American landscape and help decipher their own country's wayward soul.

IV

ON THE LINE

Be willing to paint a picture that does not look like a picture.
—Robert Henri

13

A CRISIS

In 1873 Blakelock returned from his last trip to the American West and was back in New York working in the studio he had rented on Broadway and Ninth Street above the Vienna Bakery. It was, from the description of a critic named Alfred Trumble, who visited him there, not much to speak of, "a dingy well" with a large skylight and few furnishings. The rent was twelve dollars a month. The scent of fresh bread and coffee from the famous bakery downstairs filled the building, which the bohemian artists who lived there nicknamed Cockroach Hall. But the shabby surroundings did little to depress Blakelock's spirits. "His voice had a ring of music in it," Trumble later recollected. "And . . . the extraordinary vitality of the man seemed to broaden and brighten the room, invaded through its skylight by the November fog."

What the studio lacked in luxury it made up for in location. The Astor Place Opera, important art galleries and bookstores, and the city's most successful department store, A. T. Stewart's, were located down the street. The Tenth Street Studio Building, where Winslow Homer and Albert Bierstadt had their studios, was around the corner. The Vienna Bakery itself was well known, a downtown landmark and meeting place. Among the other young artists who had studios in the

building were the Tonalist painters Charles Melville Dewey, who became a close friend to Blakelock, and J. Francis Murphy. Blakelock had the building address printed on his calling card and on at least one occasion, in 1874, he invited collectors like William Roome, John Newbrough, and John Byers to his studio to view a private exhibition of paintings inspired by his visits out west.

There was, however, another good reason to have his own studio away from his family's apartment on West Twenty-fourth Street. Shortly after his return from the West, Blakelock became reacquainted with Cora Bailey. The nine-year-old girl who had traipsed after him through the fields of Vermont in the summer of 1865 had grown up. She was now a slender, auburn-haired teenage beauty, who was soon visiting Blakelock's studio on a regular basis.

At the time that they first began to see each other, Blakelock's career was unsettled, but promising. His paintings were still being exhibited at the academy, he had a number of minor collectors interested in his work, and he sold more than enough canvases to pay for his studio and expenses. But all of that would change. Blakelock soon faced the first crisis of his painting career.

The first blow came on Friday, September 19, 1873, when a calamitous financial collapse hit Wall Street, ushering in a six-year depression. The market collapse, perhaps reawakening painful memories from his childhood, had a striking effect on Blakelock. The very next night, Blakelock wandered into the fringes of Central Park and sketched the darkened doorways and windows of a deserted shanty village. It was a damp and breezy evening with clouds drifting past the moon. The trees had begun to shed their leaves; the rattling sounds of the city streets were not so far off. It was night, but Blakelock was in familiar territory. He had spent much of August sketching the shanties and street scenes of northern Manhattan. The drawing of September 20, however, is his only sketch completed at night. Perhaps his sketchpad was damaged by the rain showers that fell intermittently that evening, perhaps he was in a dejected mood or had drunk too much wine. Back in his studio Blakelock ripped the sketch in half, using an attached bluish backing

to represent the night sky and a magnesium black ball of ink as the
moon. He then glued a wavering square of the original paper through
the middle of the sky. In three different places he scribbled "58th Bet.
6th and 5th," or a variation, "Bet. 5th and 6th Ave in 58th," as if drunk-
enly trying to anchor the location in his mind. Twice on the sketch he
wrote "moonlight," and in the center right he wrote in indecipherable
Latin *Centaur Pauper Sozodom*—something, as best as can be made out,
about the mythical half beast–half man, poverty, and being alone. Af-
ter six years of painting, and extensive trips through the wildest regions
of the country, Blakelock had gained little recognition from his efforts.
With an economic depression looming at hand, his prospects suddenly
looked less promising.

Blakelock was not the only one who was worried. While Cornelius
Vanderbilt, Jay Gould, and President Grant huddled in the Fifth Ave-
nue Hotel, at the Century Club on Union Square, the art academi-
cians were nervously sipping their brandies; the art market, too,
would soon feel the effects of this precipitous economic downturn.
Whittredge, who had been so optimistic about the art scene in 1865,
was glum: "The 'public pulse' beats weak for pictures or rather it
doesn't beat at all," he wrote that autumn. "I had a friend ask me the
price of my picture last night at the Century, but it was evident that
it was only because he was glad to see me back in town. In fact he gave
me to understand that he had no intention of buying it, and worse still,
didn't know anybody who wanted it."

Three days after the market collapse, Blakelock returned to the
shanties to draw a large, elaborate sketch of the immigrant shacks in
daylight. What at night appeared bleak and forlorn was in the day a
hive of productive activity. His drawing, too, had changed; it was more
exact and draftsmanlike. Blakelock, in sketching the Irish patching up
their shanties, seemed to be putting his own psyche back in order. In
the following weeks, he kept up his busy itinerant wanderings, mov-
ing about the city in a last flurry of outdoor sketching before winter
set in. In his studio hundreds of drawings of Western scenes awaited
him, but it was the shanties that piqued his curiosity that autumn.
He painted them exuberantly, freely wielding his palette knife and

introducing bright patches of color and, in one, a cold blue autumn sky. He was pleased with the results and submitted a shanty painting to the Brooklyn Art Association exhibit of April 1874.

Blakelock's decision to focus his efforts on his more expressive, idiosyncratic shanty paintings was made at a time when the public's taste in art was undergoing a radical change. By the early 1870s, the grand idealized panoramas of Church and Bierstadt, so popular in the 1850s and early 1860s, had lost favor. Their "ten-acre canvases" were seen as pompous conceptions that relied too heavily on a swaggering display of technique. Indeed, the whole Hudson River School oeuvre, which Blakelock's generation had tried so hard to emulate, was now being seen as hackneyed and passé.

As early as 1868, the critics were nailing the coffin shut. "Church and Bierstadt and their fellow-artists have done all for American art that they will do," wrote the *Evening Mail* critic. "Their genius has been felt, and its influence, good or bad, is at work. . . . As to whether they die to-day or tomorrow, American art, as a profession, has little interest. . . . It is to younger men . . . to whom we must look for future development and progress."

What the critics called "progress" and "development" was ambiguous. Some critics derided American painters for their technical "laziness" and extolled the craftsmanship of contemporary European realists like Meissonier. Other critics had for some time supported a more poetic or spiritual interpretation of nature that went beyond mere mimesis. A favorite painter of these critics was George Inness, who had come under the more painterly sway of the French Barbizon school. By the early 1870s Inness's landscapes were taking on the moody timbre that would later make him the nation's most widely admired landscape painter. His looser style was in ascent. The progressive critics, always clamoring for originality, were showing a nascent interest in self-expression. "It is beginning to be understood that mere imitation is not Art; that the artist whose work is worthy of our notice must express *himself* in it; that it is better to possess the imperfect effort which tells us of at least the processes of thought and labor

of him who struggles for expression of himself—of Nature as he sees and is inspired by her—than it is to be the owner of the nicest counterfeits."

This was a radical, modern idea, at best dimly understood and, in practice, barely tolerated. Expression, in the critics' eyes, did not pre-empt physical exactitude and "good taste"; the actual parameters of interpretation allowed artists by most critics were extremely narrow. Homer, at the time an illustrator though fast becoming a major figure in the art world, was often criticized for what was seen as messy or sloppy execution (the critics often confused subjective interpretation with a lack of technique). "*Lobster Cove*," a *New York World* critic wrote, referring to a fairly naturalistic Homer painting, "represents nothing on or under the earth but a dirty door-mat."

Blakelock, who was to become the most expressive and idiosyncratic nineteenth-century American painter, was still subject to this kind of literal criticism twenty years later. In fact, the nineteenth century is rife with critics who simultaneously called for a more original inter-pretation and yet were forever chortling about clouds that didn't look like clouds, waves that were the wrong color, faces that were nothing more than daubs of paint. At the heart of this confusion was a philo-sophical debate about the essence and language of art—one that would continue well into the twentieth century. Was art a kind of science based on material facts or was it a more personal and mysterious ex-pression of a higher spiritual truth?

While the larger questions remained unanswered, there was a strong consensus among the growing legion of newspaper and magazine pub-lications that covered the art world that something had to be done about the National Academy of Design. The institution was being run, they said, by old fogies who were stifling creativity. The critics were tired of the same old conventional landscapes being churned out by the academicians and their would-be successors. It was time for a changing of the guard.

In the early 1870s, as a result of changes made to the academy's selection jury and the absence or reduction of works by some of the older, more established landscape artists (some of whom chose to

boycott the academy), there arose a renewed interest in American genre and figure painting. It was an odd step forward that also signaled a kind of retrenchment. Artists like Enoch Wood Perry, Eastman Johnson, and Winslow Homer came to the fore and were recognized for their distinctly American or Yankee subjects. Their paintings' titles had a plaintive, patriotic ring: Johnson's *The Wounded Drummer Boy*, Perry's *Thanksgiving Time*, and Homer's *The Country School* displayed a sentimental realism that hardly needed interpretation or analysis.

Blakelock, too, toyed with genre painting, though his choice of subject matter was predictably idiosyncratic and dark. In 1871, after showing pastoral New England landscapes for three years at the academy annuals, he displayed two paintings that told a different story: *The Three Wyble Children of Wynockie. Departure from Home* and a sequel painting, *After They Perished*. The story of the Wyble children's demise made some of the New York area papers in late January 1870, soon after Blakelock's return from his first trip west. The Wyble children, aged five, seven, and ten, had wandered into the New Jersey woods near Mount Wynockie to collect nuts. Several weeks later the three children were found dead, lying side by side ten miles from their home.

The depiction of a sensational serial killing was an odd choice of subject matter—clearly lacking the wholesome American fervor displayed in the Homers and Johnsons that were then popular. If Blakelock's macabre paintings were an attempt to gain public attention, they failed dismally. The paintings were sold to a friend, the spiritualist Dr. John Newbrough, but they were ignored by the press. Blakelock's two Western landscapes *View Near Acapulco* and *The Hunting Grounds of Nebraska*, exhibited at the academy in 1872 and 1873 respectively, suffered a similar fate. Blakelock had at this point been showing at the academy for six years without gaining any critical notice. Perhaps it was this failure, and a growing frustration with the public's reception of his more conventional landscapes, that drove him back to the shanty series he had begun in the late 1860s. As it was, by the fall of 1873 he was deeply engaged in these more impulsive and painterly canvases.

The opening of the Brooklyn Art Association exhibition took place on April 26, 1874. It was a grand affair and a perfect opportunity for

Blakelock to take Cora out on the town. The pictures—Blakelock's shanty among them—were hung in a vast glass-roofed salon attached to a conservatory of rare plants. Not too surprisingly, though, few of the elegantly dressed guests bothered to look at the art. "Who wanted to?" a guest observed, "after he heard from the *frou frou* of silks in the corridor, the gleam of shoulders in the procession of beauty that streamed . . . up and down the stairways." A stage enclosed by a tropical bower had been erected for the orchestra. The musicians could hardly be seen behind an embankment of sweet-scented azaleas, lilies, and "a wilderness of shrubbery." The music, however, "sounded forth deliciously," and the young couples danced to Mozart and Verdi. "At half past nine o'clock the scene was anything but an artists' reception. It was a crush. It was a mass meeting. The carriages rolled in the moonlit streets bringing more and more . . ."

These openings were, no doubt, heady events for a romantic young man like Blakelock who once lived in a waterfront tenement with a crowded clutch of relatives. All the more disappointing were the weeks that followed the opening when the press once again ignored his latest work. To make matters worse, other unknown talents of his generation had already begun to be singled out in the press. George H. Smillie, the younger brother of James Smillie, who, it will be remembered, took a skittish western trip in 1871, was among them. "Mr. Smillie has positively leaped ahead," wrote the *Evening Mail* in a review of the academy annual of 1872. "And here we recognize the value of his Western tour of last summer [George had accompanied James]. Such progress as this among our younger men and we shall cease to ask who are to be the successors of Kensett, Gifford, Church, the Harts and the other veterans of today."

Reviews of these annual exhibitions were frequently featured as front-page news. Some newspapers published five, six, or more sequential reviews—spread over several weeks—of the latest exhibition, commenting on paintings in every room. Not to be mentioned in seven years was a public humiliation. Other artists Blakelock's age—few of whom had created a painting on the scale or with the skill of *Indian Encampment Along the Snake River*—were being made associate acade-

micians. Most artists belonged to the Century or some other club or organization. From what records exist, Blakelock was not even nominated for membership in the Century Club or the National Academy. It was impossible for him to ignore such treatment. Steeped as he was in the art world, Blakelock was becoming increasingly isolated. He was still being treated as an outsider, the eccentric son of an eccentric homeopath, and that would soon exact a heavy price.

In 1874 the academy, under attack for its handling of a disastrous 1873 exhibit, winnowed their selection of paintings for the annual exhibition. There was a great outcry over the rejection of two paintings by John La Farge, a leading younger member of the academy known for his progressive work. The complete rejection or omission of works by Blakelock passed unnoticed.

It was, perhaps, because of his rejection from the 1874 academy annual that Blakelock showed his work at the Brooklyn Art Association exhibits held in April and November of that year. Artists snubbed by the academy were beginning to show their best work elsewhere. His absence from one academy annual was not a disaster and might even, conceivably, have been of his own choice. But his rejections from the subsequent Fiftieth Anniversary Academy exhibit of 1875 and the important national centennial exhibit of 1876 were a serious blow to his career. Blakelock was being excluded and forgotten. In fact, he sold so few paintings that by 1876 he had lost his Broadway studio and was reduced to painting in a small wood-framed studio erected on a vacant lot on Thirty-fourth Street, adjacent to his friend Newbrough's residence (near where Macy's now stands). In 1877, Blakelock traveled to Chicago and painted a commercial mural for the Chicago Interstate Industrial Exposition. It would be his only exhibited work in the five years between 1874 and 1879.

After the fall 1874 exhibit of the Brooklyn Art Association Blakelock vanished from the art scene and his work would not again be admitted to an academy annual until 1879. By then a whole new crop of American artists trained in Munich and Paris were being either pilloried or, on occasion, championed by the critics. Among these new artists emerged some of the great names in nineteenth-century American

painting: William Merritt Chase, John Singer Sargent, Thomas Eakins, and James A. Whistler. Under the leadership of the sculptor Augustus Saint-Gaudens many of the new painters, including the then unknown Albert Pinkham Ryder, rebelled from the academy and, in 1877, founded the Society of American Artists. The "revolution" in American art that the critic Clarence Cook had alluded to in 1868 had finally come to pass. And Blakelock was nowhere to be found on its barricades.

14

MARRIAGE

Blakelock and Cora were married on Thursday, February 22, 1877. It was a balmy, springlike day, Washington's birthday; the shops had closed at noon, and the city streets were lined with American flags. The small wedding ceremony took place in the home of Lewis Francis, pastor of the Greenpoint Reformed Church in Greenpoint, Brooklyn. It was not an entirely comfortable affair. Cora was four months pregnant. Blakelock didn't have the money to pay the wedding fee, offering the pastor a painting instead of cash. The pastor was "rather annoyed" that Blakelock "should be married without any prospects of being able to support his wife." Blakelock retorted, loftily, that he was "the most capable colorist since Titian." On the rather delicate subject of where the young couple was going to reside, Blakelock, who at the time had neither a proper studio nor a residence, announced that they would be temporarily living with his new in-laws in Greenpoint.

George W. Bailey, Cora's father, was hardly as sanguine as his daughter about the future prospects of her dreamy, artistic husband and would later have harsh run-ins with Blakelock. For the moment he had little choice in the matter, as Cora was pregnant. The marriage license, filed two days earlier, is completed in Blakelock's pen and is domi-

nated by his large, declarative signature, which overruns the space allotted to the groom. Cora's neat, thin signature is almost invisible underneath. The Baileys signed as witnesses. Oddly, there is no evidence either in the documents or in the account of the ceremony that Blakelock's family was present.

In fact there are few signs that Blakelock and his family spent much time together during this period in his life. Although Blakelock was twice to live for extended periods with his in-laws, and also with the Johnsons, he never moved back in with his own parents. His father was running a busy medical practice from his home, and perhaps it would have been inconvenient to have his artistic son and his family quartered in the apartment as well. But sibling rivalry and an element of pride cannot be entirely dismissed. Blakelock's younger brother, George, had by then grown up and fulfilled the ambitions that Dr. Blakelock had once held for his eldest son. George had graduated from the College of the City of New York (formerly the Free Academy) and the New York Medical College, and he was completing a degree at the Homeopathic Medical College of New York when Blakelock got married. He would soon join his father's practice, living at home and remaining a bachelor. Many of the family responsibilities and burdens in the ensuing years would fall on him. All things considered, though, one would still expect Dr. and Mrs. Blakelock to be present at their eldest child's marriage.

A picture of Blakelock taken at the time shows him in a stiff, dignified pose, wearing an overcoat and bracing a top hat against his hip. He has grown a short, neat beard. He is handsome and looks aristocratic. But the young, starry-eyed expression of confidence of the earlier photographs has been replaced by a somewhat strained look of determination. The coat is too large for his slight frame. It's wrinkled and he's inadvertently left something, perhaps his gloves, stuffed into one of the pockets. His right hand, meant to be holding his lapel, is caught midway in air.

If Blakelock was ambitious, high-strung, and impulsive, in Cora he had found someone who was adoring, steadfast, and calm. For the next twenty-two years she would be, if not his champion, at least his an-

chor at home. At the time they were married Cora was only twenty years old and Blakelock was nearly thirty. While he had traveled to the farthest ends of the country and shown his work at the most prestigious exhibits in New York, Cora had led a simple, quiet life with her parents and an older brother, Melville, in Greenpoint. Blakelock had grown up in a series of different apartments and seen his immigrant father work his way up from carpenter to policeman to doctor. The Baileys—born Americans—had lived in the same comfortable brick house on a prominent street for at least twelve years. Cora's mother's family was quite established, and one of her aunts was married to George Wilkes, a newspaper publisher. Dr. Blakelock was an eccentric homeopath, prone to poesy and spiritual flight; Mr. Bailey was practical and ran a successful varnishing business in Manhattan.

Ferries frequently crossed the East River between Manhattan and Greenpoint, a suburb that was a good deal quieter and cleaner than the city. The Baileys lived at 118 Milton Street, a short walk up from the waterfront, on a block lined with modest town houses that featured skinny front gardens and knee-high wrought-iron gates. Ship captains and merchants lived on the block. The imposing St. Anthony and St. Alphonsus Church stood at the end of the street. These were the boundaries of Cora's childhood.

Cora was the youngest in the family. Though somewhat of a tomboy, who would still be scampering about the woods in her eighties, she was docile and accommodating by nature, dominated by stronger personalities her entire life. After the turbulent last years spent with her mercurial husband, she would live with her mother and her controlling niece, Florence, for long periods of time. Florence became particularly irksome, dictating Cora's every action, reading and censoring her letters. "She has ruled me for so long," Cora wrote. "Even when she is . . . somewhere else I can't realize that I shall feel free."

As a seventeen-year-old, the prospect of visiting a young artist in Manhattan was an unusual and liberating break from her cloistered existence in Greenpoint. Blakelock, on his part, doted on her. "When he sold a picture he would take his wife to A. T. Stewart's, which was

then the best department store in New York, and buy all kinds of things for her, and then take her to dinner at Delmonico's." They were, it appears, quite in love. Early on, in 1875, Cora posed for Blakelock in his studio in the Venetian Bakery building. The water-color, now in the collection of the Brooklyn Museum, shows Cora in close-up, her head slightly inclined toward the artist, her gentle blue eyes locked into his own. She is wearing a black vest with a loose collar, a white shirt, simple gold earrings, and a delicate gold cross around her neck. It is the most exacting and accurate portrait of Blakelock's career. Meticulously and delicately rendered, it exudes an intimacy and closeness lost in the awkward full-length oil portrait (now at the San Francisco Museum of Art) that he later based on this study. Another portrait, a pen-and-ink sketch, shows Cora reading a book, her hair slightly tousled, with tendrils carelessly falling to the side of her forehead. Many other paintings Blakelock made of a young woman standing alone in the woods, or seated with a book on a stream bank, were also, it is not unreasonable to assume, of Cora.

Friends and neighbors remembered the Blakelock couple as living in a world of their own—behind in their rent, a stand-up piano in a corner, paintings everywhere, the kids playing on the floor, a few cracked cups to serve wine in, a loaf of bread and cheese for dinner. "I am afraid that we have always lived in a rather Bohemian way," Cora explained. "Never thinking that anyone would ever care to know anything about us, how we lived, what we did or when we did anything." Of course, the neighbors were often curious about them, and the more conventional of them seemed to be offended by this idiosyncratic household. "Mrs. Blakelock was very easy going and didn't seem to worry about anything," sniffed one, implying that Cora neglected her children, which was hardly the case.

Cora read and kept up with the issues of the day, but she never joined any neighborhood or social organizations. When the Blakelocks did eventually join a church, it was the Swedenborg Church—clearly the most unorthodox, metaphysical, and controversial of its day. Not that Cora held particularly strong philosophical opinions; it was more a reflection of Blakelock's views and interests. Nor was Cora, aside

from a natural appreciation of beauty, terribly interested in the art world. Even as Blakelock was gaining a reputation as one of the more important artists of the 1880s, Cora seldom visited his studio; nor was she seen in the salons or gatherings of other artists. Though she had many friends, she was not adept or interested in improving their social standing. When Blakelock became famous, Cora confessed to being flummoxed by the overdressed socialites who were suddenly breezing in and out of her mother's modest home, dispensing advice. More often than not, Cora made fun of their ostentatious manners and neurotic attitudes. Her disengagement frustrated some. Mrs. Watrous, the wife of Blakelock's close friend Harry Watrous, doted on Blakelock but never took a liking to Cora.

Cora was, as described by her daughter Ruth, "rather unworldly," a beautiful innocent who was devoted to her family and children. In this regard she was a good match for Blakelock, whose chief desire, she often insisted, was to provide his family with a comfortable life. Though Blakelock clearly had social ambitions, at bottom he, too, was unworldly and an innocent in the ways of acquiring the social clout to promote his art.

The summer after their marriage Blakelock scraped together enough money to take Cora on a honeymoon trip to the White Mountains in New Hampshire. By the 1870s the area had become a busy resort. Huge hotels, like the Profile House, Fabyan House, and Crawford House, accommodated hundreds of guests and boasted amenities like running hot and cold water, tennis courts, billiard rooms, and bowling alleys. Orchestras played Strauss waltzes and Bach minuets. For dinner, bottles of Château Margaux and Veuve Clicquot were available (for two or three dollars) to accompany a baked trout or a beef sirloin. The guest lists were as impressive as the menus. The summer of 1877, Fabyan House was visited by the Vanderbilts, the Rothschilds, and the Harrimans. The Blakelocks may well have booked more modest accommodations, but it would be just like Blakelock to splurge indulgently on something he could not afford.

The views of the White Mountains and the scenic lakes and glens of the surrounding wilderness continued to be the major draw to the area, but the act of exploring and communing with nature had been greatly facilitated. Tourists no longer had to make the arduous trek to the 6,293-foot summit of Mount Washington on foot; they boarded a small railroad line, which had been completed in 1869, to the top of the mountain. In 1877, before arrivals at the top even had a chance to take in the expansive views, which stretched from the Atlantic Ocean to Canada, they were handed a new newspaper, *Among the Clouds*, printed daily on the summit. Scattered about the mountaintop, shaded by umbrellas and leaning over their easels, were artists whose painted views could be purchased as souvenirs.

Blakelock, too, was at work painting souvenirs, although on a grander scale. During his honeymoon he painted the Flume. Aside from Mount Washington and Franconia Notch, the Flume was and still is the greatest tourist attraction in the area. Art historians have speculated about the metaphysical and metaphorical implications of Blakelock painting this claustrophobic, dank canyon, above which was suspended a giant boulder. It may hold clues to Blakelock's religious beliefs, they imply, or to his uncertain view of the future, or perhaps to his uneasy mental state. In truth, the Flume was not a terribly original subject. Several other artists and photographers had depicted the Flume, which was known as a "romantic spot" and widely mentioned in all the guidebooks at the time. A local historian, Lucy Crawford, described the towering walls of stone that squeezed in on visitors as they trod the precarious planks laid over the rocks in the stream below. The boulder, which is now gone, was "lodged a few feet from the top of the flume; and although made securely fast, it causes a person to shudder as he passes under it," she wrote. "At all times there is quite a dampness as you pass through this fissure almost causing a chilly sensation to creep over the whole system; most of the ledge upon both sides is covered with moss and presents a cold dreary appearance even at noonday in summer."

The painting Blakelock made of the Flume, *The Boulder and the Flume*, which now hangs in the Metropolitan Museum of Art, is four

and a half feet high—Blakelock's largest painting since *Indian Encampment Along the Snake River*. Certainly, this dramatic and romantic subject held some attraction to him but, it should be added, his depiction of the canyon is not entirely bleak. A blue patch of sky is visible high above the looming walls, and two pools of strong sunlight illuminate the rushing stream that flows through the canyon. In style, it resembles many of the New England forest and stream scenes that Blakelock completed in the mid-1870s. They are, in essence, heavily painted adaptations of Hudson River School compositions. It seems that Blakelock was having a hard time breaking away from the art he had grown up admiring. There is not much new in *The Boulder and the Flume*, a concentrated effort at realistic detail albeit with a looser brush and more pigment, mostly grays and greens. It was one of Blakelock's highly accomplished, polished paintings of a popular location that the artist—a newly married man with a newborn son and added responsibilities—clearly aimed to sell for a good price. It would be, as it turned out, one of the last of his major works to be based on a specific site, or painted with such realistic detail.

Blakelock's first child, Carl, was born in July 1877. Almost two years later, in 1879, with a second baby on the way, Blakelock finally moved his family into a house of their own on the outskirts of Newark, New Jersey. In the city, after working for a year out of a studio at the YMCA, he obtained a large, drafty space in the old University Building on Washington Square where Homer and Inness painted. Oddly enough, though one might expect these added domestic and professional responsibilities to have made Blakelock a more conservative artist, painting more canvases like *The Boulder and the Flume*, in fact it was at this time that he finally began to give way to his most radical and original artistic impulses. Indeed, marriage and a settled life enabled him to make an important leap forward.

15

RECOGNITION AND CONTROVERSY

The year 1879 was a pivotal one in Blakelock's career. That spring two of his paintings, *The Captive* and *Trout Stream*, were included in the National Academy annual spring exhibit, his first appearance in that venue in six years. In tone and mood the paintings were unlike anything he had painted before. Gone were his bland, naturalistic pastorals painted with a gray-green palette. In their place a more somber, golden-hued tone predominates in a setting that is more fantasy than reality.

Cora remembered Blakelock struggling over *The Captive*, painting it first in his old way, then, she said, he "changed it all over [and] painted it . . . in the rich tone." The resulting canvas has a brooding, Rembrandt-like glow. A light that seems to emanate from deep within the painting casts a religious and unreal atmosphere on the scene. In the forest, a snow-white naked woman is tied to a tree in front of a group of the most harmless-looking Indians on the planet—fairy-tale Brahmans of the deep woods passing judgment, it seems, on white civilization. At first glance, it seems odd that Blakelock should choose such a quaint narrative and such a modestly sized, delicately handled painting to stake his reputation on, but it was a decision he would not regret.

The academy annual opened on the blustery, stormy evening of March 31. Snow and rain squalls sent hats sailing down the street and crumpled umbrellas as soon as they were opened. Still, the carriages arrived carrying New York's best-dressed ladies and gentlemen, the artists, the critics, and the collectors. The cast of characters may have changed since Blakelock's last appearance at the academy, but the hordes in attendance were undiminished. The *World* called the opening "A Wreck of Toilets [as in costumes and makeup] and A Crush of Crowds." There were too many people, the critics moaned in unison, to see the art. Blakelock's *The Captive* had little chance to be seen, much less appreciated by anyone. "It was hung in a very poor light way up above the line," Cora recalled. In the parlance of the day, it had been "skied"—banished to a corner near the ceiling. For Blakelock, who was no longer a young prodigy, this was a great disappointment. Walking home, the cold sleet dampening his coat, Blakelock could hardly have been optimistic. Some notice of his painting was critical. His career was now on the line.

Twenty-one newspapers and magazines covered the show, yet once again it appeared that Blakelock would be completely ignored. The critics' fascination with the artists who had studied in Munich—William Merritt Chase, Walter Shirlaw, and Frank Duveneck—and those who had studied in Paris, namely James Carroll Beckwith, Wyatt Eaton, and the newcomer John Singer Sargent, continued. Some critics favored the Munich school, others the more "thoughtful" Paris school. Sargent's painting of sprawling naked boys on the beach, *Neapolitan Children Bathing*, nicknamed by the art critic Clarence Cook "Little Wanton Boys," got much of the attention in the press, as did George Fuller's mystical and Barbizon-influenced paintings *The Romany Girl* and *And She Was a Witch*. The progressive critics calling for less "materialism" in painting and more individuality, feeling, and interpretation were making themselves heard—if not yet winning the day. All the more frustrating for Blakelock, whose painting *The Captive* shared many qualities with Fuller's fantastical, harmoniously toned paintings. Weeks went by and review after review appeared without

mentioning Blakelock's name. Then, a month into the exhibition, on May 2, a *New York Times* review of the show featured the thirty-two-year-old Blakelock in its headline: "Blakelock and Maynard—Pictures from France—E. M. Ward, Sargent, and O'Kelly." After twelve years as a professional artist, Blakelock was no longer anonymous.

The reviewer was Charles de Kay, a progressive critic who had given strong support to the exhibits at the Society of American Artists, where the renegades from the academy showed. De Kay steered collectors away from buying established art, warning that "what was once the most desired piece of art becomes strangely humdrum after a while." His lead paragraph on the artists in the academy exhibit introduced the eclectic, overlooked art of one "R. A. Blakelock."

In the North Room, on the north side, hangs "The Captive" too high up indeed, for any but telescopic eyes to be quite sure of its beauty, but still possessed of sufficient inherent force to suggest that something fine is being wasted on the upper spaces of the room. One can descry the "captive" bound to a tree and a council of capturers ranged behind a campfire. The figures are in keeping with the subdued russet tones of the woodland view, and the whole suggests Diaz or even Monticelli . . . What a pity that we could not have this picture on the line in the Corridor, where the portraits of two children by George W. Maynard, hang, and see the latter's work high up on this North Wall!

De Kay, in suggesting that Blakelock's paintings be hung "on the line" and that Maynard, who at Blakelock's age was already an established academician, be "skied" instead, was signaling to the public where the future lay. Furthermore, by comparing Blakelock with Diaz de la Peña, the most popular French Barbizon painter at the time, and Adolphe Monticelli, one of the more controversial, the critic was placing Blakelock in important company. De Kay went on to compare Blakelock's work to the "poetic" paintings of Albert

Pinkham Ryder and mentioned Blakelock's other "charming" pic-
ture, *Trout Stream*, which hung in another room. In short, de Kay had
welcomed Blakelock into the fold.

Cora tells us Blakelock was "greatly pleased," as she put it, with this
"favorable notice." He had good cause to be pleased; de Kay's review
would launch his reputation. It has long been thought that Blakelock's
early career in the 1880s was a lost cause, that his artistic vision was
belittled or simply passed over by the critics, that no one understood
or collected his work. In fact, in the years after 1879 and de Kay's
favorable review—a review long overlooked and never before pub-
lished—Blakelock may not always have been praised but he was sel-
dom ignored. For the next nine years his paintings would appear in
every annual exhibit at the academy. His name, frequently linked with
those of Ryder, Diaz, and Monticelli—other critics followed de Kay's
lead—would regularly be found in the arts pages of just about every
major newspaper and art journal in New York. His work was contro-
versial and attracted a number of seething reviews, but among the
important art circles there was a growing appreciation of Blakelock's
expressive, "poetic" art.

In 1880 Blakelock showed in three exhibitions, including, most
importantly, his first appearance at the more exclusive and vogue
Society of American Artists exhibition. By 1882 his paintings were
hanging on the walls of the Metropolitan Museum of Art in a temporary-
loan exhibit and had been bought by the most important collector of
American art at the time, Thomas B. Clarke. In 1883 Blakelock was
included in five major exhibits. In the fall of that year he moved into
the Tenth Street Studio Building, where Church still had his studio
and the debonair William Merritt Chase ruled the ground floor. By
1886 Blakelock's paintings—attracting glowing reviews—had been
shown in Boston, Chicago, Philadelphia, and New Orleans. In all, they
were solicited for eight important exhibitions in that year alone. Not
that Blakelock had become either famous or well off. Far from it. Yet
by the late 1880s he was well known in New York and his daring and
sometimes alarming paintings had been recognized as milestones in
American landscape painting.

* * *

To the casual observer, the paintings Blakelock completed prior to 1879 might easily be mistaken for those of a number of other Hudson River School artists. Aside from the shanty paintings there were few elements that, today, would be recognized as modern in his work. But the Hudson River style never satisfied Blakelock's need for self-expression, his relish for paint, his mystic relationship with nature. In the early '80s, helped by the support he received from critics like de Kay, he finally threw off the objective realism of the Hudson River tradition and developed the expressive mood and style that would characterize his art and make it unique.

The Captive and *Trout Stream* were two of a number of canvases completed in or about 1879 that are enveloped in a new, tenebrous tone. They mark Blakelock's first steps into the imaginative realm. In them can be discerned a new concern with depth, light and shadow, color and tone. These painterly qualities are combined with a symbolic and fanciful use of narrative elements to engage the viewer's eye. In *The Chase* a phantom Indian on horseback gallops across a clearing in the dark forest, his bow drawn and aimed at unseen prey; and in the *Wounded Stag* and *Out of the Deepening Shadows* a pursued deer, white against the shadowy woods, darts toward the silvery light of a stream. In all three paintings, the composition is similar—a dark forest, a clearing imbued with subdued light, and a central figure that appears to be no more than a fleeting image in a dream. The latter painting was, in fact, inspired not by a particular place or landscape but by a poem.

> *Out of the Deepening Shadows of a broad and gnarled oak,*
> *From the base of a mountain, whose clouded crest*
> *Looks down upon the flowing waters,*
> *A wounded deer, arrow pierced, runs in a swiftness like*
> *The Wind!*

Similarly, Blakelock's painting *Shooting the Arrow,* or *Haiwatha,* exhibited in the 1880 academy annual, was inspired by the epic poem of the same name. And Blakelock's miniature *Gertrude of Wyoming,* cop-

ied from an engraving in *The Aldine* magazine, was based on an idyllic poem by an English Romantic, Thomas Campbell.

Many of the titles of Blakelock's paintings from this period—*The Story of the Buffalo Hunt, Cloverdale, Uinta Girl, The Indian Fisherman, A Bannok Wigwam,* and his many *Indian Encampments*—point to the continued and profound influence on his art of his experiences out west. Blakelock may well have been perusing his old sketches in his studio in the University Building, but his approach to portraying the West had changed into something bordering on the abstract and symbolic. In 1880, one critic complained of *The Story of the Buffalo Hunt* that Blakelock's "rich pulpy colors" were nothing but "a series of forms that might be anything, sitting like Milton's color-studies for Death and Sin."

Undaunted, Blakelock pushed his painterly approach to a new level in a series of small panels depicting a hunting trip in the Adirondacks that he completed in the fall of 1880. In these paintings Blakelock again used the same narrative elements as in the previous year (in one painting, *Bear Hunting,* a lone bear cub stands forlornly in a forest clearing; in another, *Deer Hunt,* a hunter and two dogs are shown ambushing a deer), but his brush strokes are impulsive and wild. The result to some eyes seemed unfinished. At the very least there seems to be a battle going on, reminiscent of his struggles in the late 1860s, between Blakelock's urge to dive into a pure paint-driven landscape and his continued dependence on literal narrative elements. The latter, against the havoc of pigment in the background, appear naive and folklorish. Only one painting in the series, *The Guide,* a small portrait of a hunting guide, successfully unites Blakelock's draftsmanship and fluid painting style, his form and composition, his background and foreground into a mellifluous whole. The painting, with its feeling for human character and its broad, simple strokes of paint defining a sleeve cuff, a jacket lapel, a forehead, brings to mind the portrait van Gogh was to paint of the postal clerk Roulin eight years later.

Though the figurative element, largely symbolic, remained in Blakelock's paintings for some time to come, by the mid-1880s he was painting many landscapes devoid of any figures and bearing no resemblance to any "objective" place. Inspiration for his images came from

poetry, music, and everyday objects. Blakelock's experiments were taking him into uncharted territory, toward a vision of landscape that even today looks startlingly modern. This new landscape was "seen simply as spatial form, solid and void, surface and atmosphere, texture and color . . . refined to an abstract presence."

Blakelock was increasingly engaged in an intuitive process of painting and a mystical communion with nature. Impulsive as this might sound, Blakelock's direction in the early 1880s was a deliberate and conscious decision. Cora wrote, "His pictures are . . . so original in fact that when trying in vain to sell them he was constantly met with the remark, 'Why do you paint that way?' or 'Why don't you paint like other artists?' But he would not change his method of painting as he thought he was right and in no other way could he get the effects he desired." James W. Pattison, an artist who knew Blakelock in the mid-1880s, agreed. Blakelock, he announced with romantic flair, had "revolted" against the "slavery" of academic tradition. Blakelock's intellect may have been capricious and offbeat, but he knew which side he was on in the battle over the future direction of American art. "They told me that I should paint like Meissonier," Blakelock later sneered, alluding bitterly to the famous French realist.

Though Blakelock blazed his own radical path in American art, he was not, as has so often been implied, untouched by the trends of the times. Nor was he living totally in a world apart from his confederate artists. In the 1880s, Blakelock had studios at the University Building, the Tenth Street Studio Building, and the Sherwood Building on Fifty-seventh Street, some of the most desirable places to work in the city. The leading artists of his generation—including Chase, Homer, and Inness—worked down the hall from him. Among his friends and acquaintances were the so-called Tonalist painters Charles Melville Dewey, J. Francis Murphy, as well as, possibly—judging from the many connections Blakelock and he had in common—George Inness. These artists shared Blakelock's distaste for the realism of Jean-Louis-Ernest Meissonier (at the time considered by many to be Europe's greatest artist) and a spiritual interpretation of art that

leaned heavily on the expressive style—and political outlook—of the French Barbizon painters.

America's introduction to the works of Barbizon artists—they included Camille Corot, Jules Dupré, Diaz de la Peña, Jean-François Millet, and Théodore Rousseau—was largely due to the influence of the Boston artist William Morris Hunt. Hunt spent two years in the early 1850s in the village of Barbizon in the Fontainebleau forest with Millet, wearing peasant clothes and absorbing the French artist's political and artistic philosophy. Hunt described Millet's paintings of the countryside as "Fields in which men and animals worked, where both laid down their lives, where the bones of the animals were ground up to nourish the soil and the endless turning of the wheel of existence went on." He returned to the States a passionate humanist and follower of the Barbizon style, employing its loose brushwork, informal composition, and atmospheric use of color. "All that makes anything live," Hunt said, "is expression."

George Inness also took up the Barbizon cause, leaving behind the factual aesthetics of the Hudson River School style and adopting a more personal approach to his work. By the 1870s he was increasingly recognized as the artist who had found the optimal balance between expression and realism or, to borrow the art historian Barbara Novak's terms, the ideal and the real, the fact and the nonfact. After decades of struggle, he had finally become a successful and influential artist. Soon Inness's and Hunt's lectures and publications on art attracted a following; Inness's cogent statement "You must suggest to me reality—you can never show me reality" became something of a mantra for a growing cadre of younger painters. Among these young artists were Blakelock, Blakelock's good friend Dewey, and Murphy, all working in the Vienna Bakery building during the mid-1870s. Murphy's diary is littered with quotes from Inness (and from Emerson). And the influence of Hunt's book *Talks on Art*, published in 1875, on Blakelock's painting technique and philosophy cannot be dismissed.

Typically, Inness's landscapes were possessed of a misty atmosphere and a blurred color often mistaken for Impressionism (the Barbizon painters were the forerunners of the French Impressionists),

but what Inness was after was a spiritual, not a physical, quality. It was this evocation of immaterial reality and emotion that Blakelock, too, sought to convey.

Both Blakelock and Inness had studios in the University Building on Washington Square in the early 1880s and both moved to New Jersey—within a few miles or so of each other—about 1879. They were both Swedenborgians. Like Blakelock, Inness had a slight build and a nervous and sensitive temperament. His hair was long and unruly, his habits eccentric, and his mood swings pronounced (his eccentricities only furthered his reputation as a great genius, the very paradigm of the Romantic artist). In 1856, Inness had slit his wrists open in the first of two attempts at suicide. He was married and had children but he spent most of his time alone, working, and had little knowledge or regard for society. Inness could afford to be aloof. He was much older and far more successful than Blakelock; he owned a large property, belonged to the right clubs, and had been made an academician at the National Academy, an institution the painter held in considerable disdain.

Inness was totally consumed by two things, his art (he sometimes painted for twelve hours straight) and mystic religion. In his University Building studio—a large, simple room without the flamboyant accoutrements that were then becoming popular—he was known to keep his door ajar and treat passersby to discursive dissertations on the spiritual world, the cosmos, numerology, and art. Blakelock may or may not have dropped in. But it's hard to imagine these two artists, who shared so many interests, in such close proximity, day and night—for they also both commuted on the same Hudson River ferries to their families in New Jersey—not falling into conversation with each other at some point or another. Among their many mutual acquaintances were Brevoort, Elliott Daingerfield (who was Inness's student and both their biographers), Dr. Watkins of Montclair, and the collectors William Evans and Thomas Clarke. Inness's son, George Inness Jr., after his father's death, gave a large amount of money to the Blakelock family in 1903, indicating some affection for the artist. The most intriguing connection between Inness and Blakelock, however, is one Dr. John B. Newbrough of New York.

Newbrough's name pops up occasionally in catalogues as a collector of Blakelock's art. Lloyd Goodrich discovered that there were, in fact, ties between the three men. Newbrough often visited Inness's studio and Blakelock was a frequent guest in Newbrough's home. Goodrich identified Newbrough simply as a dentist. But it turns out that Newbrough was well known in spiritualist circles and is still known today by thousands of religious followers. In the early 1870s, when Newbrough and Blakelock first became friends, Newbrough was familiar with Swedenborgianism and was becoming interested in spiritualism. "I went to work in earnest . . . and I investigated over 200 mediums, travelling hundreds and hundred of miles for this purpose," Newbrough later wrote. "Often I took them into my own house, and experimented with them to my heart's content . . . In [the] course of time, about ten or fifteen years I began to believe in spiritualism."

Spiritualism was in vogue at the time. Groups gathered in salons and meeting halls to see tables levitate, the dead speak, and ectoplasm eject from a medium's chest. Many artists and intellectuals, ranging from Walt Whitman to William James, were also intrigued by the possibility of scientifically tapping psychic, spiritual, and unconscious forces. Perhaps something important could be learned. Some séances turned into a kind of Victorian roundtable debate on the humanities. "What science has done more than astronomy to remove superstition from the minds of the masses?" was one question posed at a spiritualist meeting attended by the National Academy of Art's curator Charles Kurtz in 1880. "What should be the characteristics of good poetry?" was another.

Newbrough, too, had larger issues in mind. "I did not desire communications from friends or relatives or information about earthly things; I wished to learn about the Spirit world . . . and the general plan of the universe." Newbrough decided to purify himself physically and spiritually in order to better communicate with the angels. He gave up meat, fish, and dairy products and took to meditating before sunrise. Soon Newbrough had lost seventy pounds and was talking to angels and seeing visions on a regular basis. The angels directed him

to buy a typewriter and, through automatism, dictated what he wrote. In 1882, the *New York Times* announced the publication of his nine-hundred-page New Age Bible called *Oahspe*. Purportedly a history of the world and the heavens, the book offers an unorthodox view of the development of the Buddhist, Christian, and Islamic religions. There is a fair amount of cabalistic jargon and a freewheeling interpretation of scripture ("Jesus of Nazareth was . . . a communist"), but the essential tenet of *Oahspe* is unconventional, not outlandish. A product of the anti-institutionalist thinking prevalent in the 1840s and '50s, Newbrough's basic argument was that the "truth" of the major religions had long ago been obfuscated and corrupted by man and his religious institutions. He advocated a mystic, nonsectarian approach to God called Faithism. The Faithist utopian vision called for all peoples and races to come together and live in small communal groups. There were to be no religious leaders, and members were to abide by the principles of temperance, vegetarianism, and nonviolence. It was Thoreau all over again, with a heavy dose of Eastern practices thrown in the mix. In fact, some of Newbrough's ideas were way ahead of his time.

While others went to church on Sundays, Blakelock often dropped in at Newbrough's home on Thirty-fourth Street. There he became familiar with *Oahspe* and with the spiritualists, Egyptologists, artists, and writers who gathered regularly at Newbrough's to discuss everything from Zoroastrianism to the Egyptian Book of the Dead. Neither he nor Inness ever became Faithists. Still, spiritualist ideas about the reality of another, unseen world certainly conformed with their Swedenborgian views, and with their artistic concerns on the mystical junction between the infinite and finite, the soul and nature, dreams and the material world. On a political level, the popular escapist appeal of spiritualism, with its close ties to transcendentalist and Swedenborgian thought, brought artists like Blakelock and Inness together with others disaffected by the tide of materialism, industrialization, and militarism sweeping the country. They were searching for an alternate reality, a counterculture. And insomuch as they were trying to express the immaterial reality of a landscape, what Inness

described as "the indefinite" and its passionate, symbolic relation to the soul, they were probing a more complex and modern conception of human consciousness.

Expressive American painters like Blakelock and Inness, as well as Dewey, Alexander Wyant, Murphy, Dwight W. Tryon, and others with a similar vision, all fairly heavily influenced by the Barbizon school, eventually came to be known as Tonalists. They identified strongly with nature and painted intimate, moody landscapes often depicted at dawn or at twilight or enveloped in mist. They sought unity and tonal harmony in their work. They preferred "poetic truth to scientific fact . . . meditation rather than activity, and reverie rather than reality." In this sense, Blakelock's identification with the Tonal and American Barbizon painters is appropriate. Certainly there was a resemblance in their work in mood, tone, and sentiment. Blakelock paintings such as *A Woodland Sunset* and *Golden Hour* bear more than a passing similarity in composition and tone to Inness's *Evening Glow* and *End of the Day*. There are striking similarities between Blakelock's dark tunnel-like forests and Rousseau's, Blakelock's solitary pond-side trees at dusk and Dupré's. But this is not to say that his works were, in absolute terms, equivalent to theirs. Blakelock's canvases quickly became more detached from reality in the 1880s, more immersed in an imaginative world of its own making and more abstract than the various works of either the Barbizon painters or the other Tonalists. Although he would, at the turn of the century, often be mentioned in the same breath as Inness and Wyant, initially the artist Blakelock was most associated with was not Inness but a more radical, idiosyncratic artist, Albert Pinkham Ryder.

Ever since Marsden Hartley discovered Ryder in the early 1900s, Ryder has been recognized as one of America's first modernists. Like Blakelock, Ryder is considered a "visionary" painter, a dreamer, his paintings often described as memories of landscapes—albeit of a more literary origin than Blakelock's. They were both born in 1847 and died only two years apart. Ryder, too, was considered unworldly, impractical, and an eccentric. He lived with his family until he was thirty and

often had little or no money. Later in life, he gained a reputation as a recluse, living alone in a dilapidated apartment on Fifteenth Street piled high with hoarded newspapers and other belongings. In the 1870s, though, even as his paintings were being regularly excluded from academy exhibitions, Ryder had his coterie of influential friends and was one of the twenty-two founders of the renegade Society of American Artists. One close friend, John Robinson, later wrote,

> I have read of Ryder being a recluse. I can hardly think that, for the small luncheon and dinner parties, where a few friends met, were never complete without him. He never talked much, he was an excellent listener, and his laugh was infectious.

A bearlike man with a reddish beard and a gentle manner, Ryder had many admirers, including the important art dealer Daniel Cottier and the progressive critics Mariana Griswold van Rennselaer and Charles de Kay.

It was de Kay's 1879 *Times* review of Blakelock's painting *The Captive* that first linked Blakelock with Ryder and, unwittingly, provided other critics, especially those critical of progressive painting, with a convenient peg on which to hang Blakelock's radical art. For the next five years Blakelock's and Ryder's reputations would march hand in hand, lauded and denounced as one.

The opening salvo, a minor one, occurred in a review of the 1880 Society of American Artists exhibition, Blakelock's first appearance there. The critic for *Art Amateur*, who condescendingly referred to Blakelock as Ryder's "pupil," dismissed their paintings as "decorations . . . rich as the accidental combinations of hues on a neglected palette."

Two months later, in a review of the academy annual—in which Ryder was not exhibited—the rhetoric against the two painters reached a higher pitch. Blakelock was again slighted as "a gentleman whose 'raison d'etre' is to give Mr. Rider [*sic*] the importance of having a 'school.'" The critic, however, was sufficiently offended by Blakelock's work to devote his lead (and the most windy effort of his review) to a heartfelt condemnation of the artist.

Mr. Blakelock follows Diaz and Monticelli, as well as his
American master; he at present practices a kind of experiment
which it is perhaps worth while to begin to do at the begin-
ning of a career, but which should be quickly supplemented
by the hard, grinding, sweaty toil of academic drawing and
accurate anatomy. When these are reasonably learnt, let our
Blakelocks and Riders [sic] take down again from the shelf
these formless gushes of art-feeling, and see if they can
recover the sense of melody, after they have perfected the
sense of form.

Many critics who considered themselves open to new ideas in art
espoused the expressive qualities of post-Barbizon art while clinging
to the old academic primacy of line and finish. "The ideal of art," wrote
the critic for *Art Amateur,* "is that which preserves the vivacy of the
first sketch and the suavity of the finished drawing together; the lu-
minosity of the un-tormented color and the evenness of well-mixed
tints. . . . Nature never displays the paint-stroke by which she gets an
effect of color." Hence critics appreciated the expressive but still rec-
ognizable and finished landscapes of Inness and Murphy, but many
couldn't fathom the work of radical painters like Ryder and Blakelock,
painters who had *deliberately* abandoned line in favor of mass, form,
shadow, and color. Blakelock and Ryder believed, as did William Mor-
ris Hunt, that the "world is a collection of juxtaposed colors, masses
of dark and light," and that "objects are not defined by outline, but by
color." They were, in fact, drawing *with* color, becoming pure color-
ists. Blakelock sometimes resorted to using the butt of his paintbrush
to add a line to a form or figure, while Ryder had early on given up
drawing almost entirely. He described an epiphany he had while paint-
ing in a field: " I squeezed out big hunks of pure, moist color and tak-
ing my palette knife, I laid on blue, green, white and brown in great
sweeping strokes. As I worked I saw that it was good and clean and
strong. I saw nature springing into life upon my dead canvas. It was
better than nature, for it was vibrating with the thrill of a new cre-
ation. Exultantly, I painted until the sun sank below the horizon."

Ryder and Blakelock were inventing a new language, a new method of painting that had, in some ways, more in common with the work of the New York abstract expressionists of the 1940s and '50s than it did with art of the nineteenth-century academic painters of their time. Indeed, the distance between their art and that of their contemporaries was such that important differences between their own works were, at first, overlooked. In the 1882 academy annual exhibition catalogue a Ryder painting was mistakenly attributed to Blakelock, further confusing the critics. "Imitation, the sincerest form of flattery could go no further than it is pushed by Mr. R. Albert Blakelock," de Kay wrote, trying to excuse Blakelock for an act he did not commit. "He has caught Mr. Ryder's way of working about as nearly as it can be done."

Both painted dark, imaginative landscapes charged with personal emotions, and both experimented with painterly qualities of tone and color. Ryder's figures had the same unearthly and symbolic quality as Blakelock's. His most famous painting, *Death on a Pale Horse*, depicts the ghostly figure of Death riding, scythe in hand, around a tenebrous racetrack. Indeed, it has been pointed out that Ryder's painting, completed in the late 1890s, bears more than a passing resemblance to Blakelock's *The Chase*, made some ten years earlier.

Blakelock was gratified by the attention he was getting in the press, but he bristled at the notion that he was copying Ryder. Blakelock, after all, had been exhibiting at the National Academy since 1867, six years prior to Ryder's first appearance. He did not know Ryder and had little prior exposure to his work (Ryder had studied at the academy but showed there only once in 1870s). De Kay himself pointed out that Blakelock's preferred subject was forest interiors, while Ryder's was the sea. Blakelock was far more engaged in the surface of his paintings while Ryder held a conspicuous interest in simple abstract forms and mythology.

Still, the pairing of the two artists, once made, was not easily shaken off. By 1884 the two painters had come to represent the radical element of American art. They had become famous in their own circle, consistently referred to as the "radical colorists" or, as one critic wailed, "con-

scientious fanatics in the pursuit of color ideas." At the controversial 1884 Society of American Artists exhibit they became a particularly contentious flash point. The show was something of a turning point, a last stand for those resisting the future direction of American art. Blakelock, who had already sold two important landscapes in the exhibit to the collector Thomas B. Clarke, was mentioned—both praised and denounced—in most of the major newspaper reviews.

The conservative critics were predictably negative about the exhibition and especially harsh in singling out "radical" painters' works. The *Post* issued a blanket condemnation of the exhibition and took particular exception to its principal organizer, William Merritt Chase. "Mr. Chase's *Young Orphan* . . . is a pointless, indolent muddle of color without any element of genuinely artistic feeling in it," the critic charged. The *Daily Graphic* called Blakelock's work "little more than foolishness."

In *Art Amateur*, William James Stillman (a devotee of Church and Ruskin) characterized the annual as "the greatest charlatanry that the public of New York has ever been amused by." He pointedly and lengthily attacked Blakelock and Ryder for what he mistook to be their artistic stance. "[They] fancy that art is enough and that nature has no place in the studio." And though he grudgingly granted them their "poetical feeling and sincerity," Stillman persisted in condemning their unorthodoxy. "Their art," he concluded, "is a mistake."

Stillman's review of the show is frequently cited by scholars. At best, it provides a skewed interpretation of what was happening, which was in fact a good deal more ambiguous. Many critics, if they hadn't already climbed on board the de Kay train, were thinking about it. The *Sun*, in a long, muddled discussion of Blakelock's paintings, pouts about his "artlessness" and sighs wistfully at his "profound subtlety of color" before finally concluding on a positive note.

> Mr. Blakelock dispenses as much as possible with the more
> obvious materials of landscape . . . [He] achieves tone in the
> most emphatic manner, and, occupying the field alone with
> Mr. Ryder, he never fails to be interesting.

The Nation, too, was in the throes of making up its mind about the two painters, Blakelock and Ryder, who were daring to redefine the parameters of American art. In the April 1884 edition, a long discussion of the boundaries of expressive painting inconclusively relegated Blakelock and Ryder to "the artistic limbo of still-born genius." That they were being alluded to now as geniuses, of any kind, signaled an important change in attitude. Indeed, the critics' objections were becoming increasingly theoretical.

> Of Mr. Blakelock's landscapes, which ought not to be passed without notice, it is not easy to decide what to say. That he has great poetical feeling and a strong sense of the unity of landscape subject matter, is as clear as that he has allowed certain theories of execution to interfere with freedom and the variety of treatment which the varying material of nature demands.

While *The Nation* and the *Sun* equivocated, other publications were already applauding the new direction being taken in American art. The more progressive critics widely approved of the 1884 Society of American Artists exhibit. Blakelock received glowing notices from many publications, including the *Tribune,* the *World,* and the *Mail Express.* His paintings were cited in the *World* as being "among the best works shown" at the exhibit. The *Times* concurred, calling Blakelock's landscapes "rich and powerful." Clarence Cook in the *Tribune* ventured that Blakelock's two landscapes were "the best work of his which we have seen, marked not only by rich coloring, but by the possession of a distinctive character." Other publications alluded to Blakelock's "glorious," "luminous," "rich," and "charming" work. Noticeably lacking from many of these articles was any twinning of Blakelock with Ryder. After 1884, there would be scant mention of a Ryder school. Blakelock was on his own, making his own waves. In 1879 Blakelock had been an unknown; six years later, he was being recognized as a daring innovator who was taking American art in a new direction.

16

EAST ORANGE

In late May 1877, shortly after his marriage, Blakelock came to East Orange to draw the countryside. One pen-and-ink sketch looks down a country lane from the shade of some tall trees into a bright, sun-warmed field. A scantily clad branch droops across the blank-paper sky, the leaves and trunks of the tree darkly etched against the light—as tranquil as a Japanese engraving. The spot where Blakelock chose to sit for an hour or so appears to be utterly still and peaceful. One can just about hear the proverbial crows calling in the distance and the dry scratch of squirrels in the underbrush. The pastoral setting of East Orange, where Blakelock had come in recent years to visit his aunt Emily and uncle James Johnson, offered Blakelock a retreat from the competitive and restless atmosphere of the city. Here he could find a measure of peace and calm. Before long he decided this quiet hamlet would be his future family's home.

By the time of his critical notice at the 1879 academy exhibit, Blakelock, Cora, and their two children, Carl and Marian, were living on the outskirts of Newark, where Blakelock found occasional work as a drawing teacher. The following year, the Blakelocks rented a small, old clapboard house on Evergreen Street in East Orange. Most days,

Blakelock commuted into the city to paint at his studio in the University Building on Washington Square. When he wasn't working, he made the round of dealers trying to sell a painting. He occasionally visited Dr. Newbrough or mingled with other artists, such as his friend Charles Dewey, who was also regarded as an iconoclast. In the late afternoon or early evening, he left the busy streets of Manhattan and returned by way of the ferry and the Lackawanna railroad to the cozy genteel setting of East Orange.

In the mid-nineteenth century, East Orange, New Jersey, was a bucolic retreat, a quaint town surrounded by farms and woodland at the foot of Watchung Mountain. The aging Asher B. Durand still lived in South Orange in the early 1880s, and was visited by fellow artists from the city, such as McEntee and Whittredge. Inness and other artists formed a colony in the nearby village of Montclair. Walt Whitman lived in Camden. James Johnson, who was well established as director of the Orange Vocal Society and a church choir leader, owned a comfortable house on Pulaski Street in East Orange, with a large garden in the back.

By 1880 the town had three churches and a Swedenborgian congregation. The main street was lined with shops illuminated in the evening by flickering gas lamps. Fifty of the more affluent residents even had phones. The train, which cost fifteen cents, left every half hour for the New York ferries until 11:20 at night. In the early '80s, the town built its first public library and a music hall. Some aspect of religious belief or church life found itself on the front page of the *Orange Chronicle* every day. Tickets to the Mendelssohn Union Choral concerts and the performances of the Haydn and Handel societies were highly coveted and raffled off by various organizations. The whole town turned out—decked out in the silk-lined suits, lace bolero jackets, chiffon blouses, and feather-dressed hats that they had bought at Best & Co.—for concerts given by visiting orchestras in their new music hall. Other nineteenth-century issues and causes also pressed for attention. Orange citizens organized groups for the emancipation of women, temperance, Indians' rights, and the prevention of cruelty to animals; they even set up an anti-cursing society. The Swedenborgians—Blakelock later be-

came a church officer—published a philosophical broadsheet and gathered every Tuesday evening in a musty room they rented above Main Street to discuss such esoteric topics as "The Relations of the Temporal Things which are Seen to the Eternal Things which are not Seen."

By the mid-1880s an influx of wealthy businessmen from New York added an aura of society and snobbery to the area with the establishment of three lawn tennis clubs, a hunting club, and a gun club. In 1884 Thomas Edison, the great scientist lighting up the streets of New York, established his laboratories near Llewellyn Park, a mile or two from Main Street. The town Blakelock had moved to was a rapidly growing place with a population of eight thousand that would soon double. But much as it was increasing in sophistication and numbers, East Orange remained remote and pastoral compared with the havoc of New York City. Beyond Main Street and a few other developed roads in the Oranges, the area was open farmland interrupted only by tree-lined lanes, snaking brooks, and pockets of woods. The Blakelocks' home on Evergreen Street, less than half a mile from the Brick Church train depot, was one of only two houses on the entire road. The other house, a proper new residence, belonged to the Schochs. The Johnsons' house was a short walk away.

Accounts of Blakelock's time in East Orange are muddled and inaccurate. Blakelock's first stay lasted until the summer of 1884. His second residency in the area began in late 1887 or early 1888—he was there for the great blizzard of '88—and ended in nightmarish conditions in early 1891. By then Blakelock's mental health had deteriorated, his existence reduced to a bewildering tangle of actual threats and fictitious conspiracies. These last, deluded days in Orange have cast a large shadow over the entire period, which is often depicted as a bleak succession of ordeals. In fact, Blakelock's circumstances and his outlook on life changed dramatically during the years that he lived there. In East Orange, in the early '80s, Blakelock had difficult moments. But it was also a period of time when his career was on the rise, his family and friends were close by, and the future looked promising. When he was not in his studio in New York, Blakelock could often be

found in his uncle's leafy garden painting the idyllic, domestic scene about him. It has been forgotten that it was in East Orange, this once Eden-like pubescent American suburb (by the 1980s a burned-out ghetto split in two by a highway), that Blakelock experienced, as an adult, the closest thing he had ever had to a happy home.

Albert E. Schoch was a church organist in East Orange. He became Blakelock's good friend (despite misgivings from members of his family, who found the Blakelocks short of proper churchgoing neighbors). In the evenings, when Blakelock returned from the city, he would often stop off at the Schochs' to smoke a cigar and hear Schoch play the piano, particularly Beethoven and Wagner. "He was as fond of my music," Schoch later recalled, "as I was of his pictures. I learned to appreciate art and he learned how to understand music." That was not entirely true. Blakelock had been singing since he was a child, and often continued to do so on musical evenings at his uncle's home. According to some, though, including the Schochs, who were professional musicians, Blakelock's knowledge of the piano was rudimentary. "He simply dabbled at it. He didn't read music, he improvised . . . but there was a glimmer of soul in it," Schoch admitted.

Inspired by Schoch, Blakelock took lessons and exchanged a number of paintings for a stand-up piano; it was originally in his studio in New York and later carted about from residence to residence. In the mid-1880s music became increasingly important to his work. Fellow artists in the Sherwood Building heard Blakelock playing the piano for hours at a time. Like Whistler, Blakelock believed in the synthesis of music, emotion, and color, once telling a critic in 1886 that he wanted the colors in his paintings "to flow upon the senses" like a "melody." Some of his paintings he named after musical compositions. The most well known, *Moonlight Sonata* (now in the Boston Museum of Fine Arts), was completed in the Schochs' living room, in the late 1880s, while Blakelock listened to Mr. Schoch play Beethoven's famous composition. But at the time Blakelock first arrived in East Orange, he was still grappling with "real" landscape, albeit from an increasingly abstract and imaginative perspective.

Schoch remembered a late afternoon when he and Blakelock were sitting on the Schochs' front porch. They were looking off to the west, where a storm had just passed and the sky was filled with unusual colors. "I wish you could paint a sky just like that," said Mr. Schoch. Blakelock said that Schoch would have his wish, and a few days later he handed him a painting of the sky. "It's yours," the artist told Schoch. "It was more than a reproduction," Schoch said. "It was a Blakelock." The painting may, in fact, be *Street in East Orange*, an emotionally charged work well in advance of its day. Schoch insisted that Blakelock, even at this precarious stage in his career, "knew he was a great painter" and that he "followed his own ideals with absolute confidence . . . He could paint with anything—palette knife, cloth, pumice and what not."

The "what not" included meat skewers that Blakelock wrapped in rags and scratched across the surface of his paintings to bring out the underlying colors. When Blakelock ran out of rags and skewers, the Schochs resupplied them. They also bought several of Blakelock's paintings and provided the occasional bottle of milk or loaf of bread when money was particularly short. For though Blakelock's confidence may have been bolstered by the attention he was attracting in the New York papers, during his first two years in East Orange, he had a hard time keeping up with the rent.

Blakelock, an indefatigable worker, always had a painting to sell—his house was full of them—but he rarely found buyers who would pay a decent price for one. At the 1879 academy annual, neither of his paintings—*The Captive*, which had a price tag of $350, or *Trout Stream*, offered for $100—initially sold. Other painters faced the same situation. Of the more than seven hundred paintings on exhibit, only thirty-eight were sold by the final week of the show. Most of the paintings that did sell in the early 1880s were either quaint genre paintings like John G. Brown's saccharine street urchins or the occasional classic landscape painted by an established academician like Whittredge.

It was much the same at the controversial Society of American Artists exhibitions, which hung fewer than a hundred paintings. Though well attended by fashionable New York society, the exhibits achieved

negligible sales. "No one sold anything, we were popularly supposed to be producing art for art's sake, and we were left severely alone to that delightful occupation," observed the artist Harry Low.

Despite the florid rhetoric about art, the nation, driven by a boom-and-bust economy, had little use for art, especially American art. The great robber barons of America, the Vanderbilts, Astors, and Morgans, scoffed at American art and opened their wallets only for select European masters. American art was seen as decidedly inferior in quality. With the exception of defining Americana masterpieces like Homer's *Life Line*, which sold for $2,500 in 1884, and patriotic horn-blowers like Charles Ulrich's *In the Land of Promise*, the great march to discover a national art, begun so exuberantly in the days of Church and Bierstadt, had largely foundered. As McEntee noted sadly in his diary, "No one seems to take the least interest in the work of American artists."

To sell a painting artists simply offered it again and again to various buyers and dealers for an increasingly discounted price until it became too cheap to refuse. Schoch, for instance, eventually bought *Trout Stream* for an unknown amount, but probably for a fraction of the initial asking price at the academy. The collector Thomas Clarke remembers Blakelock showing up in his office with canvases rolled under his arm. He paid Blakelock twenty-five or thirty dollars a painting, which was, he said, a "considerable sum" in those days. Blakelock, he added, was "glad to get that amount."

The Blakelocks and Ryders, the Wyants and Murphys of the art world were all in the same boat. Murphy's income was $485 in 1878 and $577 in 1879. He wrote in his diary that he, Emil Carlsen, and Kenyon Cox would scrounge about for a few vegetables and throw them in a pot over the fire for dinner. Elliott Daingerfield was an apprentice in an art studio at the YMCA in 1880, about the same time Blakelock was in residence accumulating a pile of past-due rent bills. Daingerfield's account of this period, his first years in New York, slinking about wearing a coat too thin for the cold winters and eking "out a very meager living," demonstrates how close artists came to living in poverty and shame. "Always I kept the rule for myself—not to sleep in parks or police stations. I could go without

food and nobody [would] know, but sleep once in the police station—I could never live it down."

A decent studio in New York City by the early '80s cost between three hundred and five hundred dollars a year, and room and board another two fifty. To make ends meet artists took on odd jobs or contracted with dealers to paint a number of small paintings for a set price, usually amounting to less than five or ten dollars a painting. Even Homer, after his first blush of fame, found he still had to do contract work. "If you like the style of them," he wrote to a dealer about some paintings in the mid-'70s, "I will do 12 for $40."

"It has been said that his [Blakelock's] work is uneven," Cora wrote to Robert Vose. "That is easily explained. His best work took a long time to complete and in the meantime he had to live. Pictures were painted to keep things going. He could paint a really good picture in less time than anyone else I ever saw." Schoch remembered Blakelock dashing off a picture in a few hours, which he would then take to Nassau Street in Manhattan to raise cash. "When he sold one of his hurry-up pictures he would invest the proceeds in crackers and cheese, a box of cigars and a bottle of wine and go home and have a real 'spread.'" Blakelock was impulsive when he had cash and quicker to celebrate than to mull over his disappointments. But the potboilers remained, Cora said, the "bane of his life, he disliked so much to paint them."

To survive, the academicians crowded into the cigar-smoke-filled rooms of the Century Club, where they were served brandies by African-American waiters in black tie, to rub shoulders with dealers and connive clever studio entertainments for collectors. Blakelock, however, by all accounts impractical, spent his evenings on the Schochs' porch in Orange, talking about the sky and music.

On at least one occasion in 1880 or '81 Blakelock organized a one-man show in his own home on Evergreen Street. Among the invitees was the young woman who had once accompanied Blakelock through the fields of Arlington, Vermont, in 1865 and to whom he had given some of his first drawings. She was now married and had brought along her husband and their eight-year-old daughter, Margaret. "I dimly

remember seeing the pictures strung up in every available place,"
Margaret recalled. "I remember that Mr. Blakelock was grumpy when
either my father or mother commented on a log fence when it really
was a brook or vice versa. Mr. Blakelock was then in an impressionis-
tic stage." The confused, however well intentioned, Orange citizens
who came to Blakelock's self-produced exhibits did not buy enough
paintings to pay the bills for long.

In 1882 Blakelock gave up the house on Evergreen Street and
moved his family into the Johnsons' house on Pulaski Street. To help
with expenses he took a menial job painting plaques, trinkets, and
mass-produced landscapes in an art factory, E. C. Meekers Art Nov-
elty Shop, in Newark. Blakelock was part of a team, each paid five to
seven dollars a day, to fill in up to two dozen landscapes in several
hours. It was humiliating work that made a mockery of everything
Blakelock's generation believed about art. It was also an embarrass-
ment for an artist who was being compared in the newspapers to some
of Europe's most important painters. Blakelock gave strict orders to
the management that his name not be told to visiting customers.

Of course the other artists working at Meekers knew who he was.
H. M. Kitchell, later accused of forging Blakelock works, was part of
the team and became a friend and an imitator. Kitchell, a strongly built
man and a heavy drinker, was called "the mick" and was said to keep
a quart of whiskey on his easel tray. He "could uncork it and take a
drink with his left hand while still rubbing in color with his right."
Blakelock, lighter of frame, was less tolerant of liquor and was later
said to avoid it. Anxious to get the work done, Blakelock tacked up
half a dozen pasteboards on a wooden easel and worked on them at
once. At other times, though, he'd get so carried away with a painting
that it would have to be grabbed from him. Blakelock might have con-
soled himself by the fact that fellow artists like Ryder (painting furni-
ture) and Murphy (doing greeting cards) were engaged in the same
kind of work, but the job didn't last. His temperament eventually got
the best of him. He "got mad" at the owners, who thought he was
"swell headed," and quit. As Cora, in her typical, understated way, put
it, factory work "was very disagreeable to him."

In 1883, after a bout of work staining cordovan leather for a company in New York, luck turned Blakelock's way. The artist had, by then, attracted a growing clan of local admirers, including Ernest H. Bennett, a commissioner of East Orange. In New York, Colonel Roome, Dr. Newbrough, and other longtime collectors of Blakelock art had been joined by Thomas Clarke and Benjamin Altman. But Blakelock's most important commission, in early 1883, came from a new admirer, the silk-mill magnate Catholina Lambert.

Lambert, like Blakelock, was the son of a Yorkshireman. In 1851, he arrived in America at seventeen with his younger brother. After working with a Boston silk manufacturer Lambert struck out on his own and made his first fortune winning government ribbon contracts during the Civil War. He soon became one of the industrial tyrants of the post–Civil War period. In the 1880s, he was busy buying up mills and property in New Jersey and Pennsylvania, acquiring a monopoly in the silk trade and enough money to build, in addition to his mansion in New York, a castle overlooking Paterson, New Jersey. It was designed in the manner of a medieval fortress with massive, long battlements and walls of granite and brown sandstone. Inside, the coffered, gilded ceilings, mullioned windows, serpentine Corinthian columns, and heavy oak tables with griffin-claw feet created a dark, feudal atmosphere, capped with Versailles opulence. "This was Lambert's own work of art, hyperbolic and self-celebrating in the American-tycoon mode. Ostensibly intended as a showplace for the creative genius of other artists, it was really, like so many other American 'castles,' a showplace for its creator."

To celebrate the completion of his mansion in 1892 Lambert hired a private Erie Lackawanna train to bring some of his four hundred guests in from New York to the foot of his mountain. Lambert's fellow millionaires and wealthy socialites were ushered into the foremost attraction in the house, the three-story Grand Art Hall, which housed his enormous collection of art. From floor to ceiling in their heavy gold acanthus-leaf frames were Botticellis, Renoirs, Corots, Pissarros, Innesses, Hassams, and, in the place of honor, dominating the first-

floor north wall, the large Blakelock moonlight that was later to be-
come so famous.

While Lambert's grand fetes and firework displays were the talk
of the town, the personal tragedies that plagued his family were less
known. He was married to the delicate and beautiful Isabella Shattuck,
and the couple lost five of their children. Their eldest son, Frederick,
aged thirteen in 1875, died of scarlet fever while away at a military acad-
emy, and four years later, his ten-year-old brother died. In 1880 the
Lamberts' hopes all lay with their eldest daughter, Florence, who that
year married William Farrington Suydam. It was a good match and
Florence had a child in 1882. Less than a year later, however, she died
of pneumonia just shy of her twenty-fourth birthday. Perhaps it was
Lambert's familiarity with personal loss that drew him to Blakelock's
melancholy work. For a collector who was known to buy only "name"
artists, he made a rare exception for Blakelock, buying more than ten
of his paintings.

Several people claimed to have introduced Blakelock to Lambert,
but it was in all likelihood the ones who didn't make such a claim, the
Suydams, who did so. They were an old New York family with con-
nections to the Holy Communion Church in New York and to James
Johnson. It would not be the first time that Johnson had introduced
his nephew to someone who proved useful to him. Blakelock's eldest
son, Carl, remembered when Lambert first invited the Blakelocks to
his estate in Pennsylvania. "When I was a small boy about six years old
I remember meeting Mr. Lambert in his office. I was with my father.
At that time he asked my father to go to Hawley. We, mother, father
and I spent 2 or 3 weeks there."

It was the summer of 1883 and Lambert commissioned Blakelock
to paint a large panorama of the countryside surrounding his newly
built Bellemonte mill, in Hawley, Pennsylvania. The Blakelocks, with
Carl and Marian, who was by then four, stayed with Lambert's son-in-
law, the recently widowed William Suydam, and his young child.
Suydam, a rising young businessman when he married Florence, was a
short man with gentle eyes and an easy smile. He managed the mill
for Lambert and several years later became Lambert's business part-

ner. He and the Blakelocks got along well. Cora and the children wandered the grounds of the estate and visited the nearby lakes and streams. Their two visits to Hawley (they returned in 1891) were rare carefree moments in their lives, times that they would later remember fondly in their letters.

Blakelock spent the month making sketches for his commissioned painting, but he was uninspired by the task of producing a conventional painting on command. The result of his efforts, *Hawley Valley,* is a dully colored, naturalistic rendition of the valley and its simple houses. The most interesting element of the painting was its four-foot-long rectangular shape, and the way Lambert's new mill is barely visible amid the tall trees to the right of the painting. It would hardly have appealed to Lambert's ego and grandiosity. Of more interest to Blakelock was the second canvas he conceived at Hawley, that of Pawpack Falls. The falls were located nearby and supplied the power for Lambert's mill. More important, the intimate, lonely setting, a narrow body of turbulent water squeezed by hills and rocks, was the kind that appealed to Blakelock. Cora remembered that he worked on it "a long, long time before he considered it finished." Interestingly, it is a throwback to Blakelock's early Hudson River style of painting, complete with a dead tree on the right bank and a careful rendition of the water's clarity and motion that rivals the kind of realism found in Church's *Niagara Falls.* The date of the completion of the painting is disputed—was it after the first or the second trip to Hawley? The question is mostly a moot point. For in either scenario the painting's flawless realistic execution, dating well after Blakelock started painting his more abstract, expressive paintings, convincingly demonstrates that his ability to paint in a literal and realistic fashion remained undiminished. Moreover, it implies that Blakelock, though he chose to paint otherwise, remained at some level attached to the Romantic, ideal painting he grew up admiring; it was a tie he never quite cut off. Neither did Cora, who betrays her old-fashioned taste in estimating *Pawpack Falls* one of Blakelock's "finest works." It was, at least, one that she felt she could be proud of.

* * *

The fall of 1883 through the summer of 1884 was a busy, successful time for Blakelock. He was in the very thick of the New York art world, preparing for multiple exhibitions, selling a fair number of paintings, and figuring prominently in the city's art reviews. The commission from Lambert and several important sales to Clarke and others helped contribute toward the household expenses at the Johnsons' and the rent on Blakelock's new studio in the Tenth Street Studio Building. Simply to be working in such a hallowed place, so close to Frederic Church's and William Merritt Chase's sumptuous studios was an achievement in itself. True, Blakelock was a temporary tenant, subletting from an artist who was away, but with his name in the newspapers, several commissions to complete, and five exhibits to prepare for, he walked the halls of the Studio Building with his head up. His self-esteem had so grown that he asked for $1,500—triple what Chase was asking, but about the same price as a Wyant and Fuller—for the large landscape he exhibited that fall in the prestigious Pennsylvania Academy of the Fine Arts annual exhibition.

The Studio Building was cramped enough to ensure that the artists working there knew one another by face, even if they were not necessarily dining companions. Chase, who had taken over Bierstadt's grand studio on the first floor, could hardly be missed. He was flamboyant—he traipsed about town with two Russian wolfhounds—and gregarious. As Blakelock came in and out of the building he, undoubtedly, ran into the elegant society ladies who daily came to visit. They came to see not just Chase's paintings but the studio itself, which was famous for its elaborate decor, its silver samovars and Oriental rugs, its Japanese umbrellas and Venetian glass ornaments, and, not least, the elaborate entertainment Chase organized there to attract collectors. It's very conceivable that Blakelock found this all too crass and superficial. Certainly Chase did not have time in between his varied activities to take much heed of the eccentric artist who had just moved in. But he was too smart to ignore an artist who was being made such a fuss over in the art journals. After all, he and Blakelock were fighting the same battle, attacked and championed by the same critics. Indeed,

Chase bought a Blakelock painting and approved his inclusion in the next Society of American Artists exhibition.

That fall, however, Chase and his elegant sidekick J. Carroll Beckwith had been terribly busy organizing a project that held the interest of the entire city. Dressed in their ermine-collared cloaks and carrying pencil-thin bamboo walking sticks, Chase and Beckwith ran about town putting together an enormous exhibit of Barbizon art to raise money for the construction of the pedestal for the Statue of Liberty. The opening of the "Pedestal Fund Art Loan" exhibition took place on December 3 and was attended by former president U. S. Grant and more than a thousand guests. As an artist living in the Studio Building, Blakelock may well have been invited, but in the midst of this kind of social glitter he would have remained on the very periphery of the event, which as it was did not succeed in raising nearly enough money for the Lady.

Blakelock, though, had to be pleased about the inclusion of his portrait *Indian Girl* (*Uinta Tribe*)—a painting inspired by his trip to the Snake River fourteen years before—later that month in an exhibition of the Thomas B. Clarke collection. The much talked about exhibit, which opened on December 28, 1883, at the American Art Gallery, drew thousands of visitors and was heralded as the most important exhibit of American art since that at the Philadelphia centennial in 1876. It was a few months later that Blakelock and Ryder became the center of so much controversy at the 1884 spring exhibitions.

Blakelock's one-year stay at the Studio Building did not necessarily end his social isolation, nor gain him entrée into the tight-knit clique that ruled at the National Academy and the Century Club. But being in such close proximity to his contemporaries, such well-known progressive artists as Chase, John La Farge, and Walter Shirlaw (the first president of the Society of American Artists), as well as the Hudson River luminaries he admired as a young man—Whittredge, McEntee, and Church—did much to boost his ego and reputation as an artist. In truth, painting in the same building with many members of the Society of American Artists selection jury no doubt helped ensure Blakelock's reappearance at the society's exhibit in 1884 after a two-year absence.

Moreover, Blakelock's acquaintance with the Studio Building milieu, especially such influential artists as Chase and La Farge, would be instrumental in the great revival of his reputation at the turn of the century.

Lambert's commission and the busy events that followed appeared to have a salubrious effect on Blakelock's life at home in East Orange. Several paintings that he completed there, such as *Under the Cherry Tree*, a portrait of two children sitting in the grass, or a watercolor he made of Johnson's daughter, Grace, wearing a summer dress and straw hat, picking fruits from a garden tree, share a spirit of tranquillity, innocence, and bucolic contentment. Life in the Blakelock–Johnson home might have been somewhat bohemian and eccentric, but it was not (as most accounts of Blakelock's life would have us believe) all sturm and drang, poverty and hand-wringing. Quite to the contrary. While Johnson was not a wealthy man, his house with its large garden, where Blakelock had a studio and spent a significant amount of time, was considerably larger than many of his neighbors'. He was an esteemed musician, a respected man in the community with many friends. Blakelock's life, too, was not without promise and reward. His career and reputation, if not his income, were on the rise. He had an affectionate and attractive wife and two healthy children. He was living with his aunt and uncle, to whom he possibly felt closer than to his own parents and certainly the people who had made his life as an artist possible.

Johnson's daughter's recollection of Blakelock at this time was of a "very attractive" thirty-six-year-old man with a "sweet nature" and a "lovely disposition." Elizabeth Newbrough seconds this opinion, describing Blakelock as "slender, good looking and very gentle." Blakelock may have been sometimes "nervous" and "high strung," but he was absolutely not, Mrs. Washburn said, considered unbalanced at that time by the family (nor, it should be added, by Albert Schoch or others who knew him then). The fact that Blakelock was not financially independent and was sharing the Johnsons' home was not considered unusual for an artist. What Washburn recalled about those early days

in East Orange was not any special duress, but instead the many children in the household and the music and singing at night. The Blakelocks' two-year stay with the Johnsons on Pulaski Street, far from being a humiliation, was a continuation of the way things had been for Blakelock growing up—that is to say, an extended family living together, making music and art, just as it had been in Arlington, Vermont, and on Christopher Street in New York. Coming home from the city in the evenings it must have been a great comfort to Blakelock to know that Cora, who was pregnant again, would be taken care of and that there would be a plentiful family dinner and a warm bed for the children at night.

This faint promise of suburban bliss comes across in Blakelock's most important early East Orange period painting, *The Artist's Garden.* The painting, which now hangs in the National Gallery of Art in Washington, D.C., takes on a subject that had not yet been explored by other artists—the newly created suburban landscape. In the painting, Blakelock depicted Johnson's perfect garden, his refuge from the world. It has straight, long lines of bushy vegetables and a split-rail fence that lures the eye to the small shed, a nearby house, a garden door, and a white rooftop cupola that peaks over the dark trees into the sky. Yet there is something amiss in this seemingly domestic, peaceful scene, for Blakelock, like the surrealist René Magritte, has painted an eerie sense of bright twilight in the sky, light that travels along the edges of the rooftops and lands in speckled drops of silver on the leaves, but he has plunged the rest of the canvas into earthbound darkness. He, in effect, obliterated the image of suburban coziness he had created and left nothing behind but a feeling of "charged emptiness and sudden abandonment."

Perhaps Blakelock had a presentiment that the peaceful suburban life was not to be his. As it was, his comfortable stay with the Johnsons was about to end. In the late spring of 1884, as the critical debate in the press over Blakelock's work peaked and then shifted in his favor, his personal life was overturned. In May, Cora gave birth to twins, Claire and Ralph Melville. A few weeks later, on the morning of June

5, James Johnson died after a sudden kidney ailment. He was sixty-
three years old.

The funeral was held two days later, on a Friday afternoon at
Christ Church in East Orange. The service, "largely attended," ac-
cording to a newspaper account, brought to a close a long chapter in
the Blakelock–Johnson family history begun more than thirty years be-
fore when Emily and James Johnson moved into the Blakelocks' apart-
ment on Christopher Street. Presumably, the aging Dr. Blakelock was
there along with Blakelock's mother, Caroline, and his brother, George.
Two ministers from the Church of the Holy Communion in New York
came to deliver the eulogy and conduct the service. At least one choral
group was on hand to sing the hymns. There is no account of Blake-
lock's reaction to the loss of his lifelong friend and supporter, but we
hardly need one to know that the blow must have been substantial.

Shortly after Johnson's death, Blakelock and his family were back
in Greenpoint, living with his in-laws. A few months later, in early
December, Cora and Blakelock lost their six-month-old infant Claire.

A WATERFALL, MOONLIGHT—A TASTE OF SUCCESS

The events of the previous six months were an emotional setback for Blakelock, but his career in New York remained intact. The reviews he received, though there were fewer of them, were increasingly accepting. In January 1885, for instance, even *Art Amateur*, reviewing an exhibit at the American Art Galleries, gave Blakelock a good notice. While still associating Blakelock with his "quondam fellow-sinner" Ryder, the critic conceded that Blakelock's painting was "one of the most delightful little landscapes in the exhibition." Positive notices like that helped Blakelock sell enough paintings that year to rent a studio in the Sherwood Studio Building on West Fifty-seventh Street.

The Sherwood was the most elegant, up-to-date studio building in New York. It was also one of the most expensive. Dubbed "a Mecca of the best elements of American artists," the Sherwood was located on the corner of Seventh Avenue, in the heart of the new, uptown, aristocratic quarter of Manhattan. Ironically, it stood almost on the spot where Blakelock had, thirteen years before, drawn the immigrant shanties in the dead of night. Central Park was two blocks north, Carnegie Hall would soon be built down the street, and the new mansions on Fifth

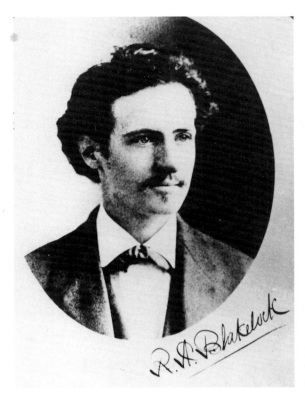

Blakelock about the time of his
travels out west, 1869–1872
(Collection of Myra Platt)

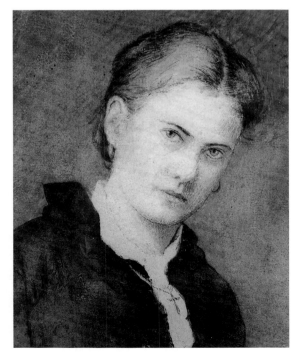

Portrait of the Artist's Wife.
Blakelock painted this
watercolor of Cora in
his studio on Broadway and
Ninth Street above the Vienna
Bakery, about 1875, before
they were married. (Brooklyn
Museum of Art, Museum
Collection Fund)

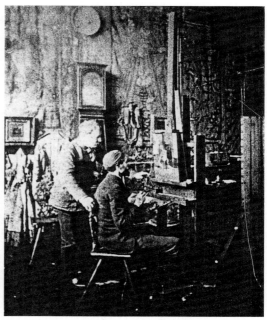

(*Top left*) Blakelock at the time of his marriage to Cora in 1877 (Collection of Myra Platt)

(*Top right*) Blakelock in his Sherwood Building art studio with Harry Watrous in the late 1880s (Collection of Myra Platt)

(*Left*) Cora with two of her children, about 1880 (Collection of Myra Platt)

The National Academy of Design's ornate Venetian-style palazzo on Twenty-third Street was the center of the New York art world in the nineteenth century. (Archives, National Academy of Design, New York)

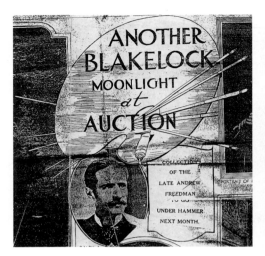

Blakelock frequently made headlines in 1916. This article appeared in the *New York Herald* on March 26, 1916. (*New York Herald*)

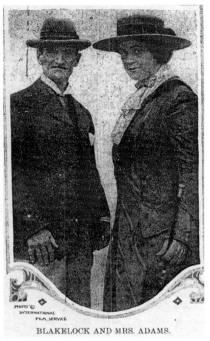

BLAKELOCK AND MRS. ADAMS.

Blakelock and Mrs. Adams on the grounds of Lynwood Lodge in New Jersey following the artist's release from Middletown Hospital (*New York Evening Journal*, September 9, 1916)

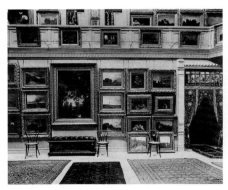

Blakelock's famous painting, *Brook by Moonlight*, dominated the north wall of Lambert's three-story art gallery, which housed one of the largest collections of private art in the country. (Courtesy of The Passaic County Historical Society)

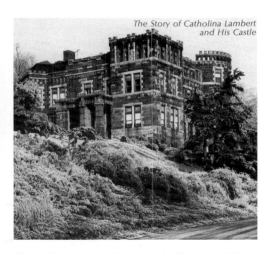

Catholina Lambert's castle in Paterson, New Jersey (The Passaic County Historical Society, Gerasimo K. Livitsano)

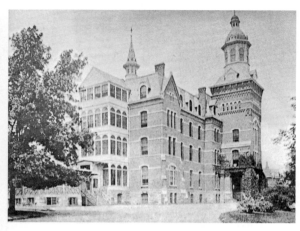

Maurice C. Ashley, the director of Middletown Hospital (*Middletown Centennial Chronicle*, Middletown Psychiatric Center Library Archives)

Middletown State Homeopathic Hospital for the insane in the late nineteenth century (*Middletown Centennial Chronicle*, Middletown Psychiatric Center Library Archives)

Cora with her children and grandchildren outside her home near Catskill, New York. From right to left foreground: Cora, her daughter Marian and youngest son, Douglas. Next to him is Cora's grandson, Chester, with his father, Carl Blakelock, and sister Virginia. Standing are Ruth Austin, Edin Blakelock, and Carl's wife, Violet. (Collection of Carol Doney)

Blakelock and Cora at Middletown Hospital in 1916. (Myra Platt Collection)

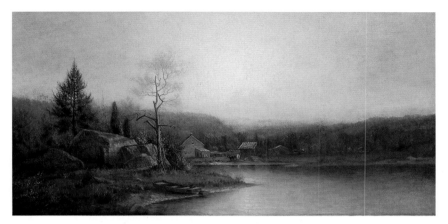

Pioneer Home, circa 1867–1868 (Collection of Mr. and Mrs. Abbot W. Vose)

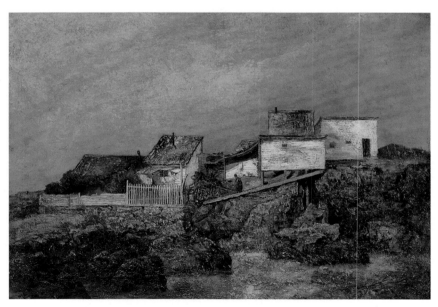

Old New York: Shanties at Fifty-fifth Street and Seventh Avenue, 1870 (Milwaukee Art Museum. Gift of Eliot Grant Fitch, in memory of his son, John Grant Fitch w1948.1.)

Indian Encampment Along the Snake River, 1871 (Courtesy of The Anschutz Collection)

The Chase, circa 1879 (Worcester Art Museum)

The Captive, 1879 (Brooklyn Museum of Art. Gift of Charles A. Schieren.)

The Guide, 1880 (Richardson-Clarke Gallery)

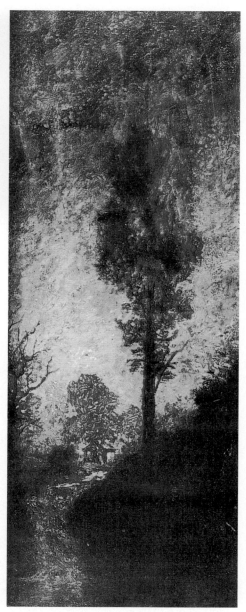

Street in East Orange, New Jersey, circa 1880 (Whereabouts unknown)

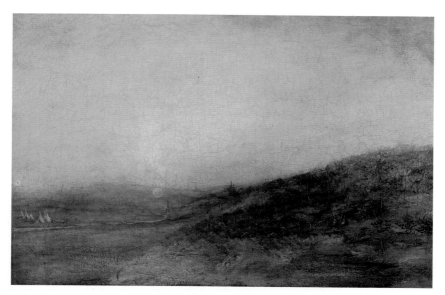

Indian Encampment at Sunset, circa 1880–1884 (Collection of Julie and Lawrence Salander, New York)

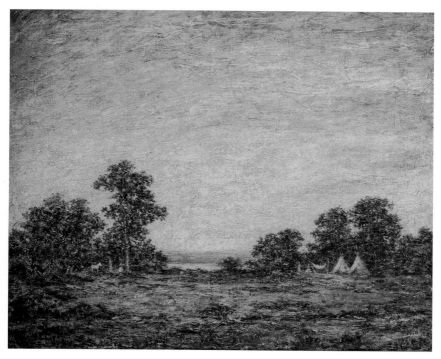

Indian Encampment, circa 1885. Similar in style to an encampment in the Metropolitan Museum of Art. (Courtesy of Salander-O'Reilly Galleries, New York)

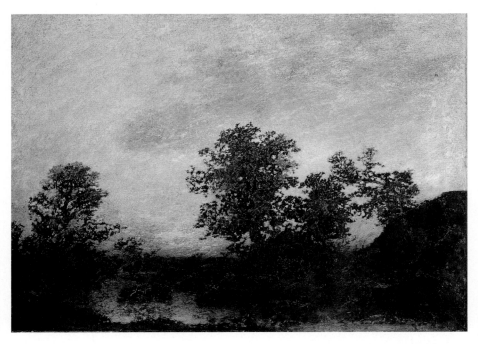

After Sundown (© Addison Gallery of American Art, Phillips Academy, Andover, Massachusetts. All rights reserved.)

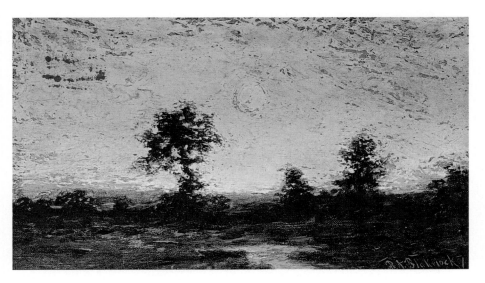

Landscape at Evening, circa 1886 (Collection of Mr. W. John Driscoll)

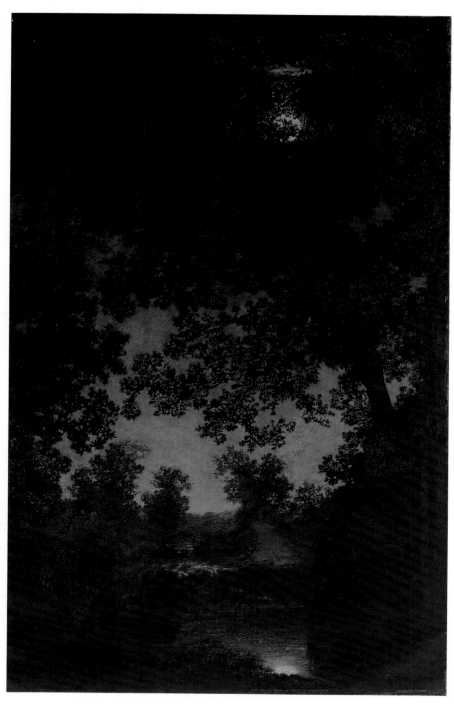

Brook by Moonlight, 1890–1891 (Toledo Museum of Art. Gift of Mr. and Mrs. Edward Drummond Libbey.)

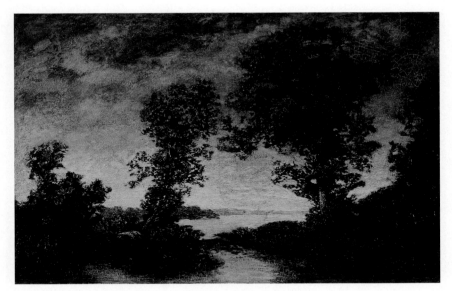

Outlet of a Mountain Lake, circa 1887 (Smith College Museum of Art, Northhampton, Massachusetts, Winthrop Hillyer Fund, 1914)

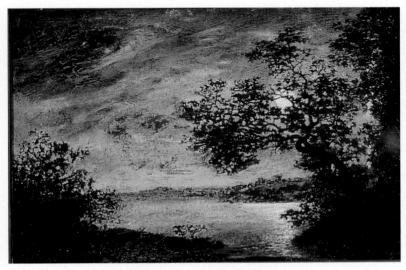

Moonlight, 1890 (Carnegie Museum of Art, Pittsburgh; Purchase)

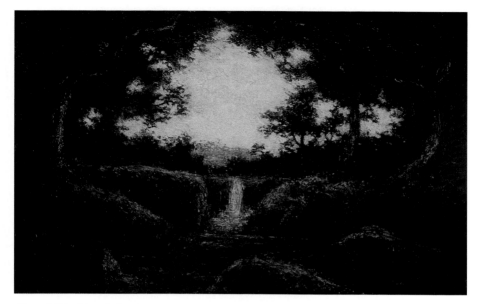

Waterfall by Moonlight, circa 1891 (Private collection)

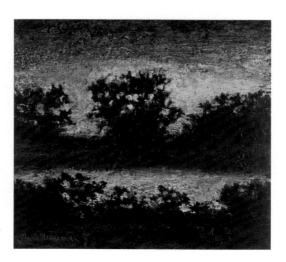

Moonlit Landscape,
circa 1888–1899
(Collection of
Ivana B. Salander,
New York)

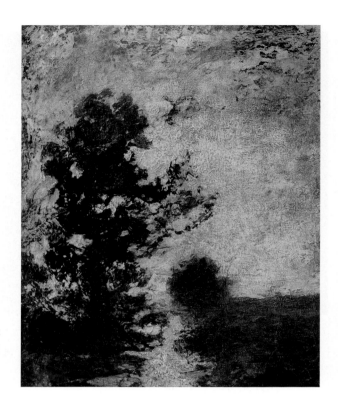

Silvery Moonlight, circa 1887–1897 (Montclair Art Museum, Montclair, New Jersey. Gift of William T. Evans, 1915.4.)

Pegasus, circa 1890–1897 (Denver Art Museum Collection: The Edward and Tullah Hanley Memorial Gift to the People of Denver and the Area, 1974.420)

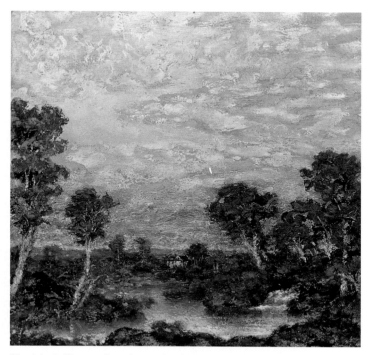

Untitled (Sunset Landscape), circa 1917 (NAA Nelle Cochrane
Woods Memorial Collection)

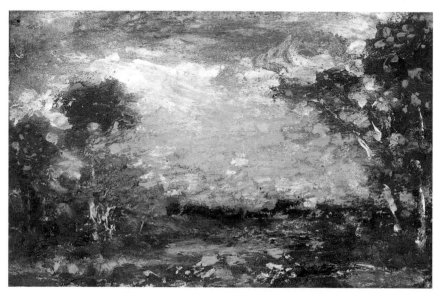

Sunset, 1916 (National Academy of Design, New York [95-P])

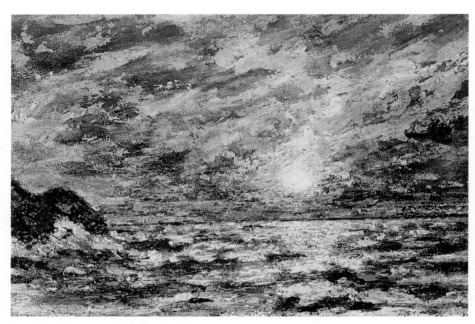

Untitled Seascape (Whereabouts unknown)

Avenue were a five-minute walk away. The studios had immense floor-to-ceiling windows, greeting areas, fireplaces, and, for those artists who lived there, suites with separate living areas. The first open-studio exhibit in the building drew some four thousand visitors.

At the time that Blakelock moved into the Sherwood, J. Carroll Beckwith, whose uncle owned the building, lived rent-free in a suite on the seventh floor with his wife, Bertha. Beckwith, or "Becky" as he was called, was a successful society portraitist and a bit of a Victorian prig. He spent as much time making sure he was mixing with the right society—he counted John Singer Sargent, whom he had met studying in Europe, William Merritt Chase, and Stanford White as his dining companions—as he did working on his art. He made sure he joined all the right clubs, was elected to the important committees, and took up all the chic causes. Mrs. Van Rensselaer Adams easily enlisted Beckwith's support for Blakelock once he became famous. But Beckwith, whose tastes in art were conservative, was never there for Blakelock when he most needed him in the 1890s. By that time Beckwith had inherited money from his uncle and was throwing parlor parties and complaining about the empty champagne bottles that his wife's friends had left littered on the floor of his studio. For lunch, he and other established artists at the Sherwood, like the muralist E. H. Blashfield and the academicians F. C. Jones and Granville Perkins, ate oysters at Delmonico's.

It was quite a different story downstairs where Blakelock had a studio on the third floor. After showing for eighteen years at the National Academy of Design Blakelock still had not been nominated for membership there, or to any other club for that matter. In his studio he had a stand-up piano, a few Indian artifacts, stacks of paintings, and not much else. His neighbors were lesser-known artists. Down the hall the young Harry Watrous, recently arrived from his studies in Europe, moved into studio eleven. At the time Watrous, who would later become president of the National Academy and Blakelock's closest friend, did not know his new, eccentric neighbor except by reputation. Apparently that reputation had grown considerably in some circles. Watrous surprised a gathering of artists, soon after his return

to New York, when he announced in a lecture that there were three great landscape painters in America—"Inness, Wyant and Blakelock."

That Blakelock chose to move into such swank and expensive quarters is paradoxical. On the one hand it attests to his rising status as an artist, his growing sense of self-importance, and his need to belong. Certainly, there were cheaper studios to be had in Manhattan; if nothing else, his choice was highly impractical. On the other hand, the fact that Blakelock worked in the Sherwood, so close to the art elite upstairs, and yet still made little headway into New York's art society, its clubs and institutions such as the Century and the National Academy, points to his stubborn idiosyncrasy and independence. "It is about impossible for genius or even brilliant talents to enter its building," Inness once snapped about the academy, "unless favored by conditions, either moral or social, with which art has nothing to do." Blakelock had several strikes against him. He did not entertain, he was the son of an immigrant, he was self-taught as an artist, and he had never been to Europe. Everybody upstairs had studied with a master in France or Germany. They had bonded in the cafés on the rue des Beaux Arts. Blakelock had spent his youth alone wandering about the West with Indians. It was a little strange. As was Blakelock; he was simply too eccentric to be acceptable in conventional, clubby Victorian society.

Blakelock's work, however, exhibited a talent and originality that the selection committees—the academicians who lived upstairs at the Sherwood—could not deny. Several critics in the 1890s would later acknowledge that Blakelock had overcome a significant hurdle: the genius of his art had been recognized despite his eccentric personality. As it was, while the gentlemen on the seventh floor worried about who would be on what committee, Blakelock, over the course of the next ten years, would create his most radical, visionary, and enduring paintings. In his Sherwood studio, at this time the only place that really mattered to him, Blakelock would come to live increasingly in his own world.

Watrous was one of the few artists who spent any time in Blakelock's Sherwood studio. He was a tidy, good-hearted man, imminently "club-

bable"—fond of the occasional prank. He painted nicely veneered, realistic portraits and interiors. Yet he had the breadth of mind to appreciate other types of painting. One day, a short time after moving into the Sherwood, Watrous heard his neighbor playing an odd tune with an abrupt aboriginal rhythm—over and over again. Finally, Watrous went down the hall to Blakelock's studio and found him at the piano. A large painting, *The Pipe Dance*, stood on an easel nearby, the surface glistening. "Are they dancing?" Blakelock repeatedly asked, pointing to the ghostlike Indians in the painting. Blakelock, evidently, had spent the day at the piano trying to relive his experience with the Assiniboin Indians on the plains of North Dakota in 1869. The painting, a fairy-tale image in a forest clearing awash with the muted colors of twilight, clearly had nothing to do with the reality it was based upon. It was largely symbolic and yet it was important to Blakelock that the spirit of the Indians remain alive.

The Indian encampments and dance paintings represent a middle ground at this point in Blakelock's oeuvre. At one extreme he would still, on rare occasions, produce a still life—a glass vase, perfectly executed, filled with luxuriant carnations and zinnias against a wall of black paint. The Indian encampments, harmonious in tone, combined a more expressive, romantic mood with a fanciful picture story. Other paintings were more imitative of the Barbizon paintings of Dupré and Diaz—desolate open landscapes with the occasional tree splaying its skeletal form across the sky. Still other open-sky landscapes were more experimental and abstract. But just what Blakelock painted on any given day depended on his capricious moods, the exigencies of the moment, and what canvases were ready to be worked on.

Blakelock's process of painting involved both whimsy and method. As time went on, and as he depended less and less on his sketches, the two became inextricably entwined, the images feeding on the process. "When the silvery ground of his picture was hard and dry, he floated upon it more forms, using thin paints much richer in quality of color," wrote Elliott Daingerfield, who provides the most detailed description of Blakelock's technique. "When partially dry these were flattened with a palette knife, the forms brought into relief by subtle

wipings, and once more allowed to dry. This process was repeated fre-
quently, and then when the surface became . . . over-glazed, he re-
duced it by grinding with pumice stone. The effect of this would bring
the under silver of his first impasto into view, and with this key . . . he
developed his theme, drawing with the darker and relieving with the
under paint."

It was a slow and laborious process. Sometimes Blakelock would take
years to complete a painting. He brushed on pigment, scraped, var-
nished, and repainted until his surfaces achieved a depth and subtlety
unmatched by his contemporaries'. Cora remembered Blakelock put-
ting away a painting for months at a time. "But he never forgot it," she
wrote. "It had to be in just the right condition to rub down before
beginning work on it again. He was always busy as there was always
some picture in the right condition."

Blakelock's Sherwood studio was filled with unfinished canvases:
seascapes, forest interiors, and Indian encampments. Watrous recalled
Blakelock walking into his studio one day with a large rolled-up can-
vas. "He unrolled it on the floor, placed some books along the edges
to keep it flat and stood there looking at it. In some places the paint
looked as if it were three inches thick and here and there the surface
had cracked from the effect of unrolling and rolling up the canvas. 'I
started it a long time ago . . . How do you like it Watrous?'" Blakelock
asked him. Watrous saw two different paintings on the same canvas—
one on either end. Blakelock asked him if he wanted to buy it. "If you
cut it in two, I'll take both halves," Watrous told him. Blakelock
abruptly rolled up the canvas and put it away. But a month or so later
Watrous found Blakelock in his studio with the canvas once again
unfurled on the floor. Blakelock had reconsidered. "There really are
two pictures on the canvas," Blakelock said. He took out a knife and
cut the canvas in two; one half, *Indian Encampment*, now belongs to the
Metropolitan Museum of Art.

By the mid- to late 1880s, some of Blakelock's experimental work
had largely abandoned any semblance of objective reality. A reproduc-
tion of a Blakelock open-sky *Landscape* in the 1886 academy catalogue
is accompanied by an explanatory note: "Painted in a suggestive man-

ner, with the aim of compassing the spirit of the scene, rather than its
literal details." The same might have been said of other Tonalists, such
as Inness or Wyant. But Blakelock had gone further. He had taken a
dangerous leap forward and eliminated just about every objective ele-
ment of nineteenth-century landscape. Gone were the prosaic cows
and sheep, the carefully shadowed rocks in a pool of water, the per-
fectly reproduced, ethereal clouds, the mountains; even his beloved
arabesque trees had been reduced to ragged dark shapes against a
milky sky. Blakelock had become so totally engaged in the process of
his painting that in some works like *Sunset Landscape* it could almost
be said that the subject of the picture had become the paint itself.
The pigment is everywhere present, scarred, scratched, shoved around
by brush and stick in a tortured attempt to represent what Inness had
called that "indefinite" other. The critics described Blakelock's works
as bits or pieces of beautiful color. Paint or color, of course, were never,
intellectually, the subject of his work, but simply the means to distill
landscape to its essence: bands of dark earth and light sky with the
trees in a tangled embrace of both. Blakelock, philosophically a Ro-
mantic transcendentalist, had transformed objective landscape into a
state of consciousness.

Blakelock took the painterly ideas of Hunt and Inness literally and
pushed them to their limit. In doggedly pursuing the path of self-
expression, Blakelock now stood apart from any other American
painter of his time, on the very threshold of creating a new vocabu-
lary. He was confounding America's preconceptions of landscape art,
scrambling the signals and changing the message. The best of his
open-sky landscapes, as Geske recognized, were his most advanced
and genuine works. They "stand apart from his trademark subjects and
. . . forecast . . . a sensory experience of phenomena that is distinctly
in advance of the conventional practice of his day." In paintings like
Landscape at Evening, Brown Trees and many of his unnamed landscapes,
Blakelock was holding up an ambiguous and, in today's terms, exis-
tential landscape or placard that few of his contemporaries could
understand. It wouldn't be until modern artists such as Marsden
Hartley came along at the turn of the century, and later still, abstract

expressionists like Franz Kline, to appreciate, intellectually, the inno-
vative nature of Blakelock's painting. "At such times," *The Nation* wrote
in 1916, "in the persons of such men as Poe or Blakelock, American art
seems to flare up and consume the boundary posts of convention and
become a law unto itself." Even Blakelock himself, though he knew the
path he was on, could hardly be expected to fully comprehend the con-
ceptual ramifications of what he was doing. He was just painting.

Ultimately, Blakelock's expressive, proto-abstract landscapes (which
he continued to paint into the 1890s) were physically and intellectu-
ally unsustainable work. Few people understood them, and almost no
one, except other artists, bought them. His more conventional paint-
ings, on the other hand, though considered charming, were not hav-
ing much impact either. Blakelock had painted himself into a corner
and needed to find a way out—a way to express his profoundly Ro-
mantic sensibility, his advanced notions of art, and his virtuosity with
color in an original, yet recognizable, format.

In the fall of 1886, with Cora about to give birth to their fourth child,
Blakelock stumbled upon a solution when he commenced work on a
large, brooding, and mysterious landscape, *A Waterfall, Moonlight*—now
in the Metropolitan Museum. The painting, noticeably more com-
posed than his other expressive landscapes, is completely imaginary
in conception yet realistically portrayed and luminous in color. Never
before had Blakelock focused all his talents on such a grand theme in
such a single-minded manner.

The inspiration for *A Waterfall, Moonlight* could have been almost
anything. Family stories have it that a similarly titled moonlight was
inspired by the image Blakelock saw in the scratched and worn enamel
of his tub, another moonlight by Beethoven's famous sonata, yet an-
other by a tree in the Schochs' yard in East Orange. While these events
may have triggered the particular composition of a painting, the *idea*
of a moonlight scene had long been a part of Blakelock's singular imagi-
nation. Blakelock first drew moonlights as a young man during his trips
to the American West. There is a dark charcoal sketch of a moonlight
forest interior in the mountains, another in the jungles of Central

America. Still later in the 1880 Adirondacks series, he painted two canvases of nighttime scenes with the moon distantly visible through the pines. The Romantic literature that Blakelock read, especially in the Aldine, was strewn with images of moonlight scenes. It was in the work of Walt Whitman, Edgar Allan Poe, and Blakelock's most frequent source of literary inspiration, Henry Wadsworth Longfellow. One need look no further than Longfellow's popular 1847 epic, *Evangeline, A Tale of Acadia,* to find a description bearing an uncanny resemblance to the sensibility found in Blakelock's *A Waterfall, Moonlight,* as well as the setting of his later Indian encampment moonlights.

Slowly over the tops of the Ozark Mountains the moon
Rose,
Lighting the little tent, and with a mysterious splendor
Touching the somber leaves, and embracing and filling
The woodland.
With a delicious sound the brook rushed by, and the
Branches
Swayed and sighed overhead in scarcely audible whispers . . .
A breath from the region of
Spirits,
Seemed to float in the air of night; and she [Evangeline] felt for a moment
That, like the Indian maid, she, too, was pursuing a
Phantom.

Blakelock may have reached back into the Romantic tradition (moonlight paintings had been fairly common since the end of the eighteenth century) for guidance, but in *A Waterfall, Moonlight,* he took the genre to another level. In earlier moonlights by other painters, whether it be Caspar David Friedrich's *Two Wayfarers,* Washington Allston's *Moonlit Landscape,* or Ryder's marine *Moonlight* of 1882, the moon was employed primarily as a scene setter—the misty white globe as an adorning prop, or as a bit player in a landscape that is really about two travelers on the lonely road, townsfolk by a river, a boat lost at sea. In *A Waterfall, Moonlight* Blakelock bravely eliminated everything but the moon, the tree,

and the water. The moon and its suffusive, otherworldly *light* become the subject, theme, and anima of the painting.

Even today, in *A Waterfall, Moonlight*'s greatly faded state, the elements of its once magical spell are discernible: the faint sulfur glow of the moon diffused through the shredded clouds, the coal-black outline of the tree casting its lonely silhouette across the night sky, the water falling with easy abandon down the rocks. Blakelock has created a vision of another world.

A Waterfall, Moonlight was, Blakelock realized, a breakthrough, and he submitted it to the academy's autumn exhibition. In terms of exhibitions, 1886 had been a banner year for Blakelock. In February, his work had been exhibited in the Boston Museum's exhibition of American artists. In April, in New York, he contributed to an exhibition at the American Art Association. A week later he was putting the finishing touches on his paintings for the annual exhibit at the National Academy, where for the first time his work was reproduced in the catalogue. And in May his paintings were again included in the Society of American Artists exhibit. Blakelock's visibility, in a sense, had never been higher. The National Cyclopedia made room for his biography in their next edition. Ironically, as Blakelock's paintings became ubiquitous at the exhibits and his acceptance more widespread, there was less ink about him in the press. Some notices appeared here and there, but on the whole the controversies Blakelock had generated in 1880 and 1884 were fading into a disconcertingly quiet acceptance. Not that Blakelock was yet considered mainstream but, rather, he had come to represent one end of the spectrum of American art. He no longer needed to be explained. As a critic at the time said of Robert Graves's important collection of American art: "The extremest range of American landscape art is represented . . . both Messrs. Bierstadt and Blakelock." As flattering as those kinds of comparisons were, Blakelock could not ignore how quickly signposts, even one as exalted as Bierstadt, were taken for granted and forgotten.

The academy's autumn exhibition was the last important show of the year. The exhibit, it will be recalled, was designed to show off the works

of lesser-known, younger artists. Blakelock, who had made his start in an autumn academy exhibit in 1867, was now included as an established artist to help draw in the public and an increasingly reluctant press. His contribution, *A Waterfall, Moonlight,* was hung alongside Winslow Homer's equally dramatic *Lost on the Grand Banks* in the south gallery.

Conspicuously, both Blakelock's and Homer's paintings offered a darker, more isolated, and far less assuring view of the American experience than had previously been popular. Homer had by then retreated to a solitary life on the coast of Maine; Blakelock was ensconced in his studio, an outsider in the inner circle. Both paintings project visions of uncertainty—in Homer, the ambiguity is conquered by heroic effort, and in the Blakelock, by a transcendent vision. By the late 1880s the romanticism of Emerson and Longfellow were distant memories and the resurgence of national optimism present in the early '80s was waning. In the spring of 1886 violent workers' strikes and protests had once again broken out in the streets. The looming threat of another depression, the imminent "closing" of the frontier, and the rampant industrialization of society had created more uncertainty about the future. In this light, America's idyllic past and its formative relationship with nature was looking more distant and attractive all the time.

When the academy exhibit opened there were few reviews in the daily newspapers. A week before the opening, the Statue of Liberty had finally been unveiled. There had already been days of celebration in anticipation of the dedication of Lady Liberty, which finally took place on a foggy rainy day in November. The city's celebrants were exhausted. The academy exhibit was a mere afterthought. In the few short reviews that did appear, most mentioned either Blakelock, Homer, or Homer Dodge Martin's paintings as being among the most impressive works in the show. It was encouraging, but hardly a knockout. Then, on November 27, *Harper's Weekly,* the most popular national magazine in the country, finally reviewed the exhibit. The two-page illustrated spread was a rave, declaring the show a hit and Blakelock its star.

The collection as a whole is by far the best autumn exhibition that has yet been made. It is brilliant, varied, and interesting, and it is full of novelties. . . . The best landscape in the exhibition is by Mr. R. A. Blakelock, a large somber composition of great depth and sobriety of color, conceived in sympathy with some of the more characteristic works of Jules Dupre, and altogether a very impressive and notable picture. We have been accustomed to Mr. Blakelock as a fantastic colorist dealing with capricious varnishes and arbitrary pigments, but . . . we confess to an unmixed surprise at seeing attributed to him a landscape so powerful as . . . [this] remarkable picture.

The *Harper's* review was the most important endorsement Blakelock would get in the 1880s. It opened the door to a potentially wider audience, and to popular success. *Harper's* lost no time in acquiring the rights to reproduce *A Waterfall, Moonlight* in an expensive edition of twenty-five wood engravings that Harper & Row published the following year. The book, edited by the critic William Laffan, contained the works of the most important American progressive painters of the era, including Inness, Fuller, La Farge, Elihu Vedder, and Ryder. Blakelock's *A Waterfall, Moonlight*, engraved by S. G. Putnam, was billed as "the masterpiece of the autumn exhibit in the National Academy."

A Waterfall, Moonlight did more for Blakelock's career than anything else he had previously painted. Its critical success inspired him over the next decade to paint a series of large, haunting moonlight paintings. Indeed, the moonlight became Blakelock's signature piece, his leitmotif, and the unknown night his predominate milieu. More than simply pictures, Blakelock's elegiac scenes became icons of America's primeval roots, its spiritual past. As with the monolithic deep-toned paintings of Mark Rothko in the 1950s, a cultlike aura developed around Blakelock's nocturnes. To view a Blakelock was said to be a mystical experience. To sit in front of a Blakelock moonlight, Dainger-

field wrote, was "to steal the spell of night and . . . commune with the Infinite."

Not surprisingly, collectors, when they bought a Blakelock after 1886, demanded a moonlight. Not least for Blakelock, the positive critical reception of *A Waterfall, Moonlight* offered the promise of financial security. After all, a "masterpiece" had to be worth something. "I remember when I painted that picture," Blakelock later said. "I was really happy because I had almost touched what I thought was good work. And I knew I would sell the picture for a fair price and the new baby would not want for anything."

A few weeks after the opening of the autumn exhibit, on December 14, 1886, Mary Florence, the Blakelocks' fourth child, was born. Her birth, at such an auspicious moment in the painter's career, seemed to augur well for the future. It was time for Blakelock to reap the rewards of a long career. But no sooner had he finally succeeded as an artist than his tenuous grip on reality loosened and his long battle with schizophrenia began.

V

MOONLIGHT

Mystical truth exists for the individual who has the transport, but for no one else. In delusional insanity, paranoia . . . we may have a diabolical mysticism, a sort of religious mysticism turned upside down.

—William James

18

DEATH AND VAUDEVILLE

What happened to Blakelock in the year following his stunning success at the National Academy's fall exhibit is a mystery. In the first ten months of 1887, after seven years of being shown consistently in the nation's most prestigious venues, Blakelock failed to appear in a single exhibition. In 1888 he showed twice at the academy but did not show there again until 1894. Blakelock's painting reached new levels of experimentation and daring in the 1890s, and his reputation among collectors, critics, and other artists continued its ascent. Yet in the next ten years Blakelock's active participation in the New York art scene was marginal. By the time lucre-hungry dealers and collectors were scrambling for his work at the turn of the century, Blakelock was locked away in an institution. Long known for his eccentricities and moodiness, in the 1890s his mind gave way to schizophrenia and he was battered by a series of emotional and financial crises from which he never completely recovered.

In 1887, Blakelock did manage to sell several important moonlights, including *A Waterfall, Moonlight* and another highly praised painting, *Moonrise*. He was able to move his family out of his in-laws' in Greenpoint, where they had been living since his uncle's death. The move

from the confines of the Bailey household was a relief. The Blakelocks moved back to East Orange and rented a house on Evergreen Street directly across the road from their old friends the Schochs. It was a clapboard farmhouse with a large front porch that wrapped around the side. Blakelock christened his new house by painting a landscape on the mantelpiece and took up where he had left off five years before. He was frequently found on his neighbors' porch, talking with Mr. Schoch. At other times Mr. Schoch played the piano while Blakelock painted. The surrounding lanes and countryside once again became an inspiration for his work. It was a welcome reunion for Blakelock and Schoch, but it was not a happy time.

In the winter of 1887–88, Blakelock's mother, Caroline, was dying of cancer. Blakelock's father, who was by then retired and going blind, and his brother George left New York City and moved Mrs. Blakelock to a house on Main Street in East Orange. Emily, Blakelock's aunt, still lived in the Johnson house on Pulaski Street. The family had re-grouped for the first time in almost a decade. Blakelock's house was within easy walking distance of Main Street, so there were ample opportunities to visit his mother.

It was a record warm winter with little or no snow. Then, late on the cloudy afternoon of Sunday, March 12, a cold rain began to fall. Within hours it had turned to sleet and then into snow. By the next day the temperature had dropped to near zero, the wind reached sixty miles an hour, and the snow was piling up into drifts ten or more feet deep. The great blizzard of 1888 had struck. For the next three days East Orange and much of New England were paralyzed. Trains stopped running. The ferries did not leave their docks. Thousands of telegraph and telephone wires were down. The Blakelocks and the Schochs were confined to their homes under a quiet blanket of snow. Hardships aside, the fresh snow spreading across the fields to the distant woods was beautiful and serene. It may well have inspired one of Blakelock's few winter landscapes, a painting he gave to Schoch about this time. He painted it on panel, using only two colors, blue and white, dexterously rubbing down to the grainy wood itself to create the thin brown spines of the forest trees.

A little more than a month after the blizzard, on April 26, Blakelock's mother died. Two days later, Blakelock and the family followed her coffin over the Hudson and East rivers, then climbed the high hill of Greenwood Cemetery. There were, by then, already eight Blakelocks in the family plot, but none had even the smallest monument erected above their graves. Nor would Blakelock's mother have one above hers.

It's commonly believed today that genetic and chemical forces are the principal causes of mental illness, yet most clinical psychiatrists also concede that stressful situations can play an important role in the onset of serious depression and manic periods among schizophrenics. A lost job, a broken heart, or the death of a loved one are frequently mentioned instigators. Caroline Blakelock first became sick with cancer the winter of 1886–87, at the very time that Blakelock's success so inexplicably foundered. Likewise, the death of his father, in 1897, would coincide with a precipitous decline in his mental state. To assume that Caroline Blakelock's prolonged illness and death set off her son's decline is, admittedly, speculative. There are no surviving letters between Blakelock and his mother. Not a word that he might have said about her was ever recorded. And though Blakelock certainly idealized women and children in his paintings, if he painted his mother's portrait (as he did his father's), it did not survive. Nevertheless, the family's quick exit from New York and Greenpoint and their gathering in East Orange clearly had to do with her illness and imminent death. The quiet Mrs. Blakelock apparently wielded considerable influence over the family. With her death Blakelock had lost another pillar of strength and support. His uncle was dead, his mother was gone, his father almost blind. For the first time in his life Blakelock was truly alone with a large family to support and no one to turn to in times of crisis except his younger brother.

The Blakelocks' situation in East Orange soon deteriorated. The anemic art market in New York, further weakened by the hiking of a controversial tax on artwork, did not help matters. By 1889 the sales of paintings at the National Academy were half that of the sales in 1884. Blakelock, who, after 1888, was no longer showing his new work

at the academy, depended almost entirely on his own efforts to sell his paintings. Cora often described his optimism in the face of his many disappointments. But at this stage in his career—he was then in his early forties, with yet another infant (Louis, born November 3, 1888) to care for and several growing children to feed—he was faltering. When he landed a contract to provide paintings to Robert Fullerton, an antiques and paintings dealer on Third Avenue, he was more than grateful. "When we lived in Orange Papa painted a lot of pictures for Mr. Fullerton," Cora later wrote to her son Allen. "Mr. Fullerton agreed to take all the pictures . . . for $25 each that Papa brought to him. We didn't have a cent then and Papa was glad to get the job." Blakelock, however, could paint the pictures, which Cora described as "not his best work," faster than Fullerton could sell them. "One day, I can remember just so well," Cora wrote. "We were as usual in great need of money Papa finished a picture to take to Mr. Fullerton. . . . Well he came back with it [the painting]. Mr. Fullerton had all he wanted. I never saw Papa so disappointed. He depended on getting the $25 from Mr. Fullerton and he didn't know what to do next as nobody would buy his pictures."

Coming so quickly on the heels of his success, Blakelock's renewed rejection from major exhibitions and the humiliation he faced at the hands of petty merchants and dealers may well have set off paralyzing bouts of anxiety and depression. Cora describes Blakelock at this time as being beset by "worries" and, at times, terribly "downcast." At the hospital there were days when Blakelock refused to lift brush to canvas and withdrew, almost entirely, from the world around him. It does not seem far-fetched to presume that in the sudden silent periods in Blakelock's career, such as his disappearance from the art scene in the late 1880s, he may have temporarily lost the courage to carry on.

He was soon months behind on his rent and frequently depended on the Schochs for basic necessities. If Marian Schoch is to be believed, the Blakelock children "were dirty and wore ragged clothes." It's hard to fathom Cora allowing the children to fall into such a state, but she herself admitted that there were times when clothing and food were in short supply. Blakelock had little choice but to get back out

on the street. Still wearing his stiff, turned-up collars and a jacket, he trudged from dealer to dealer, sometimes with his eldest son, Carl, in tow, trying to sell enough paintings to feed his family. Elizabeth Newbrough, Dr. Newbrough's daughter, remembered passing Blakelock on the street in the late 1880s. Blakelock looked so sad, she told Lloyd Goodrich, that she stopped and spoke to him. "He told her he was very discouraged and that he had had no luck. He said that some of his friends had suggested that he get a job as a organist but he said to her 'I just can't do it.'" As it was, the Blakelocks soon gave up the farmhouse on Evergreen Street for a more distant, and presumably less expensive, domicile in West Orange on Watchung Avenue. They lived there in 1889, but already by the next year they had moved again, this time to 138 Alden Street.

In these lean and difficult times, Blakelock increasingly turned for solace to the small Swedenborg community in East Orange. The Swedenborgians in town were led by Reverend Charles H. Mann, a controversial figure within the church who, for twenty-five years, was editor of a weekly journal called the *New-Jerusalem Messenger*. The Swedenborgian orthodoxy criticized the *Messenger* for being too "philosophical and metaphysical for the average man," but it was Mann's "attitude of warm support toward the woman's movement, socialistic tendencies, and . . . strong anti-ecclesiastical sentiment" that most irked the church authorities and eventually drove him from the church.

In the late 1880s and early '90s, however, Reverend Mann's liberal opinions were appreciated by the progressive elements in Orange. Swedenborgian thought often received a welcome hearing in the *Orange Chronicle*. Attendance at Mann's informal weekly sermons, always quite small, grew to about seventy regular worshipers, and in 1889, $10,000 was spent to erect a Swedenborg Church and to purchase an organ (it may have been Mann who "suggested" that Blakelock play the organ). In 1890 Reverend Mann christened Blakelock and appointed him an officer of the church. That same year, two-year-old Louis and the other Blakelock children were also christened by Mann. When the church sent the Blakelocks a large bouquet of flow-

ers in commemoration of the event, Blakelock sat down and painted the flowers.

In Mann, Blakelock found a latter-day Muhlenberg to look to for comfort and intellectual companionship. Like Muhlenberg, Mann was a visionary, a reformer, and a man of intellectual integrity. He sent delegations of women to the recalcitrant Swedenborg Association councils, made a strong case for coeducation, and handled questions of social inequality, sex, marriage, divorce, and birth control in a straightforward manner that was ahead of its time. His Tuesday-evening discussions of the spiritual ties between man and the meta-physical universe addressed ideas that had long informed Blakelock's life and work.

Blakelock's reimmersion into Swedenborgianism came at a time when he was in a reflective mood and might well have been experiencing his first "peaks"—experiences of heightened awareness—which often precede schizophrenic illness. It was in 1889 that Blakelock wrote his only known work on art, *Measure and Weight: On the Art of Painting*. The manuscript and all of Blakelock's writings have been lost (all that remains of the manuscript is the title page, which is illustrated with a cloud), but Blakelock was evidently deliberating more about his own process of painting. Judging from his work of this period and some of his titles, he was also thinking more symbolically about the times and the nation he lived in.

In the late 1880s the demise of the Native Americans, the shrinking of their reservations, and the messianic Ghost Dance they took up in a last-ditch attempt to avert extermination were widely reported in the press. For most of his life Blakelock had worked in the city, now crowded with taller buildings, noisy elevated trains, and streets crisscrossed with telegraph, electric, and telephone wires. But in his studio, his memories of his days in the Western wilderness had never left him. Twenty years later, he continued to paint Indian subjects and sign his paintings with an arrowhead. On December 4, 1890, Blakelock and millions of New Yorkers read the front-page newspaper accounts of Sitting Bull's shooting and death. A few weeks later, four days after Christmas, 350 Sioux of Sitting

Bull's tribe were rounded up at Wounded Knee by Colonel Forsyth, the commander of General Custer's old regiment. There was a brief scuffle and Forsyth's troops opened fire with their Hotchkiss machine guns on the unarmed Indians. An hour later three hundred Sioux men, women, and children lay dead on the snow. Much later, a survivor, Black Elk, described what happened: "I did not know then how much was ended. When I look back from this high hill of my old age, I can still see the butchered women and children lying heaped and scattered all along the crooked gulch as plain as when I saw them with eyes still young. And I can see that something else died there in the bloody mud, and was buried in the blizzard. A people's dream died there."

The Native Americans' country, the one Blakelock had traveled through in his youth, was gone for good. The vision of Arcadia, the vista of Church, the natural paradise of Rousseau—all were nothing more than an illusion. The industrialization of the country and the dismantled belief in a divine plan put in doubt by the apparent haphazard workings of Darwinian evolution were eroding Romantic notions about the world and the future of America. The virtues of Emerson that Blakelock had believed in as a young man, wandering the Green Mountains of Vermont with his sketchbook in hand, by 1890 had become almost irrelevant. Notions of self-reliance and transcendence were practically quaint in an age of growing mass markets, bureaucracy, and standardization. Being alone and communing with nature was an increasingly rare experience. Hence, perhaps Blakelock's funereal moonlights, paintings that the novelist Paul Auster has described as standing for "everything we had lost . . . a memorial, a death song for a vanished world." Blakelock's Indian dance paintings, completed at this time, become utterly symbolic of another age. In *A Vision of Life*—the title was changed from *The Ghost Dance*—the dancing Indians have lost all carnal reality and are painted as phantom spirits disappearing in the twilight.

The year before Sitting Bull's death in 1889, Blakelock showed at the American Art Galleries Prize Fund exhibition a dark sunset landscape with an aging, gnarled oak tree leaning precariously from a dense

copse. It was similar to many of Blakelock's other sunset and twilight canvases, but why, one critic wondered, had Blakelock chosen to call this one *America*?

In 1889 and 1890, Blakelock did not show at the National Academy nor at the Society of American Artists, but he was still painting in his Sherwood studio and had not been forgotten by the art world. His work, by then in many important collections, continued to be exhibited and received positive, though less frequent, reviews in the papers. Among Blakelock's regular supporters was Alfred Trumble, editor of the *Collector*. In its very first issue, in late 1889, Trumble in his column on American artists plugged Blakelock as a painter deemed worthy of more attention and lamented his absence from academy exhibits. A few months later, in an article on the collection of William T. Evans, Blakelock was paired with fellow Tonalists Wyant and Dewey. The *Collector* called Blakelock's *Moonrise* a "powerful" and "remarkable" canvas "glowing with misty color under a sky of vibrating obscurity." A Blakelock forest interior was described as "so rich, so strong and full of the fluttering of verdure and the strange harmonies of solitude, that it has almost the illusion of nature as well as the poetry." In December 1890, as word of Blakelock's dire financial plight spread, Trumble published a lengthy, melodramatic account of Blakelock's career. It was this ubiquitously cited article that gave birth to the legend that Blakelock was an entirely misunderstood and isolated artist.

> Neglected by a public which did not understand him; unnoticed by a criticism which dared not have an idea of its own; poor, burdened, depressed and often desperate, this man of ideals and visions never swerved upon his path.

Short on facts and long on poetic verbiage, Trumble paints a portrait of Blakelock as a lonely, mystic artist completely divorced from the art currents and influences of his time.

He had absorbed his ideas of art from that mysterious source
which no man may fathom, from that eternal vacancy of space
in which the wildest winds make splendid music. . . . I am
glad to see today, here and there in the collections of men
who feel art as well as buy it for mere money, and in at least
one dealer's gallery, pictures by this man, born and bred and
self made as an artist to our soil. . . . One strong right hand,
held out to this artist today, one word of encouragement to
him from one of our money-gorged Maecenii whose galleries
hold fortunes in well-advertised names, is all that is required.
The artist has already fought his battle for existence to a
victory with honor to himself. Who will earn the honor of
aiding him to the fame which is his due?

Trumble, in his paean to Blakelock, did him a disservice. Of course,
in some measure, the essence of the article is true. But in neglecting
to point out Blakelock's important critical triumphs of the 1880s, his
artistic kinship with the great French and American artists of his time,
the revolutionary aspect of his art, and his inclusion in the greatest
collections of American art of the day, the writer elicits sympathy and
pity for the artist instead of what he was most in need of, respect. At
this time, Blakelock was selling dozens and dozens of paintings; he
just wasn't getting paid the price that an artist of his age and stature
deserved. The reason was simple. Socially speaking, Blakelock was still
a nonentity—an outsider and an eccentric. At forty-three years old,
Blakelock not only was not an academician at the National Academy,
nor a member of the Society of American Artists but, significantly, he
did not have the organized backing of any reputable dealer. An artist
who had been "on the line" with Homer and consistently compared
to Inness, Dupré, and Diaz—some of the highest-valued artists of the
time—was being treated by buyers and collectors like a beginner.
While those artists' works were often valued in thousands of dollars,
Blakelock, childlike, ever the down-and-out enthusiast, groping from
one sale to the next, made do with enough grocery money for the next

day. It was Harry Watrous who pleaded with him at this time not to sell a moonlight for fifty dollars and, soon after, sold it for Blakelock to the important collector William T. Evans for six hundred.

Six hundred dollars was more than enough money to pay Blakelock's studio rent at the Sherwood for a year. More income came in from the thirty to forty important paintings he sold to a new collector named Lew Bloom between 1889 and 1892. This was in addition to the many paintings he sold to Charles W. Snow, the innumerable quickly produced canvases he dashed off for Fullerton, and quite a few high-priced paintings that went to Altman, Clarke, Lambert, Evans, and other collectors. Still, there never seemed to be enough money to pay his debts. Blakelock was well known for his lack of money sense. He kept no accounts, and he thought nothing of the occasional splurge. He did not, however, have expensive habits—that is, any we know of—the occasional suit ordered from his tailor, perhaps, the odd box of cigars. Blakelock's off-the-cuff remark that he threw his life away on "wine, women, and song" was, from the evidence on hand, nothing more than childish bravado (Watrous claimed Blakelock didn't have any vices). Yet Blakelock was also not entirely the lonely aesthete wasting away in his studio described by Trumble. He was, in fact, at this time spending a considerable amount of time with a new friend and supporter far away from the refined environs of the art world or the sanctity of the church. He was with Lew Bloom and his fellow tribe of actors on the vaudeville circuit.

Lew Bloom was on his way to becoming a vaudeville headliner when he met Blakelock in 1889. At the time he appeared at the H. R. Jacobs Old Skating Rink Theatre in Newark, New Jersey, with J. J. Dowling's company of actors, but he soon made a name for himself as "A Society Tramp," and by 1893 he was playing New York City's grandest vaudeville theaters. Bloom's shabby-tramp routine, stumbling from barroom to ballroom making social gaffes, was one of the first of its kind, preceding those of W. C. Fields and, of course, Charlie Chaplin. It's not hard to see why Blakelock, who had been through his share of ordeals, might have been amused by this sad-faced comic's act. Nor

is it surprising that Bloom found things in common with an inspired, eccentric, down-at-the-heels artist.

"I knew Blakelock intimately for a number of years and bought a number of paintings from him," Bloom later wrote. "I owned nearly all the good ones," he boasted, "or . . . was in some way connected in selling them for him." Bloom, prone to exaggeration, also claimed, incorrectly, to have introduced Blakelock to Catholina Lambert. In fact, he may well have *re*introduced them. Arthur Milch, an art dealer, recalled that Blakelock, Bloom, and Lambert sometimes met at a vaudeville house in Paterson, New Jersey, where Blakelock, on occasion, played the piano for Bloom's act. The three dined together and, according to the actor, Bloom himself was instrumental in selling Lambert the "big Moonlight" and "a dozen or more" smaller paintings.

There are differing stories about how Lambert acquired *Brook by Moonlight,* but they all agree on one fact: Blakelock did not get paid nearly what he had asked for the canvas. The same is said to be true for the other paintings Blakelock sold to Lambert. How much back-slapping took place, and how many expensive cigars were lit as Lambert, the shrewd millionaire industrialist, and Bloom, the charismatic actor, caroused with Blakelock, cajoling him along the way to lower prices, is anyone's guess.

"I made many other sales for him, for which I never asked or wanted a penny," Bloom insisted, somewhat defensively. "He was a pall [*sic*] of mine, and nearly all the purchasers were Theatrical Men and also friends of mine." Whatever else was true, Bloom, who was not a rich man, did have a great eye for art and bought almost forty beautiful and important paintings from Blakelock.

The Bowery, a vaudeville hangout, became a regular stop on Blakelock's circuit in the 1890s. He went there to borrow money from Frank Reside, a Bowery Street gun dealer who also bought the occasional painting. He dropped in on Bloom and the other vaudevillians at the London Theater. With his paintings under his arm, Blakelock made his way through a neighborhood renowned for its slippery dives, its beer halls crowded with workers, its sweaty dance halls, and its myriad

bordellos, gambling rooms, and small theaters. Here working-class audiences cheered as villainous capitalist moguls, their pockets stuffed with railroad stocks, were booted from the stage. Here, at a bar called The Slide, sophisticated "fairies" and "nancys" performed erotic dances. Billiard halls erupted in brawls and unwary male tourists were discreetly removed of their cash. It was a world other uptown artists wouldn't have deigned or dared to enter. Or they might have hired a guide (or, better yet, a policeman) to take them around on a nocturnal "slummer's tour."

To Blakelock, however, the boisterous working-class clamor of the Bowery was as familiar to him as the rowdy crowds of the Jefferson Market he had known as a child. Growing up the son of an English-born policeman, he had often been out on the curb beside his dad in his blue jacket, and with his cap, stick, and whistle; he had heard the songs and piano music rolling out of the humid air of a saloon as they walked by. He had heard the voices, with an English lilt, calling upon them to join in the singing. He had seen the neighborhood toughs get teary-eyed when the songs turned to hearth and home.

The vaudeville of the 1890s, where Blakelock occasionally got on-stage to play a popular melody, was born of the same world. There were still more than a few concert saloons smelling of peanuts and stale beer, some known for their randy songs and dissolute crowds and others for their bowler-hatted audiences listening to the "refined" singing of an Irish lass clad in a short frothy dress. After Blakelock was committed to the asylum, he never missed an "entertainment." On the vaudeville circuit there was endless entertainment to be had, from "Richard the Great," the bicycling monkey, who made light of Darwinism, to the velvet-voiced Italian tenors singing arias, to comics like Lew Bloom. There were so many ways to forget about the problems waiting at home.

Vaudeville eventually cleaned up and moved to more respectable neighborhoods uptown, like Union Square and Times Square. Popular theaters like Proctor's, where Lew Bloom finally got to play, were done up like mini-Versailles palaces with marble staircases and mas-

sive chandeliers. Some of the new theaters added amenities like bowling alleys and Turkish baths. Middle-class families arrived in droves for good, clean entertainment, and even the sophisticated uptown artists and their wives, like the Beckwiths, came down to be amused by the antics, titillated by the musclemen and acrobats in their skin-fitted tights. The Tonalist painter J. Francis Murphy (who had once lived in the Vienna Bakery building, but by the 1890s was an established academician) and his wife were vaudeville fans. Yet even the Murphys, though they lived a rather bohemian lifestyle, were not likely to be found backstage with Lew Bloom. Legitimate actors were found at their artist soirees, but it was rare to find any vaudevillians in that circle. The artists may have found them amusing, but they didn't invite them to their clubs or their country houses for the weekend. Nor, for that matter, did they invite Blakelock.

Blakelock played piano with the vaudevillians, he dined with his many friends (a number of sales of his work have been traced back to these dinners), he mused among Reverend Mann's middle-class Swedenborgians, and at home he did his best to fulfill the role of husband and father. He knew all these worlds intimately and yet he never found his place in any one of them. He was moving too fast—always short of cash, running from the studio to the Bowery, from the city to the country, from the church to the theater, from his art to his home. It was an increasingly fragmented world and, as schizophrenia took hold, it grew more intense. Sounds became louder, colors brighter, his interests more disparate and yet strangely more meaningful and beautiful. Everything, from the sound of a carriage door closing to the flutter of a leaf, took on a special significance. It was as if he were being let in on a secret world that no one else understood.

As Blakelock's behavior became increasingly strange and alienating, as he detached from reality, he became, ironically, ever more convinced of his relationship to everything else—passing pedestrians, governments, other planets. As his self imploded it became the center of a vast conspiracy, a fugitive from the real world. Alone in a forest of thoughts Blakelock began to ramble to himself, long soliloquies, the

words flying out of his mouth before he could form them into sentences. Only the canvas provided some solace and that, too, became threatened. In his studio, with the frightening void closing in, a strident urgency sometimes took hold of him at work, a need to make order of chaos. Looking at some sketches, he later told a doctor at Middletown, "I can't make them fast enough."

19

THE FIRST COLLAPSE

"Be of good cheer," Reverend Mann admonished his congregation in his Sunday sermons. "Have trust that all will be well, however the outlook of our mental thought." Mann's bits of positive thinking left their mark on Cora Blakelock and her brood. Cheerfulness, a Victorian virtue, was the Swedenborgian equivalent of the Protestant stiff upper lip. Blakelock was, Cora often assured others, "of a bright and cheerful disposition." Marian, their eldest daughter, said she was "sure" Blakelock had a "sunny disposition . . . and I am quite positive he inspired all the family with the faith in the goodness of the morrow." But no amount of forced optimism could alter the disintegration that was going on in front of their eyes. By the winter of 1891 the Blakelocks had moved for a fourth time in their three years in the Oranges, this time to Park Place near Llewellyn Park.

For months Cora "suspected" that Blakelock was acting in a "strange manner," but his change, she said, was very gradual. "For a long time I thought that he was merely worrying because . . . no one would buy his pictures and he was very downcast. I thought if fortune would only favor us he would be himself again." Blakelock, though, was changing. Beset by anxiety and paranoia, the man who had once

ventured forth across the desolate Western plains among the Sioux
skulked in corners, afraid to leave his house. Drumming up the cour-
age to go out, he sidled in the shadows of the road on his way to and
from the train station in East Orange, afraid that he was being fol-
lowed. Cora wrote:

> He conceived the idea that some one was trying to arrest him;
> he was afraid to venture out of the house but thought it his
> duty to provide for his family and would go away and return in
> the most round about ways so as to elude those who he
> thought were trying to catch him. He constantly imagined
> some one was trying to separate him from us and one time on
> returning home after dark and finding no light in the window,
> did not even try to enter the house because he thought some
> one had taken us all away. He started to find us and did not
> return till the next day.

In the winter of 1891 Blakelock was once again in debt to his land-
lord. The family had been evicted at least once, their possessions hast-
ily loaded onto a cart, with no certain destination ahead of them.
Blakelock had grown up in a time when being poor and in debt had
not so long before been considered a crime punishable by imprison-
ment. Even in the 1890s there was little or no safety net for the poor.
The threat of losing middle-class respectability and ending up among
the nameless and helpless masses in a poorhouse was very real. The
stigma of poverty was a prevailing prejudice that no doubt played a part
in Marian Schoch's confidential whisper that "the Blakelocks were very
disagreeable neighbors." In this atmosphere of social condemnation it
was not entirely unreasonable, according to the elliptical "logic" of the
mentally ill, that Blakelock felt pursued and feared that he might be
separated from his family or "arrested" for failing as a provider. Within a
few months of moving to Park Place, Blakelock's behavior became more
erratic, his moods manic and desperate. Cora watched helplessly one
day as he destroyed a number of large paintings. They were, she said, all

important, finished pictures. Some, their surfaces glowing with verdant and amber light, had taken years to complete.

> He cut and slashed them, then burned them. I tried to stop
> him and save the pictures but was unable to do so. He said
> that if anyone should come for him it would go hard with him
> if they found him with any pictures. Then he showed me the
> empty trunks in which he had kept his pictures so that I
> could say he had nothing.

In March 1891 Cora moved the family back in with her mother on Milton Street in Brooklyn. Blakelock was suffering from recurring bouts of insomnia, and his condition was deteriorating rapidly. Early in the week of March 23, Blakelock became so disturbed that Cora asked Blakelock's brother, George, to come to Milton Street and look after him. Forced once again to give up an independent existence in Orange to live with his in-laws, Blakelock now had to submit to being cared for by his younger brother.

Though the accounts of the next few days differ in some details, they all agree that Blakelock's psychotic episode on March 25 was preceded by the sale of one of his largest and most important paintings for a fraction of its true value. It was later commonly repeated that the painting was the celebrated *Brook by Moonlight*, bought by Catholina Lambert, but there are differing accounts of exactly when and where Lambert bought the painting. Carl, Blakelock's eldest son, who was then thirteen years old, provided the most detailed recollection of an attempted sale, not to Lambert, but to the New York department-store magnate Benjamin Altman.

> I remember going with him [Blakelock] and carrying the now
> $20,000 picture when he went to try to sell it to Benjamin
> Altman. It was the day he took it off the stretcher and I
> carried it rolled up under my arm. He offered it to Altman for
> $1,500 and Altman refused to pay more than a thousand. My

father said he wouldn't take a cent less than fifteen hundred, but he later let it go to Lambert for six hundred.

Whether Blakelock sold the moonlight to Lambert in March or later that summer, as Carl and Marian have also implied, is unclear. But all accounts agree that he did reluctantly sell a very valuable painting for between $250 and $500. And on returning to Milton Street with the cash, the family watched helplessly as he tore up the bills and threw them into the fireplace. Late Wednesday afternoon, Blakelock, who had not slept in several days, became unmanageable, tearing at his clothes, destroying furniture, and threatening Cora and the children. George Blakelock tried to administer an injection of morphine, but Blakelock became violent. The *World* was among several newspapers that described the ensuing events.

> Dr. Blakelock sent to the Seventh Precinct Station-House late last night for assistance. A policeman was sent to the house. The Eastern District Hospital was notified and Dr. Orrell responded with an ambulance. Ralph, whose clothing was badly torn, was finally induced to enter the ambulance and went to St. Catherine's Hospital. . . . Arriving at St. Catherine's Hospital the patient was taken out of the ambulance and taken charge of by the sister who acts as janitor. Dr. Orrell was just driving away when, in response to a shout from the policeman, who had remained behind, he turned back. He saw the insane man in the grasp of one of the sisters and the house surgeon who were thrusting him into the street.

Blakelock, upon hasty examination at St. Catherine's, was refused admittance on the grounds that the hospital did not accept cases of insanity. It was, by then, ten o'clock at night and Blakelock, described as being in "an exhausted condition," finally gave in to "treatment." Presumably, "treatment" meant that George Blakelock, who was still in attendance, gave his brother a shot of morphine. George and Dr. Orrell then took Blakelock to the Sixth Precinct station house, where

officers informed them that the case belonged to the Seventh Precinct, which was where Blakelock was finally taken into custody.

> He was not violent [though] . . . he insisted that it was an
> outrage to lock him up in a station house simply for being a
> very sick man, which he admitted he was. He rested comfortably on one of the policeman's cots and gave very little trouble.

Another visiting reporter left with a somewhat different impression. He described Blakelock as speaking "in violent language against the conspirators who . . . had been trying to blow him up with dynamite for years." The *New York Daily Tribune* added the important detail that Blakelock now believed the "conspiracy [was] on the part of his family." The next day, Blakelock was sent to the Flatbush Insane Asylum.

That Blakelock had been "turned out" from St. Catherine's Hospital in the middle of the night drew additional attention to the case. Two days after the event, Friday, March 27, the *Daily Tribune* wrote an editorial note that criticized St. Catherine's, a private hospital that received substantial public aid. "The treatment [Blakelock] received at the institution has caused widespread indignation among his numerous friends," the newspaper noted. The *Brooklyn Daily Eagle* in a lengthy editorial entitled "Hospitals and the Insane" also remarked on the show of support for Blakelock but took a more moderate view on the wider issue at hand. "Hasty conclusions in regard to the Blakelock case in particular and as to insane patients in general should be avoided," the editorial cautioned.

The Blakelock "case" made it into the art press as well. On April 1, the *Collector* described Blakelock as having "succumbed to the over strain of labor and anxiety and fallen victim to acute mania, the direct result of prolonged insomnia." The "Gallery and Studio" column of the *Brooklyn Eagle* offered a similar diagnosis, though the critic more than insinuated that Blakelock had always been eccentric. "The news that Blakelock has become insane will not surprise many people who knew him," the critic wrote and went on to a lengthy and largely invented description of Blakelock's "peculiar" painting technique.

"Every evening he scrapes the paint from his palette," the critic wrote, "and smears it over a canvas spreading it on as one puts butter on bread."

In other newspapers Blakelock was already being spoken of in the past tense, at times with a mythical sentiment attached to him. The angels being affixed to Blakelock's mausoleum, however, were premature. He was released from the Flatbush asylum a week after he had been admitted and was pronounced cured. "He did seem to be in his right mind," Cora said. Blakelock's wealthy patrons—perhaps chastened by the newspaper accounts of his breakdown and its supposed cause—offered their support. Benjamin Altman gave thirteen-year-old Carl a job in his department store. And Catholina Lambert invited the family back to his estate in Hawley, Pennsylvania, for the summer.

Trying to trace Blakelock's early signs of mental illness and its effect on his painting is, at best, perplexing. Prior to his collapse in 1891, Blakelock had long been fragile, excitable, and subject to capricious mood swings. Even in his twenties, his scrawled notes from his trips out west are curiously abbreviated. His drawings veer violently from one style to another. Throughout his career his paintings, sometimes as polished as an Italian old master's, at other times have a naive literal quality associated with "outsider" art. Yet for every painting that displays a quality of "madness," for lack of a better term, there is another from the same period that is utterly "sane." Indeed, a large body of his moonlight oeuvre, painted just prior to and following his first breakdown, displays a seductive blending of passion and attention to detail, as portrayed, for example, in his sinuous tree limbs and their intricate canopy of lacy leaves. Many of his masterpieces date from this period.

Furthermore, it has been noted by critics that much of Blakelock's later work at the Middletown asylum displays a sense of reality and clarity not seen in earlier work. One might argue that in many ways Blakelock's illness affected everything but his painting skills (though at times it seemed to add a sense of urgency and impatience). Several of Blakelock's fellow artists admitted that he was a little strange, but when

it came to his painting, they often held out that he was a genius. Like-wise, Thomas Clarke, the collector, said that even when Blakelock was in his thirties, he never understood the artist's explanations of his paint-ings, and that Blakelock had his head in the clouds. Even so, that didn't stop Clarke from admiring Blakelock's work and becoming a principal early supporter of his radical art.

Blakelock, it appears, lived in the uncertain terrain of eccentricity and genius, buffeted by the threatened onset of serious mental dis-ease. His thinking was at times bizarre and he was, at the very least, highly disorganized. There were years when the cataloguer at the National Academy couldn't even find Blakelock because the artist had failed to supply the institution with an address. As Blakelock entered his forties, his grasp on reality vacillated from week to week; like Ham-let, he might have said, "I am but mad north-north-west. When the wind is south I know a hawk from a handsaw."

The relationship between insanity and genius, madness and divinity has long been debated. Socrates saw the problem clearly, noting that there were two kinds of madness: "one produced by human infirmity, the other . . . a divine release of the soul from the yoke of custom and convention." Yet over the centuries philosophers have continued to confuse the two and often failed in their efforts to tell them apart. "Of what is the subtlest madness made, but the subtlest wisdom?" asked Montaigne. "It is only a half turn of the peg to pass from the one to the other. In the actions of the insane we see how neatly madness combines with the most vigorous operations of the soul."

In reaction to the Enlightenment the Romantics took the whimsi-cal flights of the soul, the search for the sublime, as their raison d'être. Nature in all its mystical wildness became their stomping ground and the mad creative artist, as depicted in Cesare Lombroso's wildly popu-lar *Man of Genius,* was celebrated as a hero. Such an artist reached for the airy mountaintops and plunged—often with the help of opium and wine—into the solitary depths of the horror of madness. While Coleridge and Byron played their parts in Europe, in America no writer so embodied this Gothic descent, this mystic merging with the irra-tional, as Edgar Allan Poe.

I am come of a race noted for vigor of fancy and ardor of passion. Men have called me mad; but the question is not yet settled, whether madness is or is not the loftiest intelligence—whether much that is glorious—whether all that is profound—does not spring from disease of thought.

In the late nineteenth century the romance of madness was over-done, and insanity became a kind of entertainment. The curious, well-to-do middle class bought tickets to visit madmen in their asylums, to dance at their balls. The newspapers daily recounted the quirky adventures of lunatics. Blakelock, a well-known, experimental artist, some said a genius, now considered insane, was for the period the perfect bill of fare. It comes of little surprise, then, that the vast majority of stories that we hear about Blakelock in the late 1880s and '90s are anecdotes about his quirky personality, his aberrant behavior, his "peculiar" way of painting. Significant though banal quotidian details tend to get forgotten in the crush of popular history.

With the passage of time the period between 1891and 1899, when Blakelock painted some of his most beautiful and haunting paintings, has been compressed, reduced, in the minds of critics and family, to the two crises of 1891 and 1899. In fact it was a difficult time for the Blakelocks, a period of acute financial hardship that was exacerbated by the devastating depression of 1893. This distraught picture has con-tributed to the notion that Blakelock was non compos mentis for the entire period, an incoherent man who had little awareness of his life and art. The comments from family and acquaintances that Blakelock was in his right mind between bouts of mental instability get short shrift in all the melodrama. The recent discovery of a handful of let-ters that Blakelock wrote in the mid-1890s, however, indicate that he was still quite lucid until 1897. A letter written to William T. Evans on May 19, 1896, belies in its banal and reasonable tone, and its mostly correct grammar and syntax, the idea that Blakelock was com-pletely and forever mad. "My dear Mr. Evans," it begins in a clear and elegantly slanted script,

I received your kind letter this afternoon and was glad to hear from you. In regard to the exhibition at St. Louis I am pleased to be represented by the Moonlight picture which you kindly propose to loan them.

I suppose this Moonlight picture is the one exhibited at the N.A. (National Academy). The size of the canvas 27 in x 37 in and purchased from H. W. Watrous.

I would advise you to send the picture to St. Louis in the old frame for the very good reason that you stated in your letter.

I thank you for your kind interest in my art efforts.

Yours very truly

R. A. Blakelock

Brief as the letter is, these were hardly the words of a madman; the size of the canvas, incidentally, is correct. Evans, who was at the time the most important collector of American art in the country, had received far worse. At this time he was besieged by self-serving and sometimes long, rambling letters, bordering on the incoherent, from artists—some of them established academicians—desperate to be included in his collection. Few refrained from self-promotion to induce Evans to visit their studio. George Maynard, the prominent academician (whom the *Times* suggested should have been skied instead of Blakelock in 1879), still had not sold a single painting to Evans. In July 1894 he wrote to Evans, on Century Club stationery, to say that he was working on "important" paintings that Evans might want to own. Or perhaps, he suggested, "It is possible that among your friends there may be some who would like to add to his collection one of my charming works."

The other letters Evans received were brief, businesslike notes from the likes of Inness, Homer, Wyant, Chase, and the other great American painters whose work he owned and often loaned for exhibits and would one day donate to the National Gallery in Washington. Blakelock's letter was no different from theirs, clearheaded, to the

point, and free of squeals of need. It was far from the disjointed, rambling letters that he later wrote from the asylum in Middletown.

Was Blakelock completely healthy? Probably not. But he certainly had some handle on reality and knew perfectly well what he was painting. In the final analysis, Blakelock's breakdown in 1891 conforms most closely to the condition contemporary medical jargon describes as late-onset schizophrenia. It usually afflicts people between the ages of forty and forty-five (Blakelock was forty-three). People who get schizophrenia at this age tend to show more paranoid and schizoid personality traits prior to getting sick. Their delusions and hallucinations may also be more intense during the sickness itself. However, the older a person is the better the chance for some kind of reduction in symptoms as the person ages. Significantly, one study found that the vast majority, some 74 percent of those inflicted with schizophrenia, go into a period of complete remission after their first attack. It appears that for many years in the 1890s Blakelock was indeed in remission.

20

RECOVERY AND RELAPSE

In Hawley, Pennsylvania, where Blakelock and his family retreated at the invitation of Catholina Lambert to recover from the frightening events of that spring, Blakelock busied himself making sketches of the countryside and finished several paintings. He sold at least one to Lambert. Upon the family's return to New York, there being no place for them to stay, they moved into Harry Watrous's studio in the Sherwood Building (Blakelock had by then given up his own studio) for several weeks before moving back in with Cora's mother in Brooklyn. The next two years passed without any remarkable incidents. Blakelock continued to paint at the Sherwood, sharing Watrous's studio. An informal picture taken about this time shows Blakelock sitting in front of his easel with Watrous standing at his side looking at his work. Though Blakelock was ten years older than Watrous, he looks the younger and more fit of the two. Paintbrush in hand, he sports a tight-fitting suit, a skullcap, and a short beard. His attention is fixed on the painting in front of him.

Watrous, whose career was in ascent and who would become president of the National Academy of Design in 1894, was at this time Blakelock's closest companion and chief supporter. Within the art

world Watrous had a good deal of influence, and over the course of the next seven years he would buy or broker the purchase of dozens of Blakelock paintings, many of them the most significant works of art Blakelock would ever produce.

Blakelock's principal theme continued to be moonlights, but he experimented with a wide range of treatments of the subject and often dropped it entirely to indulge in abstract painterly canvases like *Waterlilies* and *Pegasus*. A kind of inscrutable, modern fairy tale, the small, colorful *Pegasus* depicts a perfectly represented tiny white horse and rider rearing up against a molten, abstract landscape. Here, once again demonstrating his penchant to mix elements (and confounding any attempt to delineate between his "mad" and "sane" art), Blakelock has conjured up both the literal and the ideal, both realism and abstraction in a single painting.

Similarly, in pretty, decorative works like *Nature's Mirror*, Blakelock fuses a romantic naturalism (in this case a delicate nude)—lest we believe he had lost the ability to do so—with a fantasy setting. To further complicate matters, many Blakelock paintings from the 1890s, especially his marines like *Sun Serene, Sinks into the Slumbrous Sea*, are often described as Impressionistic. There is an immediacy to these works, an out-of-doors aspect, a lighter palette, and a tactile loose brushwork that is associated with that style. In fact, several nineteenth-century critics mistakenly pooled Blakelock and the Tonalists with the Impressionists, and even today curators will occasionally place a Blakelock in an early American Impressionist exhibit. But if the paintings Blakelock made in the 1890s prove anything, it is that he was first and foremost an experimentalist, and like some modernists he could switch-hit from naturalism to abstraction from one day to the next.

That said, Blakelock continued to be identified by his moonlights, a fact that was not lost on him. Stylistically, *A Waterfall, Moonlight, Brook by Moonlight*, and some of Blakelock's other large, polished moonlights are tightly wrapped in a dramatic, Gothic-Romantic sensibility. They have an elegant composition—the moon shining behind the lacy sil-

houette of an oak tree, its light reflected on a nearby stream or lake. Sometimes Blakelock varied the setting. In *The Three Trees* the misty moonlit trees are high on a cliff above the ocean, with a picturesque Long Island lighthouse in the background. Well drawn and easily recognizable, these paintings sold and provided a dialogue between Blakelock and the cultural sensibility of his time. Yet there are others that are far more ambiguous and abstract, evoking the timbre of Chopin or Ravel, or the imagination of Mallarmé.

There are a number of nocturnal landscapes that take on a hallucinogenic quality, the atmosphere bathed in a green or amber tint, the horizon weirdly bent, as if one were viewing the scene through a fisheye lens. In *Enchanted Pool* and particularly in *Waterfall by Moonlight* (also called *Woodland Scene, Waterfall and Brook*) Blakelock's vision departs from his nineteenth-century contemporaries', abandoning almost all ties with reality. These paintings are essentially tunnels of light draped in blackness. Hardly landscapes, they exist in a solitary world of their own making, dreamlike gateways into the subconscious.

In *Moonlight*, now in the Corcoran Gallery in Washington, D.C., Blakelock has eliminated the forest, leaving only one or two small isolated trees and a great sky of diffused blue-green light. There are a number of these wide-open-sky moonlights, slow, meditative paintings upon which Blakelock spent months perfecting their glowing surfaces and exploring the colors of night. In contrast, paintings like *Moonlit Landscape, Silvery Moonlight*, and *Moonlight and Clouds* are more spontaneous, almost completely abstract, their surfaces repeatedly added to, scratched, and rubbed down to reveal underlying layers of color and light. In *Silvery Moonlight* the dark shape of the tree's branches and leaves is entirely outlined by the quickly dabbed overlay of the lighter sky, a technique and feeling remarkably similar to twentieth-century American paintings like *Hemlock*, a 1956 painting by the abstract expressionist Joan Mitchell. These paintings resist physical description; it's all about the surface and emotion, an unsettled mix of tranquil beauty and frightening isolation. *Water-lilies*, one of Blakelock's most radical and modern works of the period—an

up-close abstraction of olive and bluish lily pads against the black water—dispenses with the reality of the lilies he had made in a sketch, replacing it with a feeling of solitude and mystic contemplation.

Blakelock's raw, impulsive interpretation, and his jarring juxtaposition of almost fluorescent colors and darkness in paintings like *Outlet of a Mountain Lake* and *Twilight,* seem modern in temperament. Yet again, there is something classic and nostalgic about their fiery skies and composition that still reminds one of the work of Frederic Church or Thomas Cole. Blakelock, understandably, never could completely turn his back on his own century and create, entirely on his own, a new art form. Rather, he was like a prophet or shaman, mumbling descriptions few could understand, while pointing up ahead toward a new land yet to be discovered.

Blakelock's seventh child, Ruth, was born in 1892. A year later, in the spring of 1893, the nation's long-simmering economic malaise developed into a full-scale depression. Once again, dozens of Wall Street firms collapsed. Once again, tens of thousands lost their jobs. The socialists organized "hunger demonstrations," and anarchists like Emma Goldman told the crowds that they need only storm the mansions of the rich to find relief (she was soon arrested). In this perilous atmosphere it was difficult for Blakelock to find buyers and he frequently found it necessary to ask Watrous for advances on his work.

In the summer and early fall Watrous spent his time at his house in the Adirondacks, so Blakelock was obliged to go to Watrous's brother Walter's offices at Wilson, Adams & Co. (a lumber-supply outfit) on Forty-second Street for funds. On at least one such occasion— September 1, 1893—Walter Watrous suggested that Blakelock write to his brother acknowledging his debt. Blakelock, obtaining a sheet of Walter's business stationery, wrote, in a rather stilted tone, the following note on the spot.

Dear Harry W. Watrous,
　　I received your kind letter with enclosed check for $35.00 advanced on the Indian Encampment . . . Your brother, Walter,

has advanced me in all $200 since you have been away on work to be selected by you from the seven or eight pictures which I am engaged upon, at your studio 58 W. 57th Street.

The family are all well at present. I hope you will be down sometime in Sept. or Oct.

Yours truly,

R. A. Blakelock

A month later Blakelock was back to borrow more money and wrote another short note, this one from home, greeting his friend this time in a less formal tone.

Blakelock's inclusion of complete dates, addresses, and the amounts of money borrowed (or advanced on sales of his paintings) was clearly an attempt on his part to sound financially responsible and businesslike. Blakelock's debts weighed on him and he made every attempt to repay the people who had lent him money. Elizabeth Newbrough remembered Blakelock borrowing ten dollars from her mother and returning several weeks later with the money and a painting, *Rocky Mountains*, which he gave her and which was worth, even then, many times what he owed.

To make ends meet, Blakelock continued to produce a prodigious amount of work, which was sold to an ever-widening circle of buyers, from millionaires and politicians to antiques dealers and magazine editors. In Brooklyn, in the early '90s, the art dealer Henry D. G. Rohlfs bought a whole trunk of unstretched canvases from Blakelock—Rohlfs claimed some three hundred.

Still, at a time when Blakelock's art was regularly shown in private exhibits at the Union League Club—whose members included the Vanderbilts, Astors, and Morgans—the New York Athletic Club, and the Lotos Club, the artist had to walk the streets to sell the majority of his work. Fellow artists Frederick Ballard Williams and Charles Warren Eaton remembered Blakelock as the most energetic salesman among them.

We used to sit and wait for customers to come to us—and often we waited in vain—but Blakelock would take a canvas

out in the morning and say, loudly, that he wouldn't come back until he had sold it, and he never did. . . . He always made a sale. He would start with the art dealers on Fifth Avenue, if he didn't succeed there he would go over to Broadway or drift into the small shops on the East Side. He may have asked for $50 for a picture early in the morning, but as evening drew on he would sell for $10, $5 or anything.

Between the nickel-and-dime paintings and the larger, more important ones sold by Watrous, Blakelock managed to get by. At the end of 1894, though the depression still gripped the city, the Blakelocks moved out of Cora's mother's house in Brooklyn and took an apartment at 44 East 110th Street in Harlem. It was a perilous step, the beginning of a series of moves that would end in disaster.

The Blakelocks now lived a block from Central Park in a neighborhood that had been settled primarily by German immigrants with a smattering of Jewish Poles and Russians. In 1895, they moved a few blocks south to 106th Street, and again, in 1896, to 54 East 101st Street. In one of Cora's compressed accounts of this period, she wrote much later that Blakelock's mind became troubled soon after their move to Harlem. However, other letters and Blakelock's medical records, based on the information she gave to doctors at the time, indicate that it was two years, not just a few months, before Blakelock's mind once again gave way to serious delusions. Several letters from Watrous to Evans— one dated as late as December 15, 1896—imply that Blakelock was still producing impressive work and that Evans had purchased a number of his paintings at this time. There is no mention that Blakelock was experiencing any particular trouble, and the artist's own letter to Evans, dated May 19, 1896, betrays no obvious sign of instability. Likewise, several glowing reviews of Blakelock's work in a Lotos Club exhibition (a selection from Evans's collection), in November 1896, do not allude to Blakelock's previous brush with madness. The incident, then five years old, had largely been forgotten. Nevertheless, Blakelock's constant dislocation indicates that he was under considerable strain. One friend remarked, "Not all of us realized the depth of poverty under which he

labored. He wasn't a talkative or communicative man, and he hid his troubles under a lofty manner."

Cora and Blakelock's eighth child, Allen Osborne, was born on January 19, 1897. Blakelock rushed down to Watrous's studio to borrow fifty dollars. A few days later he returned for another fifty, explaining that there were a lot of expenses to be paid for with the new arrival in the family. The situation at home was dire, Blakelock's mental state, at best, fragile. Even so, he tried to keep up his spirits. When Watrous asked how many children he had, Blakelock responded lightly that he had always wanted "an octave," and now he had one. Marian, Blakelock's eldest daughter, described the family's attempts to deal with their poverty at home.

> The winter Allen was born there was an incident that I have never forgotten and it seems typical of our disposition to make the best of our circumstances enjoying and getting happiness out of the little we did have and if it were not for this trait I do not believe we could have survived the awfulness of our poverty. In this winter the fire went out because there wasn't any more fuel to keep it going, we were busily sifting the ashes and one of the little brothers, after getting a shovel full of coal exclaimed "Look, ain't we lucky?" . . . We all had a good laugh over our being so lucky, whether we cried or laughed, it made us feel better.

A few months after Allen was born, on Sunday, April 25, Blakelock's father died in East Orange. The tall, gaunt gentleman doctor had become a regular sight on the streets of East Orange. Though he and his son George were well-respected physicians, Dr. Blakelock Sr. had long been unable to practice because of his blindness, and he died a poor man. It was left to George Blakelock to look after things and take care of his father's funeral and burial. Blakelock wasn't there. Once again the death of a close family member precipitated a crisis in his life. It was with his father's death, Cora later wrote to her son Allen, that Blakelock, who had been teetering on the edge for some time, began

to act "queer" again. Though Blakelock "thought a great deal" of his
father, she wrote, he wouldn't go to the funeral or allow her or any of
the family to attend for fear that something would happen to them.
The loss of his father was more than Blakelock could handle. A short
time after Dr. Blakelock's death, Cora recalled, the family lost their
apartment. "Twice we were dispossessed," Cora wrote to Allen. "Once
when you were a baby . . . the few things belonging to us were put out
on the sidewalk and we had to wander around with the kids trying to
find a place to get into for the night."

The family may have stayed briefly at the YMCA, in Watrous's stu-
dio again, then ended up back in Harlem. Blakelock's mental health
deteriorated and his behavior became more bizarre. Cora wrote:

> I found again that his mind was unbalanced. We moved again
> and again. We would live but a short time in a place before it
> was known that there was something wrong [with him], and we
> would be requested to move. Still, as he was, I thought, harm-
> less and as he always retained his love for me and the children I
> didn't like the idea of having him taken away. At this time he
> had a very fantastic way of dressing. He had a beard and wore
> his hair very long. He made for himself all sorts of sashes and
> belts of old richly colored embroidery. To these he attached
> long strings of beads and trinkets of all sorts. He also carried an
> old dagger which he made no effort to conceal. Of course, he
> attracted a great deal of attention dressed this way and many
> people thought him a dangerous person, and were afraid of him.
> I am positive he would never use it . . .

Even in this deluded state Blakelock continued to work in Watrous's
studio and comb the streets for buyers, sometimes selling paintings
that he had completed years before. C. W. Kraushaar, an art dealer,
remembered meeting him in the street once.

> I was walking along under the uneasy impression that some-
> body was following me, and at length the feeling became so

strong that I turned. As I did so a small cadaverous man with his legs tied up in gunnysacks shouted. "Hulloa Kraushaar; Yes it's me! I thought you told me that you wanted to buy one of my pictures?" He held one hand behind him and waved at me violently with the other . . . but he talked rationally enough. "Why yes I do," replied I, "but you never brought me one." "Well here it is," said Blakelock bringing a picture from behind him. It was the scene, painted in 1868, of the northwest corner of Fifty-seventh street and Seventh avenue with squatters huts and stables. . . . I bought the picture off him in the street and he accompanied me to my store, where I paid over the money he asked for it. The amount was $45.

By 1898 the family's situation had become desperate. "We were so poor," Cora wrote, "and had such hard work to get along with so many little children . . . that I didn't think of anything else." Often Cora didn't know where the next meal for the children was going to come from. Blakelock's delusions, meanwhile, were spiraling out of control. At times he called himself Julius Caesar, and once he told Watrous that he was "the savior" and had been sent to "save his soul." When Watrous returned to his studio one day with the building superintendent, Blakelock attacked them with his dagger. Shortly afterward Blakelock was once again sent to the Flatbush asylum, but he did not stay there long. "I went to see him and they told me he could go home with me as he was all right," Cora wrote. "[But] going home he said so many queer things that I knew he was not all right."

Cora and the children rarely discussed their difficult final years in Harlem. "I hate to talk about it and I never do," Cora said. But it did seem to prey on her and she relented somewhat, writing Allen in the same letter that she might talk privately about these "things," but that she couldn't put it down on paper. The children's memories of the events are vague and scanty. Of all the children, only Carl and Marian were old enough to have developed a relationship with their father before he became sick. Carl recalled that his father had given him painting lessons when he was a child, and he seemed proud to have

once walked the streets with his father's paintings under his arm. In 1899 Carl was a thin, handsome man, twenty-two years old, working to support his mother and siblings. There were many things he would have remembered in detail, but he chose never to reveal them.

Marian, the most sophisticated of the children, also kept mum. She was close to her father, perhaps his favorite. She remembered him keeping her home from school one day so that he could paint her portrait, then later folding the portrait up and carrying it around in his pocket. She studied her father's work and, several years later, became an artist before she, too, suffered a breakdown. Ralph Melville, the third eldest, was also close to his father and, later, went to great lengths to try to wrest him from Mrs. Adams's control.

The other children were too young to remember much of their father. Ruth remembered him wandering about the house stashing paintings under the beds and eating hazelnuts. Douglas, the youngest, never knew his father at all. He refused to even discuss him. Indeed, several of Blakelock's surviving grandchildren recall their parents deliberately avoiding any mention of Blakelock's name.

What happened to the Blakelocks in the 1890s was painful and embarrassing. Cora tried to put a good light on things, emphasizing Blakelock's love and affection for his family, but it was clearly more complicated than that. Blakelock's dedication to his family was more than matched by his devotion to his art. Some family members, especially his sons, felt that he sacrificed his family's welfare to further his ambitions as an artist. Certainly, his two worlds, domestic and artistic, were often at odds with each other. Blakelock was often away in his Manhattan studio painting while Cora was left to deal as best she could with the children and the problems at home. Conversely, Cora took little interest in his career as an artist and said she never believed it would amount to anything. Meanwhile, Mr. Bailey, her father, was left paying the bills. During his first breakdown in 1891, Blakelock voiced resentment toward Cora and his father-in-law. In the late 1890s he became increasingly angry, abusive, and, at times, violent. He threatened his father-in-law and Carl—the two men who were working and contributing to the family income. It might be said of his

change in behavior that "it was the disease talking." No doubt it was. But there were painfully real conflicts at work as well.

In December 1898, after Blakelock's return from Flatbush, Cora conceived their last child. It would seem a peculiar time to have another child. But whether Cora had any choice in these matters at this point is doubtful. By her ninth month of the pregnancy, Blakelock's long battle against schizophrenia was drawing to a close. Completely under the sway of his delusions and depressions, Blakelock stalked about the house half naked, violent, and abusive. Penniless, he believed that he was a wealthy man. He had once painted the shanties of the homeless and the poor; now that he was one of them, he claimed to belong to the conservative and elitist clubs that had for so long shut him out. He had once crossed the Western plains and identified with the Indians, but now he believed he was related to the Rothschilds, or, at other times, that he was the Duke of York. He ranted about fantastical sums of money and thought his paintings were worth millions.

Blakelock's obsession with money, though a product of his schizophrenic delusions, came at a time when the nation was riveted by the same subject. Ever since the Civil War the true value of government printed money, known as "greenbacks," had been questioned and ridiculed. In the 1870s David Wells wrote *Robinson Crusoe's Money*, a satirical tale about an island where artists were employed to paint the material demands of its inhabitants (a new suit of clothes was simply painted on the client's body). In 1886, the trompe l'oeil artist William Harnett was arrested by the Secret Service for painting reproductions of U.S. bills. In the 1890s, at a time when the government's gold deficit was being supported by issuing bonds to the great banking families like the Rothschilds, the question of money and value, of the gold standard and silver coinage, became the central issue of the 1896 presidential campaign. Wells's book was reissued, other artists followed in Harnett's footsteps counterfeiting money on canvas, and newspaper cartoonists did a brilliant job of mocking the idea of value by decree. Upon a drawing of a Raggedy Ann doll, (reproduced in Lawrence Weschler's *Boggs: A Comedy of Values*), Thomas Nast wrote, "This is not a Rag Baby but a Real Baby by Act of Congress." Upon a drawing of a

cow, he made the surreal observation, "This is a Cow by the Act of the Artist."

In this context Blakelock's once joking reference to Watrous that one of his paintings was a "government bond" does not seem so outlandish or crazy. He would soon take that a step further not only by actually painting money, as other artists had already done, but also by trying to use it. On one side of small rectangular pieces of cloth he painted landscapes, and on the other side he wrote out the enormous denominations—as much as a million dollars—of the "bills." After years of churning out paintings to pay the rent, and years of watching collectors turning paintings into cash, in his mind, landscape, that onetime Holy Grail, had become another form of legal tender. After a lifelong battle against disease, against real and imagined obstacles, Blakelock the young, romantic painter, the mystic searcher, had become a kind of artist-alchemist. Like the Rothschilds or the Morgans he read about so frequently in the newspapers, Blakelock believed that he could turn a piece of paper into gold.

Years later, trying to explain to a visitor what had happened to him, Blakelock picked up a sheet of paper and calmly started to fold it into squares.

"I can divide this paper into equal angles and one of them will be inverted below the other. Anything that my mind conceives appears when it is executed, not as I have imagined it, but in an inverted and incorrect image of the idea with which I started." He stared at the two angles he had formed in a puzzled way. "I tried to make it come out right, but it can't be done. Life is like that. Anything I do affects my life in a strange way that I had not intended."

It has been written that Blakelock's third mental collapse was precipitated by a collector haggling over the price of a painting, that Blakelock came back to the house empty-handed, and that Cora, who was about to give birth, sent him back to accept the collector's final, niggardly offer. When Blakelock returned home the second time, the

story goes, he either tore or burned up the money. But that account is more than likely a journalist's imaginary reprise of the events of 1891. The medical reports forwarded from the Long Island State Hospital at King's Park to Middletown make no mention of it. They provide a more blunt, unromantic description of the event. "[He] had threatened to kill members of his family. Threatened to kill his son because he bought a new coat. Claims he is the Duke of York. That he supports the whole neighborhood. . . . He undresses himself and gets in a nude condition before his family. . . . He has been very ugly while at home."

Cora clung to the belief that he was harmless, that he was still, at heart, the gentle, idealistic man she had married, to the very end. "I was never afraid of him," Cora wrote a few years later. "But at last the doctors said it was unsafe to have him at home, that it was absolutely necessary to have him taken away. That date I can never forget, it was Sept. 12, 1899. On that day my youngest child was born."

21

MONEY AND MODERN ART

Shortly after Blakelock was taken away, his reputation began an ascent that would culminate in his return to New York City sixteen years later as the most celebrated artist in America. It was a singular time for Blakelock's artistic resurrection. On the one hand, radical American modernists of all stripes had discarded Victorian decorum and embraced self-expression, leaving the grim strictures of academia in the dust. Simultaneously, the traditionalists, ambushed by modernity, rushed to endorse the American avant-garde of yesteryear, principally the Tonalists such as Inness and Wyant and the visionaries Blakelock and Ryder, and claim them as one of their own. Thrown into this mix of forces was a mounting call for a national art, an art that uniquely expressed the American spirit.

In February 1900, only five months after Blakelock's institutionalization, his work was selected to be included in the American exhibit of art at the Universal Exposition of Paris. The fair, an international event of unprecedented dimensions, was an ideal occasion for America to show off its technological wizardry and its nascent cultural ambitions. The American art committee aimed to refute the long-prevalent notion that American artists were inferior to the French masters, that the

New York art scene was nothing more than, as the French commissioner Alfred Picard had once suggested, a "brilliant annex" to Paris. The jury, which included William Merritt Chase, Winslow Homer, and John La Farge, had a clear mandate from the president's commission to define an independent American school, a national art free of foreign influence. Consequently, the art of cosmopolitan expatriates like John Singer Sargent and James Whistler was minimized. In their stead, the "masculine," typically American scenes of Homer and Thomas Eakins and the spiritual, moody landscapes of the Tonalists were put at the forefront. "To such fearless and dominating personalities as the late George Inness, Homer Martin, A. H. Wyant and a score of others still living, we must look for the establishment of a National Art," the committee declared in the introduction to the catalogue. "These men sound a clear, strong note of originality; and their influence on the art of their country is pronounced and permanent."

Also included were American Impressionists and budding modernists such as Alfred Maurer, William Glackens, Childe Hassam, and Maxfield Parrish. Blakelock's landscape, untitled, exhibited in the American pavilion in the Grand Palais, was awarded an honorable mention, the first prize of his career.

That Blakelock had been selected for the exhibit and that his paintings were recognized as being particularly American was hardly surprising. His work had been included at an important international fair in New Orleans in 1884, the World's Columbian Exposition in Chicago in 1893, and in St. Louis in 1896. For quite some time Blakelock's work had been well known to influential critics and curators such as Charles Kurtz. In 1889 Kurtz, who later became the assistant director of the American art committee for the 1900 Paris exposition, favorably compared American "colorist" painters to the French masters. "There are now living in France very few painters who can equal the best landscape painters here," he boasted. Kurtz named Blakelock, Inness, Wyant, John Henry Twachtman, and Ryder as being among those American painters who had achieved a level equal to that of the French. Clearly, Kurtz's was a partisan opinion, but his aim was not a chauvinistic attempt to topple the French, whom he admired. The

bias against American art was so prevalent at the time that Kurtz was simply arguing for a place in American museums (particularly the Metropolitan Museum of Art in New York) for these great American painters. By the early 1900s, the ideas of critics like Kurtz had taken hold; the Tonalist/visionary painters, the realists, Homer and Eakins, and the expatriates, Sargent and Whistler, were regularly being paraded as America's masters. Critics and art historians quibbled as to their exact ranking, and the debate between the realist and expressive camps continued. But through it all Blakelock was increasingly recognized as an American original, one of the leading artists who had helped shape modern American landscape painting.

Charles H. Caffin, in his 1907 history *The Story of American Painting*, put Blakelock and Ryder in the same post-Barbizon camp as the leading Tonalists, while distinguishing them as "independents." "Simply as pictorial convention," Caffin wrote about Blakelock's paintings, "a symphony of color . . . intended to affect us in a purely abstract way, we shall find the best of them extraordinarily original and inspiring." Indeed, it was Blakelock's difference, his daring, idiosyncratic vision, his unusual, musical use of color, and his dark native subject matter, that made him such a compelling example of American art.

In December 1900, William T. Evans, who must be counted at this time as one of Blakelock's foremost patrons, loaned his collection of Blakelocks to an exhibition he organized at the Lotos Club in New York. It was Blakelock's first one-man show, and it precipitated a scramble among other collectors and dealers for his work.

The importance of Evans's support of Blakelock has been underestimated, if not entirely ignored. A common misconception about Blakelock's career is that his work was not collected prior to 1900. At best it's allowed that one or two paintings were bought by close friends and the odd collector. In fact, important collectors like Thomas Clarke, Benjamin Altman, Robert Graves, and George Hearn (it was his painting that went to Paris) had, early on, acquired several Blakelocks. Charles Schieren, the mayor of Brooklyn, bought at least eight Blakelocks, Lambert more than ten, and Evans, who began to collect Blakelock's work in 1887, eventually may have had more

Blakelocks (he had twenty-two in 1903) in his collection than he had of any other painter except George Inness.

In January 1900 Evans sold his entire collection for hundreds of thousands of dollars—a fact not lost on the newspapers—and soon after bought Inness's former Montclair estate and started to put together a new American collection. The new collection was almost entirely like the old one, composed largely of the Tonalists he favored (in some cases, it seems he rebought pictures he had sold), with the addition of a great deal more Blakelocks and American Impressionists like Childe Hassam, Theodore Robinson, and J. Alden Weir. Several years later, in 1907, Evans donated an initial gift of some fifty paintings, including several Blakelocks, from his collection to the National Gallery of Art, providing the foundation for, and in large part defining, the nation's first major collection of American art.

In the wake of Evans's Lotos Club exhibit, interest in Blakelock's work exploded. In 1902 Frederick S. Gibbs, a conscienceless New York politician, suddenly amassed seventy-six Blakelocks, published a catalogue of the paintings, and put them on exhibit, once again at the Lotos Club. After Gibbs's death less than two years later, the paintings were promptly sold—one for more than three thousand dollars. The Gibbs exhibit prompted *Pen & Brush* to write the first lengthy assessment of Blakelock's art and career, which became the boilerplate for future articles about the painter.

The article, written by Frederick W. Morton, part hype, part fluff, part critical analysis, described Blakelock's life as "one of the saddest romances of American art." Blakelock, Morton wrote, was a man of "genius who dreamed strange dreams and told them in remarkable color schemes till the thread of reason broke under the strain." Echoing the romantic treatment Blakelock had received in the *Collector* in 1891, the artist was described as a mystic naïf, a dreamer, a poet with a passion for music and art. Morton emphasized that Blakelock was self-taught and completely isolated from the artistic community.

> With no art training whatever, with no means with which to tide over the period during which he was to make his name as

a painter, with no friend to offer him guidance or lend him assistance, he settled in New York, opened a studio and from the outset posed as a professional artist.

Blakelock's life, Morton intoned, was one of constant hardship, and his paintings were "accorded only derision and neglect." Morton's research did not extend in any meaningful way into the events and trends of the early 1880s. He did not mention that Blakelock worked in the Tenth Street Studio and Sherwood buildings, that he was, in at least some respects, in the thick of the artistic ferment of the time. There was no discussion of the Barbizon school, the pitched critical battles over the expressive art of Blakelock and Ryder in the early 1880s, and the important early support Blakelock had received from progressive critics like Charles de Kay. Likewise, Morton missed Blakelock's critical success in 1886 and didn't explain how Blakelock's work came to be "ranked . . . with Inness, Wyant, and Homer Martin, the great trio of American landscapists." To delve into the nuances of Blakelock's career would only have muddied the waters of his overly romantic account.

Morton did describe Blakelock's process of painting, and he understood that Blakelock's intention was to portray a personal impression and not the minute details of a landscape. "For the recording of this expression little was needed . . . hence many of his best works are little more than a mere hint of a landscape," he wrote. But the full measure of Blakelock's radical ideas would have to be left to later critics to appreciate. Morton, without quite explaining it in critical terms, came to a conclusion others had voiced before him. Blakelock—despite his artistic flaws—was "a colorist second to none that America has produced." Moreover, he was an artist, Morton asserted, belonging to a different realm. "One cannot stand before a Blakelock canvas without in a sense stepping out of the commonplace, the tame, the prosaic, the conventional . . ." he wrote. "He stands quite alone among American artists as an original creative genius whose endowment was unusually artistic and whose sense of the beautiful was peculiarly acute."

With increased attention now poured on his work, some critics, like *Harper's* Annie Nathan Meyer, began to draw a distinction between Blakelock's dramatic, elegant moonlight crowd pleasers and his more radical, innovative work. She went against the grain in estimating Blakelock's expressive, "poetic" paintings (as opposed to the more theatrical works) as being more impressive than the work of Inness, at the time considered America's greatest landscape painter.

The art dealers, who, after 1902, rushed to handle Blakelock's work, made no such distinctions. Important dealers such as the Knoedler and Macbeth galleries in New York and the Vose Gallery in Boston were soon selling Blakelock's moonlights, Indian encampments, and forest interiors as fast as they could get their hands on one. In 1903 Macbeth, who would later put on the famous "Ashcan" exhibit, sold some seventeen Blakelocks. Many paintings that Blakelock had sold for less than fifty dollars were now selling for more than five hundred, and there were others that sold for close to a thousand dollars. "Few American artists deserve a higher niche in the Temple of Fame," Macbeth drooled. The Gibbs sale of more than thirty Blakelocks in 1904 yielded almost $10,000, with *The Pipe Dance* selling for $3,100. Blakelock's paintings, the *New York Evening Post* noted, were suddenly everywhere.

In 1903 Evans and others close to Blakelock (interestingly, George Inness Jr. was the largest contributor) raised a fund of several thousand dollars for Blakelock and his family. But this renewed flurry of interest in Blakelock, the man, died down soon after. By 1905 the painter had been for the most part forgotten. Few people knew he was in an asylum or even that he was still alive. Blakelock's art, however, continued to have a life of its own. Daingerfield reported that his moonlights and evening-glow paintings were greatly admired among artists and collectors. Almost ten years after the Gibbs sale, in 1913, in an auction of paintings from Evans's collection, the prices of Blakelock paintings eclipsed those of every other American painter. In the first session Blakelock's *Early Evening* sold for $1,200. In the second session Blakelock topped Homer, Inness, and Wyant when his *Moonlight*, bought by Senator W. A. Clark, sold at a record auction price of

$13,900. Three years later, Blakelock's *Brook by Moonlight*, the painting bought by Lambert in 1891, would set yet a higher record price when it came up for auction in the same Plaza Hotel ballroom.

By 1913, the year of the infamous Armory Show, the old conventions of painting had fallen to the wayside, and the growing force of modernism, in both its realistic and abstract guises, had taken hold. The American Impressionists had held independent exhibitions as far back as the 1890s. Meanwhile, a younger generation of painters, the realist, so-called Ashcan school—including the artists George Luks, John Sloan, and George Bellows—and the affiliated "Eight," including Arthur B. Davies and William Glackens, rebelled from the National Academy in 1907 under the leadership of Robert Henri. The Ashcan contingent brought gritty urban scenes to life in their canvases. Meanwhile, at Alfred Stieglitz's 291 Gallery (opened in 1905), the abstract modernists—Marsden Hartley, Arthur Dove, and Georgia O'Keeffe—were radically questioning rules of perception.

Though these young modernists had widely diverging styles, they shared a common, fundamentally personal approach to art. "Building on the attitudes implicit in Tonalism, American Impressionism . . . and such visionaries as Albert Pinkham Ryder, the artists of the new generation used art as a means of personal expression," writes Matthew Baigell in his recent history of American art. "Both groups sought ways of self-discovery . . . They wanted to probe and illuminate interior states of mind—that which is felt—along with the reality that lies behind appearances rather than to illustrate the externals of life." Not surprisingly, in their renewed search for the "spiritual reality" in art, these artists turned back to the transcendentalism of Emerson and Thoreau for guidance and to their own dreams and imaginations for inspiration. In this context, Blakelock's art looked ahead of its time and could not have been more relevant.

22

MIDDLETOWN AND CATSKILL

Blakelock was transferred to the Middletown State Hospital on June 25, 1901. He had left the Long Island State Hospital, accompanied by Dr. W. Farraud, early that morning and arrived at the depot in Middletown before noon. Horse-drawn wagons were still the only means of transportation from town to the asylum. It was a slow, uphill ride, and the sun was directly overhead. Blakelock, fifty-three years old, was wearing a loose white jacket, a vest, a stiff collar twice as wide as his neck, and a large tie. His hair was shortly cropped, his cheeks sunken and unshaven. His face was furrowed with a pinched, anxious expression, and his eyes were glazed and distracted, as if they were not seeing what was in front of them.

At the hospital, Blakelock was admitted and taken to be examined by Dr. Seldon Talcott, the director of Middletown. The medical clinic was stark and utilitarian. Bright bouquets of oblong electric bulbs hung from the ceilings. The tables, spindly-legged stools, and washbasin stands were constructed of wrought iron and glass. Blakelock was measured (5 feet, 5¾ inches), weighed (102 pounds, down from 127 pounds), photographed, and otherwise thoroughly examined. Dr. Talcott indicated that Blakelock was in good health and noted

his "principal mental symptom" as being "very voluble." Talcott was a product of the mid-nineteenth century, a homeopath who still wore a wide-lapel frock coat, kept his hair long, and maintained a groomed mustache and a long scraggly beard, as had Blakelock's father. He had no problem getting Blakelock to talk about himself.

Blakelock immediately launched into a manic spiel about his career and his connections with the Union League Club. "Says that he was taken to Long Island Hospital through [a] mistake and that he was very willing to work while there. While in Brooklyn he says he was sought after a great deal socially—had to stop work at one time because it was too hard for him, not that he was 'nervous' but simply 'tired.'"

On October 25, 1899, about a month after Blakelock was taken away from home, Cora had signed court papers certifying her husband as insane and committing him to the Long Island State Hospital in Flatbush. He was kept there for seventeen months before Cora had him transferred to the more bucolic and well-cared-for surroundings at Middletown. At the Long Island Hospital, Blakelock, it was observed, occasionally became "surly," "boastful," and "violent." Yet left to his own devices, the records indicate he was mostly "agreeable" and "quiet." At a time when he was receiving his first-ever one-man exhibits in New York, Blakelock spent most of his time picking vegetables on the hospital farm and reading books and newspapers.

At Middletown, Dr. Talcott diagnosed Blakelock with dementia praecox. At the time physicians still used skull calipers, photographs, and facial-expression charts to help them determine the category and cause of their patients' insanity. Medical understanding of mental illness at the turn of the century was rudimentary. The causes of insanity of newly admitted patients at Middletown included "disappointment in love," "domestic trouble," and "worry and overwork." At a minimum, causes such as masturbation and immorality had been eliminated. Phrenology was on the wane, and advances made by Freud in psychology and Darwin in biology were encouraging a more refined approach to a condition that soon would be viewed increasingly as a physical disease. As

it was, the majority of patients admitted to Middletown were listed simply as having a "predisposition" to insanity, or the cause was put down as "unascertained."

In Blakelock's case, Talcott had the medical reports first filed at Kings Hospital to aid with his diagnosis. He knew that Blakelock was often in an "exalted" state, that he had been abusive and violent at home. He knew Blakelock was still terribly deluded and paranoid. Talcott didn't know, however, quite what to do about Blakelock's illness. Middletown was a progressive hospital and Talcott a fairly enlightened man. He had introduced commonsense reforms to ease the stress of confinement on his patients. Social amusements, arts and crafts, and outdoor activities—there was an "Asylum" baseball team—were encouraged. He had an arsenal of homeopathic drugs at his disposal for every kind of symptom. Arsenicum 11 was prescribed for anxiety that caused fainting, and *Rhus toxicodendron* for phobias, such as the fear of fire. For symptoms like Blakelock's, Talcott prescribed belladonna—the best drug, he said, for manias, restlessness, and, among other things, the tendency to take off clothing. Judging from Blakelock's prescription sheet, Talcott tried a little bit of everything on Blakelock. But after thirty years as director of Middletown, Talcott must also have suspected that none of the drugs in his medicine chest was likely to cure Blakelock's condition.

At the end of the day, violent or unruly patients at Middletown were subject to some of the same experimental treatments being used by other asylums. At Middletown there were special wards where electrical stimulation, bed harnesses, thyroid gland extractions, and hydrotherapy were used to subdue patients. Talcott particularly believed in the salutary benefits of enforced rest, in which patients were tethered to their beds by a long-sleeved, padded waist. "When first placed in bed, the patient may, for a short time, be unusually restless, but after a few days, a marvelous calm steals over the senses," Talcott wrote.

Fortunately, during the first few days that Blakelock was at Middletown, he was well behaved. Perhaps he was distracted by his new and unfamiliar surroundings. He was often out walking, and according to

notes taken four days after his arrival, he was "very gentle." That quickly changed. By mid-July he was throwing temper tantrums, contradicting the doctors, and refusing to obey their orders. "[He] seems to want to convey the impression that there is absolutely nothing wrong with him, and resents any action which might show that he was not in good health." Blakelock sometimes confused his physician with Mr. Bailey, his father-in-law, or believed that the doctor was somehow related to Cora. His deepest desire seemed to return home to his family and his work. "[He] Declares it is not right to put him here and keep him in such a state of mind that he cannot work. Demands to be allowed to go home." As late as 1906 Blakelock was still subject to fits of rage and homesickness. "This morning was storming up and down the ward and cursing about being kept here like a pauper and demanding his money and tickets to go home. Everything said to him simply increased the torrent of abuse."

Blakelock blamed the physicians for his mental condition, accusing them of invading his home and putting cocaine in his eyes. It was, he said, "an outrage," as he had come here to stay two weeks and had been kept in the hospital like a lunatic. "You destroy my business and have done it for 25 years, through the woman I married. . . . You ought to be ashamed."

Blakelock was sometimes "sent to Ward 25" to calm down. As time went on his fits of anger became less frequent and were of shorter duration. The nurses noted that his morning fits were over "in a few minutes" and that he was then "quiet for the day." As early as 1902 and 1903, Blakelock was spending most of his time either outside wandering the nearby countryside and sketching, or in his room painting or making jewelry with whatever materials, if any, that were available. The attendants, not the most sophisticated judges of art, were sometimes impressed by his work, but they also noted that it was "very uneven, most of it being a degeneration of the extremist impressionisitic methods." At work, Blakelock was calm and relatively "normal." The doctors stated that "when one is able to turn the conversation away from himself and his delusions, which is quite

hard to do, he talks with considerable intelligence on art matters." (They were also surprised by Blakelock's medical knowledge, his ability, for instance, to correctly name all the facial muscles or describe his own medications.) He was often found playing the piano or quietly reading a newspaper.

There were times when Blakelock seemed aware of how ill and helpless he was. "Why is it that my head is hit this way and that way, until I am all confused? That is not right," he lamented. "I want to be sent home." Blakelock, though, was not sent home. And his confusion continued indefinitely. In the sixteen years he spent at Middletown, Blakelock was sometimes coherent, often deluded, and at other times not present at all. The doctors remarked on these "varying moods," noting that "some days [he] is pleasant and talkative, other days . . . insolent and insulting." His delusions about his financial worth, his social status, and his secretive relations with the government continued. He told the doctors that a duty was imposed on his paintings because of their resemblance to Barbizon and Impressionist art. When told of his election as an associate at the National Academy of Design in 1913, Blakelock said that he knew why he had been declared insane. "It was simply because they could not remove his paintings from the State of New York."

Cora and the children remained at Mrs. Bailey's house on Atlantic Avenue in Brooklyn after Blakelock had been taken away. In his absence the house seemed calm and quiet. Yet there was also a hollow feeling that lingered in the wake of Blakelock's long struggle and the retreat of his indestructible spirit. Cora and Marian fought to keep the family together, but the circumstances were as difficult as ever. Carl had fallen in love and would soon be married and have a family of his own to care for. Marian, nineteen, applied herself to her painting, but sold few of them. That left Cora with no source of income and several young children still to feed. She took in odd sewing jobs and otherwise barely got by with the help of friends and relatives.

In 1903, as Blakelock's work was again selling and in the news, Cora was visited one evening shortly after Christmas by Louis A. Lehmaier and Mr. and Mrs. Carlton Wiggins, influential art patrons who had heard of the Blakelocks' plight. Mr. Lehmaier and the Wigginses were rather embarrassed to find the family huddled about the fire with few belongings. They asked if Cora had any Blakelock paintings for sale, and she told them she had only one left, *The Big Tree*, which Lehmaier bought on the spot for six hundred dollars.

In the months that followed, Lehmaier, Wiggins, and William Evans started a fund for the Blakelocks, which raised at least two thousand dollars and, according to some sources, considerably more. The money was put into a trust, but it came too late to help in Cora's attempt to have Blakelock paroled from Middletown and brought home. The money did allow her to continue, once or twice a year, to visit Blakelock and provide him with occasional art supplies and new clothes and shoes. Mary, who had turned seventeen in 1903, went to see her father once on her own, but there is no indication whether the older boys visited their father. Blakelock clearly looked forward to seeing Cora and did all he could to induce her to come more often. A letter he wrote in September 1904 was fairly typical.

Dear Cora—

This is the day before the county fair day, and tomorrow I may be invited to visit the same as I have, for the three seasons in September, this being the fourth season of a proposed visit. I have some sketches in oil colors for you ready and all the material I have, given by you for your favor is laid out in picturesque fashion, of some degree of interest in it that I think will interest you. I would like you to call and see me at the hospital as soon as possible for the pictures; and not wait so long as you did last time an interim of seven months . . .

I have not been at home, in my household living rooms for a long time five years going on six and of course do not know of the many changes that might take place but however you may believe that I am devoted to your welfare and general prosper-

ity and await your coming so that I may hear from by your
presence by letter. Hoping that all are well at home. Carl E.,
Marian, (Claire) Ralph Melville, Mary, Louis, Ruthy, Allen,
babies and all.

I remain as ever with affectionate regard

Yours truly,

R. A. Blakelock

There is no mention of the possibility that Blakelock might be re-
leased in any of the letters at this time, and it is uncertain what, if
anything, ever came of Cora's request. The most obvious conclusion
is that Blakelock was still not well enough to come home.

In 1905 Cora used whatever money was left to move the children
into a respectable Victorian clapboard, Mower House, in Leeds, New
York, a few miles from Catskill. The town of Catskill, situated at the
confluence of Kaaterskill Creek and the Hudson River, had once been
a popular summer destination for the gilded set who came to enjoy
the romantic wilderness of the Catskill Mountains.

By the time Cora and her children moved into the area, the town
was a shadow of its former self. The wealthy had long since fled to
Saratoga and been supplanted by New York City's lower middle class,
who started to arrive when the railroad was built in the 1870s. They
came for the fresh air and nearby mountain hikes and stayed in inex-
pensive boardinghouses and cottages. Mower House was quite large,
by far the most comfortable home the children had ever lived in, situ-
ated on a rise with a view of the surrounding fields. The countryside,
Marian wrote in a letter to Vose, was beautiful and the family, on the
whole, better off in the country, where it was less expensive to live.
The younger children were doing quite well in the local schools.
Marian enjoyed her new surroundings. During the winter the children
tobogganed down the long hills, and in the summer, they learned how
to swim in the local streams. There is a later picture of Cora, leaning
back in the deep grass, her children—well dressed and looking as if
they had been brought up on fresh milk, honey, and warm bread—
lounging at her side, with their collie, Buster, nearby. Only the dis-

tracted expressions on their faces—just one child is looking at the camera and smiling—suggests the hardship they had experienced.

"Of course there are many wants still," Marian wrote. "The country folks are very much interested in our private affairs and as they don't know much about us they draw on their imagination and it is surprising what a fantastic lot we have learned about ourselves. We do not care much. It is rather amusing than otherwise, though sometimes we have a longing to lose ourselves in the city."

Marian was also frustrated by her career as an artist, which had come to an impasse almost as soon as it had begun. In 1903 two of the first paintings she sold turned up in a gallery with her father's signature. The case went to court and got into the press. Afterward, dealers didn't want to handle her paintings, which, they said, too closely resembled the work of her father and would only inspire further forgeries. "I have not sold a *single* picture since the time the name on my work was changed," she wrote to Vose in 1908. "Am I not checkmated every time I try to move?" The forgery incident was impossible for Marian to forget, and some of her letters to dealers took on an obsessive and aggrieved tone. Marian was a talented artist, but she didn't see what was wrong with painting like her father, and as long as she did, no one, not even Watrous, would touch one of her paintings.

After a few years, money was soon running low again. It was hard for the family to keep up with the school tuitions (ten dollars a term) and the twenty-cent daily carfare. An attempt to run a boardinghouse in 1910 ended in failure, and the family left Mower House for a much more spartan summer cottage on Kaaterskill Creek. Marian took outside work doing laundry, and she continued to help Cora take care of the children and complete the many chores around the house. The two were inseparable. But Marian was an intelligent and restless young woman, aching for a different kind of life. At times she would ramble like her father, and in the fall of 1915 she suffered a breakdown and was put into the Hudson River State Hospital. A letter written a short time later by Cora to the Chicago art dealer J. W. Young implies that Marian's illness was not as severe as her father's. "Marian's condition is about the same as it has been for the past two months," Cora wrote. "She is cheerful and

perfectly satisfied to remain where she is. She says nothing about coming home. . . . I am terribly lonesome without her."

It was about a year after Marian went away, in early March 1916, that Cora was surprised one day to find a stranger standing by the door of her secluded cottage. It wasn't often that she had visitors. The young man identified himself as a reporter for the New York daily newspaper the *World*. He was there, he told her, to talk about her husband. It was still winter in Catskill; the snow was thick on the ground and it was cold. Cora, who was fifty-nine years old and had just walked through the snow back from town carrying provisions, invited the reporter inside her small home.

Cora's house was situated at the bottom of a steep wooded ravine, close to the banks of Kaaterskill Creek and a little more than half a mile from the main road and trolley line into Catskill. Carl lived with his wife, Violet, and three children in a smaller cottage a hundred yards away.

Cora's house did not have electricity or heating. In the winter the fire had to be kept burning continuously, snow melted for drinking and washing, suppers made, and provisions walked in from town. Cora "declared she didn't mind the walking, nor even the cold in the little frame house," wrote the reporter. If Cora did mind, she didn't say so. She was used to making the best of what she had.

Her home was humble, a big step down from Mower House, but it was not, as some newspapers suggested, "a shack." The downstairs had a living room, a bedroom, and kitchen. Upstairs were two smaller bedrooms for the children. In the living room a threadbare Oriental rug covered the bare floor, and there were two rocking chairs, a small table, and an old divan.

On the mantelpiece, Cora had placed her few decorative objects, a small pitcher, a candlestick, and a painting or two. Among her remaining artworks, she kept several sketches that Blakelock completed at Middletown and a small painting of flowers that he made when he was just a boy. "I haven't had the heart to offer this for sale," she told the reporter. "It's all I have."

Cora had not had the money to visit her husband in three years. She was, however, aware of his growing reputation and the increasing value of his paintings. She had heard about the spectacular sale of his painting for $20,000 at the Catholina Lambert sale in February. It's unlikely, however, that she knew anything about the intention to create a Blakelock fund, or had heard of the Reinhardt Galleries exhibition— recent developments, which as of early March, had not yet been publicized. In any event, she jumped at the invitation by the *World* reporter to pay her way to New York City, and from there to visit Blakelock in Middletown, saying she would come the very next day.

On March 17 Cora went to Manhattan to meet Mrs. Adams. The two women could not have been more dissimilar. Though approaching sixty, Cora still had the tomboy exuberance and long hair—often slightly in disarray in photos—she had when she married Blakelock. But years of hardship had taken their toll. She was thin, her hair was completely white, her face was lined. Out of her element in the city, Cora appeared meek and simple in manner, wearing a plain white blouse and long dark skirt under her winter coat. The cocky, youthful Mrs. Van Rensselaer Adams, on the other hand, wore only the most fashionable clothes. Mrs. Adams was definitely in charge. It was she who had contacted the *World* and arranged for them to visit Mrs. Blakelock and pay her way.

Cora was impressed with Mrs. Adams's social connections, her brio, and her philanthropic credentials. She, of course, had no idea about the slippery events in Mrs. Adams's past. She appreciated what she thought were Mrs. Adams's efforts to help her family and, initially, expressed her gratitude publicly on several occasions. If she had any reservations about Mrs. Adams's brash personality, she kept them to herself. Mrs. Adams, for her part, was on her best behavior. She had a great deal at stake in the day's events, which she had carefully planned to attract support for the Blakelock Fund and which would soon appear in detail in a front-page article in the *World*.

The touching reunion between Cora and Blakelock at Middletown, put on for the benefit of the public, came off almost without a hitch. It was only in the confined space of Blakelock's room, when Mrs.

Adams directed Blakelock to show the group his latest work, that things got messy and the full intent of Adams's visit became clear.

> In the shoe drawer Blakelock rummaged for a little cardboard box containing his paints. Laughingly he apologized for the unpretentiousness of his "studio." Secreted in his dresser drawer he disclosed his paintings, the work of the last few months. The best of his work, done in oil on a cigar box cover, he said he could not give his wife because he had done it for "the committee," which proved to be comprised of the ward keeper, the doctor and one of the patients. Rather than cross him, Mrs. Blakelock accepted the sketches he was willing to turn over to her . . .

Mrs. Adams hovered nearby, supervising the transfer of this potentially valuable hoard (though much of it was done on scraps of wrapping paper, or bits of cardboard and cloth), which she had already arranged to have taken out of Cora's hands and appraised in New York. She was not happy about Blakelock's reluctance to part with some of the paintings, and she became insistent when he refused to sign one of his sketches. Blakelock said he couldn't sign any of his work while he was in the hospital. He did, however, sign a work as "A-1," standing for Albert the First. But this was not good enough for Mrs. Adams. She again asked him to sign his full name but, as Earl Harding, the *World* editor who accompanied the party, observed, "All of Mrs. Adams's persuasiveness could not induce the artist to sign his name to the sketch."

Mrs. Adams did not often take "no" for an answer, and in the future, she would repeatedly try to force Blakelock to paint and sign his work. But in the presence of Mrs. Blakelock and Mr. Harding, Adams had to restrain herself, mixing her frustration with flirtation and promise. In effect, the scene had the makings of a coy lovers' quarrel, for it ended in a draw. Blakelock promised "with apparent interest" to paint a special painting for Mrs. Adams and sign it "Blakelock," if she would give him an autograph of President Wilson in return (she had obviously mentioned her acquaintance with the president).

The remainder of the visit, as far as Mrs. Adams was concerned, was window dressing. Mr. and Mrs. Blakelock were trundled off to have a photograph taken of them. It's a stiff, formal portrait. They are sitting side by side. Blakelock is locked in a dignified pose while his wife, her head cocked in his direction—as if in response to the photographer's request—is trying to smile. Half their faces are hidden in shadow.

After the photo session Blakelock played Wagner on the piano and Dr. Ashley provided Harding with an upbeat appraisal of the patient's condition. Blakelock's illness had been arrested, he said, and his physical condition had improved. He was showing increasing interest in his work. Ashley implied that, with the proper support and environment, Blakelock might eventually resume his painting career. Mrs. Adams was less cautious. Blakelock, she said, might "yet produce his greatest work."

It is curious that while many other people were quoted in regard to Blakelock's "improving" condition, no such opinion was ever attributed to Mrs. Blakelock—the one person, of course, who would really know. It seems the man Cora saw at Middletown had not changed all that much. True, he was no longer violent and out of control. He had moments of clarity and intelligence. The new attention being focused on him had brightened his general outlook. But the visit must have underscored to Cora that her husband remained, in a fundamental way, unconnected to reality.

Elsewhere Cora wrote that she would gladly take Blakelock back home and look after his needs if adequate support was made available. She evidently did not believe he was capable of providing for the family with his art. The most Cora Blakelock hoped for was to stand by her husband's side when he was finally recognized for his achievements and, by being there, in some way help ensure a brighter future for their children.

VI

FAME AND MISFORTUNE

Art is cheap but priceless.
—Dave Hickey

THE REINHARDT
GALLERY EXHIBIT

On Tuesday morning, April 11, 1916, Blakelock, sixty-eight years old, wearing an expensive suit, beret, and glasses, stood on the corner of Thirty-fourth Street. On this same street, he had once painted in a makeshift studio on a vacant lot, and just down the block he had attended the spiritualist meetings at Dr. Newbrough's home. Now office buildings and department stores reeled upward, blocking the sun. Subways shook the ground beneath his feet. Automobiles and hobbie-skirt streetcars known as "Broadway battleships" jammed the streets. The sidewalk crowds threatened to trample any obstacle in their path. It was "a city verging on madness, unlike anything man has ever seen," wrote Henry Adams earlier in the century. "The cylinder has exploded and thrown great masses of stone and steam against the sky."

Riding up Fifth Avenue in a taxi, Blakelock was surprised to find expensive department stores, hotels, and mansions crowded shoulder to shoulder along this once sparsely settled avenue. The area was so altered that Blakelock said it reminded him of pictures he had seen of Paris boulevards. Within a few minutes the taxi had pulled up in front of the Woodstock Hotel on Forty-third Street. Blakelock entered the

lobby, where Beatrice Adams, Harry Watrous, and various reporters were waiting for him. Blakelock, spotting Watrous, crossed the lobby in a great hurry and threw his arms around his old friend.

A short while later Blakelock, still smiling like a child on his birthday, Watrous, and Adams entered the spacious Reinhardt Galleries on Fifth Avenue. The galleries had been cleared of all but a few of Blakelock's friends—and, of course, the journalists, who followed Blakelock throughout the day, observing his every word and gesture. "At the doorway the half dozen who were with the artist who had created all this forgotten beauty instinctively stood back while he slowly walked to the center of the room, where he stood speechless, as if dazed by the memory that crowded into his distracted mind," Smith wrote (adding gratuitously, one suspects, that Blakelock had tears in his eyes).

Blakelock spent an hour and a half at the gallery. With Dr. Ashley and Mrs. Adams at his side at all times, and a growing number of friends gathering around, he slowly reviewed his work. By all accounts, his memory of the individual paintings was remarkable.

> He remembered where and when he had painted them, the
> particular difficulties that he had solved in every canvas, the
> intricate problems of technique that a mass of autumn foliage
> or the glimmer of moonlight on water had caused.
>
> He recalled the men who had bought them of him, the
> collections in which they had been shown, the opinions of the
> critics who have left not even a name behind them.

In all there were forty-three paintings in the exhibit, which was curated by Elliott Daingerfield, Watrous, and the art publisher Frederic Fairchild Sherman. The earliest painting, *Indian Encampment on the James River, North Dakota*, dated back to the early 1870s and was the only canvas completed in his early, naturalistic phase of painting (*Indian Encampment Along the Snake River* was not exhibited). *The Indian Madonna, Hiawatha*, and *Story of the Buffalo Hunt* represented work from the early 1880s. The latter painting, once described by a critic as noth-

ing but a series of "rich pulpy colors," was in 1916 considered by *American Art News* to be the "most complete of the Indian pictures." There were many of Blakelock's harmoniously toned Indian encampments but, by and large, most of the paintings were the mysterious and emotionally laden landscapes, sunsets, and moonlights that Blakelock had completed in the 1890s. A number of the paintings were highly abstract and not the less praised for being so. Of course, the painting most everyone wanted to know what the artist thought of was *Brook by Moonlight,* which had recently been bought by the Toledo Museum for the record price of $20,000.

As Blakelock circled the room, more old friends and acquaintances were allowed into the galleries, and quite a knot of people had gathered about him by the time he reached the famous moonlight. Blakelock discussed technical aspects of the painting and, according to some of those present, allowed that it was one of his best works. "I have always been fond of that painting," he said. "It is quiet and companionable. It has harmony, and there is music in a good painting . . . It is good, very good." It appears, too, that Blakelock tossed off a more ambiguous response. "Well, I suppose it may be my masterpiece," Blakelock reportedly added, "but I have liked some others better."

In front of the other great moonlight, bought by former Senator William A. Clark in 1913, Dr. Ashley was overheard asking Blakelock if he could paint an identical picture. "'An artist can only paint just O-N-E,' he replied spelling out the 'o-n-e' to emphasize that a picture is a creation, not a reproduction." It was hardly the answer that Ashley and Adams were hoping for.

"You have inspired many young artists, Mr. Blakelock," another guest couldn't help gushing, "to find a new possibility in the subtleties of color and harmony. American art owes a great deal to you." Blakelock continued to study the painting in front of him. "You are mistaken, my friend," he said. "The artist is nothing, his art is everything." This was the kind of quote the *Tribune*'s reporter, Smith, loved to write up, if not invent.

There were other things being said at Reinhardt's that Smith and other journalists decided it was wiser to keep out of print. It was later

admitted that Blakelock said that a number of the paintings in the exhibit were fakes. And only one reporter noted the strange fact that neither Mrs. Blakelock nor the children were present. Blakelock was overheard "solicitously" asking for "Lady Blakelock." This was as much Cora's moment as his own, and it was a bitter disappointment not to share the triumph together. Adams had not, it seems, warned Blakelock that Cora would be absent, and he pointedly told her he was disappointed. Mrs. Adams, never at a loss for words, quickly explained to those listening, including an inquisitive reporter, that Mrs. Blakelock was in Brooklyn at the home of her mother. "It was not thought wise to risk too much excitement on his [Blakelock's] first day abroad." Then, before Blakelock could think too long on the matter, she whisked him out of the exhibit and on to a nonstop series of publicity events.

Blakelock was taken to Arnold Genthe, one of the country's top photographers, for a photo shoot. Genthe's pictures of Blakelock were formal, touched-up portraits, the kind usually taken of statesmen— indeed, Genthe had recently done Mrs. Woodrow Wilson's portrait. But another, less formal picture of Blakelock taken that day is more telling. It shows Blakelock on the street, one hand in his pocket, the other holding a cigar. There is a corny swagger to his stance; he looks the successful merchant, the immigrant who made good out on the town. The cuffs of his expensive Brooks Brothers suit hang too far over his wrists, the beret, sizes too large, dwarfs his head, giving him a slightly Chaplinesque quality. This looks more like the Blakelock that we know—the child of the streets, the lover of vaudeville, the diminutive champion of a hard-fought life.

Not that Blakelock was ready to take on a life of freedom in the public arena. After a banquet lunch at the Woodstock Hotel, as Dr. Ashley prepared to return to the asylum, Blakelock nervously quipped, "We must get back to Middletown some time this afternoon. You know," he told the others, "at Middletown we have one great quality, our staying power." Ashley reassured Blakelock, telling him the afternoon was his to do as he pleased, and left him in the guardianship of Adams and Dr. Moore.

Blakelock was taken to Knoedler, where another, smaller exhibit of his work was on view. He, however, was more interested in the Sorollas on a different wall, and at the Metropolitan Museum he left his own works to view the paintings of Diaz and Dupré. Smith then drove the small entourage up Riverside Drive and over to Grand Central Station to view the massive domed ceiling, all of which Blakelock immensely enjoyed. The day was not yet over. Cass Gilbert, the architect of the Woolworth Building—then the tallest in New York—had arranged a tour of Mr. Woolworth's private offices and a visit to the top. Blakelock, who was not fatigued, "dragged" his "exhausted" entourage into the subway and downtown to the Woolworth, "where two or three . . . weary friends plunged up and down in elevators in his company."

The grand tour finally ended at Erie Station. "Blakelock protested that he was not in the least tired for the tenth time, and insisted on shaking hands and telling his friends what a good time he had had and that he hoped to see them all very soon." To Mrs. Adams he gave a special gift, his handkerchief, on which was written his name and the hospital ward number, 17. "He gave her the handkerchief because he had no card, and he said he wanted Mrs. Adams to keep it as proof to his friends that he really had been to the city." Perhaps he was also thinking of his wife and children, who had been kept away from sharing his day of triumph, a day he watched evaporate as dusk enveloped the countryside on the two-hour train ride back to Middletown.

24

THE REAL MRS. ADAMS

Blakelock's visit to New York was a success. His behavior, demon-strating what was described as "a poise creditable to a sane man," enhanced the likelihood of a longer parole. The story, featured in doz-ens of newspapers around the country, increased Blakelock's fame and attracted larger numbers of visitors—among them European royalty and important contemporary American artists like Robert Henri and George Bellows—to the exhibit. If Mrs. Adams had one regret, it was that she had not brought Blakelock into New York sooner. The at-tendance during the opening week of the show had been somewhat disappointing, and by the time the public had been churned up by all the publicity surrounding Blakelock's visit, the exhibit was about to close. Five days later, on April 16, the final day of the Reinhardt exhibit, the gallery announced that 2,518 people had paid a dollar each to see the Blakelocks.

Fortunately, that was only the tip of the iceberg. Amid a growing clamor to extend the New York show, Chicago, Boston, San Francisco, and other cities around the nation began to organize their own Blakelock exhibits. In addition to the entrance fees, several thousand dollars was raised from the sale of Blakelock paintings at the Reinhardt and

Knoedler exhibits and the contributions of wealthy private individuals. Yet another exhibit in New York that April at the Macbeth Gallery included a large block of Blakelock paintings.

> If we needed proof that the already established American school of painting could hold its own against the invasion of the "new art," we should find it in the present exhibition of American pictures at the Macbeth Galleries. . . . Blakelock is here . . . as he is everywhere this month of his great revival. He shows on one hand blazing sunsets, and on the other cool, pearly gray green landscapes . . . He is practically alone in the nervous sharpness and vibration of his touch . . . one that snaps and sparkles as if charged by electric current.

Reviews like this helped drive up the price of Blakelocks being sold at auction, and a portion of the proceeds was often being promised to Mrs. Adams's fund. On April 18, for instance, John McCormack, a well-known Irish opera singer, paid four thousand dollars for a Blakelock landscape, seven hundred dollars of which was donated to the fund. Meanwhile, in Chicago, the J. W. Young Gallery exhibit of twenty Blakelock paintings due to open on April 27 was being cranked up into a major event. Mrs. Blakelock had been invited to attend, and the Chicago papers urged its citizens not to be surpassed by New York's generosity. The day before the Young opening, on April 26, Blakelock was finally elected a full academician of the National Academy of Design. His election to the academy and the unrivaled success of the shows that spring marked the high point of his career. It was a triumphant two months, a time when Blakelock's important contribution to American art was finally acknowledged and celebrated.

Just how much money Mrs. Adams eventually raised for Blakelock is uncertain. Robert C. Vose estimated that the fund amounted to more than $35,000. At a time when twenty dollars was sufficient to buy a silk-lined suit, $1,200 was the annual rent on a new, luxurious four-bedroom apartment, and $4,000 bought a country house, any sum close to that amount would have comfortably provided for Blakelock

and his family for many years. As it was, additional funds amounting to thousands of dollars a month were being donated, and it was essential that Adams quickly organize the Blakelock Fund to her liking.

At the Biltmore Hotel meeting on April 3, Adams had announced a plan for the organization of the Blakelock Fund. The Astor Trust Company volunteered to act as custodians of the fund, and a former assistant district attorney, William H. Edwards, had offered to draw up the necessary papers. Robinson, director of the Metropolitan Museum of Art, was on hand to lend support, and John Agar, a prominent New York lawyer and president of the National Arts Club, had also agreed to help. Honorary committee members included J. Carroll Beckwith, the Impressionist painter and academy president J. Alden Weir, Daniel C. French, the sculptor of the Lincoln Monument in Washington, the art dealer Roland F. Knoedler, Earl Harding of the *World*, and a number of prominent New York patrons of the arts. The money raised, Adams assured everyone, was to be used to aid Blakelock and his wife and children. It appeared to be legitimate and backed by all the right people.

The day after Blakelock visited the Reinhardt exhibit, Mrs. Adams finally invited Cora and her two youngest children, Douglas and Ruth, to view the exhibit. Hundreds of people were in the gallery, and Adams had arranged for journalists to be present to record Mrs. Blakelock's reaction. Cora was, understandably, overwhelmed by all this sudden attention. Though she had been unfairly kept away the day before, she had little but gratitude to express toward Mrs. Adams. "I saw too much of the poverty and suffering in which all this was created, to realize, until now, how much beauty my poor husband conceived," she said. "Truly, I am grateful for all that is being done." That afternoon Adams rushed Cora over to meet Agar and other members of the Blakelock committee to explain that the fund was being set up for the benefit of the Blakelock family. Some kind of legal documents, Adams mentioned, would be sent to Cora for her to sign in a few weeks' time. Days later, Cora was off to Chicago—all expenses paid—to attend the opening of the Blakelock exhibition at the Young Galleries. Young had published an expensive catalogue complete with letters and a senti-

mental foreword written by Cora and the children. There were photographs of Marian and Douglas. Cora was treated like a queen, and the show was universally praised. On her way back to New York by train, she might have believed, justifiably, that the family's financial problems were finally behind them and that the future was bright.

On May 19 Mrs. Adams officially incorporated the fund, with Agar as president, George F. Kunz as treasurer, and herself as secretary. In practical terms, however, neither Agar nor Kunz had the time or the inclination to oversee the actual day-to-day running of the fund, which was entirely left up to Adams. She took an office on Liberty Street— apparently "donated" by the lawyer William Edwards—hired a full-time secretary, and ordered stationery printed with the names of all the honorary committee members from various cities around the country. On July 8, Adams and Agar were quietly appointed by the New York courts as joint custodial committee for Blakelock, thereby securing Adams's complete legal guardianship over Blakelock's personal and financial affairs. By late August Mrs. Adams had arranged for a spacious private studio and residence—complete with a grand piano—to be prepared for Blakelock in a private clinic called Lynwood Lodge, near West Englewood, New Jersey.

On August 30, Adams wrote to Cora suggesting that she find a suitable house to live in. Adams promised to pay the rent, purchase any furniture needed to make the house a "comfortable abode," and provide a weekly allowance for other necessities. She also announced that "it has been decided to place Mr. Blakelock in a private sanitarium . . . where he may have special care and attention." She did not say where the sanitarium was and just when Blakelock was to be moved.

Appreciating your reluctance to assume care of Mr. Blakelock at this time and the fact that for seventeen years he has been, with few exceptions out of touch with his family, it has been decided to make this arrangement for the winter. By Spring he may be so improved that you could feel a home could be provided for you together; he having an attendant . . . I trust

you will give my suggestion your consideration and let me
hear from you soon, what you decide to do . . .

> I am sincerely yours,
> Mrs. Van Rensselaer Adams

Without waiting to hear back from Cora, Adams, armed with a
court writ on September 5, removed Blakelock from Middletown and
placed him in his new accommodations at Lynwood. Dr. Ashley, in a
curt one-sentence note, informed Cora that Blakelock had been
taken by Mrs. Adams to an undisclosed location in New Jersey.

Up to this point Mrs. Adams appears to have acted with complete
authority and confidence. Though the Blakelock family would soon
call her bluff, and some art periodicals had objected to the egregious
exploitation of Blakelock's condition, not a single person of authority
questioned Adams's "philanthropy" or credentials. No one, it seemed,
realized who Mrs. Adams actually was, and her shady history would
not be uncovered for many years.

Largely through the research of the art historian Dorinda Evans, it
was later discovered that Adams was not at all who she represented
herself to be. To begin with, her name—Beatrice Van Rensselaer
Adams—was mostly a fabrication. She was born in the small Hudson
River Valley town of Fishkill, New York, in 1884, and her maiden name
was Sadie Filbert. Fishkill had a small river-fishing industry and was a
stopover for steamers traveling up and down the Hudson. Sadie's
mother was a housekeeper for one of the more affluent families in the
area. From an early age, Sadie saw firsthand the kind of life she was
missing and was determined not to follow in her mother's footsteps.
Fishkill didn't hold her for long. At age sixteen, with only a few years
of home tutoring to her credit, Sadie moved to New York with her
older sister, Katie. Two years later, she landed a husband.

One of the names her husband went by was Louis Adams. Sadie told
her friends he was a millionaire from Chicago. He was "a tall, fair, well-
dressed man" with a "cool and collected demeanor." Mr. Adams's cool-
ness came in handy in his profession, as he was a swindler and occasional

speculative investor. One of his favorite ploys was to offer young women a promising position with an important firm in exchange for a down payment or fee, then make off with the money. On several occasions he took these women for a ride in his car, then drugged and robbed them. He may have met the young and unemployed Sadie that way, but she, evidently, had outwitted him.

For several years Mr. Adams got away with his scam, traveling about the country with Sadie and their two children in tow. Then, in 1906, he was caught in Chicago and charged with swindling Carrie Chapman out of a thousand dollars. He was arrested under the name George Wallace and charged with larceny. Wallace, alias Adams, posted bail and fled the state.

The Adams family returned to Sadie's hometown of Fishkill and hid out in a local boardinghouse. Mr. Adams went on occasional "business trips" to New York City and New Jersey. In October 1906, however, the police—tipped off by the Adamses' Hungarian nurse—came to the boardinghouse to arrest Mr. Adams, first name now Benjamin, for having lured Eleanor Wood of Montclair, New Jersey, into his car and robbing her of one hundred dollars. Mr. Adams told the police that he was a publisher from Kansas City, but the authorities confirmed that he was the man known as George Wallace, also wanted in Chicago. When he was handed a court summary of the charges against him, Adams looked up from the dime novel he was reading and remarked, "I have nothing to say. I don't know anything about the occurrences mentioned." The "young and pretty" Mrs. Adams showed up briefly at her husband's jail cell to say good-bye. He gave her most of the cash he had left in his pocket, amounting to forty-five dollars, and she left.

In the spring of 1907 Mrs. Adams, only twenty-three at the time, left her two children in an orphanage in Albany and went to Chicago to seek help from her husband's former business associates, among them Harold F. McCormick, an executive of International Harvester, and Henry P. Crowell of the Quaker Oats Company. McCormick and Crowell at first considered Mrs. Adams "a sad and touching" case. They advanced her money on her husband's small share of a mining investment and suggested she train to be a nurse. By this time, though,

her daughter had died of diphtheria in the orphanage, and Mrs. Adams soon returned to collect her son, Van Rensselaer. Not long afterward, she abandoned her medical training. Nursing was clearly not her line of work. By 1909 she was back in New York City with a new name, Beatrice Van Rensselaer Adams.

Crowell, who knew about Mrs. Adams's husband and was wary of her character, thought that Mrs. Adams would never be able to land a responsible job. But Mrs. Adams had her own ways with older, wealthy men, and eventually she secured a paid position as a fund-raising secretary for the endowment association office in New York of Lincoln Memorial University. The university, which was in Cumberland Gap, Tennessee, provided an education for poor women and children.

Mrs. Adams was a devoted and persistent letter writer who was adept at luring influential people to sit on her board. Though there are no university records indicating Adams's affiliation with the university—nor is it known how much money she actually raised and sent to the university—within a few years she had broadened her cause to raising money for all southern educational institutions in need of assistance.

Mrs. Adams scored her biggest coup in 1914. In an effort to be appointed a representative to the National Child Labor Committee Annual Conference in New Orleans, she began a relentless letter-writing campaign to President Wilson and officials in his administration. When, on the eve of the event, the president had yet to select his representative, Mrs. Adams took a train down to Washington and announced that she would be going to New Orleans at her own expense. The day before the conference was to end, the administration finally capitulated and wrote a letter appointing her as the president's representative to the conference. In the future Mrs. Adams would trumpet her role as a representative of the president of the United States, though, in fact, she never even attended the conference in New Orleans.

About this time Mrs. Adams's interest in her southern causes fizzled. In the summer of 1915, while visiting a friend in Catskill, she heard about Mrs. Blakelock and the children, who were by then living

in the house by Kaaterskill Creek. After the sale of Blakelock's moonlight in February 1916, Mrs. Adams made her first trip up to Middletown and, six months later, she had the country's most valuable painter secluded in a studio to which only she had free access.

Blakelock's ten-day stay at Lynwood Lodge in New Jersey almost spelled complete disaster for Mrs. Adams and her plans for the artist. It began well enough with Blakelock's arrival by train in Paterson, New Jersey, on the afternoon of September 5. Once again, Mrs. Adams had alerted the press, which covered the event in full detail. And once again Dr. Ashley found time in his schedule to personally accompany Blakelock on a long, tedious train ride. Indeed, it seems that Ashley, who was fond of sharp suits and powerful cars, was as adept at public relations as he was an able and stern administrator. He published almost no scholarly work during the twenty years he was superintendent of Middletown. Instead, he spent much of his time traveling to various conferences and politicking in Albany.

He never missed a Blakelock event. He seemed genuinely fond of the painter, but his cavalier treatment of Mrs. Blakelock casts some doubt on his motivation and judgment. From the beginning he had taken quickly to Mrs. Adams's plans and made several trips to New York to promote the Blakelock Fund. Ashley never hesitated to allow reporters to interview Blakelock, and he readily answered their questions about the artist's mental health and his suitability for parole. The doctor chose his words carefully, but his support of Blakelock's parole was never in doubt. "Blakelock is insane," he initially warned at the Biltmore meeting in April. "He probably will never be a normal man." But then he went on, "I do not say that he will not be able to enjoy himself, and he may be able to do excellent work . . . Put him in his natural environment and I think he will accomplish something."

By the time of Blakelock's visit to New York, Ashley's tone had become more strident. "Call that man insane, in the sense that the world regards insanity!" Ashley exclaimed to a reporter at the Reinhardt exhibit. "It is absurd. Blakelock is not normal, but to say that he should

be confined to an institution for his own good or for the good of society is worse than senseless, it is brutal . . . Today's experiences apparently have done Blakelock immeasurable good. They have stimulated appreciation and ambition. They have verified all that I have said, and more, as to the promise of his 'coming back' if funds are provided for his care." More and more, Ashley's comments would echo Mrs. Adams's own words. She had him under her spell.

Later, Ashley would dispute some of the opinions attributed to him in the newspapers, which were, undoubtedly, prone to exaggeration. He could not deny, however, that he had released Blakelock into Mrs. Adams's care long after it became obvious that she was not protecting but abusing Blakelock. The first release was, legally, a six-month probationary parole, but in the end, Blakelock remained in Adams's care for more than two years. Ashley, having received kudos for the progress shown by his famous patient, displayed little interest in ever taking Blakelock back. Nor did he show the slightest concern for Blakelock or his family during the fiasco that ensued almost immediately upon Blakelock's move to Lynwood Lodge. Ashley, it seems, was at the time preoccupied with buying a new, larger, more powerful automobile. He settled on an eight-passenger, eight-cylinder Cadillac, one of the most expensive cars of its time, and the only one for the moment in the entire county. Unless Ashley had undisclosed perks, which was unlikely at a state-funded hospital, it is not at all clear how he could afford such an expensive and luxurious automobile on his small annual salary.

Mrs. Adams, meanwhile, had spent a considerable sum on Blakelock's accommodations at Lynwood Lodge, a private sanitarium run by Dr. Andrew L. Nelden. His bedroom was furnished with a mahogany dresser, a velvet-upholstered divan, bookshelves, and reproductions of Corot, Millet, and Rembrandt on the walls. Blakelock's studio was a converted bungalow situated in the garden surrounded by Lombardy poplars and fruit trees. It was a large, long room lit by a ceiling skylight and wide windows with views of the surrounding countryside. A baby grand piano had been placed in one corner of the room, while an easel complete with tubes of paint, brushes, and a clean stretched canvas had

been placed front and center. On his arrival, photographs were taken of Blakelock standing in front of the blank canvas that Mrs. Adams hoped would soon be transformed into a valuable masterpiece. Mrs. Adams then asked Blakelock to play the piano for the assembled guests and journalists.

Blakelock was described in the reports as enthusiastic, grateful, and well mannered, much the same as he had been the previous April. In public, he managed to keep his delusions under reasonable control. However, except for one transparently invented passage, neither the *New York Times*, the *World*, nor the *Tribune* bothered to quote anything he said, which in fact often dissolved into a kind of free-association chatter.

> He would launch into a critical analysis of a picture, an analy-
> sis that would be brilliant and vivid until perhaps in the
> middle of a sentence his power of concentration would fail
> him, he would suddenly lose the thought he was trying to
> express. In a moment, however, a new thought would come to
> his mind and he would talk volubly until the same trouble
> would recur again.

By and large, the journalists seemed in agreement with Dr. Ashley that Blakelock, though muddled and often incoherent, was, in Ashley's new phrase, "artistically sane." They put forward the view, espoused by both Ashley and Adams, that in the idyllic setting of Lynwood, he would again paint, if not masterpieces, then, at the least, important works.

Blakelock had, in fact, spent much of the spring and summer at Middletown quietly painting. Many of the works he did at this time—such as *Landscape 1916*—are small, colorful, suggestive landscapes done on cigar box lids and art board. The degree of naturalism employed in these paintings varies tremendously. Some are literal and illustrative, others mimic the pointillist, impressionistic feeling of Maurice Prendergast, while still others have the warped forms of Thomas Hart Benton. They are all brighter and show little of the melancholy mood

so prevalent in his earlier work. Freed of commercial constraints, the work Blakelock did at the hospital feels, at times, livelier and more approachable than the somber canvases of the 1890s.While not appreciated at the time, many of his Middletown landscapes deserve to be counted among his most interesting work. They show a remarkably adept application of paint to suggest with just a few strokes of his brush the slight trunk of a birch tree, the canopy of foliage, the splattered light of the setting sun. For years, Blakelock had been working on a tiny scale and had mastered the ability to set forth the details of fairly broad landscape in the space of a few square inches, all the while maintaining the dash and spontaneity associated with an impressionist style.

It was in the same manner that Blakelock completed about this time a naive painting of himself and Mrs. Adams, standing gallantly hand in hand on a patio under the moonlight. Mrs. Adams said that he made this painting for her in appreciation of her efforts to help him. Clearly, he was still thoroughly taken with her. A photograph at Lynwood, likewise, shows them standing only inches apart, implying that they were an inseparable team defiantly facing the world, if not indeed a romantic couple.

At Middletown, following his visit to New York, Blakelock had begun to receive letters and inquiries from art dealers, newfound "friends," and acquaintances. His fame had, in just a few months, spread across the country (on August 6, for example, thousands of people lined up to see the unveiling of a new Blakelock painting at the Golden Gate Park Memorial Museum in San Francisco). While some of this attention was heartfelt and well meaning, Blakelock would soon find himself caught up in a web of intrigue and machinations over which he had little control. After the Chicago show—also a great success—Young sent Blakelock a letter and a number of photographs of paintings for Blakelock to authenticate. Young asserted that his gallery was raising money for the Blakelock Fund, but his main concern was deciphering the many Blakelock forgeries that were suddenly flooding

the market. Likewise, when William T. Cresmer, a Chicago art col-
lector, visited Blakelock at the hospital in August, he arrived with a
photograph of a Blakelock painting from Knoedler that he wanted the
artist to verify as his own. Cresmer got even more than he bargained
for. Blakelock authenticated the painting, then gave Cresmer one of
his $1,000,000 painted bills and, in addition, an autographed photo-
graph of himself.

Mrs. Anna Clarence Siegel also visited Blakelock at Middletown
around this time and struck up a friendly correspondence with him.
Judging from her letters, she was not an art collector and did not ap-
pear to have an ulterior motive. She was the first to try to obtain per-
mission to visit Blakelock at Lynwood and among the first to run up
against Mrs. Adams's formidable, if at first polite, line of defense. "I
regret it will not be possible to grant your request to see Mr. Blakelock
at this time," Mrs. Adams wrote Siegel on September 7. "There are a
few really old friends and associates who have made the same request,
but for the present it has been decided to protect Mr. Blakelock from
too much excitement. Personally I think Mr. Blakelock's family have
the first claim to his attention in his greater freedom and it is desir-
able that they should be the first to see him . . ."

In fact, Mrs. Adams, after gaining publicity and approbation from
the press, did not want Blakelock's family or anybody else to visit
him at Lynwood Lodge. She became particularly incensed at Mrs.
Siegel who, perhaps sensing that something was amiss, made inquir-
ies about Mrs. Adams. "I am at a loss to understand why you should
assume to call at the offices of the Blakelock Fund and demand of
anyone there that they give you personal information concerning
me," Adams wrote Siegel the next day. "You called up Lynwood
Lodge one night about two weeks ago and made some statements
that are inexplicable, in view of the fact that you are a total stranger
to me. I talked to you there. I know what the conversation was, al-
though you did not know to whom you were talking." Mrs. Adams
was referring to a conversation that, if it was not a figment of her
increasingly manic imagination, took place *before* Blakelock had even

arrived at Lynwood. That meant that Siegel was aware of the move beforehand and already had some reasons to suspect Mrs. Adams. Siegel's inquiries, however, got her nowhere. Adams simply impugned that Siegel was not really a "friend" of Blakelock's—just another opportunist—and shut her out, stating that "at present it is necessary to protect him from the public."

25

A BATTLE OF
HIDE-AND-SEEK

In early September 1916, after having received Mrs. Adams's letter promising generous financial support, Cora went about searching for an appropriate house for herself and her children. She assumed that her husband would soon rejoin the family as well. Although it had already been five months since the Reinhardt and Young exhibitions, and she had yet to see a cent from the Blakelock Fund, at this point Cora had little reason to suspect Mrs. Adams of foul play.

After all, it wasn't just Mrs. Adams who was involved in establishing the Blakelock Fund. This was a major public endeavor involving some of the most prestigious individuals and institutions in the country. In one way or another, the Metropolitan Museum, the National Academy, the Astor Trust Company, the *World*, John Agar—a member of the board of a dozen important institutions and president of the National Arts Club—some of the country's most prestigious artists and galleries, and so on—even the president's name had come up—were associated with or had helped promote the Blakelock exhibitions and the fund. Every step along the way, Mrs. Adams and the fund had been endorsed and praised in newspapers across the country. With all the publicity surrounding Blakelock exhibitions, his important works con-

tinued to sell for thousands of dollars, and Cora was besieged by requests to authenticate still other Blakelocks, which dealers hoped to sell for thousands more. Money appeared to be pouring in to the Blakelock Fund. It was almost a foregone conclusion that Cora and the children would, with wise investments, be living in considerable comfort for the foreseeable future.

It took several months for all this heady euphoria to wear off. When, by late September, Adams had not fulfilled her promise to provide money for a house nor responded to a letter from Cora asking about her husband, Cora was as bewildered as she was angry. It was hard to believe that Mrs. Adams had duped *everybody*, that the fund was actually some kind of hoax, and that Cora had somehow lost any say about her husband's future.

After she had sent her first letter, Cora waited in vain for a response from Mrs. Adams. Then, a week later, she sent Carl down to see Blakelock at Lynwood Lodge. Carl, a lanky man, sweet-tempered and quiet, hardly knew what he was getting into. Taking a day off from his work painting cars, he went to Lynwood on Friday, September 15. On his arrival at the clinic Dr. Nelden told Carl he wouldn't be able to see his father without Mrs. Adams's prior permission. Carl called Adams on the phone. Adams, uncharacteristically, was caught off guard by his call. She was used to dealing with the aging and hitherto docile Mrs. Blakelock, someone she felt she could easily manipulate. Carl was a thirty-nine-year-old father of three. He may not have been terribly sophisticated or verbose, but he was not, she would find, easily put off. Adams made an appointment to meet Carl in the city later that day, but she never showed up. She thought Carl would simply give up and go back home. When he called her back a second time, she was audibly rattled. Mumbling excuses as to why she had not been able to make the first appointment, Adams said she would meet Carl someplace else at a different time. As soon as she hung up the phone, Adams did something totally unexpected—she panicked. Nothing else can explain the drastic action she subsequently took.

While Carl went off to their designated meeting place, Adams got hold of a car, drove out to Lynwood, and told Blakelock to quickly pack

his bags for a trip to the city. Adams abruptly explained to Dr. Nelden that Blakelock had expressed a desire to meet his other guardian—Mr. Agar—and that she was taking him to New York for a short visit. In truth, she feared the jig was up. Carl would reclaim Blakelock and she would be left with nothing or, worse, exposed as an imposter. She had hardly packed Blakelock out the back door when Carl, having given up on their second appointment, arrived at Lynwood determined finally to see his father. Dr. Nelden told Carl that Mrs. Adams had just taken Blakelock away, but he would not say where.

The next day, the first of a series of ever more sensational stories appeared in the newspapers about the incident, or some variation on it. The *Tribune* headline read: "Guardian Fears Plot to Confine Blakelock—Mrs. Adams Tells of Conspiracy to Put Him in Asylum." Mrs. Adams's masterful spin on Blakelock's sudden departure from the idyllic setting of Lynwood was that unnamed "enemies" were planning to have Blakelock reconfined "to a state institution in New Jersey." On Sunday, more details were forthcoming. "Blakelock in City," the *New York Times* declared, "to Escape his 'Foes.'" Those "foes" Mrs. Adams now identified as a conspiracy of shady art dealers and art forgers. "Those among the art dealers who have spurious Blakelocks to sell are greatly concerned over his freedom," she told the *Times*. "With Mr. Blakelock going about the country certifying those paintings which are bona fide, it has become exceedingly difficult for the dishonest dealers to dispose of their fakes. I am not ready just now to state just who are behind the movement to embarrass me in my attempt to keep Mr. Blakelock free, but it would seem they are being aided from a quarter where one would least expect it."

Outrageous as it was, Adams was suggesting that the Blakelock family might be linked, however unwittingly, to a "plot" by nefarious art dealers to send Blakelock back to the asylum. "Mrs. Adams told of one dealer who had . . . for no apparent reason other than gain taken a great interest in Mr. Blakelock and his family. She seemed to regard it as significant that Carl Blakelock, the artist's . . . son, should have tried to visit his father on Friday last for the first time in nearly eighteen years."

Mrs. Adams's story did not go completely unchallenged. Some reporters had contacted Dr. Nelden. He said he knew nothing about any plots and added that Mrs. Adams had told him only that she was taking Blakelock into New York to meet Mr. Agar. Dr. Nelden was apparently having second thoughts about Mrs. Adams and even insinuated that Blakelock's sudden, unsupervised departure from the clinic was not entirely appropriate or legal without his consent. Carl told the *Evening Journal* his father was being exploited, and Mrs. Adams further confused the issue by first telling some newspapers that she had brought Blakelock to New York merely to do some shopping. Questioned by the *Times* on these various inconsistencies, however, Mrs. Adams remained staunchly on the offensive. "Dr. Nelden takes himself too seriously," she said. "He was merely a landlord for Mr. Blakelock, who never received treatment of any sort while at the sanitarium. In letters which passed between Dr. Nelden and myself it was explicitly agreed that Mr. Blakelock's stay at Lynwood Lodge was indefinite, thus giving him power to leave when he chose." Adams then, like a good politician, switched the subject to the "vigorous campaign" that she said would be waged against dealers who were selling imitation Blakelocks. Subsequently, Mrs. Adams also let it be known that there were now threats upon her life, that there were assassins lurking, and that Blakelock's safety was in jeopardy.

Given a good story, the newspapers obliged Mrs. Adams by ignoring the complicated niceties of what had actually occurred at Lynwood on Friday. On Monday, the *New York Evening Journal* splayed the Blakelock story in a banner headline across the top of its front page: "Blakelock Hides in New York to Foil Plot." Subsequent stories concentrated on the campaign against Blakelock's enemies. According to Adams she had, with the help of the National Academy, formed a committee with Harry Watrous and Elliott Daingerfield to track down Blakelock fakes. The district attorney's office, Adams asserted, had already begun an investigation, and she said that those manufacturing bogus Blakelocks would soon be prosecuted. It didn't really matter how much of this was actually true; Mrs. Adams had once again won the war over public opinion. She had not, however, freed herself of Cora.

On September 22, Cora wrote the district attorney's office to find out how Adams and Agar had been appointed the sole guardians of her husband. She then wrote Adams a letter asking her why Carl had not been allowed to see his father and why she had not been informed of Blakelock's removal from Lynwood. Cora wanted to know where Blakelock had been taken. Furthermore, according to a legal document prepared by her lawyer, Cora said in her letter that she "would not tolerate any future arrangements for Mr. Blakelock's care being made without consulting her." A few days later, on September 29, Adams finally wrote her back. Her tone was distant and aloof, and she made frequent references to her position as Blakelock's legal guardian. She wrote in part:

> Mr. Blakelock is very well and very happy in the charge of doctors who are acceptable to the officials of the State of New York.
>
> At any time you desire to see Mr. Blakelock we will arrange to have you do so. We are endeavoring to protect him and, therefore, are not making his address public . . .
>
> You wrote me a letter which I received a few days before your son's arrival in New York. Why did you not mention the fact that he expected to pay a visit to his father in the next few days? I have no regular office hours; my services are voluntary and it is not to be expected that any one coming here to the offices unexpectedly without appointment, will find me. Please advise me a few days in advance when you plan to visit Mr. Blakelock.
>
> <div align="right">Yours very truly,
Mrs. Van Rensselaer Adams</div>

In Catskill, Cora and her children debated what to do next. They had received a reply from the district attorney's office informing Cora that she had signed a waiver in early summer allowing Adams and Agar to become Blakelock's guardians. Cora remembered being sent a legal document, which she had signed and sent on to the district attorney's office, but her understanding was that it made *her* a

committee of one for Blakelock. Cora, trusting Mrs. Adams's inten-
tions at the time, did not closely inspect the document, which was
vaguely worded and did not specify who would be on the commit-
tee. Now Cora wanted to see the original papers (she had not kept a
copy) and further probe the formation of the Blakelock Fund and its
committee. That, however, required a formal investigation and a
lawyer, and the Blakelocks did not have the money for that kind of
expense. In light of the circumstances, they decided to make another
attempt to find and see Blakelock himself before proceeding with
an expensive investigation.

This time it fell to Ralph Melville, who was by then working for
General Electric in Schenectady, to find his father. The process was
better planned than the first attempt, and efforts were made to avoid
Adams whenever possible. Melville, likely on the advice of Harry
Watrous, first called John Agar for help. Watrous (who had declined to
be on the fund committee because he did not agree with Mrs. Adams's
methods) believed Agar was a trustworthy, upstanding man. He had a
sterling reputation, which of course was the very reason Adams had
asked him to be president of the fund. Agar, however, was at first reluc-
tant to give Melville any information and referred him to Mrs. Adams,
who he said was in charge. It might have been that Agar was simply too
busy and really didn't know what was going on (he had not, as yet, even
met Blakelock). That was, at least, Cora and the family's initial impres-
sion. On the other hand, Agar was a sophisticated man. He could not have
entirely ignored the Lynwood incident, which had been bandied about
in all the newspapers. He had also known Mrs. Adams for more than six
years, and they occasionally lunched at the elegant Banker's Club on the
fortieth floor of the Equitable Building. So he must have known some-
thing about her character. As it was, Agar informed Melville that Blakelock
had been taken to a sanitarium in Riverdale directed by Dr. Flavius
Packer. This was all, he said, that he could tell him.

Two days later, on October 23, Melville met Agar at his office on
Nassau Street. He asked Agar if there would be any objections to his
seeing his father that day. Agar did not think there was any reason
why he shouldn't be able to see him, and a call was put through to

Dr. Packer in Riverdale. Packer also agreed that Melville could come up that day and see his father. However, when Melville arrived in Riverdale a few hours later, he was told that Packer had left for the day. Melville would have to see a Dr. Baker, who informed him that Dr. Packer had been mistaken and, in fact, Melville would not be able to see his father without written permission from Mrs. Adams.

Melville spent much of the next two days trying to get in contact with Mrs. Adams and Agar in order to obtain permission to see his father. He confronted a seemingly endless series of evasive maneuvers and lies—much as had Carl on his visit to Lynwood. Both Adams and Agar, Drs. Baker and Packer, as well as the counsel for the Blakelock Fund, Mr. Edwards, made themselves as inaccessible and contrary as possible. Finally, Melville, having lost all patience, threatened Dr. Baker with an investigation and then marched into the Blakelock Fund offices on Liberty Street and demanded to see Mr. Edwards. He was told that Edwards happened at that moment to be talking to Mrs. Adams on the phone and that he could speak directly with her.

> Mr. Blakelock asked Mrs. Adams when she could arrange to meet him. Mrs. Adams' reply was that she was not in town and that she could not meet him. Mr. Blakelock then asked Mrs. Adams that she phone Dr. Baker and change the instructions she had given him so that he would not be barred from seeing his father. This she declined to do saying that Mr. Agar would attend to the matter for him. Mr. Blakelock then told Mrs. Adams he would make one more endeavor to secure the necessary permit from Mr. Agar at his office and if he could not be located . . . he [Melville] would start an investigation immediately. At this point Mr. Edwards who was in the adjoining room stepped in and told Mr. Blakelock that he guessed they could arrange the matter for him and then wrote a note to Mr. Agar asking that a permit be given to him.

Melville did finally obtain a permit from Agar allowing him to see his own father. The permit stipulated, however, that the visit was to

be made under Dr. Packer's "rules." At one o'clock, Melville arrived at the Riverdale sanitarium and saw his father in a visiting room under the watchful eye of an attendant. It was an awkward reunion for Melville. His father was blithely unaware at this point of the cloud of intrigue that surrounded him or the great lengths to which Melville had gone in order to visit him. Blakelock was simply happy to see his son. When Melville asked him if he had been doing any painting, Blakelock invited him to his room to see some of his recent painted sketches. The attendant, however, quickly intervened and said that Melville was not allowed to visit his father's room. Another lengthy confrontation with Dr. Baker ensued, but eventually Baker relented, and Melville was permitted to accompany his father to his room. Melville noted that there were no special furnishings nor any artists' materials or equipment in the room. "The paints used in making the sketches being what he [Blakelock] had always had at Middletown."

The Blakelocks were furious at the way the family had been treated by Adams and the committee. Clearly something was very wrong with the way the Blakelock Fund was being operated. In November, the Blakelocks hired a lawyer, August C. Streitwolf, to further investigate the committee and draw up a formal complaint. Several letters were exchanged between Streitwolf and the district attorney's office, and a detailed and lengthy account of both Melville's and Carl's attempts to see their father was written up. "In the face of the foregoing facts," the complaint alleged, "it would seem that the intention of the 'Blakelock Fund' is not being carried out." However, for some reason—either the costs of the investigation were too great or their case was not strong enough—the Blakelocks' legal complaint never made it to court.

26

TWO YEARS OF FREEDOM

Though Mrs. Adams had successfully deflected the investigations of the Blakelock family, she still had to be careful. In early February 1917, Cora finally eluded Mrs. Adams's elaborate security apparatus when she and Robert C. Vose paid an unannounced visit to Riverdale and actually managed to see Blakelock. Adams was alarmed. A day or two later, on February 13, she rushed Blakelock back to Middletown for a day. The purpose of this hurried visit, a month before Blakelock's six-month parole expired, was to renew her custody over Blakelock. It appears that Dr. Ashley was not even present at the hospital at the time of Adams's surprise visit. Notwithstanding the Lynwood debacle, Ashley gave the order, presumably by phone, for his subordinates to quickly sign the release papers. Adams was soon happily on her way back to Riverdale with her ward firmly in charge. Her fears that Cora and Vose, a powerful figure in the art world, might disrupt her plans had been put to rest. From then on, Mrs. Adams remained in firm control of Blakelock's destiny.

The Vose Gallery in Boston was one of the oldest and most prestigious art galleries in the country. It had been the first to introduce Barbizon art to America and was an early supporter of the work of

George Inness. At the time that Robert Vose visited the Riverdale clinic, he was about to open the first major solo exhibition of Blakelock's work in Boston. It was being called one of the most important events of the year in the city, and as soon as the doors opened, it was mobbed by throngs of people. Despite the hype, the critics in Boston were more thoughtful than many had been in New York. The Boston critics had been subject to Blakelock publicity for more than a year, and, wary of what one critic called Blakelock "propaganda," they were quick to point out that the "sob stuff" had been overdone. That only made their more analytical and, on the whole, glowing reviews more impressive. They were among the few critics at the time to go beyond rhapsodizing about Blakelock's poetic genius—though they did that, too—and point out that his art, in fact, was not inspired out of thin air. Blakelock "has given us a resume of the Barbizon school with little new in technical capacity but with a strange, original vision, a weird significance of form which the older men would not have understood, something which has found a more national realization in some of our modernists, but with him was more felt than actually conscious," wrote one sophisticated Boston journalist. The critic for the *Boston Globe* corrected those who held that Blakelock could not draw, calling him "a consummate landscape draftsman" and a "master . . . way ahead of his time." Blakelock's popular moonlights received somewhat reserved praise for their beauty and "old-fashioned romantic" theatricality, while his more innovative landscapes like *The Golden Hour* and *The Glow, Evening* were hailed as masterpieces. "His paintings will live when paintings that are merely dexterous will be dead or forgotten," wrote the *Globe*.

Vose was an enthusiastic promoter of the art he sold. No doubt the opening of the Boston show and the possibility of acquiring some new Blakelock art played a role in his sudden visit to Riverdale that February. But Vose had also long been interested in Blakelock's work and had been in touch with Cora as early as 1905. He had visited the family in Brooklyn when they were destitute and, on several occasions, had helped them out financially—and would continue to do so in the future. In fact, he had become a trusted family confidant.

A week after Vose's Riverdale visit, Marian Blakelock, perhaps having heard that Blakelock had once again been placed in Adams's care, wrote to Vose from her hospital room in Poughkeepsie, pleading that he do something to help her father rejoin the family in Catskill. Cora, too, must have told Vose of her difficulties with Adams and may well have asked him to come to New York to help her. No sooner had they arrived at Riverdale than Vose saw for himself what the family was up against. Dr. Packer tried to bar them from seeing Blakelock without the necessary permit from Adams. But Vose was a man of substance, with a strong personality and an iron will. "I exploded," he later wrote. "This is Mrs. Blakelock, she will see her husband now!" After a brief consultation, they were admitted, and Blakelock was brought in to see them. "Ralph came down and rushed up and hugged his wife," Vose wrote. "For several minutes you would not have known he was not normal. Than he became very serious and asked Mrs. Blakelock if she had received the check for $25,000 he had sent her. She said she had and all went smoothly again." Vose and Cora then went to Blakelock's room, where he showed them his latest work, offering some of the paintings to Cora. Packer, however, told Cora that she could no longer accept paintings from her husband and that absolutely no work was allowed to be taken away. Vose told Packer he would buy the pictures from Adams if she would inform him of the price.

Adams would not sell any of the paintings and had no interest in the Boston show, which was not donating its proceeds to her fund. But she was furious at this breach of her security and challenge to her authority. At this time she had Dr. Packer sending Blakelock's mail to her before Blakelock was even allowed to read it. That Vose and Cora actually saw Blakelock without her knowledge completely unraveled Adams. After renewing Blakelock's parole papers in Middletown, she sent a flurry of accusatory letters to Vose, insinuating, as she had with Anna Siegel, that he was an opportunist whose only interest was to obtain Blakelock's paintings to enrich himself. Furthermore, she wrote that Vose had improperly circumvented her legal authority by seeing Blakelock without her permission. Vose defended himself, reminding Adams of his long relationship with the

family. The Blakelock sketches he had offered to buy, he added, were hardly considered valuable pieces of work. There was no end result to the exchange, except that Vose's nickname for Adams—the Vampire—began to stick.

It's ironic that Blakelock, whose mind had been so long mired by paranoid conspiracy theories and whose life was now truly under the control of "a committee," was the last to understand what Adams was doing to him. Considering the circumstances it is not at all surprising. For the first year and a half that he was out of Middletown, Blakelock lived a fairly spoiled existence. Packer's private clinic in Riverdale was, in fact, an exclusive and expensive retreat for mentally ill patients from wealthy families. These patients were used to being well treated, served proper meals, and supplied with amenities. Blakelock, being one of the least disturbed of the residents, also enjoyed a considerable amount of freedom. While family and friends were kept away from Blakelock, he was not at all restricted to the clinic. On the contrary, frequently he was out on the town. "We went out often," Albert W. Davis, one of Blakelock's attendants at Riverdale, recalled. "He liked the subway, he liked shows with a lot of dancing and action, he liked to take walks . . ." Davis took Blakelock on shopping expeditions, car rides, and museum and gallery visits. "He went to Knoedler's every so often to pick out his own pictures from forgeries," Davis said. Blakelock was "very active," clean-shaven, well dressed ("he liked clothes"), and "always kind and polite." Those who saw or visited Blakelock at the time—including his family and Vose—noted that he was healthy and in exceptionally "good spirits."

"It seems to do him a great deal of good to visit the galleries," Adams wrote later that spring. "He purchased a new fountain pen to make sketches, or notes he calls them, for pictures." At Riverdale, Davis remembered Blakelock being quite busy making new sketches, even some still lifes of flowers and "beautiful roses." Of course, it was important to Adams that Blakelock continue to paint, and she made sure he was available to important benefactors who might be interested in his new works (as long as they donated the proceeds to the fund).

"Mr. Blakelock has been very much elated over his recent visit to you, and has carefully guarded the box of cigars you gave him," Adams wrote after a luncheon in early June with the important New York art dealer Roland F. Knoedler. "His attendant offered to carry them home for him, and he said, 'Oh no, I'll carry those. Mr. Knoedler gave them to me.' With his box of cigars and his own eighteen million, he has been as happy as a lark."

Adams did not see Blakelock nearly as often as one might imagine, but when she did take him on an outing that first year, she treated him with kid gloves and indulged his every whim. "You should see him in his new tan Shantung silk suit and Panama hat," she wrote to Knoedler two weeks later. "He is very nifty, and persists in the idea that he wants to go to Lake George for a while. It would cost no more to send him there for a little while than it does at the sanitarium," she mused.

As long as there was money coming into the fund, it suited Adams to treat Blakelock well and send him wherever he wanted. The summer of 1917, Blakelock went to Lake George in early July and didn't return until the end of October. Adams joined him for brief visits, but otherwise she spent her summer elsewhere. Being an unattached, attractive woman of uncertain background, Adams was not terribly popular among the married-matron set that reigned at the posh resorts of the Adirondacks, Saratoga, and Newport. It seems that Adams had few women friends and was unable to induce even a single female philanthropist to join the Blakelock Fund committee. Finding a suitable place to land for vacation presented her with something of a problem. She did not want to spend all her time boxed up with Blakelock, nor could she be seen with the older, married men who were her most constant supporters. But it was not beyond the realm of possibility that Adams had arranged to spend private weekends with some of these men, men with yachts, expensive cars, and country homes. She had plenty of cash, in any event, to do as she pleased.

At first there was such a surplus of funds that at the end of July Adams wrote Knoedler to ask him why he had sent the fund a check for $250. "I am very sorry to have troubled you . . . but you know you

send us checks so frequently that it is hard to keep track of them." Things were going well and Adams wanted to make sure they stayed that way. She flattered Knoedler—as she must have done the other men she needed—doling out praise in order to get what she needed. "It is through you alone that Blakelock reaps the benefits of his great works. To you he owes many months of peace and plenty and independence." Knoedler was the most consistently generous member of the fund committee, but Adams always wanted more. "He [Blakelock] has painted four paintings that seem very promising," she wrote Knoedler. "He is very serious about a commission from you to paint some pictures. I have noticed that he has repeated the conversation along the line which you and he had one day when he called at your galleries." It was the end of the summer and Adams was thinking ahead, making arrangements for the fall. She told Knoedler that Blakelock was "very much in earnest" about his desire to obtain a studio at the Sherwood and that he was looking forward to a promised trip to the Frick Galleries with Knoedler upon his return to the city.

Knoedler was too smart to get wrapped around Adams's little finger the way so many others had. But if such prominent men as Agar and Ashley, Kunz, Edwards, and Packer were willing to do just about anything—including acts that might not have been entirely legal—to please and protect Adams, her doting effect on a man as fragile as Blakelock appeared all the more powerful.

Her short visits to see Blakelock in the Adirondacks that summer and fall were special occasions. Their time alone together in the country appears to have inspired Blakelock's most complete portrait of Adams. Voluptuously reclined on a wicker love seat, outdoors under a tree, with her long dark hair unfurled, Adams is posed as an alluring Venus. She is the earth goddess, at once erotic and maternal, stern and beckoning. Blakelock has painted an idyllic house in the background and, in the foreground covering her legs, a bank of colorful flowers and leaves. Though not clear in reproductions, the brilliant flora at Adams's feet in the original painting is thick and encrusted like the brilliant "gems" Blakelock had written about in his slavish poem to

Adams upon their first meeting. "He gave to she, the dark/ . . . Gazelle eyed one . . . /To Venus, of eastern daughters in sight,/ Of the distant exotic, gems so bright/ Under the fresh leaves growing,/ In Arbor Vitae, the south wind blowing." Though there have been other interpretations of this painting, clearly during the late summer of 1917, Blakelock still saw Adams as his attractive guardian and champion, his "Beatrice." Adams, no doubt, was flattered to have the undivided attention of the country's most celebrated artist.

In November Blakelock returned from the country to the sanitarium in Riverdale and, for a while, things continued as they had before. Blakelock resumed his outings to the city and his social visits to Knoedler. There he would sometimes meet old acquaintances. One cold rainy evening at Knoedler's, he caught up with J. Francis Murphy, the Tonalist painter who had once lived in the Venetian Bakery building in the 1870s. In January 1918, Adams again wrote to Knoedler to thank him for taking Blakelock on another excursion. In February, a Blakelock landscape in the Hearn collection caused a stir when it sold at auction for $17,500. Much to Mrs. Adams's displeasure, however, Mrs. Clarkson Cowls, Hearn's daughter, refused to donate any money from the sale to the Blakelock Fund. It was a turning point for Mrs. Adams. The fund, which had hitherto been lined with cash, was now beginning to dwindle, and with the war still on, there were few new sales bringing money into her treasury.

By the late spring of 1918 Mrs. Adams's expenses, her suite at the Lorraine Hotel, her staff of assistants, her fashionable clothes and costly luncheons about town, had seriously diminished the fund's assets. Mrs. Adams's letters to Knoedler took on a more pestering tone. She had already inquired several times about the sale of a painting, *Canoe Builders,* and now rather curtly informed Knoedler that it was "necessary for the fund to get contributions to meet the future expenses for Mr. Blakelock." Adams was still seething about the Hearn sale and furious about dishonest dealers selling fake Blakelocks. They were casting a pall on the Blakelock market and, she said, must be "put out of business."

Adams persevered with the district attorney's office, and in May, an investigation was launched. Adams maintained that there was a conspiracy to flood the market with spurious Blakelocks. She received some support from Watrous, who told Assistant District Attorney John T. Dooling that he had been given thirty Blakelocks to authenticate, which turned out to be fakes, including one from the Corcoran Gallery in Washington. Dooling told the press he had information that there was a factory in Brooklyn where artists were turning out scores of Blakelocks. "These painters can turn out copies which defy detection by all but experts," he said. On May 28, Blakelock was called in to pass judgment on four paintings that Dooling had subpoenaed from various collectors. Blakelock looked them over carefully and declared all but one—owned by Charles A. Schieren, former mayor of Brooklyn—fakes. Mrs. Adams told reporters that she hoped the investigation would "bring to justice the clique, who have been trading on Blakelock's name and who I think are responsible for keeping him in the asylum for so many years." Yet hardly a week later, Dooling announced he was about to close the investigation, saying the fakes were not being made in New York after all. "Very few of the spurious paintings have been seen or sold here," he said. "Most of them have been sold in the West." Dooling mentioned a "syndicate" that had branch offices in Chicago and Oklahoma and said he was forwarding evidence to the proper authorities.

Mrs. Adams, however, pressed on with her own investigation. She was convinced that the Young Gallery in Chicago was responsible for selling a number of fake paintings made in the New York area. A month after Dooling gave up, Adams, accompanied by a detective, went to Lynbrook, Long Island, and paid a surprise visit to the art studio of H. M. Kitchell, whom she accused of supplying Young with fakes. "That's a supposed Blakelock, isn't it?" she said, pointing to a painting on the wall when she entered the studio. "Kitchell replied that it was a lithograph facsimile of a Julian Rix, and that others of the same kind could be bought for about $1 at any drug store." Adams clearly knew little about art. The art periodicals rallied to Young and Kitchell's defense, portraying her as a philistine who had long ex-

ploited Blakelock for sensationalistic purposes. But Adams, this time, was not entirely off the mark. Kitchell, it turned out, was none other than "the mick," the painter who had once worked alongside Blakelock in the art factory in Newark in the early 1880s. Kitchell did indeed paint a great deal like Blakelock and admitted to supplying Young with dozens of paintings. Kitchell, though, said he signed his own name to his work. He added that he had donated a picture to the Young show in Chicago and that it brought $305—money donated to the Blakelock Fund. Adams would have none of it and had the detective serve Kitchell with a subpoena to appear in Dooling's office. Kitchell appeared and admitted that he had "touched up" one of his paintings that had come back to him with a Blakelock signature on it, but not much else was ever proved.

In late June Mrs. Adams wrote to Knoedler saying that Blakelock was at Lake George and would be staying there until November. She again railed against Mrs. Cowls and inquired about the *Canoe Builders.* Her letters were becoming ever more plaintive, irritable, and repetitive, the purpose of her lavish praise of Knoedler ever more transparent. She would need, she told Knoedler, another $250 a month to pay for Blakelock's and his assistant's expenses. Someone named Harrison Morris had just sent in a check for $250. Knoedler had sent the fund five hundred dollars on June 8, and would send another thousand dollars by the end of the summer. Some of this money, according to the fund treasurer George Kunz, went to help defray the costs of the forgery investigation, but there was no accounting for the rest of it. In fact, even when Blakelock's estate was settled in state court several years after his death, Adams provided no explanation for the first year and half of the fund's existence, a time when she had spent easily between $10,000 and $20,000. By the summer of 1918 most of the stash was gone, and her honeymoon with Blakelock was over.

27

THE LAST YEAR

Adams arrived in Lake George in 1918 a different person than the generous benefactor Blakelock had known the previous summer. She was irritable, critical, and temperamental. Her hopes that Blakelock would paint her valuable masterpieces had been dashed. She was not at all happy with his work (though she told others his paintings were the best he had done since being set free). She said that he was lazy and was not paying for his share of the expenses. At times she ranted and became violent. "One day when he was painting she came into the room and flew into one of her tantrums because she thought he was spoiling a picture. She slapped him and gave him a punch over the heart." The incident traumatized Blakelock, who told Cora and others about it months later. Over the course of her stay that summer, Adams did more than physically abuse Blakelock; she broke his heart and spirit. He now saw his "Beatrice" for what she was—an ogre bent on bleeding him for all he was worth. He was afraid to be alone in a room with her. On several occasions he tried to escape the house.

By the time Blakelock returned to New York in November, their relationship had so deteriorated that Mrs. Adams immediately made

plans to send Blakelock back to Middletown to "discipline" him. Her letter to Dr. Ashley betrays a frighteningly distorted view of the situation.

> I plan to take Mr. Blakelock to Middletown Saturday . . . This time it appears advisable to have him remain longer than a day, for the modest quiet unassuming man whom you knew at Middletown . . . has developed into an arrogant self important, overbearing man. This is singular because he is in excellent condition and did two moonlights here small, but as fine in composition as any he ever painted. It has been a summer of great hardship for me—he took to climbing out second story windows. One nurse is not sufficient to watch him until he has the cooling effect of a sojourn at Middletown. It is in his more sane moments he is so mean. As a matter of discipline I thought if he were placed in a different ward it would not seem so like a visit. I'll tell you more in detail when I see you.

The truth was that once the money stopped rolling into Adams's bank account, Blakelock was expendable. Rather than keep him at the expensive Riverdale sanitarium, she quietly (for obvious reasons, Adams did not inform the newspapers) returned him to Middletown. Meanwhile, she kept her swank suite at the Lorraine Hotel in Manhattan. Ashley, as compliant to Adams's wishes as ever, had Blakelock sent upon his arrival at the hospital to a general ward.

In November in Middletown it was already cold. Nights and mornings were frosty, and sudden flurries of snow warned of the fast-approaching winter. Nevertheless, Adams left Blakelock without a winter coat or even a change of clothes. He had only the shirt and jacket he'd worn when he arrived. He had no reading glasses, and he appeared utterly demoralized and weak. His childlike enthusiasm and his energy had vanished. Contrary to Adams's account, Blakelock had not become difficult and overbearing. If anything, he was more subdued and despondent. "Patient is quiet, no trouble, never seen to talk

to himself" was one of the few observations made by a staff physician at the time. He ate poorly, lost weight, and spent more time sleeping and resting. Without his glasses, he could hardly get about. In January he fell in the hall and cut his right eye. Most surprising, Blakelock refused to go outdoors at all.

After almost three months at Middletown a doctor finally sat down to talk to Blakelock about Mrs. Adams's allegations. Blakelock, if anything, sounded plaintive and hurt. "Said he did nothing in New York, but what a sound mind would and he made all the nice pictures which they ordered. He left them everything, all his winter clothes etc. It is fatiguing to his mind to paint and he has the privilege of resting here. Suddenly interrupts . . . and says 'Whatever is sensational in this account I wish left out.'" Blakelock had had enough of being manipulated.

Despite his docile behavior Ashley kept Blakelock in a general ward for five months, until the very end of March. By the time Blakelock was finally allowed back to his old ward, he was wearing state clothing. He still had not been supplied with reading glasses. He weighed seventy-six pounds. Letters sent to Mrs. Adams requesting clothing and other necessities for America's celebrated artist remained unanswered. In fact, Adams would have left Blakelock shirtless and shoeless to die in Middletown if the promise of lucre had not once again directed attention Blakelock's way.

In February, Knoedler wrote Adams to say that a sale of *Canoe Builders* was finally under way and that he would donate the entire sum of the sale (it eventually sold for $1,350) to the fund. A few weeks later still better news arrived. Back in 1880 Blakelock had fallen behind on his rent on an art studio at the YMCA—many artists had studios there at the time—and had given the organization a painting, *The Necklace*, in lieu of back rent. Thirty-nine years later the YMCA discovered they still owned the painting and offered to sell it and pay Blakelock any proceeds above and beyond the initial debt and interest of four and a half percent. The "forgotten painting," as it would soon be called in the press, turned out to be a good one, an Indian scene painted the same year as *The Captive*, 1879. Knoedler was hopeful that it would sell for several thousand dollars. "I too, just the same as you," Adams wrote

back, "want to get all that is possible for Blakelock. Even $5000 did not seem too much. Had anyone said ten thousand I'd be happier still." Adams also had high hopes for three paintings Blakelock had finished the previous summer, which she had Agar frame and hang in the National Arts Club. In March, Blakelock's painting *Enchanted Pool* received wide publicity after it was awarded first prize at an exhibition of contemporary American paintings in Chicago. Once again Blakelock was looking valuable.

After Cora and her children's efforts to free Blakelock from the grasp of Mrs. Adams's committee failed in 1917, their hopes of gaining some say over Blakelock's future and asserting some control over the fund that had been raised for their benefit faltered. They simply did not have the legal or financial clout to get anything accomplished. There were other circumstances to be considered as well. America had joined the war in Europe, and Douglas and Allen had enlisted. Marian was still in the institution in Poughkeepsie. Carl was painting cars, struggling to get by. Ralph Melville was married and had a demanding job at General Electric in Schenectady. It wasn't easy to get away, keep track of Blakelock in New York, and finance a complicated legal battle in the courts. Blakelock's return to Middletown had been carefully kept out of the press. The Christmas presents the family had sent to Riverdale were sent back to them with no forwarding address.

Sometime during the winter of 1918–19, however, Cora moved in with her niece, Florence, on Atlantic Avenue in Brooklyn. Being in close proximity to Manhattan, she tried to locate her husband. Finding that he was no longer at Riverdale, she made several futile trips to Agar's office. Agar finally gave her an address in Lake George, but when she wrote there, she was told that Blakelock was no longer in residence. On March 10, 1919, Ralph Melville wrote Agar's office, requesting once again for him to inform the family of Blakelock's whereabouts.

Dear Sir:

Will you kindly advise me at your very earliest convenience the present location of Mr. Blakelock, my father . . .

As you are one of the two members of this committee, I am
writing to you for this information and also to express my
inability to understand why the committee does not inform
Mrs. Blakelock when a change is made in the location of Mr.
Blakelock . . .

It is very evident that Mr. Blakelock's committee is antago-
nistic to his wife and family. If there is any good reason why
this should exist I would be glad to know of its cause.

<div style="text-align: right">

Very truly,

Ralph M. Blakelock

</div>

Agar never bothered to respond to Ralph Melville's letter. On
April 15, Ralph Melville wrote a curt note to Mrs. Adams demanding
to know where his father was being kept. Watrous, too, at this time
wrote Dr. Ashley inquiring about Blakelock's whereabouts and well-
being. He also enclosed a press clipping that apparently alluded to
Blakelock's disappearance and put Ashley on the defensive. "You
know, of course, that Mr. Blakelock was returned to the hospital some
time last November by Mrs. Adams," Ashley wrote back to Watrous.
"He occupies the same ward, and enjoys the same privileges of the
institution that he had prior to his leaving some two years ago." Tech-
nically, Ashley wasn't lying, but he omitted the fact that Blakelock had
just been returned to his old ward, that he had no clothes of his own,
that he only recently had been given a pair of glasses to read with, that
he was despondent. "His mental condition remains practically as it was
when he went away. I cannot see that there has been any change," he
maintained. "I think you understand that personally I have never
claimed that Mr. Blakelock was any better or was recovering, and I am
not in any way responsible for the matter appearing in the news-
papers." Ashley was suddenly putting some distance between himself
and Adams. Nevertheless, he must have informed her of his letter to
Watrous. For the very next day, on April 24, 1919, Adams finally wrote
back to Ralph Melville, telling him that his father was "temporarily"
at Middletown. "You will be glad to know, however," she wrote

smugly, "that he is not at Middletown as a public charge." With the family once again breathing down her neck, and the possibility of additional funds pouring in, Adams (with Ashley's help) was doing her best to cover up her abusive neglect of Blakelock over the winter. Without delay, she set about selling a new story to the press.

On Monday, June 9, the *New York Times* published a front-page article on Blakelock, reflecting Mrs. Adams's version of the events of the past year. It was finally officially announced that he had been returned to Middletown—for his own good. Despite the best efforts of the committee, the story said, it had to be admitted that Blakelock had not regained his sanity, that though he continued to paint interesting paintings, they would probably never reach the level of his masterpieces. The Blakelock Fund, now described as "small," had through Mrs. Adams's valiant efforts been able to afford Blakelock two years of freedom. He had fully enjoyed his fame, his return to New York, his reunion with old friends. The sale of *The Necklace* would soon enable his "friends" to once again have him released from Middletown for the summer. However, the last paragraph of the article cautioned, "The old painter has been found to grow increasingly irresponsible unless under some restraint"—a single sentence that provided Mrs. Adams with all the cover she needed.

Cora was soon in touch with Blakelock, who wrote her back two letters saying he wasn't feeling well, "in fact he felt downright sick." Cora then went to Middletown as quickly as she could arrange it, but Mrs. Adams had beaten her to the punch. "The day before I was there Mrs. Adams had been there," she wrote Allen, who was now working for Vose in Boston.

> One sure thing Papa doesn't like her [Adams] any more. He said he wouldn't stay alone in the room with her. He made Mr. Gaffe one of the attendants in the ward, a very nice fellow, stay with him all the time she was there. He said Mrs. Adams wanted him to go to Lake Placid with her, he didn't want to go and told her he didn't feel able. He said he has

never felt well since she maltreated him last summer at Lake
George . . . He said Mrs. Adams wants everything he paints
and that she has more than her share now.

Blakelock, now angry, sounded like he finally knew exactly what was
what. And Cora didn't know what to do to help him. A few days after
her return from the asylum, she read in the papers that the YMCA
painting, *The Necklace*, had indeed been sold for four thousand dollars.
The accounts were conflicting, some stating that three thousand dol-
lars of the proceeds were going directly to Blakelock and another ac-
count saying that Mrs. Adams would be using the money to give
Blakelock a vacation. One newspaper reported that Blakelock had al-
ready left for the Adirondacks. Cora wanted to stop Adams from get-
ting her hands on the money, but she didn't know how.

The news in the papers about the sale of *The Necklace* and Mrs.
Adams's total control over Blakelock's life and finances worried many of
Blakelock's friends. For quite some time, Watrous, Vose, and a few mem-
bers of the press had voiced serious concerns about Mrs. Adams's han-
dling of the Blakelock Fund. An acquaintance of Mrs. Blakelock we
know only as the "countess" was irate. As soon as she heard the news
about the sale of the painting, the countess "came tearing over" to see
Cora. "She set me nearly crazy telling me what I should do," Cora wrote.

On Friday she came again . . . She wanted me to go out and
telegraph Ralph to come down immediately and have an
injunction put on that money. Ralph would have been fright-
ened out of his wits if I had. He would surely have thought
something terrible had happened here. Because I didn't fall in
with her plans, she went on awfully. She called me all sorts of
things because I just sat still and let that woman take Papa.
She thinks the whole family has no feeling. I told her I had
friends interested then she wanted to know who they were
and what they had done. Then she warned me against *friends*
tried to get me to say I shouldn't trust any one but her.
Anyway she went off mad because I didn't let her [illegible

word] the job. Florence tried to say something to her and she flew at her as if she would take her head off. So you see I feel upset.

Cora was actually terribly worried about her husband's physical well-being. She wrote Allen another letter almost identical to the first. She thought it was imperative that Blakelock be removed from Adams's care. She wanted Vose to visit Blakelock as soon as possible; if not, she said, she feared that Adams would soon have him taken away someplace else. Cora was inundated with friends and advice. But having already approached the district attorney's office, having prepared a legal investigation and engaged in innumerable, futile attempts to work out an understanding with Adams and Agar, she didn't see what else she personally could do.

The only person with the authority to protect Blakelock from Adams was Dr. Ashley, and he seemed prepared once again to stand aside and let Adams have her way. By early July, between the proceeds from *Canoe Builders, The Necklace,* and more recent paintings that Knoedler would soon sell, Adams had more than four thousand dollars in the fund at her disposal. But she needed Blakelock at her side in order to spend it. On July 3, she sent a male nurse named Thomas L. Hughs to pick up Blakelock at Middletown. Blakelock protested to the hospital staff that he did not want to be put in Mrs. Adams's care again. "The patient did not wish to go," the attending physician noted. "[He] said that he wanted to stay here as he did not like Mrs. Adams." Nevertheless, despite Blakelock's pleadings, despite the condition in which he had been returned to the hospital in the fall, and despite the fact that he was in poor health due to advancing arteriosclerosis, Ashley turned him over to Adams. A month later, Blakelock was dead.

The Adirondacks was one of Blakelock's favorite places to paint. As early as 1868 he had gone to Port Kent to paint *Lake Champlain.* At that time the Adirondacks were still wild and undeveloped, far less settled than the White Mountains in New Hampshire. It was in the Adirondacks that Cambridge intellectuals including Ralph Waldo Emerson, James

Russell Lowell, and Louis Agassiz set up their Philosopher's Camp in 1858—a place, Emerson wrote, far away from any signs of civilization.

> *No placard on these rocks warned to the polls.*
> *No door-bell heralded a visitor,*
> *No corner waits, no letter came or went,*
> *Nothing was ploughed, or reaped, or bought, or sold;*
> *The frost might glitter, it would blight no crop,*
> *The falling rain will spoil no holiday.*

In the Adirondacks Blakelock had paddled down lonely streams and drawn the great black roots of giant hemlocks wrapped around the rocks at water's edge. Here he had painted lonely cabins buried in the rusty red foliage of fall. Here in the deep woods he had seen a frightened deer dart across a clearing, fleeing for its life. And here, in 1880, he had sketched Cora sitting by a lake reading a book, the guide leaning against a cool rock, the canoe nudged against the bank. The Adirondacks, with their raw sculpted peaks and their deep forgotten forest valleys, were as close to the West as Blakelock could find in the East. It was everything the city could never be; it was a second home.

The house Blakelock was taken to in 1919, Kingsley Cottage, is found at the end of a long dirt road halfway up Cobble Hill overlooking the village of Elizabethtown and the surrounding valley. Pleasant Valley, as it was once called, is high up in the northern Adirondacks, nestled by hills. Schroon Mountain, painted by Thomas Cole in 1837, stands thirty miles south, and Keene Valley, often visited by Winslow Homer and once home to painters Alexander Wyant and Walter Shurtleff, is twelve miles to the west.

The "cottage" was the largest house in a group of five "camps" established by William Morgan Kingsley at the turn of the century. The camps were known as the Balsams for the sweet-scented pine trees that once sheltered the hillside. Kingsley was chairman of the U.S. Trust Company, a treasurer at New York University, and an active member of the YMCA board. Having just helped sell *The Necklace*, Kingsley was obviously well acquainted with Blakelock's circum-

stances—and if he hadn't been, Adams made sure that he was. She certainly was not shy about the need to find Blakelock a place to stay in the Adirondacks for the summer. Kingsley, however, couldn't just offer her his Adirondack camp for free, as he had often done for the YMCA in the past. He had just divorced his wife, Susan Kingsley, a spiritualist who had moved to California, and given her the property. Perhaps, he suggested, the ex–Mrs. Kingsley would lease it to Adams for the summer. Mrs. Kingsley agreed, at a cost, according to Adams's wildly inflated bookkeeping, of some four hundred dollars a month.

Kingsley Cottage is a rambling Adirondack shingle house with bay windows, sleeping porches, and expansive verandahs and, at the time that Blakelock stayed there, it had an unusual porte-cochere archway entrance. The inside of the house was as typically in the Adirondack-style as was the outside. It was dark and woody, the floors mahogany, the walls wainscoted with cedar, the furniture wicker. There were three great stone fireplaces to stand beside in the chilly evenings. Outside, a path, partially overgrown today, led to a nearby stream where guests—over the years they included J. P. Morgan, William F. Buckley Sr., and Helen Keller—could sit on a bench, read their books, and listen to the bells of the cows grazing in the nearby pastures.

It was an ideal place to spend the summer. Under any other circumstances it would have served as an idyllic and elegant retreat for Blakelock to have shared with his wife and family. As it was he was sharing the house with Mrs. Adams, whom he now loathed and feared. He would not, however, be intimidated by her, and he refused to lift a pencil or brush all summer. He was ill and frail. He took no interest in the scenery. Aside from a lakeside walk he took with his old friend Harry Watrous, he rarely ventured outdoors. How Adams reacted to this apathy is a mystery that Blakelock took with him to his grave. Did she rant and abuse him? Or did she finally realize that this thin old man was helpless and dying, that the emperor she had created had no clothes, that her ship was sailing for good over the horizon?

Mrs. Adams's own self-serving, conflicting, but at times eerily confessional accounts indicate, unfortunately, that she was anything but

accepting during those last few weeks at Kingsley Cottage. "He seemed to understand what his career had been," Mrs. Adams said. "The delusion that he was immensely wealthy had been taken away by persons who instead of humoring him in his belief that he had great riches, had told him repeatedly that he had nothing and finally had impressed that fact upon him," Adams stated with an anger that is almost palpable. Clearly, she and Blakelock's attendant were the only "persons" she could have been referring to. It is not hard to imagine Mrs. Adams berating Blakelock for his delusions of grandeur, insisting to him that he was nothing without her.

"I know now that I have no money," Mrs. Adams claimed Blakelock had said. "I painted the pictures and sold them for almost nothing. I knew then what they were worth, though no one else would admit it at the time."

The last Middletown hospital reports indicate that Blakelock was far more subdued and possessed a sober, less deluded appreciation of his circumstances. Blakelock had coherent conversations with Cora about Mrs. Adams and her plans for him. It would be naive, however, to believe that he had been miraculously cured of his condition, that his mind had somehow completely cleared. In fact, the reports noted continued, sporadic bouts of irrational ramblings. Sometime before in Middletown, Blakelock had written, "If I am insane I am not conscious of it. I am not a paranoiac. I am not in the period of senility nor aged dotage for I can whistle and sing." Blakelock, despite his many burdens, had always had heart. No matter how low his spirits had fallen, every spring he took to the fields and woods, carrying with him his paints and the enthusiasm of a young man. Only at the end, surrounded by the beauty that had kept him alive through so many dark periods, did he finally lose his inspiration. His ailing heart and his broken spirit were failing him.

By August the days had grown too hot to stay indoors at Kingsley Cottage. It was better to be out on the porch, where one could see the valley stretched out below. A faint breeze shook the shade of nearby trees over the lawn. At times, the thwack of a golf ball and the ensuing applause could be heard faintly rising from the Cobble Hill golf tourna-

ment taking place at the bottom of the hill. If Blakelock looked straight ahead across the valley, in the notch between Raven and Wood hills, he could make out the Green Mountains of Vermont across Lake Champlain. It was there, in Arlington, Vermont, that he had painted his first landscapes. What were at first simple attempts to portray the land in front of him, to paint a pretty picture, had become, over a span of fifty years, a kind of kaleidoscope of the artist's soul.

If it were possible to reduce all his paintings to colored images on small squares of paper and bind them into a tiny book, and if one were to quickly flip through it, the images would alternate between fact and fiction, reality and abstraction, the somatic and the ethereal, and finally come to a halt on an image that family tradition holds was his last painting. It's a seascape, furiously painted, unambiguously modern and expressive. Above the frothing green and white waves, the sky is lit up in mangled stripes of red, white, and yellow, as if the sun's setting light was a pool of methane struck by a match.

On Saturday, August 9, Blakelock got up from bed and went into his bathroom to wash up. He was standing at the sink when he became dizzy and collapsed. Mrs. Adams and the nurse found him about ten A.M., lying unconscious on the bathroom floor. They carried him to his bed and called the doctor. By the time the doctor arrived, Blakelock was dead.

Mrs. Adams traveled down to New York City on Sunday and, in the evening, announced to reporters that Blakelock had died. She had not yet been able to find his family to discuss the funeral services. Blakelock's body would arrive the next morning and be taken to Grace Church. On Monday morning the news of Blakelock's death was on the front page of newspapers across the country. Most editors could not resist appending "mad" to descriptions of Blakelock in their headlines. A few were more dignified and gave Blakelock his due as a "noted" painter, and in the *New York Sun* he was once again given the honorarium the "Greatest of American Landscape Painters."

Mrs. Adams did finally get in touch with Cora and said she would meet her and the children at the Lorraine Hotel in New York. Of course,

when the family arrived at the hotel, Mrs. Adams was unavailable. Her
secretary told them that Mrs. Adams did not think it was necessary for
the family to see her personally and that they should go on to the under-
takers to see about the funeral arrangements. At Grace Church the fam-
ily waited to see Blakelock's body. When the casket was opened they
noticed that there was a bad gash across the nose. The undertaker re-
peated what some newspapers had already reported—that Blakelock
had hit his head on the faucet of the sink when he collapsed. The cause
of death was officially recorded as arteriosclerosis.

Naturally, as Cora and the children stared down at Blakelock's bat-
tered face, they could not help but think of the things he had told
Cora about Mrs. Adams. Later, some family members questioned the
official cause of Blakelock's death, saying that his body was bruised
and that it was Mrs. Adams's beatings that had killed him. Mrs. Adams
was violent at times, but both Cora's observations and the hospital
reports indicate that Blakelock was dangerously ill and weak when he
left the hospital. The day before he was discharged, he had weighed
only seventy pounds.

The funeral took place on Thursday morning, August 14, at ten o'clock
at Grace Church at Tenth Street and Broadway. Cora knew the cor-
ner intimately. It was just down the street from Blakelock's old stu-
dio in the Venetian Bakery building, where he had painted her portrait
in the early 1870s. At that time Grace Church was barred to nonmem-
bers. Now, on that warm summer morning, the large doors had been
flung open for Cora and the other mourners. Inside the dark, incense-
scented church, a smattering of important figures had gathered for
the funeral. The famous sculptor Daniel C. French, representing the
National Academy of Design, was there, as were William M. Kendall,
representing the U.S. Commission of Art, Francis Jones of the Met-
ropolitan Museum of Art, and the millionaire arts patron Augustus
Healy. There were also a few artists who had either rushed back to
the city or didn't have the means to go away in the first place. Adams
and her gang of reporters as well as Agar and Dr. Ashley, of course,
were there too. A few stragglers from the street filled the back rows.

After Reverend Charles L. Slattery's eulogy was over and the final hymn had been sung, Mrs. Adams had the final word on the steps outside, where she addressed the reporters. After reading President Wilson's brief message of regret, she couldn't help adding a few words of her own. Adams dropped the news that she had had several talks with the president about Blakelock, whom, she said, Wilson had always greatly admired and, she added, the president was "especially pleased at the efforts to save the unfortunate painter from the hardships of poverty." Two days later Adams would announce that the Blakelock Fund was depleted and insolvent.

After Mrs. Adams's chat with the reporters, the small crowd quickly dispersed—all but two art critics, who lingered on the steps, marveling over Blakelock's life. One of them noted how quickly the few artists who had shown up had scattered. The street was empty. It was the middle of August, and many people were away. To anyone standing under the church spires on Tenth Street and Broadway, it fast appeared that nothing had happened here at all.

EPILOGUE

The mischief surrounding Blakelock's last years continued for some time after he died. Almost as soon as he was buried, the newspapers finally picked up on the fact that there was something suspicious about the way the Blakelock Fund had been handled. The *Boston Herald* reported on August 24 that Cora had been kept away from her husband and that neither she nor the family had ever received a penny from the fund. Mrs. Adams declared that the fund was nearly insolvent, but others wondered how four thousand dollars could have been spent in the last month of Blakelock's life. Robert Vose was the most vociferous in his condemnation of Mrs. Adams. He wrote to William Cresmer, the Chicago collector, asking if he had any friends on the committee whom he thought might pressure Adams for a full accounting. "I have much to say to you," he wrote in a biting tone, "of the treatment that the family have received from this warm hearted, self-denying, self-forgetting, philanthropist, Mrs. Adams." He also wrote to Harry Watrous, saying that it was essential that Adams not be appointed executor of Blakelock's estate. Watrous in turn wrote George Kunz, the fund's treasurer, urging him

to supply Blakelock's son Allen with information about the fund. The committee was, as usual, uncooperative and stalled for time.

Two years later, in 1921, Ralph Melville Blakelock was appointed the administrator of Blakelock's estate. Within days of signing the legal documents necessary for her son's appointment, Cora had Blakelock exhumed from his grave at Woodlawn and moved to Kensico Cemetery in Westchester. Perhaps Cora simply wanted Blakelock laid to rest in a place of her own choosing. As family members have implied, there was an intent on having an autopsy performed to verify the cause of Blakelock's death. As it was, he was transferred on July 29, 1921, to Kensico Cemetery but was kept in a storage crypt (though the burial plot was fully paid for by the fund) for another eight years. As soon as Blakelock was transferred to Kensico, Mrs. Adams petitioned the court to settle and close the estate, but Ralph Melville, as administrator, demanded that she account for all expenses accrued by the Blakelock Fund since 1916.

It took another three years of legal wrangling before Adams and Agar provided a list of Blakelock's drawings and paintings in the committee's possession, and a paltry two-page statement that supposedly accounted for all the money received and disbursed by Adams since the date of her appointment as Blakelock's guardian. Incredibly, the statement reports no income for 1916, the year most of the money was donated, and only one disbursement for 1917, for seven dollars. The accounts for 1918 and 1919 are, with the exception of the funeral and burial costs, obviously incomplete and inaccurate. Based on Adams's faulty accounting, the court finally, on October 10, 1924, ordered the committee to pay the Blakelock family (after money was taken out to pay for the committee's expenses and lawyers' fees) $184.07. It also ordered that all of the re-maining sketches and small paintings, amounting to several dozen minor works, be handed over to the family. In 1925 Ralph Melville obtained the last painting in the committee's possession and signed papers clos-ing the estate. On March 8, 1929, Blakelock was buried again, for the last time. There was no money for a headstone.

Mrs. Adams, though, did not disappear. Peculiarly enough, while the legal proceedings were still going on, in 1924 she moved into the

house next to the farm in Leeds, New York, where Cora was living with her daughter Mary Florence Vedder and her husband. "I often see her going out and in her house, but have never met her," Cora wrote her son Allen. For several years Adams tried to raise money to write a biography of Blakelock, but the project never succeeded and then she vanished from sight.

More than seventeen years later, on December 23, 1941, in New York City, Adams collapsed on the street near Grand Central Station. She was picked up, ranting about Blakelock, just steps from an exhibit of his work at the Grand Central Galleries, and taken to King's Park State Hospital, where she was diagnosed as suffering from paranoid schizophrenia. She told the disbelieving doctors there that she had once rescued the artist Ralph Albert Blakelock from an asylum and was responsible for making him famous. She had devoted her life to ferreting out Blakelock forgeries, she insisted, and was being persecuted for doing so. Furthermore, she grandly informed the physicians, dressed in her state-issued pajamas, she was a woman of great wealth and had many influential friends. The doctors, however, noted that, four years after her admission, she had yet to receive a single letter or a visit from anyone.

Blakelock's legacy to his family was tainted. In the aftermath of the Adams affair, the market for Blakelocks cooled and the family was unable to sell the small paintings they had been left for any significant amount of money. Not that they necessarily wanted to sell the paintings any longer. Many family members were angry at the way the family had been treated by art dealers in the past, and refused—and still do today—to sell any of their few remaining paintings. While Blakelock's importance as an American artist was a source of pride, the family's feelings toward art in general were ambivalent, riddled with fear and suspicion. After Marian was hospitalized, and Mary Florence experienced bouts of mental instability, dread of a "Blakelock curse" ran through the family. Carl, a talented artist himself, painted landscapes quietly in a garage but kept the results to himself. Blakelock's grandchildren were warned away from being artists

and even about writing on Blakelock for school projects. At home, Blakelock's name was rarely mentioned.

In 1947, when Lloyd Goodrich was researching material for the Blakelock retrospective at the Whitney Museum, Cora declined to be interviewed. She told her daughter Ruth that she didn't want to talk about the past anymore. A few years later, on February 11, 1950, Cora, aged ninety-four, died of pneumonia in Poughkeepsie. The breadth of her life span was remarkable. She had seen, as a child, Lincoln during his presidential campaign in New York and had traipsed about the countryside with young Blakelock at a time when Frederic Church's arcadian panoramas enthralled the nation. She died in the nuclear age as Jackson Pollock's chaotic drip paintings shocked a country reveling in martinis and Frank Sinatra.

Many Blakelocks managed to move on. They spread across the country and became teachers, engineers, bankers, and generals, and one, Walter Blakelock Wilson, even dared to become an artist. Some of the elder Blakelocks remained quietly on their wooded properties in New England, and it is Blakelock's legacy to some of them that is most striking. A few of Blakelock's grandchildren and great-grandchildren have inherited not just the artist's features and transparent blue eyes, but also the delicate sensibility described by so many of his contemporaries. Cautious and private at first, they are easily ignited by their own thoughts. The words come pouring out, intelligently, touching on various ethereal subjects, before returning and landing safely back on earth. They have skirted the more dangerous Blakelock genes, but their emotions lie just beneath the surface and, like children, they are easily moved to sudden tears and laughter. Being with them is to be, in a way, with Blakelock himself. Sitting in their wallpapered living rooms, with an old clock ticking loudly, everyday baubles on the shelves, and tiny fairy-tale Blakelocks on the walls, the proximity of the artist's spirit is striking. For there is a home-spun, down-to-earth quality about these Blakelocks and yet still something exotic, something of the windswept moors of Yorkshire in them as well.

* * *

Far too much has been said about the tragedy of Blakelock and not
enough about his triumphs. That Blakelock's art was highly recog-
nized and influential in defining American art at the turn of the cen-
tury was a great accomplishment in itself, and one that Blakelock
himself was not unaware of. As early as 1884, Blakelock was recog-
nized as an innovator, a radical painter whose approach to art was far
more personal and emotionally charged than that of his peers. Since
1900 he has been considered by many critics and art historians as
among the most important and original nineteenth-century Ameri-
can painters. Yet the degree to which his paintings impacted the art
world has been underrated and often forgotten. In fact, the people
who actively encouraged and believed in Blakelock's work reads like
a who's who in the art community of the time—from protean collec-
tors like William T. Evans to the publisher and editor in chief of *Art
in America*, Frederic Fairchild Sherman, to artists such as William
Merritt Chase and J. Alden Weir. Robert Henri, arguably the most
influential American modernist and teacher at the time, was an ad-
mirer, as was George Bellows, a renowned painter of the Ashcan school,
who said that Blakelock was a genius who had "made a strong impres-
sion not only upon American art, but upon the art of the world." What
Bellows meant was not that Blakelock's work had influenced Euro-
pean art, but that it had *stood up to it* at a time when Europeans were
still seen as the only game in town. Blakelock made Americans look
to themselves for inspiration.

Among the many encomiums flung Blakelock's way during the pe-
riod of his celebrity, perhaps the most flattering was his inclusion in
shows like the one of American paintings at the Hamilton Club in
Chicago in 1917 (where he won first prize). At such exhibitions his
paintings were no longer hanging beside the work of nineteenth-
century artists of his own generation (with the exception of George
Inness, whose work was also often included) but alongside the most
influential young American modernists and Impressionists of a new
generation, artists like Childe Hassam, Guy Wiggins, and Robert

Henri. Blakelock, who had, with Albert Pinkham Ryder, so upset no-
tions of art back in the 1880s, and had gradually impressed the radical
vision of his experimental work upon the critics arrayed against him,
had made the leap into a new century of art.

Though the crowning exhibitions of 1916 were a triumph for
Blakelock, in the long run Adams's publicity circus and the sensation-
alist tales of Blakelock's hardships may have done his reputation more
harm than good. While Ryder's legacy to modernism was quietly as-
sured by his friendship with Marsden Hartley and his inclusion in
the landmark Armory Show of 1913, many felt, in the aftermath of
Blakelock's sudden notoriety and fame, that he needed to be brought
back down to size. There was something vulgar and uncouth about all
this money and attention being thrust at Blakelock. He was not, some
needed to point out, *the* greatest American artist ever. Many of his
paintings were repetitive. Some thought his vaunted imagination was
actually quite limited, that perhaps this was the true effect of his ill-
ness on his painting. He obsessively painted the same subject, it
seemed, over and over again. Hartley said "a single good Blakelock is
beautiful," but was less impressed, initially, with them as a whole.
Among the hundreds of paintings Blakelock churned out for quick
cash, many indistinguishable from the forgeries, there were few mas-
terpieces. As time went on, the battle that Blakelock and Ryder fought
in the 1880s was forgotten, and the nuances of Blakelock's climb to
fame were glossed over.

Nevertheless, throughout the several decades following Blakelock's
death, he was included in most of the important museum retrospec-
tives of American art. Once again he joined Inness, Whistler, Sargent,
Chase, Homer, Eakins, and Hassam. When, in 1930, the Museum of
Modern Art temporarily winnowed America's defining artists to the
triumvirate of Homer, Eakins, and Ryder, none other than Hartley
criticized the exclusion of Blakelock. Blakelock and a few others, he
argued, should have been included as a "plausible basis for a genuine
American art."

By the early 1940s it seemed that Blakelock's reputation was on its
way to being fully restored. A solo exhibition of his work in 1942 at

the Babcock Galleries in New York prompted the influential critic Edward Alden Jewell to call Blakelock "one of the greatest artists America has produced." Jewell added, "By every right he deserves a niche equal in importance to the positions held by Winslow Homer, Albert P. Ryder and Thomas Eakins." Five years later, in 1947, the first major Blakelock retrospective was held at the Whitney Museum of American Art.

In his review of the Whitney exhibition, Robert Coates, the critic for *The New Yorker* who coined the term "abstract expressionism," called Blakelock one of the "strongest individualists" in the history of American art. He, too, grouped him at the top with Homer, Eakins, and Ryder. "Blakelock was completely outside his period artistically and despite an early attempt to conform he could not help moving further and further away from the accepted tradition as his style matured. He was a . . . visionary."

It was in the late 1940s that American art, in the wake of modernism's waning glory, was stung to life by the initial three instigators of abstract expressionism, Willem de Kooning, Jackson Pollock, and Franz Kline. Whether this new American movement represented the continuation or failure of modernism, or whether it was more about self-*creation* than self-expression, need not detain us here. It has been widely recognized that there is a correspondence of philosophical concerns—a transcendentalist view of the self and an awareness of the "symbolic equivalents of natural forces and inner states"—between the Romantic American artists of the nineteenth century, the first modernists, and the abstract expressionists. Pollock's favorite American artist was Ryder and one of Kline's was none other than Blakelock. Historicity aside, the many parallels between nineteenth-century Romantics like Blakelock and the abstract expressionists are, as the art historian William Seitz pointed out, quite striking. "They value . . . expression over perfection, vitality over finish . . . feeling over formulation, the unknown over the known . . . the individual over society, and the inner over the outer." It could be argued that Blakelock's embrace of abstraction and emotion, and his active, impasto treatment of the canvas surface in paintings like *Water-lilies* and *Silvery Moonlight*,

closely evoke the abstract expressionist idea of painting as an experi-
mental event or action. Blakelock, carried away by his love of paint,
used meat skewers and poured water over his canvases; the abstract
expressionist painters tried everything from airbrushes to just plain
pouring paint from cans.

Since the late 1940s Blakelock has disappeared and come back again
in different guises. Each new show of his work has revealed new as-
pects of the artist, further confusing the critics. Blakelock has been
described as a visionary, a romantic, an outsider artist, and a Hudson
River School eccentric. A 1996 exhibition of the work he did in the
asylum at Middletown only accentuated the confusion. Roberta Smith,
a *New York Times* art critic, observed that, paradoxically, Blakelock's
paintings at the hospital displayed a "clarity of vision" missing from
his earlier work. She noted his "delicate yet commanding use of line."
At the same time she saw in other paintings "rich colors and strangely
physical surfaces," as well as a strong element of experimentation and
abstraction that reminded her of painters like John Marin, Pollock, and
Lee Krasner. Above all, Smith concluded, moving in a slightly dif-
ferent direction, Blakelock's paintings conveyed "his quiet, almost
joyous attention to nature." Almost eighty years after he had died,
Blakelock still refused to be typecast as any one kind of painter.

One of the most ambitious exhibitions of Blakelock's work to date,
which took place in 1969 and included more than a hundred of his
paintings and sketches, was called "The Enigma of Ralph A. Blake-
lock." David Gebhard, who wrote the introduction to the catalogue,
despaired that more had not been written about Blakelock and finally
concluded that it was, in fact, Blakelock's ambiguity that connected
him to contemporary art.

As it is, Blakelock will most likely remain an enigma to critics and
the public alike, and not merely for theoretical reasons. Though
Blakelocks can be found in almost every major museum in this coun-
try, much of his best and most experimental work is in private hands,
in small public collections, or has been lost. Additionally, Blakelock's
strange pigments and varnishes are not lasting. Many of his paintings,
like those of Ryder, are fading at an alarming rate. As many as half of

the Blakelock paintings owned by major national museums are no longer presentable. Paintings once described as glorious gradations of color are becoming dark, the whites curdling to yellow, the reds and oranges turning brown, areas of subtle shading becoming slabs of tar. The rare large moonlights in good condition continue to hold prominent places and are paraded around the country from time to time as American treasures. Forgotten gems that have survived, and rediscovered masterpieces like *Indian Encampment Along the Snake River*, continue to stun viewers and achieve record prices. But too many of Blakelock's works are slowly fading in the cooled-down, dust-free sanctuaries of museum storage racks. One day a young curator will walk back there looking for a Blakelock and pull out the rack and see practically nothing in the frame at all.

Blakelock discovered new regions of the American landscape that went beyond the pastoral and touched upon our fundamental relationship with nature and the unknown. It's an area that would monopolize the attentions of American artists and poets of the twentieth century. We can only hope that Blakelock's paintings will survive as a testament to his pioneering explorations in paint and a reminder that his deep love of nature and lasting search for a transcendent experience goes on and continues to be repeated from generation to generation. To forget Blakelock would be to miss, in part, an important step along the path to our cultural identity and a momentous rite of passage in American art.

SOURCE NOTES

Abbreviations

AAAS	Archives of American Art, Smithsonian Institution
ACCNY	Archives of City College of New York, CUNY
ASCUNL	Blakelock Inventory, Archives and Special Collections, University of Nebraska–Lincoln Libraries
GP	Lloyd Goodrich Papers, Archives of American Art, Smithsonian Institution
KC	Knoedler & Company
MPC	Myra Platt Collection
MPCL	Middletown Psychiatric Center Library
NYCMA	New York City Municipal Archives
NYHS	New York Historical Society
VGC	Vose Galleries Collection

Introduction

ix The Sunday following . . . *New York Times Sunday Magazine*, "An Appreciation of Ralph Albert Blakelock's Paintings," 9/17/1919.

x *"The Indian Encampment . . ."* Ibid.

xi A call to Woodlawn . . . Conversations with Woodlawn Cemetery and Kensico Cemetery clerks, January 2000.

xi Blakelock had, in fact . . . Ibid. Blakelock was transferred from Woodlawn to Kensico on July 29, 1921, but was not buried at Kensico until March 8, 1929.

1 News

3 He was on his way . . . Harrison Smith, *Saturday Review*, "Genius in the Madhouse," 4/31/1945, p. 14; and see *New York Tribune*, 4/6/1916.

4 Two weeks before . . . *World,* 3/19/1916, p. 1.

4 He was transferred . . . Medical records, ASCUNL.

4 Indeed, there was such . . . *New York Evening Post,* 2/21/1903.

5 An important exhibition . . . Moulton and Ricketts Galleries, Chicago, 1913.

5 "Although higher prices . . ." Unidentified newspaper clipping, "In Lambert Collection . . . Remarkable Paintings," February 1916, MPC.

6 He received enthusiastic . . . *Harper's Weekly,* vol. xxx, no. 1562, 11/27/1886, p. 760. One of several forgotten reviews that were critical in determining Blakelock's career.

6 They were repeatedly . . . See, for instance, Royal Cortissoz, *New York Tribune,* 4/4/1916.

6 Accepted Lambert's final . . . See, for instance, *World,* 3/19/1916.

7 The suave auctioneer . . . Unidentified newspaper clipping, "$20,000 Is Paid For Blakelock Painting," February 1916, MPC.

7 "Blakelock was by nature . . ." Raymond Wyer, *International Studio,* "Art and the Man: Blakelock," 7/1916, p. 19.

7 Indeed, Blakelock's radical paintings . . . See William C. Seitz, *Abstract Expressionist Painting in America,* Harold Rosenberg, *The Tradition of the New,* John Gordon, *Franz Kline 1910–1962,* Barbara Rose, *American Painting,* and others for connection between Blakelock and Ryder and abstract expressionist art.

7 "It goes, in certain directions . . ." *The Nation,* vol. 102, 5/4/1916, p. 473.

8 Photographs of Blakelock . . . See *World,* 3/16/1916, 3/20/1916, 3/27/1916, *New York Times,* 3/23/1916, 4/2/1916, *New York Herald,* 4/26/1916, and others.

8 Still, Harrison Smith, who . . . Harrison Smith, op. cit.

8 "So repugnant was . . ." Frederick W. Morton, *Brush & Pencil,* "Work of Ralph A. Blakelock," vol. 9, no. 5, February 1902.

9 "When the barbaric . . ." Elliott Daingerfield, *Art in America,* "Ralph Albert Blakelock," 1963, no. 4, p. 84, reprinted from 12/1913 issue.

10 "He was a combination . . ." Moulton & Ricketts Galleries, *Catalogue of the loan exhibition of important works by George Inness, Alexander Wyant, Ralph Blakelock,* "An Appreciation" by Harriet Moore, Chicago, 1913.

10 He sometimes rambled . . . *World,* 3/19/1916.

10 "Blakelock is no longer . . ." Ibid.

11 "He . . . sits around . . ." *New York Times,* 4/2/1916.

11 "He is as harmless . . ." Ibid.

11 "One sketch, especially attractive . . ." *World,* 3/19/1916.

12 At least that was . . . Middletown State Hospital, *Centennial Chronicle 1874 – 1974,* MPCL.

12 Female nurses stood . . . Ibid.

13 The job was . . . Middletown State Homeopathic Hospital, *Annual Report of the Middletown State Homeopathic Hospital,* 1913–14, MPCL, pp. 23, 29, 31–32, 50.

13 The doctor led Smith . . . *New York Tribune,* 4/6/1916.

13 "The first glimpse . . ." Ibid.

2 The Asylum

15 "[He] wants it understood . . ." Medical records, July 1901, ASCUNL.

15 Uncooperative, he sometimes . . . Ibid., various dates.

15 Patients were strapped . . . *Annual Report* 1913–14, op. cit, p. 14; *Centennial Chronicle*, op. cit.

15 "He was extremely . . ." Letter from Cora Blakelock to Robert C.Vose, 1/10/1906, ASCUNL.

15 "My Dear Cora . . ." Letter from Ralph Blakelock to C. Blakelock, medical records, no date, ASCUNL.

16 "Home again, I cannot . . ." Ibid., 10/1903.

16 "Patient slowly but . . ." Medical records, 5/27/1914, ASCUNL.

16 Late-onset schizophrenia . . . E. Fuller Torrey, M.D., *Surviving Schizophrenia*, New York, 2001, pp. 125–27, 133–34.

17 The key determinant . . . Ibid.

17 He had periods . . . Medical records, 4/2/1904, ASCUNL.

18 "everything in the landscape . . ." Abraham A. Davidson, *Ralph Albert Blakelock*, 1996, pp. 183–84.

18 "The laws of the art . . ." *Appleton's Cyclopedia of American Biography*, 1887, p. 287.

3 Beatrice Adams

20 Adams may have . . . Ralph Blakelock, poem, MPC; see also Davidson, op. cit., p. 154.

20 In his note . . . Ibid.

20 Most important to Adams . . . Dorinda Evans, "Art and Deception: Ralph Blakelock and His Guardian," *American Art Journal*, vol. 19, no. 1 (1987), pp. 39–50. Evans's article provides many important facts about Mrs. Adams and her life.

21 "It would certainly . . ." Ralph Blakelock, note, MPC; see also Davidson, op. cit., p. 154.

22 "the most American . . ." Frank Jewett Mather, Jr., *The American Spirit in Art*, New York, 1927, p. 59.

23 "To think that . . ." *New York World*, 3/19/1916.

24 "If lovers of art . . ." Ibid.

24 "The truth should . . ." Ibid.

24 "truly representative of artists . . ." Ibid.

25 A glowing review . . . *New York Tribune*, 4/4/1916.

25 In the meantime . . . Smith, op. cit.

25 "I was just the man . . ." Ibid.

25 "I poured all this . . ." Ibid.

4 Release

28 Aware of the growing . . . *New York Times*, 4/2/1916.

28 "A new suit . . ." *New York Tribune*, "Blakelock, Free for Day," 4/12/1916.

29 "Everything on the long journey . . ." Ibid.
30 "Dr. Ashley . . . was astonished . . ." Ibid.
30 Blakelock spoke so much . . . *Middletown Times Press*, 4/12/1916, Middletown Psychiatric Center clippings scrapbook, p. 77.
31 "Blakelock is a little man . . ." *New York Tribune*, 4/12/1916.

5 From Yorkshire to New York

35 "The air is clear . . ." *New York Evening Post*, 10/15/1847.
35 Busy, respected practice . . . Mr. Blakelock appears as a practitioner and a committee member in many reports of the Homeopathic Medical Society of New York State during the mid-1860s and early 1870s, NYHS.
36 "He called it . . ." C. Blakelock to R. Vose, 4/7/1919, MPC; see also Davidson, op. cit., p. 7.
36 "She looked upon . . ." William Gerdts, "Ralph Albert Blakelock in New Jersey," *Proceedings of the New Jersey State Historical Society*, Newark, 1964, p. 125.
36 Mrs. W. D. Washburn . . . GP, "Notes on Conversation with Mrs. W. D. Washburn," 5/13/1947, AAAS; also Davidson op. cit., p. 7. Whitney Museum of American Art, *Ralph Albert Blakelock Centenary Exhibition*, introduction by Lloyd Goodrich, 1947, p. 9.
36 "plenty of money . . ." Ibid. But Washburn was much younger than Blakelock, and her memories date from a later period.
36 The doctor was . . . Many articles and encyclopedia biographies of Blakelock incorrectly state that he came from an affluent family. Davidson's brief account of the Blakelocks' beginnings in America (based partially on the Washburn interview) is also not always reliable. Blakelock's father did not bring the family to America (he was only ten years old at the time of their arrival in 1828), nor is the family tree he provides accurate. And Mrs. Washburn's statement that the family "always had plenty of money" is misleading, as Mr. Blakelock did not become a doctor until Blakelock was about fourteen years old. It has also been suggested that Blakelock spent part of his childhood in East Orange (see Davidson, pp. 29–30) with his aunt Emily and uncle James Johnson. But the Johnsons did not move to the Oranges until after 1865, and Blakelock did not move into their house on Pulaski Street until 1882.
36 His father was not . . . Trow, *New York City Directory*, 1847. Edwin Burrows, *Gotham*, New York, 1999, p. 475.
36 He had attained . . . New York City Common Council, *City Manual*, 1850, NYHS. The city manuals list Mr. Blakelock as a policeman from 1848 until 1861. The Homeopathic Society of New York State reports do not list Mr. Blakelock as a member until 1864, though some reports are missing due to the Civil War, NYHS.
36 For most of that time . . . Mr. Blakelock's salary as a patrolman, which he remained for more than ten years, was meager. City Manual, op. cit., correspondence with Virginia Blakelock, who has family wills and testaments.

37 And at Greenwood . . . John Blakelock requested one in his will, but there was no money to buy one.

37 Blakelock's father was . . . *Orange Chronicle*, obituary, 5/1/1897, p. 6.

38 "It lay among . . ." Peter Hunter Blair, *World of Bede*, 1990, p. 140.

38 "We have frequently . . ." Ibid., p. 117.

38 "Soon after the battle . . ." Janet Blakelock, *The Blakelocks*, typed excerpt of book, supplied by Douglas P. Blakelock.

38 They were renowned . . . Ibid.

38 His grandson, Albert . . . Ibid.

39 Even as an old man . . . Letter from C. Blakelock to A. Blakelock, 4/7/1919, MPC.

39 In 1828, Blakelock's grandfather . . . *Orange Chronicle*, op. cit.

39 By 1834, he had opened . . . Trow, *New York City Directory*, 1834.

40 The "year of national ruin" . . . Edward Robb Ellis, *The Epic of New York City*, New York, p. 242.

40 "This is the most . . ." As quoted in Ellis, ibid., p. 242.

40 His eldest son, Luke . . . Family tree provided by Douglas P. Blakelock.

40 But Ralph Blakelock . . . GP, Washburn, op. cit.

40 The population had almost . . . Burrows, op. cit., p. 576.

40 It was to this street . . . New York City directories supply addresses for the Blakelocks' carpentry shop and Christopher Street residence.

41 Mr. Blakelock had married . . . The Blakelocks' marriage date and information on Caroline Carey Blakelock come from her son's marriage license, her own death certificate, the family album of Dorothy Scanlon and Ruth V. Schmidt (Blakelock's granddaughters), and the *Orange Chronicle*, Dr. Ralph Blakelock, obituary, 5/1/1897.

6 Village Life

42 At one time . . . Trow, *New York City Directory*, 1847–48, 1850–51; Dogget, *Street Directory*, 1851.

43 The appointments, admitted . . . George W. Walling, *Recollections of a New York Chief of Police*, New York, 1887, p. 33.

43 On July 26, 1848 . . . New York City Common Council, *City Manual*, 1850, NYHS.

43 "The merely physical . . ." Walling, op. cit., p. 34.

43 Mr. Blakelock's duties . . . New York City Common Council, op. cit., 1854.

44 Ralph Blakelock's brothers . . . Trow, op. cit., 1850–51 and street directory 1851. See also family tree.

44 Like the Blakelocks . . . *Orange Journal*, obituary, 6/7/1884, *Orange Chronicle*, obituary, 6/7/1884.

45 "A few times a week . . ." New York City Common Council, op. cit. Manuals for 1850–60, *Public Schools* section.

46 Two days after Christmas . . . NYCMA, death record for Caroline A. Blakelock, 2/1/1864.

46 Mr. Blakelock moved his . . . Trow, op. cit., 1852.

47 The Crystal Palace . . . David Reynolds, *Walt Whitman's America*, New York, 1996, p. 302.

47 The art exhibit . . . Ibid.

47 We can take . . . J. W. Young, *Catalog of Works of R. A. Blakelock*, Chicago, 1916, p. 7.

47 Brimming under all . . . Ibid.

47 "Albert was always . . ." GP, Washburn, op. cit.

48 "It was very painstaking . . ." Ibid.

48 He was a large . . . Anne Ayres, *The Life and Work of William Augustus Muhlenberg*, New York, 1880.

49 In a sermon in 1820 . . . Ibid., p. 334.

49 "This will rebuke . . ." Ibid.

49 "The free pews . . ." William A. Muhlenberg, letter to the editor, unidentified newspaper clipping, 1846, St. John the Divine archival library, New York.

49 "I remember . . . how . . ." Charley Clowes, quoting Dr. Clinton Locke in *Men and Movements in the Episcopal Church*, New York, 1946, p. 363, St. John the Divine archival library, New York.

50 "He at once gathered . . ." Ayres, op. cit., p. 192.

50 "The benefit to a boy . . ." Ibid., p. 223.

50 Many years . . . Letter from C. Blakelock to R. C. Vose.

50 She seems almost unable . . . Ayres, op. cit., p. 99.

50 She found the reverend . . . Ibid., p. 100.

50 Indeed, it was Lawrence's associate . . . Church of the Holy Communion, Parish Register 1846–81.

51 In the mid-1850s . . . Burrows, op. cit., p. 748.

51 "The underworld was . . ." Ellis, op. cit., p. 277.

52 Over the weekend . . . *New York Times*, 6/5/1857, 6/8/1857.

52 The police force voted . . . Ibid., p. 278.

52 In the Jefferson Market . . . *New York Times*, 6/10/1857, p. 1.

52 They marched off . . . Ibid.

53 A few months later . . . New York City Council, *City Manual*, 1859.

53 Inside it had . . . Annette Blaugrund, *The Tenth Street Studio Building*, the Parrish Art Museum, 1997.

54 Its residents included . . . Ibid., pp. 14–18.

54 The critics' praise . . . David Huntington, *The Landscapes of Frederic Edwin Church*, New York, 1966, p. 5.

54 One viewer described . . . Ibid.

55 Viewers were encouraged . . . Ibid.; also Robert Hughes, *American Visions*, New York, 1997, p. 162.

55 At a time when . . . Ibid.

55 The walls of the studio . . . Blaugrund, op. cit.

56 He was also . . . Gerdts, op. cit., p. 123.

56 "Church goes there . . ." Undated letter from Rome, Jervis McEntee to Worthington Whittredge, Jervis McEntee Papers, addition, AAAS, Washington, D.C., office.

57 "Bierstadt is certainly . . ." Ibid., letter from W. Whittredge to J. McEntee, 10/16/1865.

7 The Blood

59 "The . . . public attach . . ." *New York Evening Post,* 6/18/1849, p. 1.

59 The practice of bleeding . . . Martin Kaufman, *Homeopathy in America,* 1971, p. 2.

59 "Tis a very hard . . ." Ibid.

60 Two quarts of blood . . . Ibid., p. 5.

60 The consequence of ingesting . . . Ibid., p. 5.

60 The situation had grown . . . Ibid., p. 13.

60 But their Jacksonian . . . Ibid., p. 23.

61 "Illness only exists . . ." As quoted in Carol B. Perez, M.D., "Homeopathy and the Treatment of Mental Illness in the 19th Century," *Hospital and Community Psychiatry,* vol. 45, no. 10 (October 1994), p. 1031.

61 According to Hahnemann's . . . Kaufman, op. cit., p. 25.

61 "He [Hahnemann] felt . . ." Ibid.

62 Unlike the orthodox doctors . . . *The American Homeopathic Review,* "Theory of Life," no. 2, p. 54, NYHS.

62 "This, in effect, meant . . ." Kaufman, op. cit., p. 26.

62 Dr. Blakelock began . . . His obituary incorrectly states that he graduated from Bellevue Medical College well before it was established in 1860. A search of the college files failed to find a record of his attendance. However, since no records were kept of the night-class program, which began in the late 1850s, it's possible that Blakelock attended those classes while he was still working as a policeman. The annals of the Homeopathic Medical Society of New York confirm that by the mid-1860s, Dr. Blakelock was an M.D. and served on various committees with the president of the organization.

62 In 1861, after the birth . . . Transactions of the Homeopathic Medical Society of the State of New York, 1864, p. 279; Trow, *New York City Directory,* 1861.

63 There were, in addition . . . There are several detailed anatomical drawings by Blakelock in the collection of the Adamson Duvannes Gallery collection.

63 Cora maintained that . . . C. Blakelock to R. Vose, 4/27/1906, VGA.

63 Blakelock had grown up . . . Eric Foner, *The Story of American Freedom,* New York, 1998, p. 54.

64 "I have no chair . . ." Walt Whitman, *The Portable Walt Whitman,* edited by Mark Van Doren, 1973, "Song of Myself," p. 90.

65 "This age is . . ." As quoted in Reynolds, op. cit., p. 264; *The Journals of Ralph Waldo Emerson,* Boston and New York, Houghton Mifflin, 1909–14, VIII, p. 477.

65 Whitman went out . . . Reynolds, op. cit., p. 265.

65 These "correspondences" extended . . . Matthew Baigell, *A Concise History of American Painting and Sculpture,* New York, p. 153.

67 By 1862, the services . . . Church of the Holy Communion, Golden Jubilee, *The Churchman,* 12/12/1896, p. 807.

67 He wanted his son . . . Letter from C. Blakelock to R. Vose, 6/10/1906, ASCUNL.

68 Eighty-five students failed . . . *Annual Report of the Free Academy,* 1864, p. 22, ACCNY.

68 By virtue of . . . S. Willis Rudy, *The College of the City of New York: A History 1847–1947,* ACCNY.
68 "The city cars . . ." Ayres, op. cit., p. 348.
69 "How strange this . . ." Rudy, op. cit.
69 The curriculum placed . . . Rudy, op. cit., p. 52.
69 As his school records attest . . . City College of New York, summary of Blakelock's school record, 2/26/1947, ACCNY. The summary says Blakelock "was not in the very top group of the Class, but he was a good student. He had no demerits for breaches of discipline." In his first semester, Blakelock ranked fifty-eighth out of 297 students and in his second seventy-second out of 223 students. A rare surviving roll book shows Blakelock testing in the top five or six students in his class in history and literature.
70 Drawing at the school . . . Rudy, op. cit., p. 28.
70 His aesthetic posture . . . Ibid., p. 147.
70 "That which ought . . ." John Ruskin, *Modern Painters,* preface, 1844.
70 "We believe that . . ." As quoted in John Taylor, *America as Art,* National Collection of Fine Arts, 1976, p. 121.
71 "If I ever painted . . ." Unidentified newspaper clipping, 1918, ASCUNL.
72 Not a week . . . David B. Dearinger, *Rave Reviews: American Art and Its Critics,* New York, 2000, p. 83.
72 "His love of painting . . ." Letter from C. Blakelock to Robert C. Vose, 1/10/1906, ASCUNL.
73 On February 1 . . . New York City Municipal Archives, death records.
73 In January 1866 . . . Ibid.; also Greenwood Cemetery burial records

8 The Art

75 "Three or four times . . ." Lillian Aldrich, *Crowding Memories,* pp. 55–56.
75 "Everything and everybody . . ." Jervis McEntee papers, letter from Worthington Whittredge to J. McEntee, 10/16/1865, AAAS Washington.
76 In the evenings . . . GP, Washburn, op. cit., AAAS.
77 "I met Mr. Blakelock . . ." Letter from C. Blakelock to R. Vose, 1/10/1906.
77 "When Albert was . . ." Letter from Margaret Hewitt to Ms. Gamble, 6/8/1960, Montclair Museum files.
77 It's dated August 1865 . . . Montclair Museum Collection.
78 Blakelock took this advice . . . Pennsylvania Academy of the Fine Arts, *Entry Form,* 1883, AAAS.
78 The painter Benjamin Champney . . . McGrath, *White Mountains,* p. vii.
78 Emerson wrote that . . . Ralph Waldo Emerson, *Selected Essays,* Penguin, 1985, pp. 47, 73.
79 "To the artist . . ." Reynolds, op. cit., p. 300.
79 Artists aimed for . . . William Wordsworth, *Lines, The Major English Romantic Poets,* edited by William H. Marshall, Washington Square Press, 1973, p. 130.
79 "Standing on the . . ." Emerson, op. cit., p. 39.
79 "Trust your own . . ." As quoted in Hugh Honour, *Romanticism,* 1979, p. 16.
79 "The laws of the art . . ." National Cyclopedia of American Biography, op. cit.
81 "One radiant outburst . . ." VGC. Poem found on the back of a Blakelock canvas.
81 The earliest known . . . The house in the painting closely resembles other

Canfield residences near the river that may have been rented by the Johnsons. Visited by the author.

81 They left "the little Blakelock" ... Letter from F. N. Canfield to Dr. John P. Munn, 4/5/1928, Fogg Museum files.

82 Johnson's daughter later told ... GP, Washburn, op. cit.

83 Similarly, as Davidson ... See Davidson, op. cit., p. 39.

84 "By the standards ..." Eric Homberger, *Scenes from the Life of a City*, New Haven, p. 218.

84 "Some portions of ..." Edgar Allan Poe, *Doings of Gotham*, as quoted in Homberger, op. cit.

85 "Here practically at ..." Nebraska Art Association, *Ralph Albert Blakelock 1847–1919*, catalogue of an exhibition at the Sheldon Memorial Art Gallery, essay by Norman Geske, 1975, p. 10.

86 The experienced academician ... Jervis McEntee papers, *Diary*, 3/24/1882, reel D180, AAAS.

87 It would not ... Ibid., 11/24/1878.

87 On varnishing day ... National Academy of Design Fall Catalogue, 1867, painting no. 309.

89 "The first Fall ..." *New York Times*, 11/15/1867.

9 Up the Missouri River

93 In June 1869 ... Ralph A. Blakelock, handwritten notes, Sheldon Memorial Art Gallery. Blakelock's brief notes were written in a drawing pad in which there are also sketches of Indians, plains animals, and pioneers. The notes begin at Fort Pierre (previously incorrectly identified as Fort Prine, which doesn't exist) and comment on the Indians and places his visited as he traveled up the Missouri to its confluence with the Yellowstone.

93 Here, too, that George Catlin ... Paraphrased from Charles E. DeLand, *South Dakota Historical Collections*, v. 1, p. 344. Also quoted in Robert Taft, *Artists and Illustrators of the Old West*, 1953, p. 45.

93 "It was an ideal spot ..." DeLand, op. cit., p. 344. Information on Fort Pierre also comes from Taft, op. cit., p. 45.

94 "Hundreds of lodges ..." Ralph A. Blakelock, notes, op. cit.

94 "Blakelock took a boat ..." J. W. Young Gallery, clipping from *Catalog of 62 Paintings and Bronzes*, Chicago, 1946, in Goodrich papers, AAAS. Young knew the Blakelock family, who, it appears, provided him with this account of the trip. The specific references to Duluth and the not widely known trading route through Minnesota to the Dakotas adds credibility to the account, which also fits neatly with Blakelock's own notes.

95 "There is a sublime ..." George Catlin, *Letters and Notes on North American Indians*, vol. 2., New York, 1973, p. 165.

95 He left little ... Copies of Blakelock's itinerary are in ASCUNL and GP. The sketchpads were cut up and distributed to members of the family. Many sketches are at the Sheldon and others at the Adamson Duvannes Gallery. Although the exact dates of Blakelock's trips remain uncertain, it's possible to confirm certain routes and times by carefully examining his itinerary, notes, and dated sketches and paintings.

96 All but the hardiest . . . Worthington Whittredge in his autobiography wrote: "It was impossible for me to shut out from my eyes the works . . . I had recently seen in Europe, while I knew well enough that if I was to succeed [in America] I must procure something new and which might claim to be inspired by my home surroundings . . . Very few independent minds have ever come back home and not been embarrassed by this problem," "The Autobiography of Worth. Whittredge, 1820–1910," ed. John I. H. Baur, *Brooklyn Museum Journal*, 1942, p. 42.

96 "The fact that . . ." Lloyd Goodrich, *Ralph Albert Blakelock Centenary Exhibition*, catalogue, Whitney Museum of American Art, 1947, p. 12.

97 "Six years later . . ." Nancy K. Anderson, *Thomas Moran*, Yale University Press, 1997, p. 48.

97 "is always a little risky . . ." Albert Bierstadt, letter published in *The Crayon*, 9/1859, p. 287.

97 Whittredge had a lower . . . Whittredge, op. cit.

98 "He had very little money . . ." Letter from C. Blakelock to R. Vose, 1/10/1906, ASCUNL.

98 During his trip . . . Blakelock notes, op. cit.

99 "This can not be . . ."Agent of Crow Creek Agency, letter, 5/17/1869, Dakota superintendancy, military records, roll M251, U.S. National Archives.

99 The situation was . . . Agent J. R. Hanson, letter, 5/19/1869, Upper Missouri Agency, Military Records, roll M887, U.S. National Archives.

99 Catlin speaks of . . . Catlin, op. cit., p. 165.

100 "Unlike the Sioux . . ." Blakelock, notes, op. cit.

100 They were poor . . . Ibid.

100 "The dog's liver . . ." George Catlin, *Notes of Eight Years*, vol. 1., catalogue item 437, Dog Dance Sioux, New York, 1848, p. 286.

100 Nominally on a reservation . . . General Henry A. Morrow, letter from Fort Buford, 11/19/1869, Dakota superintendency, military records, roll M251, op. cit.

101 "No communication or contact . . ." Ibid.

101 General Morrow observed . . . Ibid.

101 A rough drawing . . . Dorothy Scanlon collection.

101 In the morning . . . Blakelock, notes, op. cit.

102 It was not unknown . . . See for instance Charles Larpenteur, *Forty Years as a Fur Trader*, New York, 1898, pp. 328–29.

10 Indian Paintings

103 "cottonwood bark is . . ." Blakelock, notes, op. cit.

104 "Buried was all . . ." Henry Wadsworth Longfellow, as quoted in Davidson, p. 60, op. cit.

105 Although the one account . . . J. W. Young Gallery, clipping, op. cit.

105 Taking the Bozeman trail . . . Adamson Duvannes Gallery in Los Angeles owns more than a hundred sketches. Emigrant Gap, Humboldt River, Corinne, and several drawings of stagecoaches are among the scenes Blakelock sketched.

106 The sketches of . . . Collection of sketches, Sheldon, op. cit., and Adamson
 Duvannes, op. cit.

11 The Pacific and Home

108 His journey from . . . In September 1869, the Pacific Mail Steamship Com-
 pany reduced its schedule to a single monthly Panama departure. The S.S.
 Colorado was the only ship to make the stops along the Mexican coast that
 corresponds with Blakelock's drawings, at least one being dated Septem-
 ber 1869.
108 On "steamer day" . . . John H. Kemble, *The Panama Route*, Berkeley, 1943,
 pp. 152–53.
109 "We have no noise . . ." Ibid., p. 148.
109 According to the report . . . *Panama Star & Herald*, 10/1/1869.
110 Every summer, he headed . . . Church of the Holy Communion and National
 Academy records, as well as many dated drawings and sold paintings, indi-
 cate that Blakelock spent most of the winter/spring of 1869–70 and 1870–
 71 in New York City.
110 He became a . . . Letter from John Emmans to Warren Adelson, 10/25/1918,
 ASCUNL; American Art Association, *Catalog of the Estate of William Roome*,
 New York, 1926.
111 One of the first pictures . . . Blakelock made several preparatory drawings
 for the painting, which is dated and inscribed on the back; notes on the
 painting and Roome at the Boston Museum of Fine Arts.
111 Homer's paintings *Low Tide* . . . Margaret C. Conrad, *Winslow Homer and the
 Critics*, Princeton, 2001, p. 22.
111 "total disregard of . . ." Ibid.; *New York Evening Express*, 11/24/1869.
111 Roome paid Blakelock . . . Boston MFA notes and Roome catalogue, op. cit.

12 To Wyoming

112 Blakelock began his . . . Blakelock's itinerary specifically mentions the Kan-
 sas Pacific Railroad and lists many of the railroad stops in a clear east-to-west
 progression through the states and territories of Kansas, Colorado, Wyoming,
 Utah, and Nevada. This route corresponds with one he drew on a map. Still,
 scholars have been thrown off by Blakelock's inclusion of his stops on the
 way back, heading east, even though these place-names have been carefully
 grouped and circled in separate paragraphs. By skipping the eastward para-
 graphs the trajectory of his westward journey becomes evident. Unknown or
 less familiar place-names often indicate side trips Blakelock took along the
 way, including a detailed itinerary of his excursion into the Wyoming wilder-
 ness. Careful study of the list also confirms that this itinerary took place after
 the spring of 1870 (see notes below) and does not correspond to his trip and
 notes of 1869. The completion of *Indian Encampment Along the Snake River*
 in the first half of 1871 strongly suggests, if not confirms, that Blakelock's
 Wyoming trip took place in the summer of 1870.
112 Once in Kansas City . . . Blakelock itinerary; this Kansas Railroad link opened
 in the spring of 1870.

112 "Never a tree . . ." *New York Tribune,* 6/22/1869.
113 Blakelock, on a shoestring . . . Denver is conspicuously missing from Blakelock's
 itinerary. In the summer of 1870, the train tracks stopped some distance east
 of the city. A stage was provided to the railroad link north of Denver, which
 brought him to the next town on his itinerary, St. Vrain's Creek near Boulder
 and the town of Greeley, where the Utopian Meeker Colony had recently been
 established. Blakelock also lists side excursions to Long's Peak and Bear River,
 in the nearby Rocky Mountains, and the obscure Horse Tail Creek (now Cedar
 Creek) located about one hundred miles northeast of Greeley in the middle
 of nowhere—but with a good view of the Pawn Buttes.
113 Cheyenne also boasted . . . *New York Tribune,* op. cit.
113 In July, John A. Campbell . . . John A. Campbell, letter to Washington,
 7/25/1870, box file E1:1, Wyoming State Archives.
113 "I am sick . . ." Grace Raymond Hebard, *Washakie,* New York, 1980.
114 "Alive with Indians . . ." Cheyenne *Daily Leader,* 5/5/1870.
114 Likewise, the famous surveyor . . . F. V. Hayden, *Preliminary Report of the U.S.
 Geological Survey of Wyoming (1870),* vol. 4, published 1871, p. 1. See also
 letter from Sanford R. Gifford to Worthington Whittredge, 8/4/1870, which
 provides details on the expedition's contacts with the military—they needed
 permission and escorts to travel in certain areas—and the uncertainty of
 traveling in "hostile" Indian territory, AAAS, Washington.
115 In the late 1960s . . . Letter from Franz Stenzel, M.D., to George Faddis,
 1/14/1968, ASCUNL.
115 His extensive knowledge . . . Hayden, op. cit., vol. 6, p. 9.
116 He was soon . . . Formerly called Camp Augur, the post's name was changed
 to Camp Brown in the spring of 1870.
116 The Lander's view . . . *Wind River,* Adamson Duvannes Gallery, Los Angeles.
116 The post was . . . Hayden, op. cit., vol. 4, p. 37.
116 Either he was . . The Shoshone were friendly with and sometimes inter-
 married with the Bannock and Uinta Indians whom Blakelock met up with.
118 "Both the picture's . . ." Sotheby's, *American Paintings Catalog,* essay by Robin
 E. Kelsey, 5/24/2000, p. 206.
119 Blakelock spent much . . . The painting of such a large canvas as *Snake River*
 may have been the impetus for Blakelock renting the studio on Broadway.
 It was certainly too immense to be completed at home.
120 On August 25, 1871 . . . *Deseret Evening News,* 8/25/1871.
120 There were theaters . . . *San Francisco Chronicle,* 9/9/1871.
121 "Dinner soon after . . ." Smillie family papers, James Smillie diary, 7/11/1871,
 AAAS.
121 The scalp dance . . . Catlin, vol. 1, op. cit., p. 286.
123 "In his art . . ." Goodrich, *Centenary,* op. cit., p. 14.
124 "Where there were . . ." Taft, op. cit., p. 105.
124 With the exception . . . Goodrich, op. cit.

13 A Crisis

127 The scent of . . . Emerson C. Kelly, the unpublished biography of J. Francis
 Murphy, ch. 7, AAAS.

127 "His voice had . . ." Alfred Trumble, *The Collector*, 1890, p. 43.
127 Among the other . . . Kelly, op. cit., ch. 7.
128 Blakelock had the . . . Davidson, op. cit., p. 82.
128 The very next . . . Nebraska Art Association, op cit., *Moonlight, 58th Between 5th & 6th Avenue*, cat. no. 128, p. 48.
129 Twice on the . . . *Centaur* being the mythological half horse, half man; *Pauper*, poor or poverty—an obvious reference to the inhabitants of the shanty; *Sozodom*, or it could be *Solodom*, neither word being common Latin usage, but Blakelock may have been reaching for a derivation of *solum*, meaning alone.
129 "The 'public pulse' . . ." W. Whittredge to Jervis McEntee, 11/2/1873, Jervis McEntee papers, AAAS, Washington office.
129 Three days after . . . Museum of the City of New York, Shanty drawing, 9/22/1873.
129 In the following . . . There are a number of dated city sketches made during this period, including a shanty, dated September 22, one of the Hudson River at Sixty-fourth Street on September 30, another of West Fifty-seventh Street, and still others on Manhattan's Upper West Side. See also letter from Marian Blakelock to Robert C. Vose, 1908, for reference to dated sketches of this period.
130 "Church and Bierstadt . . ." Dearinger, op.cit., p. 94, and *New York Tribune*, 5/4/1868.
130 Other critics . . . Most notably James J. Jarvis. Clarence Cook, on the other hand, admired Meissonier.
130 "It is beginning . . ." *New York Evening Mail*, 4/14/1871.
131 "*Lobster Cove*," a *New York* . . ." *New York World*, 4/24/1870, quoted in Margaret C. Conrad, *Winslow Homer and the Critics*, Princeton, 2001, p. 34.
133 "Who wanted to? . . ." *Brooklyn Eagle*, 4/28/1874.
133 The musicians could . . . Ibid.
133 "Mr. Smillie has . . ." *New York Evening Mail*, 4/18/1872.
134 In 1877, Blakelock . . . Unidentified newspaper clipping, "Allen Blakelock: Tragic Career of his Painter Father," MPC.

14 Marriage

136 Blakelock and Cora . . . New York City marriage license, 2/19/1877; Davidson erroneously dates the marriage to 1875; consequently, his dating of paintings like *The Boulder and the Flume* are also off.
136 Cora was four months . . . Cora's premarital pregnancy may be the reason why she sometimes told outsiders that she and Blakelock were married in 1875. According to family documents, Carl's birth date was July 6, 1877.
136 The pastor was . . . Letter from Lewis W. Francis to L. Goodrich, 2/26/1947, GP, op. cit.
136 Blakelock retorted, loftily . . . Ibid.
138 Dr. Blakelock was . . . Suggestions that the Baileys were related to James Bailey of three-ring circus fame, an orphan who had no children, could not be verified by the author.
138 "She has ruled . . ." Letter from C. Blakelock to Allen Blakelock, dated "Tuesday afternoon," MPC.

138 "When he sold . . ." GP, Washburn, op. cit.
139 "I am afraid . . ." Letter from C. Blakelock to R. Vose, 2/26/1908, MPC.
139 "Mrs. Blakelock was . . ." GP, Notes on Conversation with Marian Schoch, 4/11/1947, AAAS.
140 In this regard . . . Letter from C. Blakelock to R. Vose, 6/10/1906, op. cit.
140 For dinner, bottles . . . Sara Welch, *A History of Franconia*, New Hampshire, 1972, p. 80.
141 Blakelock, too, was . . . Frederick Morton, *Brush & Pencil*, vol. IX, no. 5 (February 1902), "Work of Ralph A. Blakelock," p. 261.
141 The boulder, which . . . Lucy Crawford, *The History of the White Mountains*, 1883, p. 198.
142 They are, in essence . . . See, for instance, Kensett's unusually painterly landscape *Bash Bish Falls* (1885).
142 Blakelock's first child . . . Birth dates for the children are listed in Dorothy Scanlon's family album, and also Douglas P. Blakelock's family tree.

15 Recognition and Controversy

143 Cora remembered Blakelock . . . R. Vose interview with C. Blakelock, VGC.
144 "It was hung . . ." C. Blakelock to R. Vose, 2/26/1908.
145 "Blakelock and Maynard . . ." *New York Times*, 5/2/1879. This first review of Blakelock's work was somehow overlooked and has never been published before. It was previously believed that Blakelock's first review occurred a year later and that he was panned.
145 De Kay steered . . . Ibid.
146 Cora tells us . . . Letter from C. Blakelock to R. Vose, 2/26/1908, MPC.
147 "Out of the . . ." Geske, op. cit., p. 39.
147 Blakelock's miniature *Gertrude* . . . Davidson, op. cit., p. 70.
148 In 1880, one critic . . . *Art Amateur*, June 1880.
148 In these paintings . . . Davidson, p. 102, op. cit.
149 This new landscape . . . Geske, op. cit., p. 17.
149 "His pictures are . . ." Letter from C. Blakelock to R. Vose, 6/10/1906.
149 Blakelock, he announced . . . James William Pattison, "The Art of Ralph Albert Blakelock," *Fine Arts Journal*, Chicago, October 1912, p. 641. Pattison had a studio in the Sherwood Building, where he knew Blakelock in the mid-1880s.
149 "They told me . . ." *New York Tribune*, 4/16/1916.
150 "Fields in which . . ." William Morris Hunt, *On Painting and Drawing*, New York, 1976, p. vii.
150 "All that makes . . ." Ibid., p. 81.
150 To borrow the art . . . See Barbara Novak, *American Painting of the Nineteenth Century*, New York, 1979, p. 98.
150 "You must suggest . . ." George Inness quoted in Nicolai Cikovsky, Jr., *George Inness*, 1993, p. 99.
150 Among these young artists . . . Kelly, op. cit., ch. 7, AAAS.
151 It was this evocation . . . For the philosophical similarity of Blakelock's and

Inness's works, see Taylor, op. cit., pp. 128–30. *America as Art,* National Collection of Fine Arts, 1976.

151 In 1856, Inness . . . Cikovsky, op. cit.

151 In his University Building studio . . . Cikovsky, Jr., op. cit. p. 103.

152 Lloyd Goodrich discovered . . . GP, Conversation with Elizabeth Newbrough, 6/5/1947, AAAS.

152 "I went to work . . ." John Ballou Newbrough, as cited in Nelson J. Jones, *Thaumat-Oahspe,* Melbourne, 1912, p. 5.

152 "What science has . . ." Charles Kurtz papers, diary notes entitled "Prophetic Spirits," AAAS.

152 "I did not desire . . ." J. B. Newbrough, op. cit., p. 6.

153 The *New York Times . . . New York Times,* "Dr. Newbrough's Oahspe," 10/21/1882.

153 There were to be . . . See, for instance, John Newbrough, *The Light of Kosmon,* Los Angeles, 1939.

153 While others went . . . GP, E. Newbrough, op. cit.

153 There he became . . . *New York Times,* op. cit.

153 Still, spiritualist ideas . . . See, in general, Novak, op. cit., p. 147.

154 They preferred "poetic . . ." Baigell, op. cit., p. 155.

154 Ryder, too, was . . . See Lloyd Goodrich, *Albert Pinkham Ryder,* New York, 1959.

155 "I have read . . ." Ibid., p. 17.

155 The critic for *Art Amateur . . . Art Amateur,* April 1880, p. 90.

155 Blakelock was again . . . *Art Amateur,* vol. III, no. 1, June 1880.

156 "Mr. Blakelock follows . . ." Ibid.

156 "The ideal of art . . ." Ibid.

156 Blakelock and Ryder believed . . . Hunt, op. cit., p. vi.

156 "I squeezed out . . ." Goodrich, op. cit., p. 13.

156 Ryder and Blakelock were . . . See William C. Seitz, *Abstract Expressionist Painting in America,* Harold Rosenberg, *The Tradition of the New,* John Gordon, *Franz Kline 1910–1962,* and others for the connections between Blakelock and Ryder and abstract expressionist art.

157 "Imitation, the sincerest . . ." *New York Times,* 3/30/1882.

157 Indeed, it has . . . Nebraska Art Association, N. Geske, op. cit., p. 13.

157 Blakelock was gratified . . . GP, Washburn, op cit.

158 Indeed the show . . . The next year, when Thomas B. Clarke first purchased Ryder's work, the artist wrote him a letter expressing gratitude that the public was finally coming around to his art.

158 In *Art Amateur . . . Art Amateur,* July 1884.

158 The *Sun,* in a long . . . *New York Sun,* 6/1/1884, GP, op. cit.

159 "Of Mr. Blakelock's . . ." *The Nation,* May 29, 1884.

159 Blakelock received glowing *Mail Express,* 5/7/84.

159 His paintings were . . . *World,* 5/25/84.

159 Clarence Cook in . . . *Tribune,* 5/25/84.

16 East Orange

160 One pen-and-ink sketch . . . Gerdts, op. cit., pp. 121–27.

160 Blakelock, Cora, and their two . . . 1880 U.S. Census, Newark, 11th ward, vol. 6, ed. 66, sheet 28, line 48.

163 "He was as fond . . ." Unidentified newspaper clipping, 1916, ASCUNL.

163 "He simply dabbled . . ." Ibid.

163 Like Whistler, Blakelock . . . National Cyclopedia, op. cit.

164 "I wish you . . ." Unidentified newspaper clipping, op. cit.

164 Of the more than . . . *New York Times*, 6/1/1879.

165 "No one sold . . ." Pisano, *William Merritt Chase*, Seattle, 1983, p. 40.

165 "No one seems . . ." Blaugrund, op. cit., p. 90.

165 He paid Blakelock . . . *New York Herald*, 5/4/1913, GP, op. cit.

165 "Always I kept . . ." Elliott Daingerfield papers, unpublished autobiography, AAAS.

166 "If you like . . ." GP, op. cit., reel N631.

166 "It has been said . . ." Letter from C. Blakelock to R. Vose, 2/26/1908.

166 "When he sold . . ." Unidentified newspaper, op. cit.

166 But the potboilers . . . Letter from C. Blakelock to R. Vose, 3/27/1906, UNLSCA.

166 "I dimly remember . . ." Hewett, op. cit.

167 In 1882, Blakelock . . . Baldwin's Orange directory 1882–83; letter from H. Cornell Greening to Edwin A. Jewell, 1/13/ 1942; Washburn conversation, GP, op. cit.

167 Blakelock was part . . . Letter from C. Blakelock to R. Vose, 1/10/1906; *American Art News*, "Blakelock Again Exploited," undated (summer 1918) clipping, UNLSCA.

167 Blakelock gave strict orders . . . Letter from Henry H. Peck to R. Vose, 1/13/1928.

167 Of course, the other artists . . . Allen P. Crawford, unpublished biographical sketch of Hudson M. Kitchell, ASCUNL.

167 He "could uncork . . ." Letter from H. Cornell Greening to Edwin A. Jewell, 1/4/1946, GP, AAAS. Greening himself was a heavy drinker and is a biased and not always reliable source; still, many of the details he provides ring true and are corroborated by other sources such as Crawford.

167 At other times . . . Ibid.

167 He "got mad . . ." Ibid.

167 "Factory work was . . ." Letter from C. Blakelock to R. Vose, 1/10/1906.

168 After working with . . . Flavia Alaya, *Passaic County Historical Society*, "Silk and Sandstone: The Story of Catholina Lambert," Paterson, 1984.

168 "This was Lambert's . . ." Ibid., p. 12.

168 From floor to ceiling . . . Ibid., pp. 12–14.

169 "When I was . . ." Letter from Carl Blakelock to Mrs. Frederick Suydam, 2/8/1957, quoted in Diana Strazdes, *American Painting and Sculpture to 1945 in the Carnegie Museum of Art*, Pittsburgh, p. 75; see also Davidson, op. cit., p. 99.

170 Cora remembered that . . . Letter from C. Blakelock to M. Ricketts, 3/20/1912, *Fine Arts Journal*, vol. 33, July 1915, VGC.

171 They came to . . . See Blaugrund, op. cit., and Pisano, op. cit.

172 The opening of . . . Maureen C. Obrien, *In Support of Liberty*, the Parrish Art Museum, Southampton, New York, 1986, p. 17.

173 Several paintings that . . . See Gerdts, op. cit., p. 126; Davidson, op. cit.,

p. 105. Likewise, a pen-and-ink wash, *Children in the Hen House*, is almost Winslow Homer–like in its tidy, domestic appeal.

173 Johnson's daughter's recollection . . . GP, Washburn, op. cit.
173 Elizabeth Newbrough seconds . . . GP, E. Newbrough, op. cit.
174 The painting, which now . . . Franklin Kelly, *American Paintings of the Nineteenth Century, Part I*, National Gallery of Art, New York, 1996, pp. 41–44. This article provides an excellent description of the painting and its context. However, it relies in part on Marian Schoch's and Ruth Blakelock's memories to establish whether or not the Blakelocks had a garden and to determine Blakelock's state of mind when he painted the picture. Ruth's memory is irrelevant, as she was not yet born, and Schoch's recollection dates from the Blakelock's *second* stay in East Orange. More reliable, in this case, is H. C. Greening, who lived across the street and described the "extensive" Johnson garden, where he said Blakelock had a studio.
174 In the painting . . . Blakelock knew the land behind the Johnson house intimately. In one series of inks of the garden shed/studio, Blakelock drew the exact same scene at dawn, noon, and, most startlingly, under the starlight.
174 He, in effect . . . National Gallery, op. cit.
175 The service, "largely attended . . ." *Orange Journal*, 6/7/1884, p. 1; see also *Orange Chronicle*, 6/7/1884.

17 *A Waterfall, Moonlight*—A Taste of Success

177 The first open-studio . . . Blaugrund, op. cit., p. 79.
177 By that time . . . Carroll Beckwith, *Diaries*, 4/3/1885, roll 4798, AAAS.
177 His neighbors were . . . Amy Cross painted flowers in studio 8, and George Eichbaum, in studio 10, did portraits.
178 "It is about impossible . . ." Cikovsky, *George Inness*, op. cit., p. 84.
179 One day, a short . . . A well-known story often repeated. See Goodrich, *Centenary*, op. cit., p. 20.
179 "When the silvery . . ." Daingerfield, *Ralph Albert Blakelock*, p. 19
180 "But he never . . ." Letter from C. Blakelock to R. Vose, 2/26/1908, ASCUNL.
180 "He unrolled it . . ." This story was told many times in slightly different permutations. See *New York Herald*, 5/4/1913, and GP, AAAS.
180 "Painted in a suggestive . . ." National Academy of Design Annual Exhibition Catalogue, 1886, p. 129.
181 Blakelock had become . . . Nebraska Art Association, op. cit., *Sunset Landscape*, catalogue no. 23.
181 Blakelock, philosophically a . . . See Gelpi and Wilmerding, op. cit.
182 "At such times . . ." *The Nation*, op. cit.
182 His more conventional . . . In the 1886 National Academy annual exhibit Blakelock exhibited his experimental *Landscape* and a finely drafted and finished painting called *The Pleasure Boat*. Neither left much of an impression with the critics, who seemed, if anything, confused.
183 "Slowly over the tops . . ." Henry Wadsworth Longfellow, *Selected Poems*, "Evangeline," New York, pp. 63–64.

183 The moon was . . . There were other American painters, for instance, de Haas, who painted moonlights devoid of figures, but he did so in a realistic, unimaginative fashion.

184 Blakelock had created . . . Davidson, op. cit., p. 110.

184 Some notices appeared . . . The first important French Impressionists show was held in New York in the spring of 1886, and it was their turn to be condemned by the press.

184 "The extremest range . . ." *Art Amateur*, vol. 16, no. 4, 1887.

186 "The collection as . . ." *Harper's Weekly*, vol. XXX, no. 1562 (11/27/ 1886), p. 760.

186 *A Waterfall, Moonlight* . . . William Laffam, *Engravings on Wood*, New York, 1887.

187 "I remember when . . ." *New York Sun*, 8/17/1919; this article is more valuable than most in that it was based on original interviews with some of Blakelock's acquaintances.

18 Death and Vaudeville

191 In 1887, Blakelock . . . Exhibited in the academy autumn exhibit of 1887 and sold to the collector William T. Evans, this painting is likely the *Moonrise* now in the National Museum of American Art.

192 In the winter . . . New Jersey State Archives, death certificate B88.

193 A little more . . . Ibid.

194 "When we lived . . ." C. Blakelock to A. Blakelock, dated "Monday," MPC. Fullerton didn't deal in paintings until the late 1880s, so Cora is clearly referring to the family's second stay in Orange.

194 If Marian Schoch . . . GP, Marian Schoch, op. cit.

195 "He told her . . ." GP, E. Newbrough, op. cit.

195 The Swedenborgian orthodoxy . . . Marguerite B. Block, *The New Church in the New World*, New York, 1932, pp. 315–16.

196 When the church . . . Letter from C. Blakelock to Allen Blakelock, 3/19/20, MPC, letter from C. Blakelock to R. Vose, 3/27/1906, ASCUNL.

196 He sent delegations . . . Block, op.cit., p. 340.

196 It was in . . . A copy of the title page is in GP, op. cit.

197 "I did not know . . ." Black Elk, *Black Elk Speaks*, University of Nebraska Press, Lincoln, 2000, p. 207.

197 "everything we had lost . . ." Paul Auster, *Moon Palace*, New York, 1989, excerpted in Salander–O'Reilly Galleries catalogue, "Ralph Albert Blakelock," New York, 1998.

197 In *A Vision of Life* . . . Elizabeth Trebow, "Ralph Blakelock's 'The Vision of Life/The Ghost Dance': A Hidden Chronicle," *Art Institute of Chicago Museum Studies* 16, no. 2 (1990), 178–83; Davidson, op. cit., p. 80.

198 It was, in fact . . . *Art Amateur*, vol. 21, no. 1 (1889), p. 3.

198 The *Collector* called . . . *Collector*, vol. 1, no. 8 (2/15/1890), p. 48.

198 A Blakelock forest . . . Ibid.

198 "Neglected by a public . . ." *Collector*, vol. 2, no. 4 (12/15/1890), p. 42.

198 "He had absorbed . . ." Ibid.

199 At forty-three years old . . . See Blaugrund, op. cit., for a discussion of the importance of the Century Club as a marketing tool.
200 At the time . . . *Annals of the New York Stage*, vol. XV, 1891–94.
201 "I knew Blakelock . . ." Lew Bloom, note, 9/9/1918, VGC.
201 "I owned nearly . . ." Letter from Lew Bloom to R. Vose, 1/11/1923, VGC.
201 Arthur Milch, an art dealer . . . GP, "Milch Gallery" notes, 11/22/1946, AAAS.
201 "I made many . . ." L. Bloom to R. Vose, op. cit.
201 With his paintings . . . Robert W. Snyder, *The Voice of the City: Vaudeville and Popular Culture in New York*, New York, p. 5.
202 Here working-class . . . Ibid., p. 25.
202 Popular theaters like . . . Ibid., pp. 96–98.
203 It was an increasingly . . . Heightened awareness and other initial symptoms of schizophrenia are described in Torrey, op. cit.; John E. Nelson, M.D., *Healing the Split*, New York, 1994, pp. 41–48; and Sylvia Nasar, *A Beautiful Mind*, New York, 1998.
204 "I can't make . . ." Medical records, 5/9/1912, ASCUNL.

19 The First Collapse

205 "Be of good cheer . . ." Charles H. Mann, sermon, "Cheerfulness in Life," *New Church Messenger*, 3/19/1890.
205 "of a bright . . ." Letter from C. Blakelock to R. Vose, 1/10/1906, ASCUNL.
205 Marian, their eldest daughter . . . Marian Blakelock to R. Vose, 2/28/1908.
205 By the winter . . . Ibid.
205 "For a long time . . ." Letter from C. Blakelock to R. Vose, 2/28/1908.
206 "He conceived the idea . . ." Ibid.
206 The stigma of poverty . . . GP, Schoch, op. cit.
207 "He cut and slashed . . ." Letter from C. Blakelock to R. Vose, 1/10/1906, ASCUNL.
207 "I remember going . . ." *World*, 3/19/1916.
208 "Dr. Blakelock sent . . ." *World*, 3/26/1891.
208 "He was not violent . . ." *Brooklyn Eagle*, 3/26/1891.
209 He described Blakelock . . . *World*, 3/26/1891.
209 The treatment received . . . *New York Daily Tribune*, 3/26/1891.
209 "Hasty conclusions in . . ." *Brooklyn Eagle*, 3/27/1891.
209 "The news that . . ." Ibid., 3/29/1891.
209 "Every evening he . . ." Ibid.
209 "He did seem . . ." C. Blakelock to R. Vose, 2/26/1908.
211 There were years . . . Charles M. Kurtz papers, address books, AAAS.
211 Socrates saw the problem . . . Plato, *Phaedrus*, 265A.
211 "Of what is . . ." Michel de Montaigne, from *Complete Essays of Montaigne*, edited by Donald M. Frame.
211 Nature in all . . . Gamwell, 1995, *Madness in America*, 1995, p. 97.
211 "I am come . . ." Edgar Allan Poe, "Eleonora," as quoted in *Madness in America*, p. 97.
212 The recent discovery . . . There are a number of references to 1887 as a criti-

cal turning point. See GP, Milch Gallery, op. cit., and letter from
C. Blakelock to A. Blakelock, 4/7/1919, MPC.

212 "My dear Mr. Evans . . ." Letter from R. Blakelock to William T. Evans, 5/19/1896, William T. Evans papers, AAAS.

213 "It is possible . . ." Letter from George Maynard to W. Evans, 7/22/1894, Evans papers, op. cit.

214 Significantly, one study . . . Torrey, op. cit., pp. 125, 129.

20 Recovery and Relapse

216 In fact, several . . . Technically, they are wrong. Blakelock and Inness did not believe in Impressionism as it was practiced in France. For the Americans, steeped as they were in transcendentalist philosophy, painting was not so much about putting the tactile visual blur of the flowers and fields down on canvas as it was about using nature to evoke their inner feelings.

219 "Dear Harry W. Watrous . . ." National Academy of Design Letter Book, 1891–1916, AAAS.

219 In Brooklyn, in the . . . Many of these paintings found their way into the collections of Charles A. Schieren, Brooklyn's mayor, George Buek, the president of the American Lithograph Company, and William S. Hurley.

220 "We used to sit . . ." *New York Sun,* 8/19/1919.

220 However, other letters . . . Medical records, State of New York Long Island Hospital initial history, 10/25/1899, ASCUNL.

221 "Not all of us . . ." *New York Sun,* 9/17/1919.

221 "The winter Allen . . ." Letter from Marian Blakelock to R. Vose, 2/28/1908, ASCUNL.

221 A few months after . . . *Orange Chronicle,* 5/1/1897, p. 6.

221 Once again the death . . . C. Blakelock to A. Blakelock, 4/7/1919, MPC.

221 It was with his father's . . . Ibid.

222 "I found again . . ." Letter from C. Blakelock to R. Vose, 2/26/1908, ASCUNL.

222 "I was walking . . ." *New York Sun,* 9/17/1919.

223 "We were so poor . . ." C. Blakelock to A. Blakelock, op. cit.

223 "I hate to talk . . ." Ibid.

224 Indeed, several of Blakelock's . . . Conversations with Douglas P. Blakelock, Dorothy Scanlon, Ruth Schmidt, Carol Doney, and Myra Platt.

224 Some family members . . . Ibid.

225 In the 1870s, David Wells . . . Lawrence Weschler, *Boggs: A Comedy of Values,* Chicago, 1999, p. 39.

225 In 1886, the trompe l'oeil . . . Ibid.

225 Upon a drawing . . . Ibid.

226 "I can divide . . ." *New York Tribune,* 4/16/1916.

226 "[He] had threatened . . ." Medical records, Application for Commitment, 10/19/1899, ASCUNL.

227 "I was never afraid . . ." Letter from C. Blakelock to R. Vose, 2/26/1908.

21 Money and Modern Art

228 The American art committee . . . Diane P. Fischer, *Paris 1900: The "American School" at the Universal Exposition*, New Brunswick, 1999, p. 1.

229 "To such fearless . . ." United States Commission to the Paris Exposition (1900), Dept. of Fine Arts, *Official Illustrated Catalogue, Fine Arts Exhibit, United States of America, Paris Exposition 1900*, Boston, p. 16.

229 Blakelock's landscape, untitled . . . Fischer, op. cit., p. 195. The untitled Blakelock landscape, now unlocated, was loaned by George Hearn, and was listed in the official American catalogue as number 97.

229 "There are now . . ." *The Star*, 3/17/89, p. 14.

230 "Simply as pictorial convention . . ." Charles H. Caffin, *The Story of American Painting*, p. 218.

231 Several years later . . . Since the National Gallery of Art did not yet have a space for the paintings, they were first hung at the Corcoran Gallery of Art. Two unidentified newspaper clips, 3/8/1907, William Evans, AAAS.

231 The article, written . . . Morton, op. cit., pp. 257–69.

231 Blakelock, Morton wrote . . . Ibid., p. 257.

231 "With no art training . . ." Ibid., p. 260.

232 Likewise, Morton missed . . . Ibid., p. 258.

232 "For the recording . . ." Ibid., p. 269.

232 Blakelock—despite his artistic flaws . . . Ibid., p. 258.

232 "One cannot stand . . ." Ibid., p. 269.

233 She went against . . . *Harper's Weekly*, 4/12/03.

233 "Few American artists . . ." Macbeth Gallery, *Art Notes*, April 1900, p. 199.

233 In the first session . . . For comparison purposes, a Dewing and a Fuller each brought in about $700, a Twachtman $425, a Beckwith $130, and a Ryder $150.

234 "Building on the attitudes . . ." Matthew Baigell, *A Concise History of American Painting and Sculpture*, New York, 1996, p. 192.

234 "Both groups sought . . ." Ibid., p. 193; see also Barbara Rose, *American Painting*, New York, 1980, pp. 18–19.

22 Middletown and Catskill

236 "Says that he . . ." Medical records, ASCUNL.

236 On October 25, 1899 . . . Medical records, New York State commitment papers; Blakelock was originally sent to Kings County Hospital, ASCUNL.

237 He had an arsenal . . . Carol B. Perez, M.D. , "Homeopathy and the Treatment of Mental Illness in the 19th Century," *Hospital and Community Psychiatry*, vol. 45, no. 10 (October 1994), p. 1032.

237 "When first placed . . ." Ibid.

238 "[He] seems to want . . ." Medical records, 7/1901, ASCUNL.

238 "Declares it is not . . ." Ibid., 12/1903.

238 "This morning was . . ." Ibid., 7/13/1906.

238 "You destroy my business . . ." Ibid., 1/1904.

238 The attendants . . . Ibid., 7/1903.

238 The doctors stated . . . Ibid., 5/1903.

239 "Why is it . . ." Ibid., 10/1903.

239 The doctors remarked . . . Ibid., 10/1904.

239 "It was simply . . ." Ibid., 4/12/1913.

240 They asked if . . . GP, op. cit.

240 In the months . . . *New York Evening Mail & Express,* 2/18/1903.

240 "This is the day . . ." Letter from R. Blakelock to C. Blakelock, 9/13/1904, medical records, ASCUNL.

241 Mower House, in Leeds . . . Dorothy Scanlon, photograph of Mower House.

242 "Of course there . . ." Letter from Marian Blakelock to R. Vose, 2/25/1908.

242 "I have not . . ." Ibid.

242 "Marian's illness is . . ." Letter from C. Blakelock to J. W. Young, 12/7/1915, ASCUNL.

243 Cora, who was fifty-nine . . . *World,* 3/19/1916.

243 Cora's house was . . . Information about Cora's life in Catskill comes from interviews with family members, family letters, and Davidson, op. cit., pp. 144–47.

243 Cora "declared she . . ." *World,* 3/19/1916.

244 She had a great deal . . . Ibid.

245 "In the shoe drawer . . ." Ibid.

246 It's a stiff . . . The picture is reproduced in Davidson, op. cit., p. 147.

23 The Reinhardt Gallery Exhibit

249 It was "a city . . ." Henry Adams, *The Education of Henry Adams,* New York, 1931, p. 499.

250 Blakelock, spotting Watrous . . . *New York Tribune,* "Blakelock Free for Day," 4/12/1916, p. 1. Blakelock's visit to New York was also covered in the *World,* the *New York Times,* and other dailies.

250 "At the doorway . . ." Ibid., p. 9.

250 By all accounts . . . This is not entirely unusual, as some schizophrenics are known to have astounding long-term memories, though they may have no memory of immediate events.

250 "He remembered where . . ." Ibid.

250 The latter painting . . . *American Art News,* "Blakelock Benefit Show," 4/8/1916, vol. XIV, no. 27, p. 1.

251 In all there . . . Catalogue: *Loan Exhibition of Paintings by Ralph Albert Blakelock at the Galleries of Henry Reinhardt,* ASCUNL.

251 "I have always . . ." *New York Tribune,* op. cit.

251 "Well, I suppose . . ." *New York World,* "Blakelock . . . In City Once Cruel to Him," 4/12/1916, p. 1.

251 "'An artist can paint' . . ." Ibid.

251 "You have inspired . . ." *New York Tribune,* op. cit.

251 It was later . . . *New York Times,* "Blakelock in City to Escape Foes," September 17, 1916, p. 8. Also see Harrison Smith, *Saturday Review,* "Genius in the Madhouse," March 31, 1945, p. 14.

252 Adams had not . . . *New York World,* op. cit.
252 "It was not thought . . ." Ibid.
252 But another, less formal . . . Davidson, op. cit., p. 157.
252 "We must get back . . ." *New York Tribune.* The author has paraphrased the quote, which appears in slightly different variations in other accounts, op. cit. See, for instance, *Middletown Press Times* clipping, 4/12/1916, MPCL.
253 Blakelock, who was not . . . *New York Tribune,* op. cit.
253 "Blakelock protested that . . ." Ibid.
253 "He gave her . . ." *New York Times,* "Blakelock Returns to View His Work," April 12, 1916, p. 13.

24 The Real Mrs. Adams

254 His behavior, demonstrating . . . *World,* op. cit.
254 Four days later . . . Unidentified clipping, April 16, 1916.
254 In addition to . . . Letter from Knoedler to Watrous, 4/1/1916, KC; see also *World,* "Art Lovers Generous," March 30, 1916.
255 "If we needed proof . . ." *New York Times,* "Some Representative American Paintings," April 4, 1916, MPC.
255 The day before . . . NAD Certificate signed by Harry Watrous, MPC. Article in *World* on 4/21/1916 reported that Blakelock had only recently been sent his certificate as *associate* academician—to which he had been elected in 1913—along with an NAD insignia to wear in his buttonhole. Blakelock apparently showed "keen delight" in the honor, in contrast to his reaction three years before. This short article also mentions the approximate number of people who attended the exhibit in New York and the growing interest in other cities for a similar exhibit.
255 Robert C. Vose estimated . . . R. C. Vose, typed manuscript, "Notes on Ralph Albert Blakelock," VGC.
256 It appeared to be . . . The meeting was widely reported in the press. See, for example, *World,* "Blakelock Benefit," April 3, 1916, p. 11.
256 "I saw too much . . ." *World,* "Blakelock Delighted over New York Trip," 4/13/1916.
256 Some kind of . . . Cora signed the waiver on June 28, 1916; see Evans, p. 49, op. cit.
256 Young had published . . . J. W. Young, *Blakelock, His Art and His Family,* Young's Art Galleries, Chicago, 1916, MPC. The exhibition was held from April 27 to May 13 and was widely covered in the newspapers. Young had previously been in New York and accompanied Cora and her children to an auction at the Plaza Hotel; see *World,* "John M'Cormack Pays $20,000 . . . ," 4/15/1916.
257 On May 19, Mrs. Adams . . . Letter from New York Secretary of State office to August C. Streitwolf, Esq., 11/11/1916. Also reported in the newspapers, MPC.
257 On July 8, Adams . . . The joint committee was appointed July 8, 1916. Letter from Attorney General E. E. Woodbury to August C. Streitwolf, 11/13/1916, MPC.

257 Adams promised to pay . . . Letter from B. Adams to C. Blakelock, 8/30/1916, MPC.

257 "Appreciating your reluctance . . ." Ibid.

258 Dr. Ashley, in a curt . . . Letter from M. Ashley to C. Blakelock, 9/5/1916, MPC, ASCUNL.

258 To begin with . . . Evans, op. cit. Much of the detailed information that follows on Adams's early life and her "charitable" work in New York City comes from Evans's article. For more sources, see Evans's extensive footnotes.

258 Two years later . . . Ibid.

258 He was "a tall . . ." *New York Times,* 10/6/1906.

259 "I have nothing . . ." Ibid.

259 He gave her . . . Ibid.

259 McCormick and Crowell . . . Cited letter from H. P. Cromwell to H. F. McCormick, 10/20/1907, in Dorinda Evans, op. cit.

260 When, on the eve . . . Evans, op. cit.

260 In the future . . . Ibid.

260 In the summer of 1915 . . . *New York Evening Post,* 4/4/1916.

261 Once again, Mrs. Adams . . . See, for instance, *New York Times,* 9/6/1916; *New York Tribune,* 9/6/1916; and *New York World,* 9/10/1916.

261 He never missed . . . Dr. Ashley was frequently quoted in newspaper articles that appeared about Blakelock in March and April 1916. Information about his career was taken from the files of the MPCL. See retirement notice in the *New York State Hospital Quarterly,* 1922–23, p. 479. The hospital clippings books contain articles that refer to Ashley's frequent trips and expensive cars.

261 He seemed genuinely . . . For example, letter from M. Ashley to C. Blakelock, 9/15/1916, op. cit.

261 "Blakelock is insane . . ." *New York Times,* 4/4/1916.

261 "Call that man insane . . ." *New York World,* 4/12/1916, op. cit.

262 Later, Ashley would . . . Letter from Dr. M. Ashley to H. Watrous, 4/23/1919, ASCUNL.

262 Unless Ashley had . . . Ashley's Cadillac purchase was written up in the *Middletown Press;* see clipping in 1916 (October) clippings book, MPCL.

263 Mrs. Adams then . . . *New York Times,* "Artist Blakelock, Freed from Insane Asylum . . .", 9/6/1916; *New York Tribune,* "Blakelock to Woo Back Muse in Rustic Studio," 9/6/1916; *New York World,* "Artist Blakelock Is Happy in New Bungalow Studio," 9/10/1916; and *Toronto Daily News,* 9/8/1916, ASCUNL.

263 "He would launch . . ." *Middletown Press,* 4/12/1916 clippings book, MPCL.

263 By and large . . . *New York World,* 9/10/1916 op. cit.

263 Many of the works . . . Blakelock gave *Landscape 1916* to the National Academy of Design as his diploma painting in October 1916. It appears from the subject matter to have been completed that summer.

264 Mrs. Adams said . . . The painting, *Untitled—Moonlight with Figures,* was shown to the author by Dorothy Scanlon; it is reproduced in Davidson, op. cit., color plate 22.

264 A photograph at Lynwood . . . *New York Evening Journal,* 9/9/16.
264 His fame had, in just . . . *San Francisco Chronicle,* "Landscape by Blakelock at Park Museum . . ." 8/16/1916, p. 6.
265 Blakelock authenticated the . . . William T. Cresmer, typed manuscript, ASCUNL.
265 Mrs. Anna Clarence Siegel . . . Letter from A. C. Siegel to Blakelock, no date; also letter from A. C. Siegel to Blakelock, 2/2/1917, A. Propersi file, ASCUNL.
265 "I regret it will . . ." Letter from B. Adams to A. C. Siegel, 9/7/1916, A. Propersi file, ASCUNL.
265 "I am at a loss . . ." Ibid., 9/8/1916.
266 Adams simply impugned . . . Ibid.

25 A Battle of Hide-and-Seek

268 Money appeared to . . . See, for instance, *New York Times,* 9/6/1916, op. cit.
268 She sent Carl down . . . Undated three-page typed legal document, MPC; see below.
268 Nothing else can . . . Ibid. Carl and Ralph Melville Blakelock's attempts to see their father are described in detail in this legal complaint. This material was also covered by Davidson and Evans. However, the assumption that the complaint was prepared eight years later, when Blakelock's estate was being settled in New York Supreme Court, County of Orange, October 1924, is misleading. Although this document and others may have been filed as "exhibits" in that court settlement, there are several clear references in the document to "recent" events that indicate the document was, in fact, written in late 1916 or early 1917. The document refers, for example, to Blakelock being confined in Middletown "for the *past* sixteen or seventeen years." Its references to the Blakelock Fund, its "intentions," and the family's attempts to see Blakelock are all written in the present tense. For instance: "Why should it be so difficult for the members of the immediate family to visit Mr. Blakelock?" In addition, legal correspondence between a lawyer, August C. Streitwolf, acting on the family's behalf, and the New York district attorney's office also date to late 1916. The earlier dating of the document is important insomuch as it amply demonstrates that the family made a concerted, costly effort early on to extricate Blakelock from Adams's grasp. It also disputes notions that the family simply didn't care or was too removed to act on Blakelock's behalf.
269 Dr. Nelden told . . . Ibid.
269 "Guardian Fears Plot . . ." *New York Tribune,* 9/16/1916, p. 5.
269 "Blakelock in City . . ." *New York Times,* 9/17/1916, p. 8.
269 "With Mr. Blakelock . . ." Ibid.
269 "Mrs. Adams told . . ." Ibid.
269 "Dr. Nelden takes . . ." Ibid.

270 Adams then, like a . . . Ibid.

270 Mrs. Adams also let . . . *Art News*, 6/1918.

270 "Blakelock Hides in . . ." *New York Evening Journal*, 9/18/1916.

270 The district attorney's office . . . *New York Times*, 9/21/1916, p. 4.

271 On September 22 . . . Letter from E. E. Woodbury to C. Blakelock, 9/25/1916, MPC.

271 According to a legal document . . . Undated three-page document, op. cit.

271 "Mr. Blakelock is very well . . ." Letter from B. Adams to C. Blakelock, 9/29/1916, MPC.

272 Cora, trusting Mrs. Adams's . . . Medical records, petition from Maurice Ashley to the Supreme Court of Orange for a hearing to appoint a committee to act as Blakelock's guardian, 6/20/1916.

272 He had also known . . . Note from John Agar to George Kunz, 5/8/1918, NYHS.

272 This was all . . . Undated three-page document, op. cit.; letters from Watrous to the family indicate his role in an advisory capacity and his trust in Agar, ASCUNL.

273 "Mr. Blakelock asked . . ." Ibid.

274 "The paints used . . ." Ibid.

274 "In the face of . . ." Ibid. See also letters from Streitwolf to New York State authorities, 11/11/1916 and 11/13/1916, MPC.

26 Two Years of Freedom

275 Notwithstanding the Lynwood debacle . . . State of New York—State commission on lunacy discharge form signed by Ashley's subordinates, 2/13/1917, ASCUNL. In a later letter from B. Adams to M. Ashley on 11/4/1919, Adams refers to Blakelock's prior visit as lasting only a day. Davidson states that Blakelock was returned to Middletown after his first six-month probation ended in March 1917. Correspondence, medical records, and newspaper accounts, however, all document that Blakelock was paroled from Middletown on September 5, 1916, and did not return— except for the day of February 13, 1917—until November 4, 1918. He then remained at Middletown until his final parole on July 2, 1919.

276 It was being called . . . Undated clipping, "Blakelock's Genius in Vose Galleries," from Boston newspapers, MPC. See also Davidson, who cites this same review on p. 165, and identifies the newspaper as the *Boston Sunday Advertiser*, 2/12/1917, op. cit.

276 The Boston critics . . . Unidentified clipping, dated only 1917, MPC.

276 Blakelock "has given us . . ." Clipping "Blakelock's Genius . . . ," op. cit.

276 The critic for . . . *Boston Globe*, "Blakelock Pictures Show Master Hand," undated, MPC. See also Davidson, p. 165, op. cit.

276 He had visited . . . Among other things, Vose gave Allen Blakelock a job at his gallery after the war. See also Vose's *Notes on Ralph Albert Blakelock*, op. cit.

277 A week after . . . Letter from M. Blakelock to R. C. Vose, 2/17/1917, VGC.

277 "I exploded . . ." R. C. Vose, *Notes on Ralph Albert Blakelock*, op. cit.

277 Vose told Packer . . . Letters from R. C. Vose to B. Adams, 2/10/1917 and 2/23/1917, ASCUNL.

277 At this time . . . Letter from Packer to B. Adams, 2/1/1917, ASCUNL.

278 The Blakelock sketches . . . Letters from R. C. Vose to B. Adams, op. cit. See also Davidson, op. cit., p. 166.

278 "We went out . . ." Albert W. Davis notes on Blakelock, VGC.

278 "He went to . . ." Ibid.

278 Those who saw . . . For example, letter from R. C. Vose to B. Adams, 2/10/1917, op. cit.

278 "It seems to do . . ." Letter from B. Adams to R. F. Knoedler, 6/13/1917, KC.

279 "Mr. Blakelock has . . ." Ibid.

279 "You should see . . ." Letter from B. Adams to R. F. Knoedler, 6/24/1917, KC.

279 Adams joined him . . . In her letters to R. F. Knoedler that summer, Adams mentions not having been up to see Blakelock between mid-July and mid-August. See, for instance, letters from B. Adams to R. F. Knoedler, 7/30/1917 and 8/17/1917, KC.

279 Being an unattached . . . A letter written from Saratoga indicates that she did occasionally frequent the resorts.

279 "I am very sorry . . ." Letter from B. Adams to R. F. Knoedler, 7/30/1917, op. cit., KC.

280 "It is through you . . ." Ibid.

280 "He [Blakelock] has painted . . ." Letter from B. Adams to R. F. Knoedler, 8/17/1917, op. cit., KC.

280 She told Knoedler . . . Ibid.

280 Blakelock has painted . . . Painting is reproduced in N. Geske catalogue, op. cit., fig. 96, NBI 189; see also Davidson, op. cit., who dates painting circa 1917.

280 "He gave to she . . ." Blakelock poem, 2/23/1916, op. cit., MPC.

281 One cold rainy evening . . . J. Francis Murphy, *Diary,* Friday, November 30, 1917, AAAS.

281 She had already inquired . . . Letter from B. Adams to R. F. Knoedler, 5/3/1918, KC.

281 They were casting . . . Ibid.

282 "These painters can . . ." *New York Tribune,* 5/28/1918, district attorney clippings book, NYCMA.

282 Mrs. Adams told reporters . . . *Art News,* undated (late May or early June 1918), ASCUNL. See also accounts in *New York Times,* 5/29/1918, and others.

282 "Very few of . . ." Unidentified clipping, 6/4/1918, district attorney's clippings book, NYCMA.

282 "That's a supposed . . ." *Art News,* op. cit.

283 Kitchell appeared and admitted . . . *New York Sun,* 6/18/1918, ASCUNL.

283 Some of this money . . . Letter from B. Adams to R. F. Knoedler 6/26/1918, and from George Kunz to Knoedler 6/8/1918, 7/2/1918, and 9/16/1918, KC.

283 Even when Blakelock's estate . . . New York State Supreme Court—County of Orange documents, *The Judicial Settlement of the Proceedings of Beatrice Philibert Adams and John G. Agar, as Committee of the Person and Property of*

Ralph Albert Blakelock, an Incompetent Person, in front of Hon. Justice Arthur
S. Tompkins, 10/31/1924; supplied by Walter Wilson.

27 The Last Year

284 "One day when he . . ." Letter from C. Blakelock to A. Blakelock, dated only
 "Sunday," MPC. A similar version of this letter appears in Davidson, p. 168.
285 "I plan to take . . ." Middletown medical records, 11/4/1918, UNLSCA.
285 Ashley, as compliant . . . Ibid.
285 "Patient is quiet . . ." Middletown medical records, 1/31/1919, UNLSCA.
286 "Said he did nothing . . ." Ibid.
286 Letters sent to . . . Middletown medical records, 3/29/1919, 3/31/1919,
 UNLSCA.
286 "I too, just the same . . ." Letter from Adams to Knoedler, 2/20/1919, KC.
287 "Will you kindly advise . . ." Letter from R. M. Blakelock to J. Agar,
 3/10/1919, MPC.
288 "You know, of course . . ." Letter from Dr. M. Ashley to Harry Watrous,
 4/23/1919, ASCUNL.
288 "His mental condition . . ." Ibid.
288 "You will be glad . . ." Typed text of letter from B. Adams to R. M. Blakelock,
 4/24/1919, MPC.
289 On Monday, June 9 . . . *New York Times,* 6/9/1919, p. 1. This appears to be
 the article or the basis of a news item Davidson quotes from and suppos-
 edly was published in March 1917—hence the idea that Blakelock had been
 returned to Middletown two years earlier.
289 "The old painter . . ." Ibid.
289 Cora was soon in touch . . . Letter from C. Blakelock to A. Blakelock, dated
 "Sunday," op. cit.
289 "The day before . . ." Ibid.
290 "She set me . . ." Ibid.
291 She wanted Vose . . . See Davidson, p. 168. Davidson's source is a letter from
 C. Blakelock to A. Blakelock dated 6/27/1919. It is identical in parts to the
 "Sunday" letter.
291 On July 3 . . . New York State Supreme Court—County of Orange docu-
 ments, 10/31/1924, schedule "B," op. cit.
291 "The patient did not . . ." Medical records, 7/2/1919, op. cit.
292 "No placard on . . ." Emerson, as quoted in "Great Camps of the
 Adirondacks," p. 132.
292 Kingsley was chairman . . . Unidentified obituary clipping of William M.
 Kingsley, 9/17/1942; letter from Geoffrey Carleton to "Jim," November
 19, 1972, Elizabethtown Historical Society; interview with Debra Stanley,
 2/24/2002.
293 He had just . . . Interview with Debra Stanley, op. cit.
293 Mrs. Kingsley agreed . . . New York State Supreme Court—County of Or-
 ange documents, 10/31/1924, schedule "B," op. cit. See also *Lake George
 Mirror,* 7/19/1919.
293 Outside, a path . . . Interview with Debra Stanley, op. cit.

293 He took no interest . . . *New York World*, "Blakelock Dies in Adirondack Camp," 8/11/19. Although some newspaper accounts painted a cheery picture of Blakelock enjoying his last few weeks in the Adirondacks, the former account rings truer, and Middletown medical records corroborate Blakelock's loss of interest in the outdoors and general despondent outlook during the last few months of his life.

294 "He seemed to understand . . ." *New York Times*, "Ralph Blakelock, Mad Artist, Dies," 8/11/1919, p. 11.

294 "I know now . . ." Ibid.

294 "If I am insane . . ." Undated note, medical records, ASCUNL.

295 It's a seascape . . . *Untitled—Seascape*, see Geske catalogue, no. 85, NBI 258, op. cit.

295 By the time . . . *New York World*, 8/11/1919, op. cit.; see also *New York Sun*, "Blakelock, Artist Is Taken by Death," 8/11/1919, p. 7.

295 On Monday morning . . . See, for example, *New York Tribune, Chicago Daily Tribune*, and *San Francisco Chronicle*, all on 8/11/1919. Many newspapers ran lengthy obituaries the following Sunday, August 17, 1919.

295 A few were more dignified . . . Davidson, op. cit., p. 170, *New York Sun*, 8/11/1919, op. cit.

296 Her secretary told them . . . Letter from A. Blakelock to R. C. Vose, as quoted in Davidson, op. cit., p. 170.

296 The undertaker repeated . . . Ibid. See also letter from R. C. Vose to W. Cresmer, 8/15/1919, VGC.

296 The cause of death . . . Davidson, op. cit., p. 170, Elizabethtown Register of Deaths, 8/9/1919, *Elizabethtown Post*, 8/14/1919.

296 Later, some family members . . . Davidson, op. cit., p. 170.

296 The day before . . . Medical records, 7/1/1919, op. cit.

296 The famous sculptor . . . An account of the funeral and who was there appears in *New York Times*, 8/15/1919.

297 Adams dropped the . . . Ibid.

297 Two days later . . . Letter from R. C. Vose to W. Cresmer, 8/15/1919, citing *New York Herald*, 8/15/1919.

297 After Mrs. Adams's chat . . . *Art Review International*, vol. 1, no. 4, 5, 6, August–October 1919.

Epilogue

299 "I have much to say . . ." Letter from R. Vose to William T. Cresmer, 8/15/1919, VGC.

300 He was transferred . . . Letter from H. L. Edwards to C. Blakelock, 6/22/1921; Burial Certificate 261, Regulation 3201, County Clerk of New York, NUBI, Surrogate's Court, Orange County, New York, *Petition for Letters of Administration*, 7/12/1921. Conversation with Kensico Cemetery clerk, 4/10/2002. The four-hundred-dollar plot fee was paid for by the fund in Adams's and Agar's names.

300 The accounts for 1918 . . . Supreme Court, County of Orange, New York, *Judicial Settlement of the Proceedings of Beatrice Philibert Adams and John G. Agar,*

as Committee of the Person and Property of Ralph Albert Blakelock, an Incompetent Person, schedules "E" and "A," 10/10/1924.

300 Based on Adams's faulty . . . The actual amount handed over was further reduced to $174.51, W. H. L. Edwards to R. M. Blakelock, 3/6/1925.

301 "I often see . . ." Letter from C. Blakelock to Allen Blakelock, undated, ASCUNL.

301 She was picked up . . . Dorinda Evans, op. cit., p. 48; Dr. Arthur E. Soper to Dr. Walter A. Schmitz, 12/14/1943 and 1/27/1944, ASCUNL.

301 After Marian was . . . Interviews with family members, 11/2001.

303 Robert Henri, arguably . . . *New York Tribune,* "Exhibition to Aid Blakelock," 3/21/1916.

303 Bellows, a renowned painter . . . Ibid.

303 At such exhibitions . . . Eleanor Jewett, *Chicago Sunday Tribune,* "Art," 3/23/1919.

304 "a single good Blakelock . . ." Marsden Hartley, *Adventure in the Arts,* New York, 1921, p. 68.

304 Nevertheless, throughout the . . . For example, at the *Century of Progress* exhibition at the Art Institute of Chicago, Blakelock represented "romantic American painting at its best," and his work also appeared in the Museum of Modern Art's *Three Centuries of Art from the United States* in 1938.

304 Blakelock and a few others . . . Fischer, op. cit., p. 190.

304 "A solo exhibition . . ." *New York Times,* 1/13/1942.

305 "Blakelock was completely . . ." Robert M. Coates, "Blakelock," *New Yorker,* 5/3/1947, p. 70.

305 It has been widely recognized . . . Barbara Rose, *American Painting,* New York, 1980, p. 19. See also Dore Ashton's introduction to Seitz, op. cit.

305 "They value . . . expression . . ." Seitz, op. cit., p. 21.

306 Roberta Smith, a . . . Roberta Smith, "Islands of Peace in a Life Awash in Sadness," *New York Times,* 3/17/1996.

306 Above all, Smith . . . Ibid.

306 One of the most . . . An even more comprehensive traveling exhibition of Blakelock's work was later organized by Norman Geske and opened on January 14, 1975 at the Sheldon Memorial Art Gallery at the University of Nebraska, Lincoln, Nebraska.

SELECTED
BIBLIOGRAPHY

Unpublished Collections

Blakelock Nebraska Inventory, Archives and Special Collections, University of
 Nebraska–Lincoln Libraries
Lloyd Goodrich Papers, Archives of American Art, Smithsonian Institution
Myra Platt Collection
Knoedler & Company
William T. Evans Papers, AAAS
National Academy of Design, Letter Book 1891–1916, AAAS
Vose Galleries Collection

Books

Ashton, Dore. *Twentieth-Century Artists on Art.* New York: Pantheon Books, 1985.
Ayres, Anne. *The Life and Work of William Augustus Muhlenberg.* New York: Harper &
 Brothers, 1881.
Baigell, Matthew. *A Concise History of American Painting and Sculpture.* New York: Icon
 Editions, Westview Press, 1996.
Blaugrund, Annette. *The Tenth Street Studio Building.* Southampton, N.Y.: Parrish
 Art Museum, 1997.
Block, Marguerite B. *The New Church in the New World.* New York: Henry Holt and
 Co., 1932.
Broun, Elizabeth. *Albert Pinkham Ryder.* Washington, D.C.: Smithsonian Institution
 Press, 1989.
Burrows, Edwin G. , and Mike Wallace.*Gotham.* New York: Oxford University Press,
 1999.

Caffin, Charles H. *The Story of American Painting.* New York: Frederick A. Stokes Co., 1907.

Catlin, George. *North American Indians, Volume II.* New York: Dover Publications, 1973.

Cikovsky, Nicolai., Jr. *George Inness.* New York: Harry N. Abrams, 1993.

Conrad, Margaret C. *Winslow Homer and the Critics.* Princeton, N.J.: Princeton University Press, 2001.

Corn, Wanda. *The Color of Mood: American Tonalism 1880–1910.* San Francisco: M. H. De Young Memorial Museum, 1972.

Daingerfield, Elliott. *Ralph Albert Blakelock.* New York: Frederic Fairchild Sherman, 1914.

Davidson, Abraham A. *Ralph Albert Blakelock.* University Park, PA: Pennsylvania State University Press, 1996.

Dearinger, David B. *Rave Reviews: American Art and Its Critics.* New York: National Academy of Design, 2000.

Ellis, Edward Robb. *The Epic of New York City.* New York: Kodansha International, 1997.

Emerson, Ralph Waldo. *Selected Essays.* New York: Penguin, 1985.

Fink, Marie Lois, and Taylor, Joshua C. *Academy: The Academic Tradition in American Art, An Exhbition Organized on the Occasion of the One Hundred and Fiftieth Anniversary of the National Academy of Design: 1825–1975.* Washington: Smithsonian Institution Press, 1975.

Fischer, Diane P. *Paris 1900: The "American School" at the Universal Exposition.* New Brunswick, N.J.: Montclair Museum, 1999.

Foner, Eric. *The Story of American Freedom.* New York: W. W. Norton and Company, 1998.

Gamwell, Lynn. *Madness in America.* Binghamton: Cornell University Press, 1995.

Goodrich, Lloyd. *Albert Pinkham Ryder.* New York: George Braziller, Inc.,1959.

Grob, Gerald N. *Mental Illness and American Society: 1875–1940.* Princeton, N.J.: Princeton University Press, 1983.

Henri, Robert. *The Art Spirit.* New York: Icon Editions, Westview Press, 1958.

Honour, Hugh. *Romanticism.* New York: Harper & Row, 1979.

Howat, John K. *The Hudson River and Its Painters.* New York: Penguin Books, 1978.

Humboldt, Alexander von. *Cosmos Volume I.* Translated by E. C. Otte. Baltimore: Johns Hopkins University Press, 1997.

Hunt, Willam Morris. *On Painting and Drawing.* New York: Dover, 1976.

Jamison, Kay Redfield. *Touched with Fire: Manic-Depressive Illness and the Artistic Temperament.* New York: Free Press, 1993.

Kaufman, Martin. *Homeopathy in America.* Baltimore: Johns Hopkins University Press, 1971.

Kemble, John H. *The Panama Route.* New York: Da Capo Press, 1972.

Longfellow, Henry Wadsworth. *Selected Poems.* New York: Penguin Books, 1988.

Nasar, Sylvia. *A Beautiful Mind.* New York: Simon & Schuster, 1998.

National Academy of Design Exhibition Record, 1861–1900, 2 vols. New York: Kennedy Galleries, 1973.

Nelson, John E., M.D. *Healing the Split.* New York: State University of New York Press, 1994.

Novak, Barbara. *American Painting of the Nineteenth Century*. New York: Icon Editions, Westview Press, 1979.

Pisano, Ronald G. *William Merritt Chase 1849–1916*. Seattle: Henry Art Gallery, University of Washington, 1983.

Prown, Jules David. *American Painting: From Its Beginnings to the Armory Show*. New York: Skira Rizzoli, 1980.

Reynolds, David. *Walt Whitman's America*. New York: Vintage Books, 1996.

Rose, Barbara. *American Painting: The Twentieth Century*. New York: Skira Rizzoli, 1980.

Rosenberg, Harold. *The Tradition of the New*. New York: Horizon Press, 1959.

Ruskin, John. *Modern Painters*. London: E. P. Dutton, 1923.

Seitz, William C. *Abstract Expressionist Painting in America*. Cambridge, MA: Harvard University Press, 1983.

Taft, Robert. *Artists and Illustrators of the Old West, 1850–1900*. New York: Charles Scribner's Sons, 1953.

Taylor, John. *America as Art*. Washington, D.C.: National Collection of Fine Arts, 1976.

Torrey, E. Fuller. *Surviving Schizophrenia: A Family Manual*. New York: Quill, 2001.

Tuckerman, H. T. *Book of the Artists*. New York: G. P. Putnam and Sons, 1867.

Weschler, Lawrence. *Boggs: A Comedy of Values*. Chicago: University of Chicago Press, 1999.

Wilmerding, John. *American Light: The Luminist Movement 1850–1875*. Washington, D.C.: National Gallery of Art, 1980.

Articles*

"The Academy of Design," Harper's Weekly. vol. XXX, no.1562 (11/27/1886), p. 760.

"The Art of Blakelock," *The Nation* (5/4/1916), p. 473.

Coates, Robert M. "Blakelock." *The New Yorker* (5/3/1947), p. 70.

Collector, vol. 2, no. 4 (12/15/1890), p. 42.

Davidson, Abraham A. "The Wretched Life and Death of an 'American Van Gogh.'" *Smithsonian* 18 (December 1987), pp. 54–71.

de Kays, Charles. "Blakelock and Maynard—Pictures from France—E. M. Ward, Sargent, and O'Kelly." *New York Times*, 5/2/1879.

Evans, Dorinda. "Art and Deception: Ralph Blakelock and His Guardian." *American Art Journal*, vol. 19, no. 1 (1987), pp. 39–50.

Gerdts, William. "Ralph Albert Blakelock in New Jersey." *Proceedings of the New Jersey State Historical Society*, Newark, vol. 82, no. 2 (4/1964), pp. 121–27.

Morton, Frederick W. "Work of Ralph A. Blakelock," *Brush & Pencil.* vol. 9, no. 5 (2/1902), pp. 257–69.

Pattison, James William. "The Art of Ralph Albert Blakelock." *Fine Arts Journal*, Chicago, October 1912, p. 641.

Smith, Harrison. "Genius in the Madhouse." *Saturday Evening Review* 28 (3/31/1945), pp. 14–15.

*There are more than a hundred articles and reviews on Blakelock, many cited in the source notes.

Raymond Wyer. "Art and the Man: Blakelock." *International Studio* 59 (7/1916), p. 19.

Catalogues

Gebhard, David. *The Enigma of Ralph A. Blakelock 1847–1919.* The Art Galleries, University of California, Santa Barbara (1/7–2/2/1969). Text by Phyllis Stuurman and David Gebhard.

M. Knoedler & Co. *Ralph Albert Blakelock 1849 [sic]—1919* (3/3/–3/31/1973). Text by Warren J. Andelson, David D. Blakelock, and Susielies M. Blakelock.

Moulton and Ricketts Galleries. *Catalogue of the Loan Exhibition of Important Works by George Inness, Alexander Wyant, Ralph Blakelock.* March 10–22. Chicago 1913.

Nebraska Art Association. *Ralph Albert Blakelock 1847–1919.* Catalogue of an exhibition at the Sheldon Memorial Art Gallery held 1/14/–2/9/1975. Essay by Norman Geske.

Henry Reinhardt Galleries. *Loan Exhibition of Paintings by Ralph Albert Blakelock April 3 to April 15, 1916 at the Galleries of Henry Reinhardt.*

Salander–O'Reilly Galleries. *Ralph Albert Blakelock (1847–1919), An Exhibition of Paintings.* Essay by Norman Geske, 1987.

Salander–O'Reilly Galleries. *Ralph Albert Blakelock (1847–1919), Paintings.* Text by Paul Auster, Frederic Bancroft, and Floyd Skloot, 1998.

Vose Galleries. *Ralph Albert Blakelock N.A. 1847–1919, Drawings.* Boston 4/15/1981.

Whitney Museum of American Art. *Ralph Albert Blakelock Centenary Exhibition* (4/22–5/29/1947). Essay by Lloyd Goodrich.

J. W. Young. *Catalog of Works of R. A. Blakelock, N.A. and of his Daughter Marian Blakelock, Exhibited at Young's Art Galleries from April 27 to May 13, 1916.* Chicago 1916.

ACKNOWLEDGMENTS

This book would not have been possible without the help of the Blakelock family. Special thanks to the artist's great-great-granddaughter Myra Platt for her encouragement and for providing me with copies of family letters, medical records, documents, and photographs, and also to her father, Walter Blakelock Wilson, who sent me documents pertaining to the family's legal battle with Mrs. Adams. I would also like to express my gratitude to Douglas P. Blakelock (who supplied me with valuable information about his family's English ancestry) and his wife, Sally, and son, Paul C. Blakelock; also Carol Doney, Ruth V. Schmidt, Dorothy Scanlon, and Chet Blakelock for sharing their family memorabilia and for their hospitality. Thanks also to Virginia Blakelock for her informative e-mails, Susielies Blakelock, who spent many years collecting Blakelock material, and the many other family members who kindly responded to my inquiries.

The foundation for any study of Blakelock rests on the work of Lloyd Goodrich, former director of the Whitney Museum of American Art, and Norman Geske, director emeritus of the Sheldon Memorial Art Gallery at Nebraska University. Goodrich's research on Blakelock, conducted in the 1940s, includes interviews with Blake-

lock's family, friends, and acquaintances and is available at the Archives of American Art, Smithsonian Institute. I especially want to extend my appreciation to Norman Geske, who spent many years cataloguing Blakelock's paintings and provided a guiding hand in my research of the Blakelock materials he gathered, which are now housed in the Nebraska Blakelock Inventory, Archives and Special Collections, University of Nebraska–Lincoln Libraries.

Abraham A. Davidson's monograph on Blakelock was the first full-length scholarly book on Blakelock's art and the events of his later years. His extensive notes, bibliography, and illustrations were invaluable aids in researching this biography.

Important material was made available to me by Abbot W. Vose and his associates at the Vose Galleries in Boston, and the staff at Knoedler & Company, who shared with me the many unpublished letters of Mrs. Van Rensselaer Adams in their library. Jerome D. Adamson, director of the Adamson-Duvannes Galleries in Los Angeles, showed me his wonderful collection of Blakelock drawings. Many of the transparencies used for reproductions in this book were kindly provided by the Salander-O'Reilly Galleries.

Along the way I was provided generous assistance from individuals at many organizations, including the staff at Sheldon Memorial Art Gallery; Katherine L. Walter, chair of the Archives and Special Collections, University of Nebraska–Lincoln Libraries; Joy Wiener at the Archives of American Art, Smithsonian Institute; Judith McGrath at the Middletown Psychiatric Center Library, Barbara Dayer Gallati, curator of American art at the Brooklyn Museum of Art; Diane P. Fischer and the staff at the Montclair Museum; H. Barbara Wienberg, curator of American painting and sculpture at the Metropolitan Museum of Art; Jane Glover, at the M. H. deYoung Memorial Museum of San Francisco; Nancy Anderson, associate curator of American Art at the National Gallery in Washington D.C.; Linda Pryka at the Art Institute of Chicago; Mary Kate O'Hare and Holly Connor, at the Newark Museum; Diana Larsen at the Fogg Art Museum at Harvard; Selina Bartlett at the Worcester Museum; the staffs at the Museum of the City of New York, Yaddo, the New York Historical Society Library, the Frick Library, the

City College of New York archives; Heather Horgan for her work on the source notes; Whitney Jackson and the staff at the Elizabethtown Historical Society; and Debra Stanley, the present owner of Kingsley Cottage in the Adirondacks, where Blakelock died. I would also like to thank Mr. and Mrs. Joseph P. Carroll, Mrs. Joan Davidson, Leila and Henry Luce III. I am especially indebted to Patricia Bosworth and Michael Anderson for their guidance and advise.

This book never would have been written without the enthusiastic support of my agent, Russell Galen, and my editor, Joan Bingham. Finally, if it had not been for my dear friend Sarah Chace, her father, James, my wife, Stacy, and calm seas and fair skies off the coast of the island of Tuckernut, all might have ended differently.

This book is dedicated to my parents.

INDEX

Hill, Thomas, 120

Holy Communion, Church of the, 50, 56, 60, 67, 74, 110; funeral of James Johnson and, 175; progressive causes and, 48–49; Suydam family and, 169

homeopathic medicine, 59–63, 137, 236, 237

Homer, Winslow, 4, 7, 78, 185, 305; in Adirondacks, 292; correspondence with Blakelock, 213; critics and, 131; genre painting and, 132; in museum retrospectives, 304; National Academy of Design and, 87, 111; prices paid for paintings of, 165, 166; studio of, 54, 127, 142, 149; as Universal Exposition juror, 229

Hone, Philip, 40

Hudson River School, 54, 56, 76, 150; Blakelock as student of, 82–83, 118–19, 142, 147, 170; as "high brow" genre, 105; (post) modern views of, 80; waning of public interest in, 96, 130

Hughs, Thomas L., 291

Humboldt, Alexander von, 54–55

Hunkpapa Indians, 101

Hunt, William Morris, 150, 156, 181

Huntington, Daniel, 87

Huntington, David, 54

hydrotherapy, 15, 237

Impressionism, 11, 229, 231, 234, 303; Blakelock associated with by critics, 216; relation to Barbizon painters, 150

In the Land of Promise (Ulrich), 165

Indians (Native Americans), x, xii, 9, 29, 88, 178; American artists and,

97, 100, 121–22; Blakelock's mysticism and, 65; customs and rituals of, 100–102, 103, 123; dying culture of, 123, 124, 196–97; resistance to white settlement, 98–99, 113–15; trading posts of, 93. *See also specific tribes*

industrialization, 83, 185, 197

Inness, George, 4, 7, 124, 186, 199, 303; Barbizon school and, 130, 150–51; collectors and, 231; correspondence with Blakelock, 213; as friend of working people, 37; Impressionism and, 328; in museum retrospectives, 304; mysticism of, 151, 153–54; as premier landscapist, 232; studio of, 142, 149; Swedenborgianism and, xii, 65; as Tonalist, 181, 228; Vose Galleries and, 276

Inness, George, Jr., 151, 233

Irish immigrants, in New York, 33, 51, 68; shantytowns of, 84, 88, 129; in vaudeville, 202

Jackson, William H., 114

James, Henry, 65–66

James, William, 65, 152

Jewell, Edward Alden, 305

Johnson, Eastman, 84, 86, 132

Johnson, Emily Blakelock (aunt), 40, 42, 76, 87; in East Orange, N.J., 160, 192; marriage of, 44

Johnson, Grace, 173

Johnson, James Arthur (uncle), 44–45, 47–48, 55, 87; death of, 174–75; in East Orange, N.J., 160, 161, 162, 173–74; as mentor to Blakelock, 82–83, 88; summer home, 76, 77, 81